To Kay,
 Best Wishes,
 Clarke Hess

MW01054716

Mennonite Arts

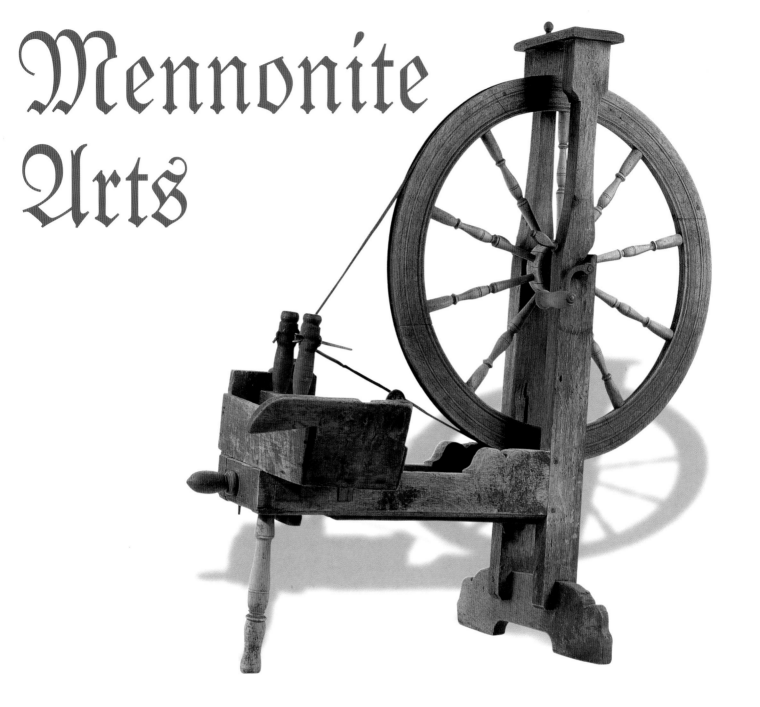

Clarke Hess

4880 Lower Valley Road, Atglen, PA 19310 USA

This is the fourth and final work in a series of books being produced by the Heritage Center Museum of Lancaster County and Schiffer Publishing Ltd. between 1999 and 2001. The series is intended to provide extensively illustrated works on the arts of the Pennsylvania Germans to a broad audience. The other volumes in this series include: *Fraktur: Folk Art and Family,* by Corrine and Russell Earnest; *Quilting Traditions: Pieces from the Past,* by Dr. Patricia T. Herr; and *Pennsylvania German Arts: More Than Hearts, Parrots and Tulips,* by Dr. Irwin Richman. Funding for this series has been made possible through a generous grant from the Pennsylvania Department of Community and Economic Development. The Heritage Center Museum gratefully acknowledges the support of State Representative John Barley for his assistance in securing this funding.

Library of Congress Cataloging-in-Publication Data

Hess, Clarke E.
Mennonite arts / Clarke Hess.
p. cm.
ISBN 0-7643-1414-9
1. Art, Mennonite. 2. Folk art--Pennsylvania--Lancaster County. I. Title.
NK835.P42 L3556 2001
745'.088'287--dc21
2001003757

Copyright © 2002 by Clarke Hess

All rights reserved. No part of this work may be reproduced or used in any form or by any means—graphic, electronic, or mechanical, including photocopying or information storage and retrieval systems—without written permission from the copyright holder.

"Schiffer," "Schiffer Publishing Ltd. & Design," and the "Design of pen and ink well" are registered trademarks of Schiffer Publishing Ltd.

Designed by Bonnie M. Hensey
Cover design by Bruce M. Waters
Type set in Zapf Chancery Bd BT/Aldine 721 BT

ISBN: 0-7643-1414-9
Printed in China
1 2 3 4

Published by Schiffer Publishing Ltd.
4880 Lower Valley Road
Atglen, PA 19310
Phone: (610) 593-1777; Fax: (610) 593-2002
E-mail: Schifferbk@aol.com
Please visit our web site catalog at
www.schifferbooks.com
We are always looking for people to write books on new and related subjects. If you have an idea for a book please contact us at the above address.

This book may be purchased from the publisher.
Include $3.95 for shipping.
Please try your bookstore first.
You may write for a free catalog.

In Europe, Schiffer books are distributed by
Bushwood Books
6 Marksbury Ave.
Kew Gardens
Surrey TW9 4JF England
Phone: 44 (0)20-8392-8585
Fax: 44 (0)20-8392-9876
E-mail: Bushwd@aol.com
Free postage in the UK. Europe: air mail at cost

I dedicate this book to my family, . . . past, present, and future.

Acknowledgments

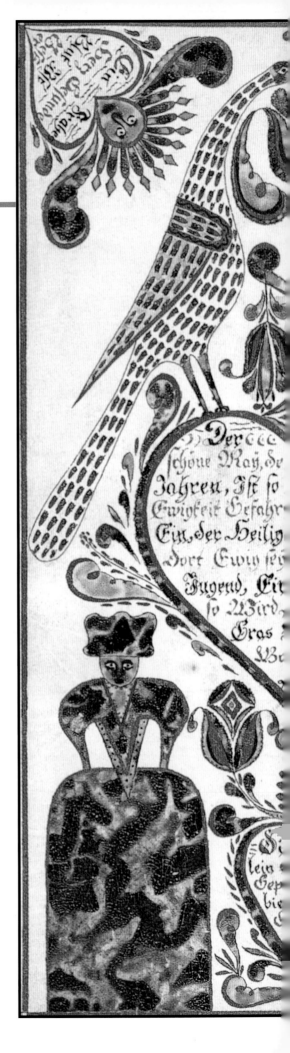

In November of 1991 Pastor Frederick S. Weiser asked if I would consider co-curating an exhibit at the Joseph Schneider Haus in Kitchener, Ontario. This exhibit would compare the traditional arts of the Mennonites of Lancaster County with those of their descendants who had established a sizable presence in the Waterloo County, Ontario, region. The exhibit was to be held in conjunction with a symposium that was titled *Continuity and Change: Pennsylvania-German Folk Culture in Transition.* I agreed to serve as a curator for the exhibit and worked closely with Susan M. Burke, the director of the Joseph Schneider Haus Museum. Although organizing the exhibit was a challenge, it was a pleasure to work with Susan Burke and her able staff. The resulting exhibit, *Changes in Latitude,* provided illustrations for the publication of symposium papers that appeared in the 1991 book *From Pennsylvania to Waterloo.*

Several years later, at the urging of Peter Seibert, director of the Heritage Center Museum of Lancaster County, and Dr. Patricia Herr, chairperson of its museum committee, I once again committed to organize an exhibit on the Mennonites. This exhibit was titled *Lancaster County Mennonites: Their Traditional Arts.* With the assistance of Peter Seibert and his always-helpful staff—Wendell Zercher, Kim Fortney, and Sandy Lane—the exhibit opened in April 1999 and continued through December. Even before the exhibit was open, Peter Seibert had posed the possibility of my authoring a book on Mennonite arts to include in their Pennsylvania German arts series, which they were jointly publishing with Schiffer Publishing Ltd. I quickly agreed with the concept, a fact that Peter probably later regretted, as deadlines approached and left without his having a complete manuscript in hand.

The scope of the book was broadened to include objects from other Mennonite settlements, particularly the folk-art-rich Franconia region of Bucks, Montgomery, Lehigh, Berks, and Chester counties in eastern Pennsylvania. While all of the exhibit objects were photographed by Bruce Waters, other photographers, including Nathan Cox and John Herr, provided numerous additional on-site photographs. It was a pleasure working with all of them. Each is a competent professional. A number of persons have provided valuable assistance by sharing their time and research: Joel Alderfer, curator for the Mennonite Heritage Center, Harleysville, Pennsylvania; Drs. Donald M. and Patricia T. Herr; Tandy and Charles Hersh; David R. Johnson; R. Martin Keen; Alan G. Keyser; John J. Snyder, Jr.; John Tannehill; Frederick S. Weiser; and Carolyn C. Wenger, director of the Lancaster Mennonite Historical Society.

Several persons who were invaluable in the process of completing the manuscript include Lee J. Stoltzfus, for helpful suggestions and preliminary editing; Dana M. Stacey, who typed and formatted the manuscript; and C. Eugene Moore, whose careful editing left my manuscript full of jots and

squiggles but provided a much-needed service. I would also like to thank Nancy Schiffer of Schiffer Publishing for her advice, encouragement, and patience.

The illustrated objects are a major component of any publication. The owners of the objects who graciously allowed them to be photographed have suffered the inconvenience caused by borrowing their objects. Some owners experienced the additional unpleasantness of having a researcher and a photographer altering their room settings in order to take on-site photographs of some of their larger pieces. All of you have my deepest appreciation for your patience and generosity. Lenders and persons who assisted include: Cory Amsler; Bruce Bomberger; Helen Booth; Jack and Ruth Bryson; Susan M. Burke; Lars Cain; Christie's; Tom Conrad; Mr. and Mrs. Dennis Cox; H. Richard Dietrich, Jr.; The Dietrich American Foundation; William F. Dupont; The Ephrata Cloister; Carol E. Faill; George S. and Carol Tucker Gadbois; J. Lloyd Gingrich; Donald C. Gish; and Esther Glick.

Also: The Germantown Mennonite Corporation; The Hamilton Club; The Hans Herr House; The Heritage Center Museum; Dr. and Mrs. Donald M. Herr; The Hershey Museum; Mrs. Ruth N. Hess; The Historical Society of Cocalico Valley; Amos B. Hoover; Joanne Hoover; Galen Horst-Martz; Harold Huber; Anthony L. Iezzi; The Jordan Historical Museum of the Twenty; The Joseph Schneider Haus; The Juniata Mennonite Historical Society; Mr. and Mrs. R. Martin Keen; James Keener; Alan G. Keyser; and Fred Koch.

Also: The Lancaster County Historical Society; The Landis Valley Museum; Miriam Lefever; Mr. and Mrs. Kenneth E. Lehman; The Lititz Historical Foundation, Inc.; Chris A. Machmer; Richard S. and Rosemarie Machmer; J. Lemar Mast; Sam and Kathy McClearen; Mary Ann McIlnay; James D. McMahon, Jr.; Mr. and Mrs. John Meck; The Mennonite Historians of Eastern Pennsylvania; and The Mercer Museum of the Bucks County Historical Society.

Also: Susan Sharpless Messimer; Jason E. Miller; Dave and Sandy Moore; The Muddy Creek Farm Library; Charles and Brenda Muller; The Peter Wentz House and Farmstead; The Philadelphia Museum of Art; Risser Mennonite Church; Harriet Polier Robbins; The Rothman Gallery of Franklin and Marshall College; Jay Ruth; The Sanford Alderfer Auction Company; Kathryn M. Shertzer; Mr. and Mrs. Wendell R. Shiffer; and Joanne Hess Siegrist.

Also: Margaret and Lawrence Skromme; Mr. and Mrs. Richard Flanders Smith; Mr. and Mrs. Clarence E. Spohn; John and Inta Tannehill; The Toad Hall Collection; Nan and Jim Tshudy; Robin Walker; Kitty Bell and Ron Walter; Frederick S. Weiser; Mrs. Mary K. Wenger; Robert C. Wenger; Winterthur Museum; and Mr. and Mrs. John W. Wissler.

Fraktur drawing, dated 1834, attributed to Samuel Gottschall (1809-98), active c. 1834-35, in Franconia Township, Montgomery County, Pennsylvania. This fraktur with its bold graphics and rich hues ranks among the finest of Gottschall's fraktur and is certainly an icon of Pennsylvania German fraktur art. The inscription translates as follows; the small hearts at the top: "A joyful heart, wholesome blood is better – All depends upon God's blessing and His grace." The central heart: "The beautiful blossoming May, of the fresh years of our youth, Is so quickly past; gone to Eternity. Now gather in the little blossoms of Holiness and Virtue, So they will be forever there, the blooms of our Youth. A blossom soon withers, so youth becomes old. The grass is cut off; upon what will you then build?" In small heart: "The flowers stand here, planted on paper. God himself will paint them, water and shine upon them." *Wove paper, watercolor, and ink, ,12.5" x 7.75". Photograph courtesy of Sanford Alderfer Auction Company.*

Contents

Introduction

The name Mennonite conjures up a variety of images depending on your point of reference. For many people the image is that of tightly knit farm families who shun modern conveniences. Farm families who travel by horse and buggy, live without electricity, and wear a peculiar style of clothing. Other people see images of the more liberal branches of the church. They see Mennonite medical workers, university professors, artists, or social workers who dress and live very much like most North Americans.

The Mennonite-related groups include a population of about 1,200,000 persons. Many of these Mennonites are not in North America. Due to a pioneer spirit and a zeal for mission work, substantial Mennonite populations live in Central and South America, Europe, Asia, and Africa. In fact, only about 444,000 Mennonites reside in North America.

The Mennonite Church traces its origins to the Protestant Reformation that was occurring in western Europe in the early decades of the 1500s. This group, originally known as Anabaptists, organized in Switzerland and Holland, and soon spread throughout Germany and into Austria, France, Belgium, and beyond. The first of these Mennonite families sailed for America in the 1640s. However, mass migration wouldn't occur until the early 1700s. This book examines the decorative art traditions of these people, often called the Old Mennonites, who settled in Pennsylvania, initially to the east of the Susquehanna River.

Many Mennonites remained in Europe. Others continued to emigrate to America as late as the 1940s, some 200 years after the end of the main migrations of the Old Mennonites into Pennsylvania. In the late eighteenth century, Queen Catherine II invited Prussian Mennonites to settle in the wide expanses of the Ukraine. Beginning in the 1870s, this group initiated a major exodus to the United States and Canada. They carried with them distinctive forms of folk art that have been studied in other publications.[1] Similarly, other smaller groups of Swiss and German Mennonites continued to arrive in the United States, primarily in the early decades of the nineteenth century. They typically established communities in the Midwestern states. Notably, a Swiss group founded the Sonnenberg Community in Wayne County, Ohio, producing a variety of traditional art forms; these also have been documented in an excellent publication.[2]

The Mennonites who settled in eastern Pennsylvania were a small portion of the larger Pennsylvania German population that had established itself in Pennsylvania, Maryland, Ohio, North Carolina, Virginia, West Virginia, and Ontario by the end of the eighteenth century. The Mennonites shared a common language, Pennsylvania Dutch, with their Lutheran and Reformed neighbors. They also shared numerous folk traditions that were reflected in the traditional arts they created in their new environment. Mennonite arts were produced within the context of the broader Pennsylvania German popu-

lation, and as such are often similar to objects produced by their Lutheran or Reformed neighbors. But differences did exist. The Pennsylvania Mennonites, for instance, displayed strong preferences for certain regional folk art forms such as fraktur handwriting examples and decorated towels. A few textile forms appear to have been unique to Mennonite needleworkers: decorated aprons and wedding handkerchiefs. The rare eighteenth century form of furniture decoration known as sulfur inlay was possibly introduced by the Lancaster County Mennonites, who appear to have owned not only the earliest examples but also the most highly decorated sulfur-inlaid objects.

Many of the objects that were created by the Pennsylvania Mennonites were reflective of their Germanic cultural traditions. In their new homeland, where they were rapidly exposed to other influences, they often modified their arts or adopted new forms as a result of the ever-present Anglo influences. Thus, within decades of their arrival in Pennsylvania, Germanic cabinetmakers were producing English furniture forms that exhibited traditional Germanic details. By 1830 Mennonite needleworkers were stitching English rhymes on their samplers and decorated towels. They were already experimenting with the English fabric art known as quiltmaking, a textile tradition they embraced so passionately that it remains to this day a defining art form of Mennonite women. Thus the realm of Mennonite Arts includes traditional, adapted, and borrowed folk forms.

The majority of objects that are included in this study were owned and/or created by Mennonites prior to 1900. Most of the objects can be documented as having been made and used by the Mennonites. Some early furniture has been included that cannot be attributed to a particular cabinetmaker; however, it is known that such pieces were crafted for Mennonite owners. This furniture is included in the book because it represents important examples of the domestic furnishings of Mennonite households, even though their makers' names have been lost. A few objects have been included that date as late as the mid-1900s. These are survival examples of traditional folk forms and were invariably crafted by members of the Old Order Mennonite community. I include them in the book to demonstrate the continuity of folk traditions that have been preserved by the more conservative Mennonite groups. A few objects have been included that originate in Mennonite communities outside eastern Pennsylvania to illustrate the transfer of folk forms to later settlements. The greatest wealth of parallel folk art forms that directly relate to the arts of the early Mennonite settlements in eastern Pennsylvania can be found in the rich folk traditions of the Mennonites who settled on the Niagara Peninsula, and northward into Waterloo County, Ontario. Their fraktur, textiles, pottery, and furniture forms not only echo their Pennsylvania origins, but exhibit a lively sense of creativity as well.

Pennsylvania German arts have long been collected for their vibrant colors, their whimsical forms, and their exceptional craftsmanship. Collectors have eagerly purchased Mennonite folk art, with the best objects commanding five or six figures. However, the true significance of an object lies not in its market value but rather in its importance as a cultural artifact: an object that links the present generation with the distant past. Its value is as a timeless reminder of the loving hands that created it, the traditions that it embodies, and the generations of owners who have treasured it ever since. It is my hope that this study will serve as an aid to collectors who already know and love Mennonite arts. It is my wish that this book will help to foster a deepened appreciation in the broader Mennonite community for the arts of our forebears.

CEH February 2001
Johannes Hess homestead
Warwick Township,
Lancaster County, Pennsylvania

Chapter One
European Origins

The origins of the Mennonite Church are rooted in the early history of the Protestant Reformation as it unfolded throughout western Europe in the early 1500s. In the city of Zurich, Switzerland, the Swiss reformer Ulrich Zwingli (1484-1531) succeeded in convincing the city fathers to accept the Protestant Reformed Church as the cantonal denomination in 1522-25, thus ending hundreds of years of Catholic control. Some of Zwingli's fellow reformers were opposed to the establishment of a state church, and they also felt that infants should not be baptized. They met secretly in January 1525 and baptized one another. Soon this renegade group became known as the Anabaptists, or re-baptizers. Among their earliest members were an ex-priest named George Blaurock along with Conrad Grebel, Felix Manz, and Michael Sattler.

This small group of dedicated reformers, preaching throughout the Swiss countryside and into Germany and Austria, soon gathered a substantial number of followers to their group, which they referred to as the Swiss Brethren. Among the tenets of their faith were the insistence on the separation of church and state, separation from the evils of the world, pacifism, and the practice of baptizing adults. It was their conviction concerning the believer's baptism that drew the ire of their cantonal authorities. Infant baptism was required by the state church. By refusing to comply, the Swiss Brethren were branded as heretics and enemies of the state. In January 1527, two years after he helped to found the movement, Felix Manz (1480-1527) became the first martyr to be executed by the Protestants in Switzerland, when he was drowned in the Limmat River (fig. 1).

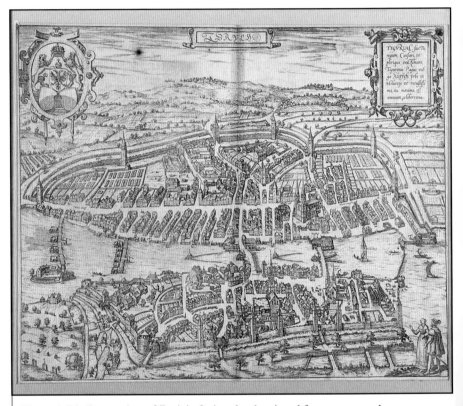

Figure 1. Bird's-eye view of Zurich, Switzerland, printed from a copperplate engraving by Braun and Hogenberg, Zurich, c. 1580. This view of the old walled city of Tigurum (Zurich) locates sites that were all too familiar to sixteenth century Mennonites. The Limmat River, flowing through the center of Zurich, was frequently the site of Mennonite martyr drownings. The Wellenburg Tower, located in the center of the river to the right, was a notorious prison, as was the Convent Othenbach, the group of buildings having a central courtyard, located to the lower left of the river. Most of the Mennonites of Canton Zurich fled to other areas, including the Palatinate in Germany, from which many of their descendants subsequently settled in Pennsylvania. *Laid paper, ink, 15" x 19.5". Private collection.*

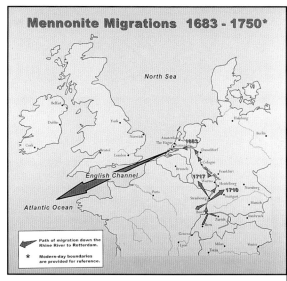

Mennonite Migrations 1683 - 1750*

North Sea

Belfast

Dublin

York

Norwich

Hamburg

Berlin

Cork

Bristol

London

Amsterdam
The Hague 1683

Düsseldorf

Cologne

English Channel

Brussels

Frankfurt

1717 Worms

Heidelberg

Nürnberg

Atlantic Ocean

Paris

Strasbourg

1710 Stuttgart

Munich

Basel

Zürich

Innsbruck

Bern

Geneva

Milan

Venice

Lyon

Turin

↗ Path of migration down the Rhine River to Rotterdam.

* Modern-day boundaries are provided for reference.

Figure 2. Mennonite migrations chart, showing the Rhine River as the major artery of the emigration from Switzerland heading northward, down the Rhine, where refugee families settled in the Alsace region of France (to the west of the Rhine), the Palatinate (north of the Alsace), and across the Rhine to the Kraichgau region (located between Heidelberg and Stuttgart). From the village of Krefeld, near Düsseldorf, the first group left Germany in 1683 to found Germantown, near Philadelphia. Other major waves of immigration occurred in 1710 and 1717, helping to establish the Franconia region, about thirty miles north of Philadelphia, and the Pequea settlement in Lancaster County, about sixty miles west of Philadelphia. *Courtesy of the Heritage Center Museum.*

Over the next hundred years thousands of Anabaptists would be martyred throughout Switzerland, Germany, Austria, Holland, and Belgium. In Switzerland others were imprisoned, were sold as galley slaves to Italy, or had their property confiscated and were banished from ever returning to their homeland. The accounts of their martyrdom were carefully gathered by a Dutch historian named Thielman J. van Braght, who in 1660 published the *Martyrs' Mirror*, as it was later called. This massive volume was later translated and printed at Ephrata, Pennsylvania, in 1748 and 1749 (fig. 35).

In Friesland, Holland, a Catholic priest named Menno Simons (1496-1561) embraced Anabaptism in 1536. He became an important church leader in Holland and beyond, and ultimately it was his name that was applied to this radical group, the Mennonites. Although the earlier names of Anabaptist and Swiss Brethren continued in use for generations, it was the name Mennonite that would eventually be accepted by all branches within the denomination. Tolerance came quickly to the Dutch Mennonites, and many of their members became wealthy urban merchants. Their generosity would later play a vital role in the story of the migration of the Swiss-German Mennonites to Pennsylvania.

In Switzerland Anabaptism spread to other cantons; however, the major Anabaptist populations were located in the villages and countryside of Canton Zurich and Canton Bern. The last Anabaptist martyr in Switzerland was Hans Landis, who was beheaded in Zurich in 1614. He is believed to be the ancestor of most of the Landis families that settled in Pennsylvania. The executions had ceased, but Swiss Brethren were still being imprisoned, with many dying due to the poor prison conditions. Meanwhile the Thirty Years War (1618-48) had ravaged the Palatinate region of Germany, destroying farms and villages and largely depopulating the region. As early as 1641 Swiss Anabaptists began to move into the area. By 1652 Ibersheim, a village on the west bank of the Rhine, was home to a number of displaced Swiss families (fig. 3).[1] In 1664 Karl Ludwig, Elector of the Palatinate, recognizing the role that these poor immigrant families could play in his effort to rebuild his territory, issued an "Edict of Tolerance." This edict allowed the Mennonites to be exempt from military service, allowed them to worship in groups of not more than twenty families, and required them to register and to pay a fee as "Mennonite Recognition Money." The generous terms offered by Karl Ludwig greatly encouraged the migration of the persecuted Swiss to join other German and Dutch Mennonites who already were settled in the region.

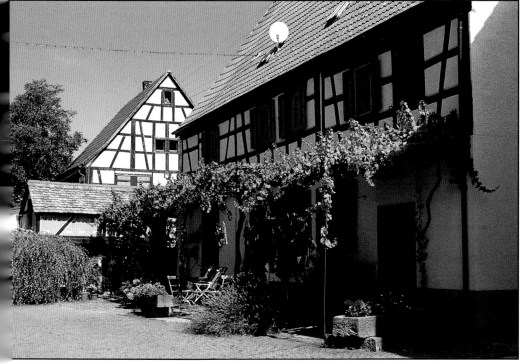

Figure 3. The village of Ibersheim, located along the west bank of the Rhine River in Rheinhessen, Germany. By the 1650s Bernese Mennonites had leased the Ibersheim estate, establishing a thriving village, and farming the surrounding lands. The village of Ibersheimershof, as it was formerly known, became an important refuge for families that had left Switzerland and would eventually emigrate to Pennsylvania. The village has remained predominantly Mennonite. *Photograph by the Author.*

In the Swiss canton of Bern, renewed persecution in 1670 and 1671 caused a mass migration of the Mennonites down the Rhine River to the German Palatinate.[2] By the beginning of 1672 it was recorded that 787 Bernese refugees had recently arrived. These families were predominantly poor, as most had had their Swiss property confiscated by the authorities. They settled in the Palatinate, west of the Rhine, and in the Kraichgau, which was then a part of the Palatinate, east of the Rhine (fig. 2). They occupied villages and Hofs (farms), helping to rebuild the soil and the ruined properties as tenant farmers. Many of these refugee families would later emigrate to Pennsylvania, after tiring of the many restrictions that local rulers continually placed on them. In 1678 William Penn preached to a small group of Quakers and Mennonites in the Palatine village of Kriegsheim. Seven years later members of this group would set sail for "Penn's Woods," arriving at the first permanent German settlement in America at Germantown, near Philadelphia.[3]

So many emigrants from the German territory known as the Kurpfalz (Palatinate) arrived in Pennsylvania, that the term "Palatine," a resident of the Palatinate, was soon a generic term that was applied to all German-speaking emigrants, regardless of their geographic origins. Most of the area which was historically included in the Palatinate is within the boundaries of the modern state of Rheinland-Pfalz. However, the portion east of the Rhine River and south of Heidelberg, the Kraichgau, is now part of the state of Baden-Wüttemberg.

During the years that Mennonites were living in the Palatinate most were not permitted to own land or practice a trade. The refugees arriving from Switzerland frequently brought few possessions, often arriving literally with the clothes on their backs. A few brought along their treasured Bibles (fig. 4) or their hymnbooks. The Bible pictured is a 1536 edition printed by Christophel Froschauer in Zurich. It is a favored translation of the Bible, so closely associated with the Mennonites that it was dubbed the *"Tauffer Bibel."* or Anabaptist Bible. This example had a fraktur bookplate added by the owner, Mathias Schnebeli, in 1708, during his stay in the Palatinate. By 1727 it was carried to Pennsylvania by the Hans Georg Bachman family, who settled in Upper Saucon Township, Lehigh County.

Few objects survive that were carried to Pennsylvania by these refugee families. The chest seen in figure 5 is an immigrant's chest, designed for the rigors of travel, with exposed iron brackets that reinforce this sturdy box. It was owned by Peter Risser (1713-1804), Mennonite resident of the village of Friedelsheim.[4] The initials "HR" on the interior of the lid likely refer to Peter's father, Hans Risser. The Risser family is believed to have originally lived in Canton Bern, Switzerland. This chest may well have been carried from Switzerland to the Palatinate by Hans Risser or his parents. Hans was first recorded as a resident in the Mennonite village of Ibersheim. In 1711 he moved a short distance to Friedelsheim. It was from here that his son Peter Risser (1713-1804) and wife Elizabeth Hershey departed for Pennsylvania in 1739, carrying this chest to Mount Joy Township, Lancaster County. Peter was ordained as the first Mennonite minister to serve the northwestern Lancaster County region. He donated land for a schoolhouse and meetinghouse. The congregation that is located there, Risser Mennonite Church, still carries his name (fig. 19).

As Swiss families continued to migrate into the Palatinate, they carried with them some specialized knowledge and traditions. Palatine rulers quickly realized their great agricultural skills, and the Mennonites were soon renowned for their innovative farm practices. One Mennonite of Swiss ancestry, David Möllinger (1709-87), is regarded as the father of Palatine agricul-

Figure 4. Fraktur bookplate in Bible. This Bible was printed by Christophel Froschauer (d. 1564), working in Zurich, Switzerland, dated 1536. Froschauer's Bibles were highly valued by Swiss Mennonites. This Bible was likely carried to the Palatinate by Hans Jacob Schnebeli, where the fraktur bookplate was added in 1708 for Matthias Schnebeli. It translates as follows: "This Bible

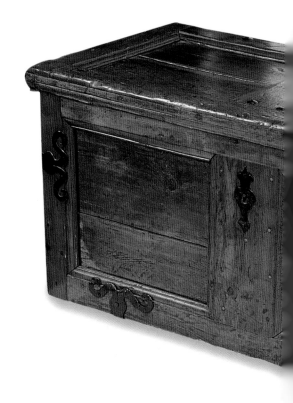

ture.[5] His two brothers, Hans Jacob Möllinger (1695-1763) and Joseph Möllinger (1715-72), were highly respected clockmakers in the Palatinate. Hans Jacob's shop was said to have been one of the most important in all of Germany (fig. 129).

The traditions of making fraktur, ink and watercolor texts with colorful decoration, was widespread in all Germanic regions of Europe. The fraktur form known as the *Vorschrift*, or handwriting example, was largely a Swiss custom. The fraktur handwriting example seen in figure 6 was penned by a member of a Swiss family living in the Kraichgau. The artist Johann Michel Brandt executed this Vorschrift on January 1, 1747, at the Cloister Lobenfeld, located in the Kraichgau southeast of Heidelberg, Germany. The likely recipient was Hans Jacob Witmer, who arrived in Pennsylvania in September 1749 on the ship *Phoenix*, settling in Lampeter Township, Lancaster County. This *Vorschrift* still remains in the possession of a lineal descendant of Hans Jacob Witmer.

belongs to me Matthias Schnebeli of Ibersheimerhof (Ibersheim), and I treasure it, so written in the year of Christ 1708." By 1727 this Bible was carried to Upper Saucon Township, Lehigh County. *Laid paper, ink, watercolor, 12.5" x 17.75". Collection of Mennonite Heritage Center, Harleysville, Pennsylvania. Nathan Cox Photography.*

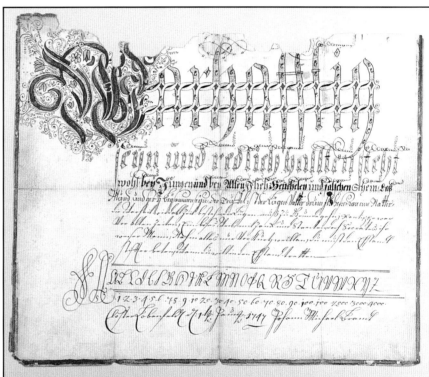

Figure 6. Fraktur writing example, written by Johann Michel Brandt, living at the Lobenfeld Cloister, in the Kraichgau, Germany, dated January 1, 1747. The artist Brandt was most likely a schoolmaster and probably presented this fraktur to Hans Jacob Witmer. He immigrated to Pennsylvania two years later, carrying this remembrance with him to his new home in Lampeter Township, Lancaster County. *Laid paper, ink, and watercolor, 13" x 16". Private collection.*

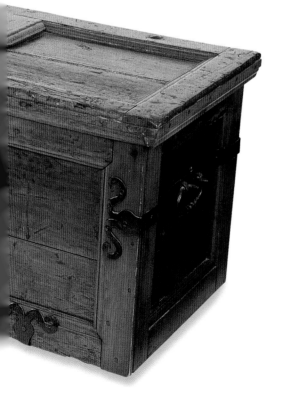

Figure 5. Immigrant's chest. This chest was likely constructed in either Canton Bern, Switzerland, or the Palatinate, Germany, by an unknown cabinetmaker for Hans Risser (b. c. 1680-90) or his parents. It was likely built c. 1680-1710. This traveler's chest, with its substantial ironwork, may well have carried the Risser family's personal objects from Switzerland to the Palatinate. In 1711 the owner, Hans Risser, moved from the village of Ibersheim to Friedelsheim. In 1739 his son Peter Risser (1713-1804) left Friedelsheim for Pennsylvania, taking this chest with him. He settled in Mount Joy Township, Lancaster County. *Pine, iron, 24.5" x 24.75" x 53.5". Private collection.*

Chapter Two
To Pennsylvania: Immigration and Settlement

The first Mennonites to emigrate to America were a small group of Dutch people who arrived in New York State in 1643, joining the already established Dutch community of New Amsterdam on the Island of Manhattan. Only a few scattered references document the existence of these early Mennonite settlers, and it appears that they were quickly assimilated by the larger Dutch Reformed population. Forty years later, in 1683, another group of settlers of mixed German and Dutch ancestry would respond to William Penn's offer of religious freedom. They set sail from England on the ship *Concord*, arriving in Philadelphia on October 6, 1683. They traveled six miles to a vacant plot of ground, where they established Germantown. This small group of settlers, mostly linen weavers, had left the village of Krefeld in northern Germany.[1] The group was largely comprised of Quakers, who were recent converts from the Mennonites. One family in the group, Jan Lensen and his wife Mercken, had remained Mennonite. Thus, the founding of Germantown marked not only the creation of the first permanent German settlement in the New World, but also the advent of the first permanent Mennonite presence as well.

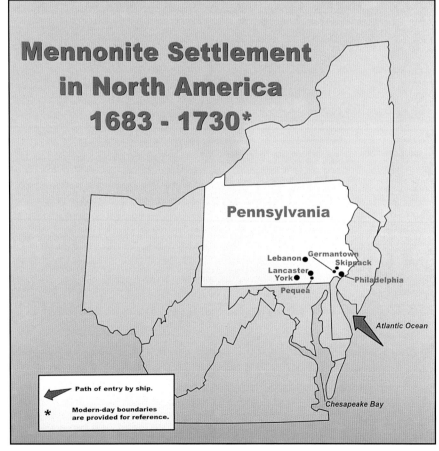

Figure 7. Chart of Mennonite settlements; the vast majority of eighteenth century Mennonite emigrants entered Pennsylvania through the port of Philadelphia. The earliest families started to arrive at Germantown, six miles north of Philadelphia, in 1683. By 1703, Germantowners were purchasing lands in Skippack, Montgomery County, and soon had established a Mennonite presence in Montgomery, Bucks, Chester, Berks, and Lehigh counties. The Mennonites who settled in these regions are frequently called the Franconia Mennonites. In 1710, a group of Swiss Mennonites traveled sixty miles west of Philadelphia to establish the Pequea settlement in present-day Lancaster County. This community initially expanded northward into Lebanon and Dauphin counties, and westward across the Susquehanna River into York, Adams, and Franklin counties and came to be called the Lancaster Mennonites. *Chart courtesy of the Heritage Center Museum.*

In 1685 a group of twenty emigrants, Quakers from Kriegsheim in the Palatinate, arrived in Germantown, bolstering the population of the fledgling community. By 1687 several more Mennonite families had arrived, including the Van Bebbers, the Keysers, and Willem Ruttinghuysen, a Dutch paper-maker. In 1690 William Rittenhouse (1644-1708) built a paper mill on the Monoshone Creek near Germantown, establishing the first paper mill in America. In 1698 he was selected as the minister for the small group of Mennonites, who held their meetings in their Germantown homes. Their first meetinghouse wouldn't be constructed until 1708, the year of the death of William Rittenhouse. His son Claus Rittenhouse (1666-1734) succeeded his father as preacher and continued to operate the family paper mill.

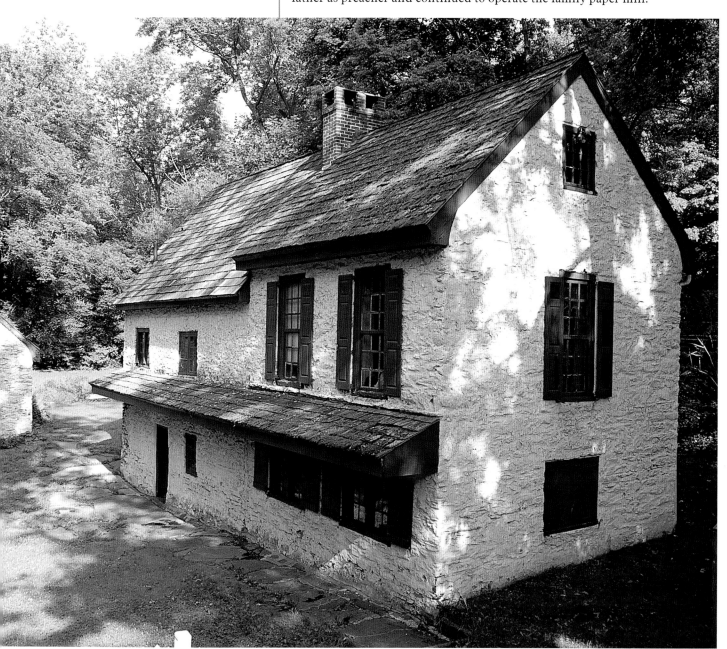

Figure 8. Rittenhouse homestead; the left portion of this stone structure was built by the Mennonite papermaker William Rittenhouse (1644-1708) in 1707. The portion on the right was added about 1713 by his son Claus Rittenhouse (1666-1734). The house is located at Rittenhousetown, a short distance from Germantown, where William established the first paper mill in America in 1690 along the Monoshone Creek. *Photo ©1996 Anthony L. Iezzi, Iezzi Photography.*

Although the earliest settlers in Germantown are known to have constructed simple log houses, by 1707 the Rittenhouse family was prosperous enough to build the stone house seen in figure 8. It must have delighted the owner, William Rittenhouse, because it closely resembled the solid masonry houses that the Rittenhouses and most of the Dutch and North German population of Germantown would have occupied in their homelands. Claus Rittenhouse expanded the house c. 1713 when he added the two-story portion.[2] Nearby stands the c. 1720 home of Claus's son, William Rittenhouse (1691-1774), who was probably the first owner of the tall case clock seen in figure 9.

The Rittenhouse clock (fig. 9) was made c. 1730 by a Mennonite miller and clockmaker named Christian Kintzing (1707-1804). Kintzing, who lived at Neuwied, Germany, near Bonn, constructed this iron and brass thirty-hour movement. A German cabinetmaker crafted the wooden hood to house Kintzing's clock works, prior to its exportation to Pennsylvania. After its arrival in Germantown, the lower portions of the case were added to enclose the pendulum and weights. This clock remained in the ownership of a Rittenhouse descendant in Germantown, into the twentieth century.[3] Perhaps it helped to inspire the inquisitive minds of William Rittenhouse's (1691-1774) three nephews, who would later enter the clockmaking trade. Jacob Gorgas (1728-98), the son of John Gorgas, a Mennonite preacher at Germantown, and John's wife, Psyche Rittenhouse, became a skilled clockmaker at Ephrata, Lancaster County. There Jacob and his wife joined the Ephrata Cloister, becoming householder members. Jacob's first cousin, David Rittenhouse (1732-96), became not only a renowned clockmaker, but also a famous astronomer who was president of the American Philosophical Society. Benjamin Rittenhouse (1740-1825), the younger brother of David Rittenhouse, followed in his brother's footsteps, also becoming a skilled clockmaker, although never quite achieving the prominence of his elder brother.

In 1703 Mathias Van Bebber received a patent on 6,166 acres along the Skippack Creek about fifteen miles north of Germantown in present-day Skippack Township, Montgomery County. Soon a few Germantown residents, including Claus Jansen and Jan Krey, had purchased plots from Van Bebber. Leaving Germantown, they created the new settlement of Skippack, which would quickly emerge as the center of the Franconia Mennonite community.

During the first few years of the eighteenth century the Mennonite populations of Germantown and Skippack grew slowly. Back in Germany the winter of 1708-1709 proved to be the harshest in memory, killing livestock and vineyards and freezing the great Rhine River. By the spring of 1709 a steady stream of "poor Palatines" traveled down the Rhine, arriving at Rotterdam, Holland, where they sought transportation to America. The alarmed town fathers transported them to England, where they were housed in refugee camps near London. Most were lacking the funds necessary for the voyage to America. This motley crowd of emigrants was a mixture of Protestants and Catholics and included some Palatine Mennonites. By the fall of 1709 more than 14,000

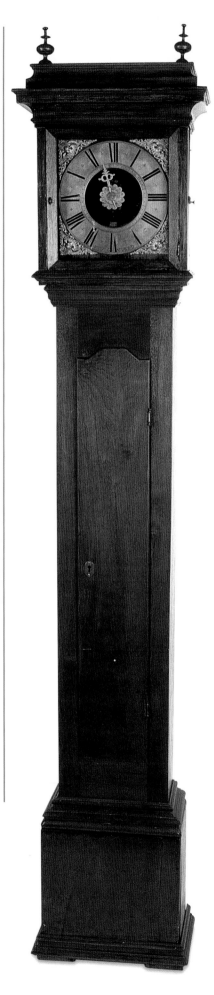

Figure 9. Rittenhouse tall case clock; the movement was made in Neuwied, Germany, c. 1730 by Christian Kintzing. The wooden hood also was built in Germany c. 1730 by an unknown cabinetmaker. The waist and base portion of the case was likely constructed in Germantown, Pennsylvania, c. 1730-40 by an unknown cabinetmaker.
The clock appears to have been owned by William Rittenhouse (1691-1774), a grandson of the immigrant William Rittenhouse (fig. 8). The younger William built a house c. 1720 a short distance from the Rittenhouse homestead. *Walnut, oak, pine, iron, pewter, and brass, 88" x 9" x 17.25". Collection of Toad Hall.*

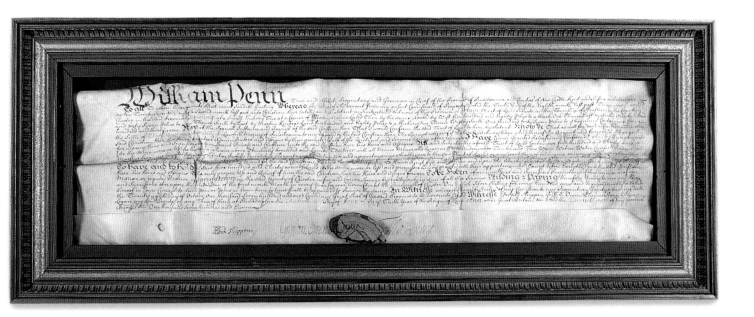

Figure 10. William Penn land patent, for 530 acres of land adjoining Martin Mylin and Martin Kendig property, from William Penn to Christian Heer, "lately an inhabitant in Switzerland . . . the 30th day of June in the tenth year of the reign of Queen Anne over Great Britain and the thirtieth year of my government Anno Dom One Thousand Seven Hundred and Eleven." Eight years later Christian Herr built his stone house (fig. 11) along the Old Conestoga Trail, which bisected his tract. *Sheepskin, ink, silk ribbon, war seal, 8" x 29.5". Courtesy of The Hamilton Club.*

refugees had arrived in England. The British government, greatly alarmed, resettled some families in Ireland, sent others to the West Indies, and forced many to return to Germany. A small number of Mennonite families were able to arrange for passage to Pennsylvania, including the Clemenses, Kolbs, and Oberholtzers. These families joined the established Germantown and Skippack communities.

A group of twenty-nine Mennonite arrived in Rotterdam in the spring of 1710. They were residents of the Kraichgau, Germany. Their families had left their ancestral homes in Canton Zurich, Switzerland, years earlier to seek refuge in the Palatinate. Finding that they had insufficient funds to purchase passage to Philadelphia, the group applied to the Committee on Foreign Needs, operated by the Amsterdam Mennonites, for additional funds. This charitable committee, administered by the wealthy Dutch Mennonites, had assisted many of their Swiss and German brethren with the necessary funds to book passage to the New World. Because the requested amount was small, the Dutch Mennonites granted their plea for assistance.[4] They boarded the ship *Maria Hope* and arrived in Philadelphia on September 23, 1710. Unlike their co-religionists, who had earlier settled in the Germantown and Skippack settlements, this group of pioneers had another destination in mind. The land that they sought lay about sixty miles west of Philadelphia along the Pequea Creek, in present-day Lancaster County.

Two members of the group, Martin Kendig (c. 1675-1748) and John Herr (1685-1756) (fig.12), acted as land agents and secured a warrant for 10,000 acres from the representatives of William Penn for "Swissers who lately arrived in this Province."[5] This nucleus of eight families traveled west to establish the Pequea settlement in Lancaster County. The community would ultimately grow to be the largest Mennonite community in the United States.

The land patents (fig. 10) for portions of the 10,000 acres were issued on June 30, 1711, to Hans (John) Herr, Christian Herr, Martin Kendig, Jacob Miller, John Funck, Wendell Bauman, Martin Meilen, and Christopher Franciscus. Their lands were along the Pequea Creek, near the Conestoga River. This was a few miles south of the site where the town of Lancaster would be laid out a generation later. This young farming community was alternately known as the Pequea or Conestoga settlement. It would grow slowly during its first few years, but in 1717 approximately thirty additional families arrived at Pequea, and by 1719 it is believed that sixty-six families were in residence.

Most of these families were of Swiss ancestry. They were predominantly from the cantons of Zurich and Bern. Absent from this community were the Dutch and North German families that constituted a significant portion of the Germantown and Skippack populations. Although the Skippack settlement also counted numerous Swiss immigrant families among their number, the cultural mix of the Franconia (Skippack) Mennonite community would remain distinctive from the overwhelmingly Swiss character of the Lancaster Mennonite community.

The abundant and fertile lands of the Pequea settlement allowed for rapid growth and prosperity. Already in 1719 immigrant Christian Herr (1680-1749), the preacher in the Pequea settlement, was able to construct a substantial stone house (fig. 11) on his 530 acre tract. He built his home using a Germanic floor plan, with a steeply pitched roof that enclosed a double attic. The Christian Herr House closely follows architectural prototypes found in the Palatinate, the temporary residence of this family with Canton Zurich origins. The Herr House also served as a meetinghouse for the Mennonites for 130 years, until the eventual construction of the Willow Street Mennonite Meetinghouse in 1849.

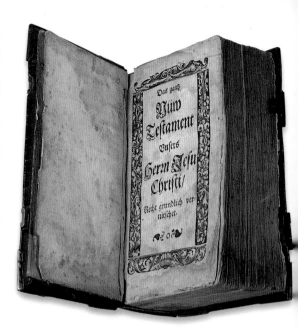

Figure 12. Froschauer New Testament, a reprint of a portion of Christophel Froschauer's sixteenth century Bible, printed by an unknown printer, likely working in Switzerland or Germany, c. 1650. This precious volume almost certainly traveled to Pennsylvania in 1710 on the ship *Maria Hope* with its owner, "land agent" John Herr (1685-1756), a younger brother of Christian Herr (fig. 11). John Herr used the rear flyleaf to record the births of his children, and in the front he recorded the following in German script, in 1720: "this Testament belongs to me Hanns Herr living in New Strasburg near Conestoga in America." *Laid paper, ink, leather, brass, 7" x 4" x 2". Collection of the Lancaster Mennonite Historical Society.*

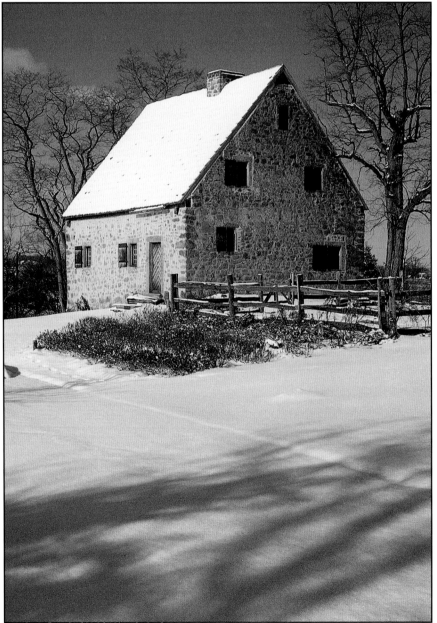

Figure 11. Germanic stone house, built in West Lampeter Township, Lancaster County, by Christian Herr (1680-1749); the stone door lintel is dated 1719. This simple farmhouse, commonly called the Hans Herr House, not only was the residence of Christian Herr, a Mennonite minister in the Pequea settlement, but also functioned as a meetinghouse for about 130 years. The basic form of the structure, the floor plan, and the architectural detailing all relate to South German prototypes — not surprisingly, since the Herrs and many of their Pequea neighbors had spent decades in their adopted Palatine homeland. *John Herr, photographer.*

As the early settlers at Pequea cleared their land and planted crops, they soon realized that the best market for their agricultural products was in Philadelphia, some sixty miles to the east. Skilled wagonmakers, who are believed to have been working in the Conestoga region, modified the standard flat-bed freight wagon to create the distinctive Conestoga wagon (fig. 13). This graceful wagon, with its double-swelled bottom, high sideboards, and hooped top, was the perfect vehicle for transporting goods to and from the city of Philadelphia. Already in 1717 John Miller, the son of 1710 immigrant Jacob Miller (1663-1739), was making regular trips from Pequea to Philadelphia, hauling freight and furs in a "Conestogoe Waggon."[6] These sturdy giants were eventually a familiar sight on the roads to Philadelphia, Baltimore, and Pittsburgh. Many Mennonite farmers purchased the wagons and the six-horse teams that were necessary to pull them. It was often the task of their teenage sons to make the regular trips to Philadelphia. The excitement that they encountered along the way spawned many tales, that have remained a part of the oral traditions of many Mennonite families. Competition from the railroads caused most Conestoga wagons to fade from the landscape by the mid-1800s. However, there was such a romantic attachment to the old freight wagons that a few wealthy Mennonite farmers in the Lancaster community, actually had Conestoga wagons built for use on their farms as late as 1900. Some families had miniature Conestoga wagons with teams built for display, while many others memorialized their wagons on the hooked rugs that graced their parlor floors.

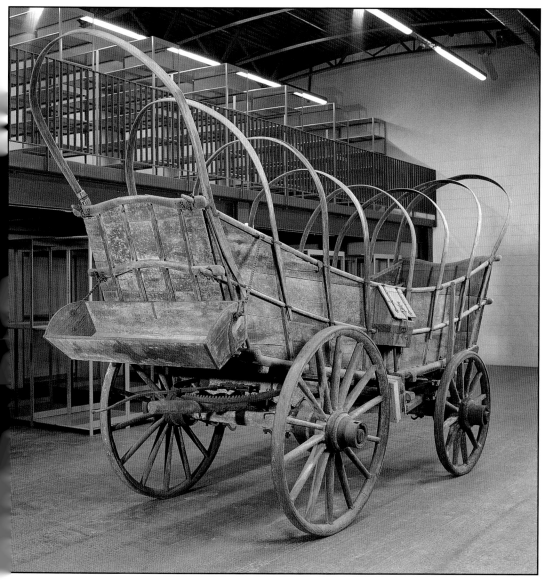

Figure 13. Conestoga wagon, c. 1800-30, unknown wagon maker, iron work signed by "JO LANDIS." The classic form of this freight wagon is evident in the dramatic curve of the bed, designed to keep the load from shifting on the long journeys to Philadelphia, Baltimore, and Pittsburgh. This wagon remained in the possession of the family of Michael Shreiner (1749-1827) of Manheim Township, Lancaster County, for nearly two centuries. *White oak, poplar, iron, 128" x 83" x 226.5". Collection of the Landis Valley Museum, Pennsylvania Historic and Museum Commission. Nathan Cox Photography.*

The immigrants who arrived in Philadelphia brought few possessions with them. A family's entire personal property frequently consisted of the contents of its sea chest (fig. 5). It often included small farm tools, copper and brass kettles, glassware, clothing and textile yardage, pewterware, books (figs. 4, 12, and 14), documents (fig. 41) including fraktur (figs. 4 and 6), garden seeds, and foodstuffs for the journey. Once they were established in Pennsylvania, they could purchase locally made goods reasonably, but imported goods remained costly. Their rural Pennsylvania settlements were blessed with an abundance of wood, which they used to construct their houses, wagons, farm implements, furniture, and treenware. Abundant local clays produced bricks, roof tiles, and redware pottery. Farmers were immediately growing flax and rais-

Figure 14. Mayer family Bible, printed by Christophel Froschauer (d. 1564) in Zurich, Switzerland, dated 1560. Beginning in 1524 a number of editions were printed by the Froschauers during the sixteenth century; only a few copies are known to have had hand-colored woodblock prints. This Bible was owned by John Meyer (c. 1700-60), a wealthy Mennonite who owned about 1,700 acres of land, much of it located

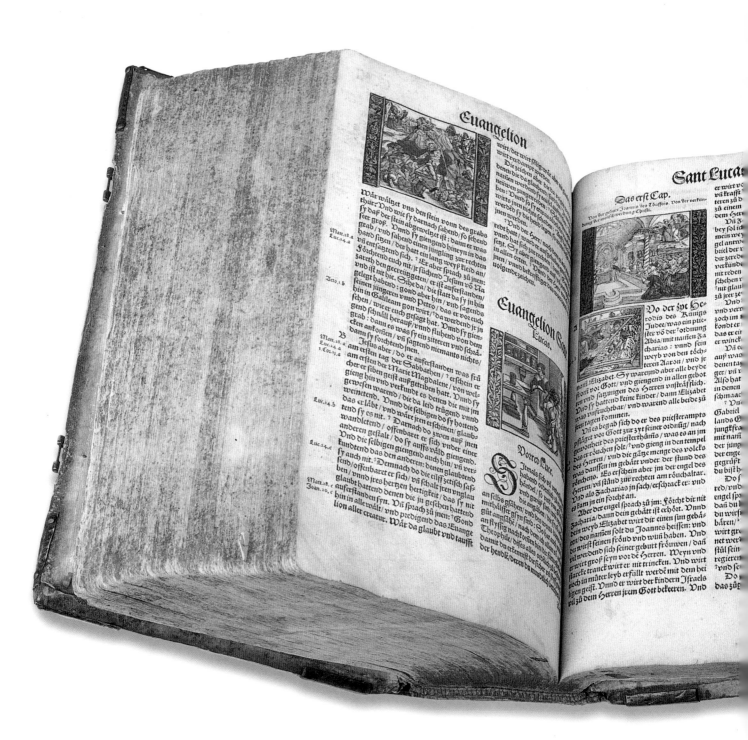

in Lancaster and Manheim Townships, adjoining the Borough of Lancaster to the west and north. About 1750 Meyer had the binding on his Bible repaired at the Ephrata Cloister. His Bible later passed to his son Jacob Meyer (c. 1720-93), and then to his son David Mayer (1772-1847), the builder of the house seen in figure 31. *Laid paper, ink, watercolor, wood, leather, brass, 14.5" x 23.25" (open). Private collection.*

ing sheep to produce the raw materials necessary for the production of their own linen and woolen textiles. Paper was being produced in Germantown by the Rittenhouses, and by the 1740s at the Ephrata Cloister in Lancaster County. It would, however, remain an expensive commodity for generations. Books were costly and highly regarded, with few persons owning more than a few books. As late as 1828 the family Bibles that were mass-produced in Philadelphia sold for the astounding price of ten dollars, which was more than ten days', wages for a typical farm worker.[7] It isn't surprising that many immigrants made specific mention of their large Bibles (fig. 14) and Martyr Books (fig. 35) when writing their wills.[8]

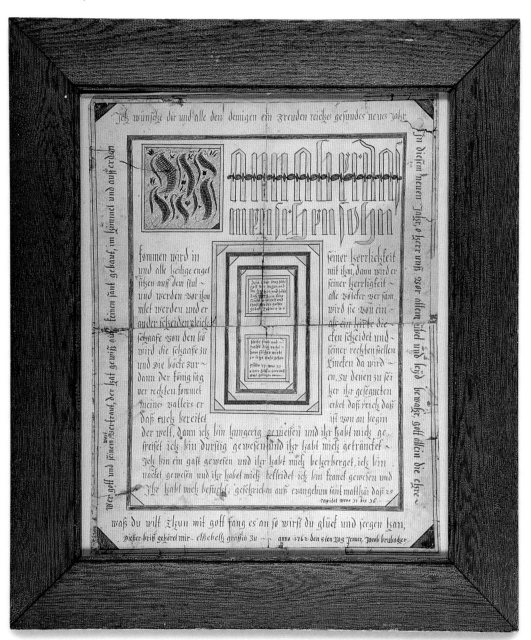

Figure 15. Fraktur New Year's greeting, written for Elisabeth Groff, signed Jacob Brubacher, dated January 8, 1762. The simple rectilinear format of this fraktur and the large embellished capital "W" is medieval in feeling. The practice of giving a fraktur New Year's greeting was an old custom in the Palatinate region of Germany, a custom that survived briefly in Pennsylvania. The artist Hans Jacob Brubacher (c. 1726-1802) begins his greeting, "I wish to you and all of your family, a joyous, prosperous, and healthful New Year . . . ". The central text was taken from Matthew, Chapter 5, verses 31 through 36. It is believed that Brubacher penned this greeting for Elisabeth (Herr) Groff (c. 1708-90), the daughter of Christian Herr (fig. 11) and the wife of Michael Groff (1707-71) of Martic Township, Lancaster County. *Laid paper, ink, watercolor, 16.5" x 13". Private collection.*

Many of the early eighteenth-century Mennonite emigrants lived long enough to realize their dreams of religious freedom and relative prosperity. Dielman Kolb (1691-1756), who had left the Mennonite enclave at Ibersheim (fig. 3) in the Palatinate in 1717, traveled on to Pennsylvania, where he settled in Lower Salford Township, Montgomery County. A respected member of the community, he was chosen as a preacher to serve the Skippack region. He and Preacher Henrich Funck traveled to the Ephrata Cloister to negotiate for the translation and the printing of the *Martyrs' Mirror* in 1748-49. Dielman Kolb acted as a proofreader to check the translation of the massive volume as it was being completed by Peter Miller. His impressive stone residence, exhibiting a strongly Germanic form (fig. 16), still stands as a tangible link between the Mennonite communities of the Old World and their transplanted offspring who thrived in the vast and fertile fields of Penn's Woods.

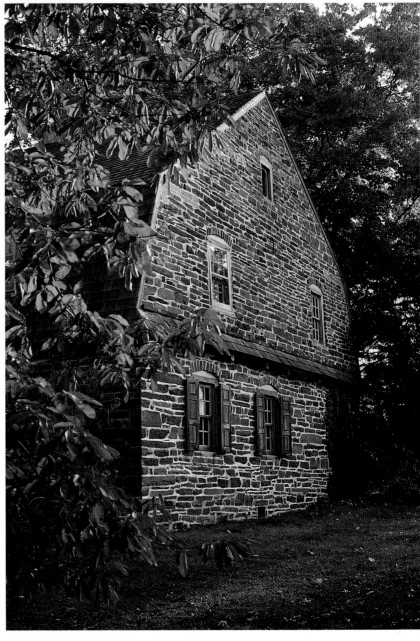

Figure 16. Dielman Kolb house, located in Lower Salford Township, Montgomery County, Pennsylvania, built c. 1740s. Kolb left Ibersheim, Germany, in 1717, traveling to Pennsylvania, where he joined his elder brothers, who had already settled at Skippack. Dielman Kolb (1691-1756) was ordained as a minister in the Skippack community. He built this substantial stone home in the 1740s, with its distinctive gambrel roof, an architectural style common in northern Germany. The pent eaves on the gable and the segmental arches above the window openings are also Germanic details.
Photograph by Jay Ruth.

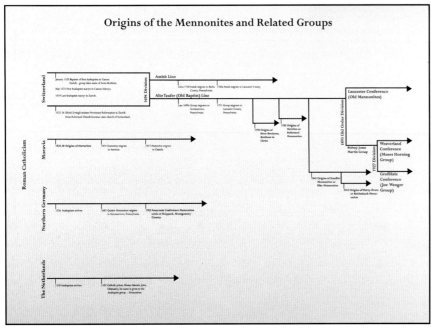

Figure 17. Chart of the origins of the Mennonites and related groups; this chart displays both origins and divisions within the Mennonite Church in Pennsylvania. The North German Mennonites who settled in Germantown in 1683 and at Skippack about 1702 included many Dutch families, and they were quickly joined by Swiss Mennonites. These families united to form the Franconia settlement in Eastern Pennsylvania. Although the Franconia Mennonites didn't suffer from as many divisions as did their Lancaster Mennonite neighbors to the west, the Oberholtzer division of 1847 successfully divided the group into the Franconia Conference and the more liberal Eastern Conference. *Chart courtesy of the Heritage Center Museum.*

Chapter Three
Prosperity and Expansion

Figure 18. Landisville Mennonite Meetinghouse, west gable. Built c. 1740 of dovetailed log construction; the steeply pitched roof, the pent eaves, the single shutters with dovetailed battens, the iron hinges, and molding profiles all relate directly to Swiss and Palatine prototypes. The door in the east gable enters into a two-room apartment. The front door enters directly into the meetingroom, which was brightly illuminated by five windows. *Photograph by the Author.*

Those in the first generation of Mennonites in Pennsylvania were preoccupied with the tasks of clearing their land and building modest homes, barns, and mills. Within the first generation of settlement they had already constructed a handful of meetinghouses; however, many congregations continued to meet for services in the larger homes in their community. This was the traditional practice in their German and Swiss homelands, where they were forbidden to build meetinghouses. Not surprisingly, the earliest meetinghouses in Pennsylvania were patterned after their most popular house type, the one-story log or stone dwelling. The meetinghouse furnishings also were based on familiar domestic furniture forms such as movable backless benches, sawbuck tables, and wall cupboards. These same forms were found in the stove room of the typical Pennsylvania German farmhouse (figs. 11 and 16).

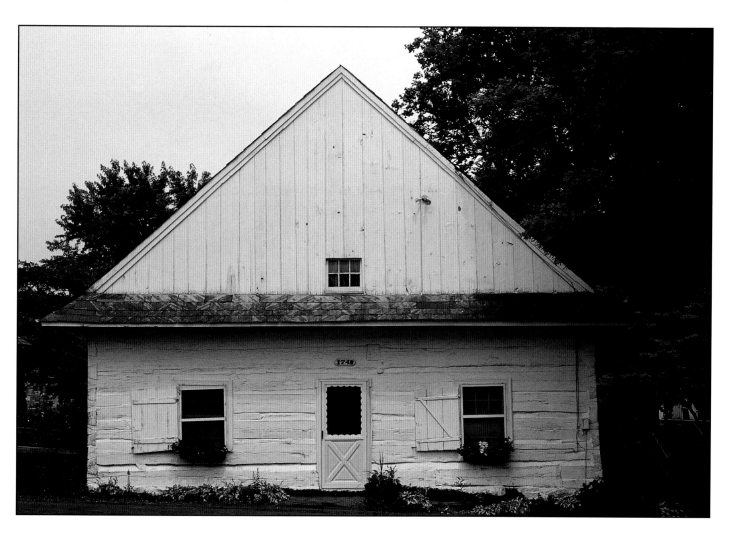

Undoubtedly, the most intact mid-eighteenth century Mennonite meetinghouse to be found in North America is the Landisville Meetinghouse in East Hempfield Township, Lancaster County. Constructed about 1740, this rare survival still retains most of its original detailing (fig. 18) built of oak and chestnut logs with pent eaves and dovetailed corner timbering. Significantly, it was designed with a portion of the structure intended to function as a living space, a two-room apartment with a central cooking fireplace that also provided a location for the iron jamb stove that heated the adjoining meeting room. Steep ladder stairs provided access to the loft and to the meat-smoking chamber that was built adjoining the chimney structure. This dwelling within the meetinghouse was normally reserved for the schoolmaster. Until the advent of the Pennsylvania public school system in 1834, all schools were privately operated, and the Mennonites organized many in Pennsylvania. Consequently, meetinghouses were used for school classes as well as Sunday worship services.

Figure 19. Sawbuck preacher's table from the Risser Mennonite Meetinghouse in Mount Joy Township, Lancaster, Pennsylvania, c. 1800. This table stood at the front of the meetinghouse and served as a lectern for the preachers. This sawbuck form was a popular style of dining table found in eighteenth century Pennsylvania German homes. *Nineteenth century grain painting over tulip wood, 30.75" x 27" x 87". Courtesy of Risser Mennonite Church.*

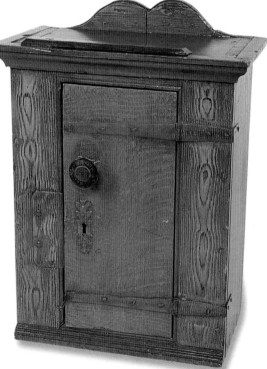

Figure 20. *Ausbund* cupboard, dated 1787, initialed "MB," from the Rapho Mennonite Meetinghouse (Hernley's), Rapho Township, Lancaster County. The single-door hanging cupboard was a popular feature in the stove room of eighteenth century Pennsylvania German homes. In the meetinghouse it held copies of the *Ausbund*, the Anabaptist hymnal that was used in worship services. *Nineteenth century grained decoration on pine, iron, and brass hardware, 26.5" x 12" x 20". Courtesy of the Lancaster Mennonite Historical Society.*

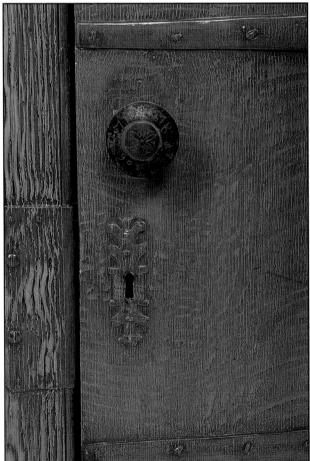

Figure 21. Detail of *Ausbund* cupboard. The iron and brass pull is incised with the date, 1787, and the initials of the blacksmith, "MB." The elaborate keyhole escutcheon is of wrought iron. *Courtesy of the Lancaster Mennonite Historical Society.*

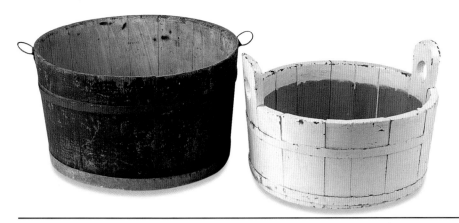

Figure 22. Foot-washing tubs. Left: c. 1867, used in the Lauvers Mennonite Meetinghouse, Juniata County, Pennsylvania. Right: c. 1860-91, used in the Susquehanna Mennonite Meetinghouse, Snyder County, Pennsylvania. The practice of washing the feet was widely observed as part of the Mennonite communion service. *Wood staves, paint, and metal bands, 10" x 14" and 9" x 15". Courtesy of the Juniata District Mennonite Historical Society.*

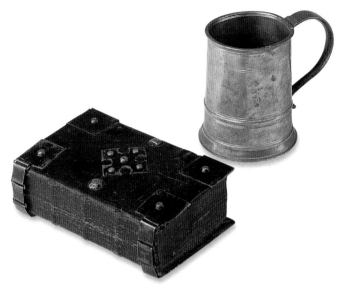

Figure 23. Pewter mug, c. 1749, made by an unknown pewterer likely working in Northern Germany or Holland. According to tradition, this mug came over from Germany with Hans Brubacher (1719-1804), of Elizabeth Township, Lancaster County. Brubacher traveled from Pennsylvania to Germany in 1749, where he met a cousin, Abraham Brubacher (1731-1811) who accompanied him back to Pennsylvania. This mug was used to hold wine at communion services at which his great-great-grandson Bishop Jacob N. Brubacher (1838-1913) officiated. (*Pewter, 4.5" x 5.25". Courtesy of the Lancaster Mennonite Historical Society.*) Printed hymnal, *Ausbund*, c. 1700, printed in Basel, Switzerland; printer is unknown. A collection of martyr hymns originally published in 1564, it remained in use among the Mennonites until after the introduction of the new Franconia hymnal in 1803 and the Lancaster hymnal in 1804. The Amish still use this hymnal today. This copy was owned in 1722 by Peter Newcomer (d. 1732), a 1719 immigrant to Lancaster County. It was next owned by Hans Brubacher (1719-1804) of Elizabeth Township, Lancaster County. *Wood, leather, paper, and brass, 5.25" x 4.25" x 4" diameter. Private collection.*

Although the meetinghouse form continually evolved, the stark simplicity of the eighteenth century meetinghouse was favored throughout most of the nineteenth century (fig. 24). Today many conservative Mennonite groups still worship in simple brick or white-sided meetinghouses, whereas the more liberal branches have constructed less traditional church buildings.

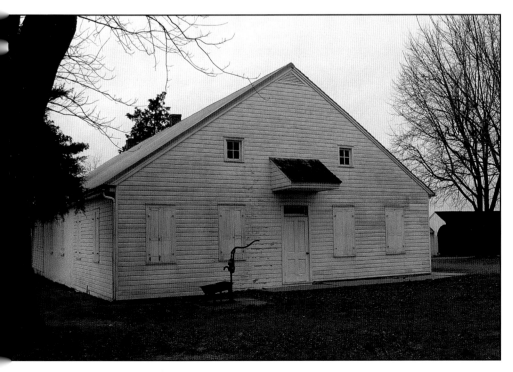

Figure 24. Exterior view of the Pike Mennonite Meetinghouse, built 1840, expanded in 1957. This meetinghouse, located in Earl Township, Lancaster County, is typical of the style of the meetinghouse that was popular among the Lancaster Mennonites in the first half of the nineteenth century. It remains popular among the Old Order Mennonites to this day. *Photograph by Lee J. Stoltzfus.*

The Landisville Meetinghouse provides an interesting contrast to the material culture of some of its members who owned the fertile surrounding farms. The Kauffmans, Hiestands, and Swarrs, prominent farmers and millers, owned some rather costly and stylish furnishings (figs. 45, 51, and 53) while continuing to reside in modest stone and log homes. Little survives from the pre-1750 period to document Pennsylvania Mennonite architecture and decorative arts, but it appears that their houses and furnishings were typically modest. After 1750 their prosperity is more evident in their fine Georgian and Federal farmhouses (figs. 31 and 32) and fine hardwood furniture (figs. 27, 28, and 29).

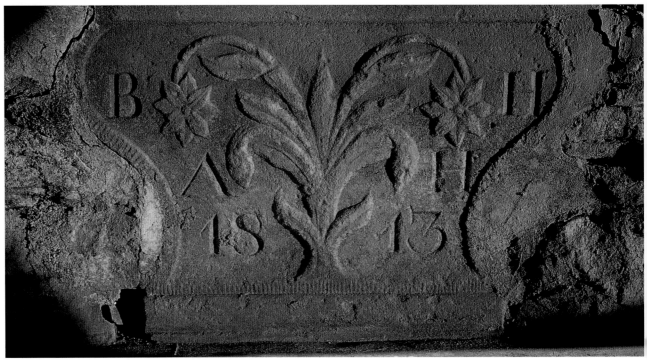

Figure 25. Stove base, dated 1740, carved by an unknown stonecutter. This sandstone stove base was used in a household in the Mennonite village of Ibersheim, Germany (fig. 3). It originally supported a cast iron five-plate stove. A few examples of similarly crafted bases are known to have been made in Pennsylvania (fig. 26). *Photograph by the Author.*

Figure 26. Stove base, c. 1765, carved by an unknown stonecutter probably working in Lancaster County, Pennsylvania. This stone base originally supported a five-plate stove, that probably stood in the c. 1765 stone house of Bishop Benjamin Hershey (c. 1730-1812) and his wife Magdalena (Roadt) Hershey of Lancaster Township, Lancaster County. The open end of a stove was built into the wall of the central fireplace where it could be fueled from the kitchen or hallway. The stove extended into the stoveroom, where it was typically supported by a simple masonry support. Shaped and carved bases, such as this example, are rarely encountered in Pennsylvania. They were, however, directly inspired by Palatine prototypes. The date and initials on this stove leg were added by Benjamin Hershey, the son of Benjamin Hershey (c. 1730-1812). The younger Hershey remodeled the farmhouse, added his initials and the date, 1813, to the old stove support, and then installed it as a datestone. *Sandstone, 12" x 16.5", courtesy of The Conestoga House. Photograph by Lee J. Stoltzfus.*

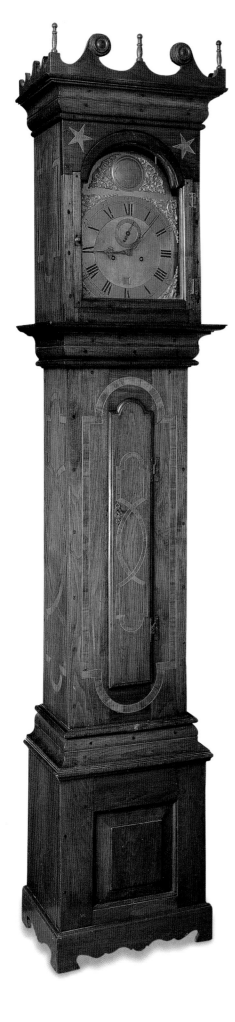

Although many members of the immigrant generation lived long enough to amass considerable wealth, they seem to have been more restrained in the manner in which they spent their wealth than were their children and grandchildren. Some conservatism remained, however. Eighteenth century Mennonites frowned on fancy clothing, and silver tablewares are absent from their household inventories. The majority of surviving, documented, Mennonite-owned furniture was made for second, third, and later generations of Mennonite families.

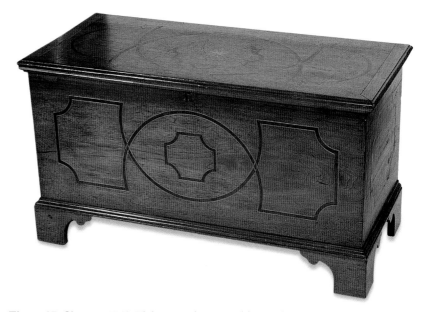

Figure 27. Chest, c. 1760-75, by an unknown cabinetmaker probably working in Lancaster County. Initialed "IK" for Johannes Kilheffer (c. 1738-97), the probable original owner, and a farmer in Manor Township, Lancaster County. The broad-banded wood inlay is baroque in inspiration and closely relates to Continental prototypes. The cabinetmaker, who was likely trained in Europe, constructed a chest that reflected not only his Germanic training but also the tastes of his client, a Mennonite farmer. *Walnut wood with inlays, pine secondary woods, iron strap hinges, a replacement brass escutcheon, 25.5" x 52" x 24.75". Collection of Toad Hall.*

Among the most recognized pieces of Pennsylvania German furniture is a group of walnut *Kleiderschrank* or clothespresses decorated with sulphur inlay. Of the nine Lancaster County examples known to the author, it appears that at least eight, and possibly nine, were made for prosperous Mennonite farmers and millers. All date between 1764 and 1780, and each has an abbreviated inscription of ownership inlaid across the frieze (figs. 30, 45, 48, and 49).[1] Although they appear to have been produced by several unidentified cabinet shops, all of the owners lived to the west and northwest of Lancaster City. It is significant to note that of the nine male owners seven had fathers who were deceased prior to the purchase of their clothespresses. Since the widow typi-

Figure 28. Tall case clock, c. 1755-60, eight-day brass clock movement by Christian Forrer (1737-83) of Lampeter, Lancaster County. Clock case by an unknown cabinetmaker probably working in Lancaster County. This clock descended in the Eaby family of Leacock Township, Lancaster County. Tall case clocks such as this example were among the most valuable possessions of many families. The prosperous Pennsylvania Mennonite families owned many fine clocks with costly inlaid or carved cases. The wide wood inlay on this case closely relates to the chest shown in figure 27. A detail of the dial may be seen in figure 134. *Clock movement, brass, iron, and pewter. Case is walnut wood with inlays, 92.5" x 13" x 19.75". Collection of Robert C. Wenger.*

cally received one-third of the estate, the other two-thirds was distributed among the heirs after the father's death. Hence most of the purchasers of this group of costly furniture were already in possession of the bulk of their inheritance and could well afford fine furnishings for their homes.

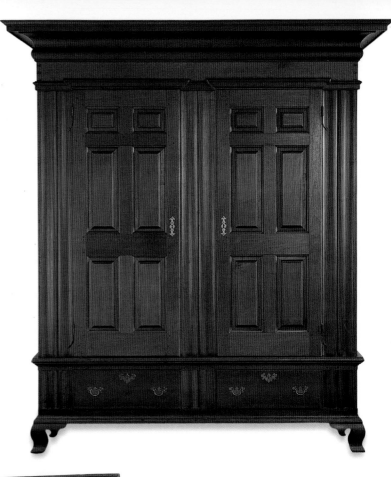

Figure 29. *Kleiderschrank* or clothespress, c. 1780-90, built by an unknown Lancaster County cabinetmaker for Christian Hershey (1762-1840). A prosperous farmer in Penn Township, Lancaster County, Christian received his parents' farm after the death of his father, Christian Hershey (1719-82); see figure 36. This clothespress may have been built for the 1786 marriage of Christian, Jr., to Elizabeth Snyder, whose father's clothespress is seen in figure 30. The Hershey cupboard, with its Georgian details, molded bracket feet, and six-panel doors, is far more English in feeling than the Schneider example, and it demonstrates the rapid acceptance of English furniture trends by the Mennonite population. However, the massive proportions, bold cornice, and rattail hinges suggest that it was constructed by a cabinet shop working in the German tradition. *Primary wood walnut, tulipwood, iron and brass, 88" x 28" x 80". Private collection. John Herr, photographer.*

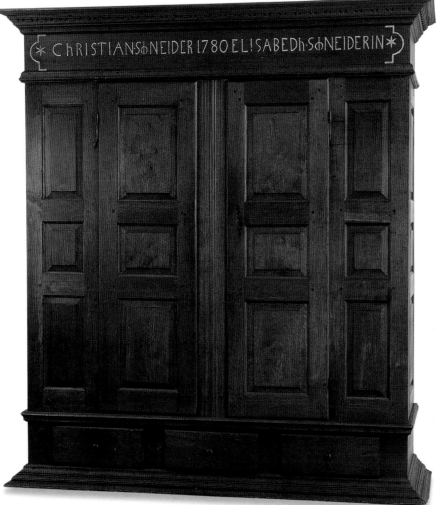

Figure 30. *Kleiderschrank* or clothespress, dated 1780, built by an unknown cabinetmaker probably working in northwestern Lancaster County. It was built for Christian Schneider (1725-95), a Mennonite farmer and miller, and his second wife Elizabeth (d. after 1795). Christian arrived in Pennsylvania in 1736 with his parents Johannes (1697-1763) and Susannah (Bauman) Schneider (1700-45). Christian's first wife, Barbara Reist (b. 1730), was the sister of Abraham Reist, owner of the Kleiderschrank shown in figure 49. Christian and Barbara Snyder settled in Londonderry Township, Dauphin County, just across the Lancaster County line, where they built a grist mill in 1769. The clothespress owned by their daughter Elizabeth and her husband Christian Hershey is shown in figure 29. This piece was obviously the product of a Germanic cabinet shop, as evidenced by the rattail hinges, the center linen-fold stile, the double wedged dovetails, the sulphur inlay, and the bold cornice and base moldings. *Primary wood walnut, sulphur, and iron, 80.5" x 24.25" x 74". Collection of Donald C. Gish. Image courtesy of the Joseph Schneider Haus.*

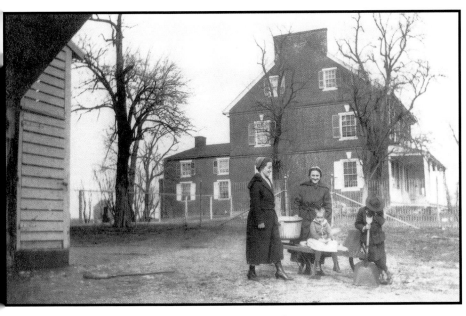

Figure 31. David Mayer house, built in 1797 by David Mayer (1772-1847) and his wife Elizabeth Rohrer (1774-1873). This Georgian mansion house was built of brick, the most fashionable building material in Lancaster County in the late eighteenth century. The interior woodwork is among the finest to be found in any Lancaster County home. This was later the home of David's son, Martin Mayer (1798-1873), who was the preacher at the Reading Road Meetinghouse, now called Landis Valley Mennonite Church. Both men were owners of the 1560 Mayer Bible, (fig. 14). *Photograph c. 1920, courtesy of by George S. and Carol Tucker Gadbois.*

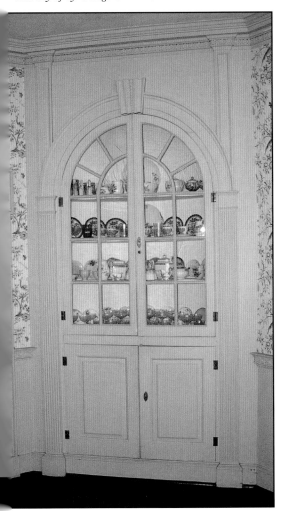

Within a generation of the first Mennonite settlements in the Franconia and Lancaster regions, the communities were already pushing northward and westward into the frontier regions (fig. 37). By 1730 families from both communities had resettled in the Shenandoah Valley of Virginia. The arrival of a steady stream of Mennonites and other immigrants into eastern Pennsylvania skyrocketed land prices and created the need for new settlements in less-developed regions. In the 1770s there were communities in western Pennsylvania, and in 1786 a group of Franconia Mennonites crossed the Niagara River to found a settlement on the Niagara peninsula in Ontario, Canada. In 1805, the formation of the German Company organized in Warwick Township, Lancaster County, gave dozens of Mennonite families living in northern Lancaster County substantial tracts of land in the Kitchener, Ontario region. Typically the purchasers of Canadian lands remained in the county while their sons, or daughters and spouses, would relocate to occupy and eventually purchase the new farmsteads.

Not all owners of Canadian lands had children that wished to relocate. When John Bamberger (1750-1818) of Warwick Township, Lancaster County, wrote his will he decreed that his Canadian lands should be equally divided among his six sons.[2] Apparently none of his offspring was interested in leaving the comfortable environs of Lancaster County, for his two tracts of "896 acres situated in Bran Township, Grand River Settlement, Upper Canada" were advertised at his estate's public sale in Warwick Township, Lancaster County, on October 16, 1818 (fig. 34). The purchaser was John Reist (1763-1843), the son of Abraham and Elizabeth (Kauffman) Reist, who owned the clothespress pictured in figure 49. Abraham Reist owned other lands in the new Canadian settlement, and in 1826 his son, John Reist, together with his wife and ten of their eleven surviving children moved northward to claim the tracts.

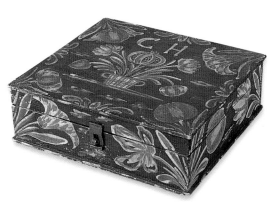

Figure 33. Bucher box, c. 1780-1800, by an unknown craftsman who has been called Heinrich Bucher. This paint-decorated box is one of a large group of similarly decorated boxes that have been found throughout southeastern Pennsylvania. This example bears the initials of the original owner, Christian Herr (1772-1846) of West Lampeter Township, Lancaster County. Herr and his descendants stored the deeds to the family farm in this box. *Pine, tin, and paint, 3" x 8.75" x 10". Collection of the Hans Herr House.*

Figure 32. Interior view of the David Mayer House, located in Manheim Township, Lancaster County. When David Mayer, a twenty-five year-old Mennonite farmer, constructed his house, he spared no expense. The interior exhibits exceptional detailing: an arched-door corner cupboard, a cornice having a carved frieze, and a chair rail with an unusual fretwork band. *Photograph by Lee J. Stoltzfus.*

The families that left their Pennsylvania homeland for new settlements carried with them many traditional Germanic folk forms, such as fraktur, decorated textiles, and furniture forms. Nowhere is the relationship more vividly dislayed than in the decorative arts of the Mennonites of Ontario (figs. 97, 98, 125, 163, 182, 244, and 277).[3]

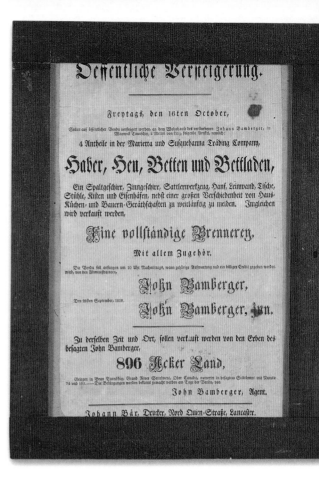

Figure 34. Public sale bill for the estate of Johann Bamberger, deceased, of Warwick Township, Lancaster County, dated September 22nd and October 16th, 1818. Printed by Johann Barr, North Queen Street, Lancaster. In addition to farm and housewares, the executors of John Bamberger (1750-1818) offered for sale a "fully equipped distillery" and "896 acres of land, lots 74 and 105, situated in Bran Township, Grand River Settlement, Upper Canada." *Wove paper, ink, 13.5" x 8.5". Private collection. Nathan Cox Photography.*

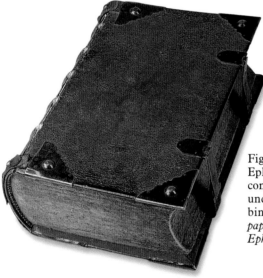

Figure 35. *Martyrs' Mirror*, printed by the Cloister Press at Ephrata, Lancaster County, 1748 to 1749. This book is considered to be the most ambitious printing project ever undertaken in Colonial America. The paper, printing, and binding were all products of the Ephrata Commune. *Laid paper, ink, leather, brass, 14" x 4.5" x 10.5". Collection of the Ephrata Cloister, Pennsylvania Historic and Museum Commission.*

Figure 36. Fraktur bookplate, by an unknown artist working at the Ephrata Cloister, Lancaster County, dated 1757. This book-plate is mounted in the *Martyrs' Mirror* (fig. 35) owned by Christian Hershey (1719-82) of Penn Township, Lancaster County. Like many other Mennonites, Hershey recorded his family records on the flyleaves of his volume. His great-great-grandson, Milton S. Hershey, was the founder of Hershey Chocolate Company. *Laid paper, ink, 14" x 8.5". Collection of the Ephrata Cloister, Pennsylvania Historic and Museum Commission.*

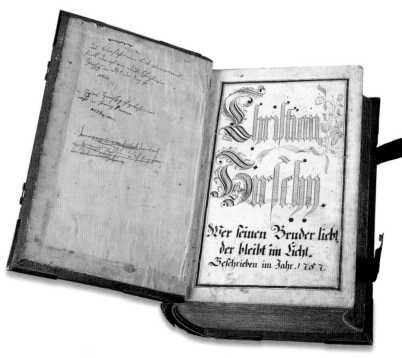

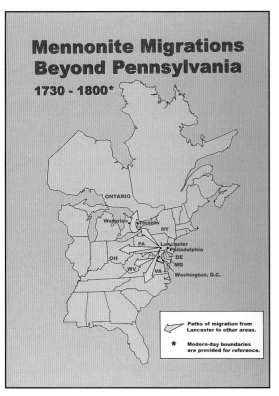

Mennonite Migrations
Beyond Pennsylvania
1730 - 1800*

Figure 37. Mennonite migration chart; as the population and land prices increased in the eastern Pennsylvania region, Mennonite settlers pushed westward across the Susquehanna River and south into the Shenandoah Valley of Virginia by the 1730s. By the 1770s there were Mennonites in western and northern Pennsylvania. In 1786 a few Bucks County families arrived on the Niagara Peninsula in Ontario; during the next few decades they were joined by hundreds of Mennonite families who established sizable settlements at several locations in southern Ontario. This pattern of out migration from the older Mennonite communities was maintained throughout the 1800s. Today it continues among the most conservative branches of the Lancaster Mennonites, who have recently created new communities in Kentucky, Ohio, Georgia, Missouri, and other locations. *Chart courtesy of the Heritage Center Museum.*

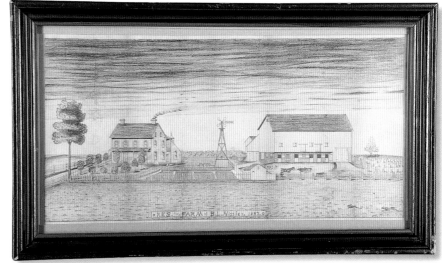

Figure 38. Rooster weathervane, c. 1853, by an unknown carver said to be a German peddler. Originally purchased by John K. Rohrer (1820-1907), this weathervane was placed on the newly built bank barn on his farm in Rapho Township, Lancaster County. *Wood, paint, iron, and tin. Photograph by Mrs. Joanne Hess Siegrist.*

Figure 39. Indian weathervane, c. 1820-50, maker unknown, from the farm of Joseph Cassel (1799-1868), Towamencin Township, Montgomery County, Pennsylvania. A classic weathervane form, this statuesque native American once graced the Cassel family barn. Joseph Cassel served as minister at the Plains Mennonite Meetinghouse. Mennonite farmers were not immune to the popular trends of the broader population. *Sheet iron and paint, 25" x 40.5". Collection of the Mennonite Heritage Center, Harleysville, Pennsylvania. Nathan Cox Photography.*

Figure 40. Pencil drawing of farm, inscribed "RES. And FARM of B.L. NISSLEY 1887." signed "H. Lin. Nissley. Del." Drawn in East Hempfield Township, Lancaster County. This depiction of the farm of Benjamin L. Nissley (1853-1930) was drawn by his brother, Henry Lincoln Nissley (b. 1861). It depicts a set of farm buildings that were likely only decades old when they were drawn. The frame farmhouse and bank barn were part of a "new" farm that was created by subdividing a large eighteenth century farmstead. The Nissleys were members of the Landisville Mennonite Congregation. *Wove paper, pencil, 13" x 25.25". Collection of Dr. and Mrs. Donald M. Herr.*

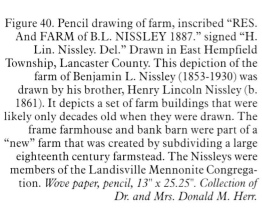

Chapter Four
The Bamberger Family: A Study in Material Culture

The Bamberger family of Warwick Township, Lancaster County, is typical of the Mennonite families that arrived in Pennsylvania during the first decades of the eighteenth century. A farm family originally from Switzerland, they worked as tenant farmers in the village of Eshelbronn in the Kraichgau region of Germany. In 1722 they were granted permission to emigrate "to remove hence to seek his fortune and subsistence in other lands" (fig. 41). With passport in hand, Christian Bamberger (c. 1682-1742), his wife Maria, and their eight children journeyed down the Rhine River to the port city of Rotterdam, Holland, to begin their long voyage to Pennsylvania. According to family tradition, two of the Bamberger daughters died during the ocean voyage. After arrival in Philadelphia, the family traveled sixty miles westward to the Pequea settlement in Lancaster County, Pennsylvania.[1]

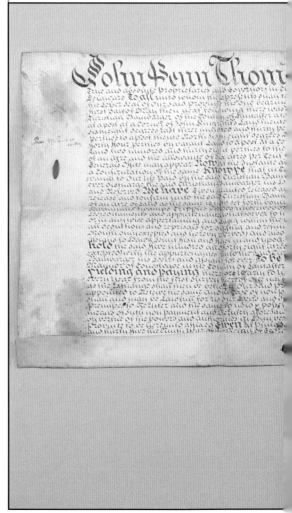

Figure 42. Bible, printed in Zurich, Switzerland, by Christophel Froschauer (d. 1564), dated 1546. Believed to have been brought to America by Christian Bamberger (c. 1682-1742). The Bible likely descended to his son Reverend Christian Bamberger (1719-87), thence to son John Bamberger (1750-1818). According to an inscription, John's youngest son, Peter Bamberger, owned it in 1820. Although the tooled leather binding is original, the spine was repaired in the twentieth century. *Paper, leather over wood, and brass, 14" x 10". Collection of the Muddy Creek Farm Library.*

Figure 41. Passport, May 12, 1722, given to the family of Christian Bamberger (c. 1682-1742), residents of Eschelbronn, in present-day Baden-Württemberg, Germany. The passport indicates that they "had been residents of the region for more than twelve years as farmers and tenants of the Baron Von Der Fels, Lord Philip Anthony." *Ink on vellum, 14" x 16". Collection of Lancaster Mennonite Historical Society.*

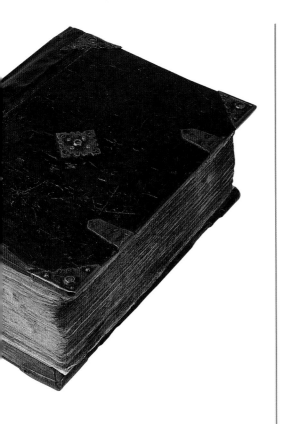

When the Bamberger family arrived in the Pequea community the settlement was already a dozen years old. Like most other Mennonite families, they likely arrived with few possessions (fig. 42) and a small amount of money. Fortunately for these families the proprietors, the Penn family, were anxious to have their lands settled and welcomed the arrival of the Swiss Mennonites, who were widely known for their agricultural skills. By making a small down payment they could secure large tracts of land, with final payment being delayed for years or even decades. In this manner many families acquired substantial tracts of land with relatively small investments. As more immigrant families poured into Pennsylvania land values soared, bringing wealth to the families that had aggressively acquired lands during the earliest period of European settlement.

After a short stay in Pequea, the Bamberger family traveled about twelve miles to the north, settling in Warwick Township. They were among the first European settlers in the northern Warwick Township region. Bamberger acquired 548.75 acres of land, with final title being granted on February 10, 1735 (fig. 43). When Christian Bamberger wrote his will on June 30, 1741, his land was already subdivided into three plantations. He willed these to his sons John and Christian and to his son-in-law Martin Bucher (fig. 63). An inventory of his possessions was taken on April 5, 1742, a short time after his death.[2] Although Bamberger owned considerable livestock and farm equipment, it appeared that his home was small and modestly furnished.

His wife Maria and six children, all of whom had married and remained in Lancaster's Mennonite community, survived Christian. His youngest son Christian (1719-87) was a minister in the Mennonite Church serving the Warwick region. A portion of the 200 acres he received from his father remains in the ownership of a descendant more than 270 years after the Bambergers first occupied the tract.

Figure 43. Patent, the first deed given by John, Thomas, and Richard Penn to Christian Bamberger (c. 1682-1742) for 548.75 acres of land in Warwick Township, Lancaster County. Dated February 10, 1735. *Ink on vellum, silk, and wax, 12" x 23". Collection of the Lancaster Mennonite Historical Society.*

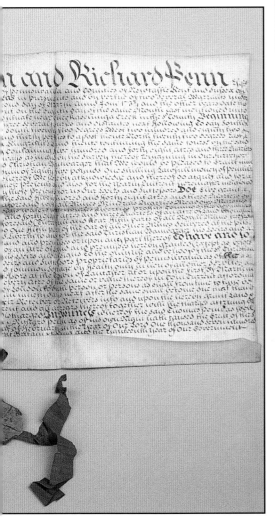

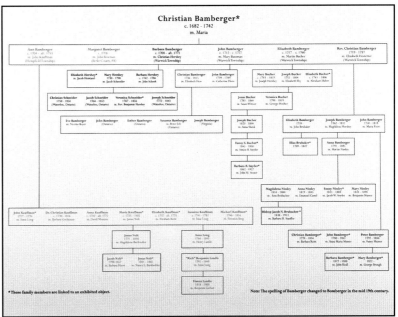

Figure 44. Bamberger Family Chart, a genealogical chart of some of the descendants of Christian Bamberger (c. 1682-1742) and his wife Maria. Many of the owners of objects pictured in this chapter are denoted by an asterisk (*), following their names. *Courtesy of the Heritage Center Museum.*

Most of Christian and Maria Bamberger's grandchildren also remained in Lancaster County, though a few relocated to Ohio, Virginia, and Ontario during the later eighteenth and early nineteenth centuries. Most of the descendants married into the established Mennonite families in the area and remained working in agriculture, either as farmers or millers. All of the descendants would have been considered prosperous in their day, and that is reflected in the objects that they owned.

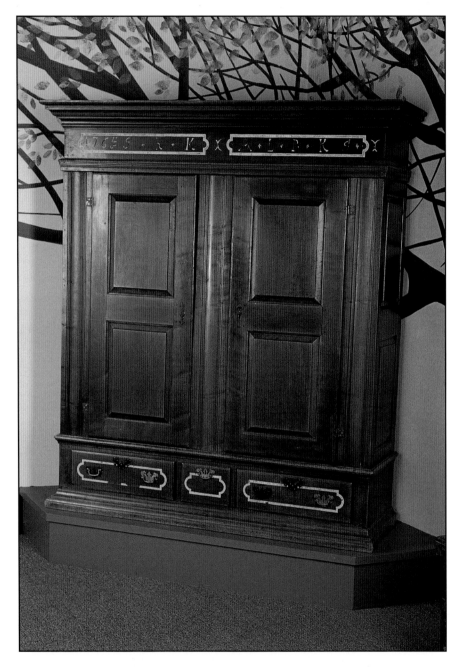

Figure 46. Chest, by an unknown cabinetmaker working in Lancaster County, probably for Michael Kauffman (1746-1816) of East Hempfield Township, Lancaster County, dated 1765. Although boldly proportioned, this chest exhibits delicately executed sulphur inlay and directly relates to several clothespresses exhibiting similar decoration. *Walnut, sulphur, and iron, 26" x 25" x 51.5". Private collection.*

Figure 45. *Kleiderschrank* or clothespress, by unknown cabinetmaker, working in Lancaster County, dated 1764, probably for John Kauffman (1727-76) and his wife Anna Elisabeth (d. 1806), living in East Hempfield Township, Lancaster County. The severely abbreviated inscription executed in sulphur inlay across the frieze, I interpret as follows:
"**1764 J**ohannes **K**auffman **A**nna E**L**isabeth **K**auffman**in**"
 1764 J h K A L K J
The letter J was frequently used to symbolize the feminine ending that was added to a woman's family name. *Walnut, iron, and sulphur, 80.5" x 25" x 73.75". Collection of Chris A. Machmer.*

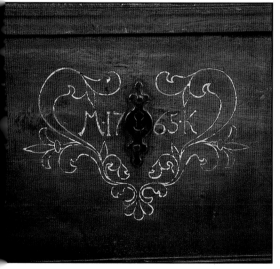

Figure 47. Detail of inlay on chest, initialed "MK 1765," probably for Michael Kauffman (1746-1816), East Hempfield Township, Lancaster County. *Walnut and sulphur. Private collection.*

By the middle of the eighteenth century, Bamberger descendants had the desire and the means to afford fine domestic furnishings. It is significant to note that one-third of the recorded sulphur-inlaid clothespresses were made for children of Christian's eldest daughter, Anna (Bamberger) Kauffman (c. 1704-aft.1755) (figs. 45, 48, and 49). Anna's husband, John Kauffman (c. 1700-59) was a prominent farmer in East Hempfield Township. He received patents on three adjoining tracts of land totaling 666 acres. The land lay immediately to the south of the Landisville Mennonite Meetinghouse (fig. 18), where they were members.[3]

After John Kauffman's death in 1759, his lands were divided into three plantations and one was deeded to each of his three sons, John, Christian, and Michael, as specified in his will. The Kauffman children received the bulk of their inheritance at relatively young ages. Yet, despite their prosperity, most of them continued to reside in their modest stone or log houses until later in life. It appears, however, that they were not opposed to purchasing costly furniture for their homes.

The great *Kleiderschrank* or clothespress was the most valuable article of furniture to be found in a Pennsylvania German household. Several Lancaster County examples exist, dating to the 1750s, with ownership inscriptions inlaid across the frieze board, utilizing either wood or pewter inlay. They are generally believed to have been produced in Lancaster Borough. In the 1760s a different form of decoration appeared on a small group of Lancaster County furniture. These objects were enlivened with the use of sulphur inlay (figs. 45, 46, 48, and 49). By cutting shallow channels of decoration into the surface of the wood, and then filling it with molten sulphur, one could achieve a distinctive form of decoration. When applied to walnut wood, the white sulphur decoration created a sharp contrast to the darker wood. This decoration found favor among the Lancaster Mennonites, and a number of the earliest documented pieces appear to have been owned by them, including at least four examples that were owned by the Kauffman siblings.

The *Kleiderschrank* shown in figure 45 is believed to have been made for Johannes or John Kauffman (1727-76) and his wife Anna Elisabeth (Long) Kauffman (d. 1806) in 1764. It is the earliest known piece of Pennsylvania sulphur inlaid furniture. Although produced by an unknown cabinetmaker, his Germanic training is evident in its execution, as seen in the heavy base and cornice moldings, extensive use of wooden pegs, and the wedged-dovetail construction. The flat profile of the molded vertical stiles resembles baroque moldings found in Swiss architecture and is also similar in feeling to moldings that were employed on the c. 1740 Landisville Meetinghouse. This clothespress never had feet and was designed to rest directly on the floor, as were many early chests, clocks, and wardrobes produced by the Pennsylvania Germans. The owner of this piece, John Kauffman, was 37 years old with a family of six children when he commissioned the construction of this piece for the one-story log home on his farmstead. In addition to farming, it appears that John Kauffman also operated a grist and saw mill on the Swarr Run, which flowed through his plantation.

In the following year, 1765, John's youngest sibling, Michael Kauffman (1746-1816), is believed to have received the chest seen in figures 46 and 47. Blanket chests were the basic unit of furniture in the Pennsylvania German household. Teenage children, both male and female, typically received a chest from their parents in preparation for marriage. Michael received this chest at age nineteen, the year prior to his marriage to Veronica Berg (1746-1813), the daughter of Andrew Berg, a 1750 Mennonite immigrant. At the age of twelve, Michael was deeded a 220-acre plantation, where he later farmed and also worked as a physician. His inlaid chest boasts a scrolled heart with fleur-de-

lis executed in sulphur inlay. This same design appears on several related clothespresses.

In 1768 another sibling, Anna (Kauffman) Mumma (c. 1732-c.1780), and her husband David Mumma (c. 1728-91) commissioned a walnut clothespress to be built for their house in West Hempfield Township near the village of Silver Spring. This finely crafted cabinet is shown in figure 48. It too is the product of an unknown cabinetmaker working in the German tradition. The panel configuration is designed to complement the five-panel door style that was popular in Switzerland and in the Pennsylvania German region prior to the Revolutionary War period. In the last quarter of the eighteenth century the English six-panel style became popular on interior doors and clothespresses (fig. 29) throughout the Pennsylvania German countryside, as Germanic taste in furnishings and architecture was gradually anglicized to favor Georgian and Federal forms. By 1775, the Mumma family had moved to Baltimore County, Maryland, selling their West Hempfield Township homestead to their son John Mumma.[4]

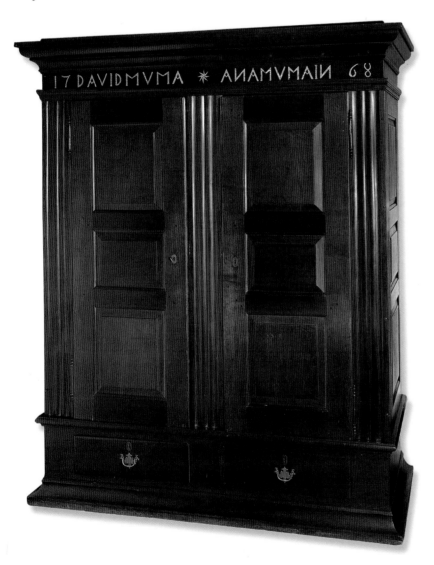

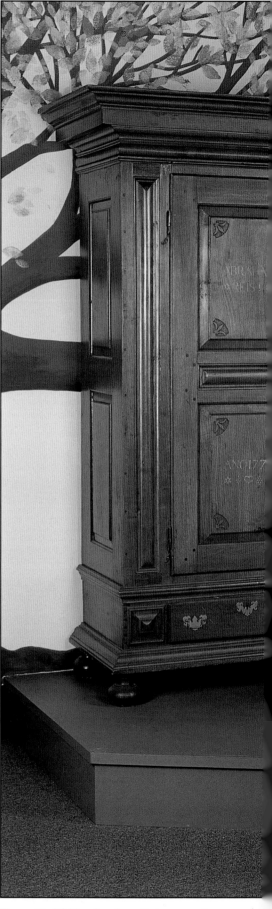

Figure 48. *Kleiderschrank* or clothespress, by an unknown cabinetmaker working in Lancaster County for David Mumma (c. 1728-91) and Anna (Kauffman) Mumma (c. 1732-c. 1780), dated 1768. The three molded vertical stiles adjoining the doors are frequently found on Lancaster County clothespresses and some chests over drawers. The so-called castle hinges, which are original, are of a design popular in the third quarter of the eighteenth century. The brass pulls and escutcheons are replacements. *Walnut, sulphur, iron, and brass. 84.5" x 27.25" x 74.5". Collection of Richard S. and Rosemarie B. Machmer. Nathan Cox Photography.*

Figure 49. *Kleiderschrank* or clothespress, by an unknown cabinetmaker working in Lancaster County for Abraham (1737-1813) and Elizabeth (Kauffman) Reist (c. 1737-after 1775), dated March 8, 1775. A magnificent example of Pennsylvania German cabinetmaking, this clothespress boasts carved

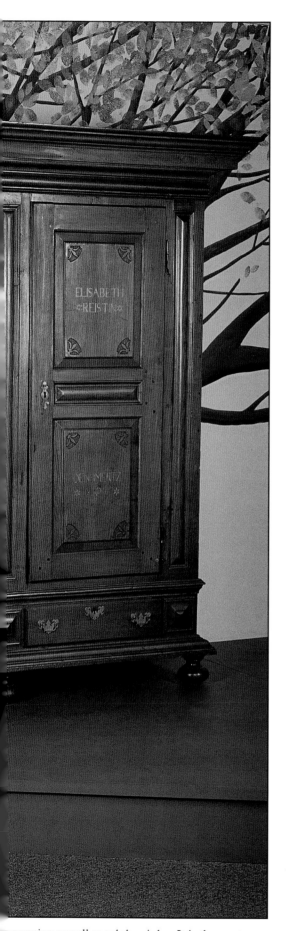

The last sulphur-inlaid object known to be associated with the Kauffman family is shown in figure 49. This impressive *Kleiderschrank* is dated March 8, 1775 and was built for Abraham Reist (1737-1813) and his wife Elizabeth (Kauffman) Reist (c. 1737-after 1775) as a furnishing for their substantial stone farm house that was built in 1774 and still stands on their Penn Township farm. Abraham was the son of Peter and Anaclore (Boyer) Reist, 1724 immigrants. He received a portion of his father's lands, where he farmed and operated a distillery, becoming very prosperous. He also owned lands in Waterloo Township, Ontario, where his son John Reist eventually settled. The Reist clothespress, with its relief-carved fleur-de-lis in the corners of its panels, is certainly from the same cabinet shop that produced at least seven closely related clothespresses, some also having sulphur inlay. Most of them were originally fitted with ball feet and boast large stepped cornices, as does the Reist example. Exhibiting massive proportions and exquisite detailing, they are considered to be among the finest examples of Pennsylvania German cabinetmaking.

The latest recorded sulphur-inlaid *Kleiderschrank* is shown in figure 30; it bears the date 1780. The owner of this example, Christian Schneider (1725-95), a wealthy farmer and miller in Londonderry Township, Dauphin County, was married to Barbara Reist (c. 1730- after 1769), an elder sister of Abraham Reist (fig. 49). After Barbara's death Schneider married a woman named Elizabeth (d. after 1795) and they commissioned this walnut clothespress, perhaps in celebration of their marriage. An unusual feature is the dentil molding with its alternating square and pointed teeth. The hinges, commonly called rat-tail hinges, are a continental Germanic form that was popular in Pennsylvania, Ohio, Virginia, North Carolina, and Ontario (fig. 98).

The wall cupboard (fig. 50) is another furniture form that was popular in Pennsylvania, as well as in the German regions of Europe. Wall cupboards, or

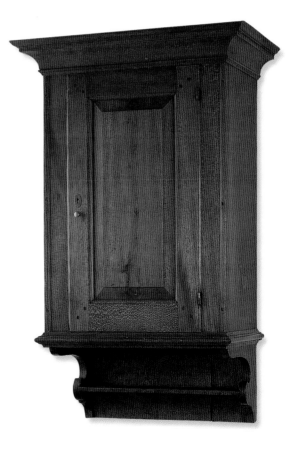

Figure 50. Wall cupboard, by an unknown Lancaster County cabinetmaker, built c. 1760-80 for Isaac Long (1742-98) and Susanna (Kauffman) Long (c. 1741-82) of Landis Valley in Manheim Township. Constructed of sycamore wood, this one-door wall cupboard exhibits a graceful cove- molded cornice. The cabinet sides extend to form shaped brackets that support the exposed shelf. Isaac and Susanna Long occupied the two-and-a-half-story stone house built by Isaac's father, Johannes Long (1693-1767). The house still stands, with a portion of the original clay tile roof remaining intact. *Sycamore, iron, and brass, 43" x 15" x 28". Collection of Mr. And Mrs. Richard Flanders Smith. John Herr, photographer.*

ecoration as well as sulphur inlay. It is the most aborate article of furniture known to have been roduced for a member of the Christian Bamberger l. 1742) family. *Walnut, sulphur, iron, and brass, 91" x ⅃" x 86". Heritage Center Museum Collection through the nerosity of the James Hale Steinman Foundation.*

corner shelves, were frequently found in the *Stube*, or stove room of the house, where they held Bibles, hymnals, and other small objects. They were usually hung in the corner opposite the heating stove, where the corner benches and dining table were located. This gracefully constructed cupboard was originally located in the two-and-a-half-story stone mansion house of Isaac Long (1742-98) and his wife Susanna (Kauffman) Long (c. 1741-82) of Manheim Township, Lancaster County. Likely constructed c. 1760-80, this cupboard could well have been part of the *Aussteier* (outfitting) for their c. 1764 marriage.

The tall case clock (figs. 51 and 52) was built for John Hiestand (1766-1858) and his wife, Barbara (Hershey) Hiestand (1772-1805), of East Hempfield Township, Lancaster County, a member of the extended family of Christian Bamberger (d. 1742). John Hiestand, a wealthy Mennonite farmer, was the nephew of Jacob Hiestand and his wife, Elizabeth (Hershey) Hiestand. John's extensive land holdings were located northwest of the Landisville Meetinghouse. This impressive piece of cabinetry houses an eight-day clock movement signed by two prominent Lancaster Borough clock makers, George Hoff (1733-1816) and his son John Hoff (1776-1818). The movement is dated 1797. The walnut clock case is exceptional in its detailing. The relief-carved base is the only example known on a Lancaster County clockcase (fig. 52). Historian John J. Snyder, Jr. feels that the case may be the work of Jacob Hiestand (1767-1834), a first cousin of John Hiestand, who was both a farmer and joiner and lived between Manheim and Mount Joy, Lancaster County. John and Jacob Hiestand were grandsons of Jacob Hiestand (d. 1772), a 1727 immigrant to Pennsylvania.

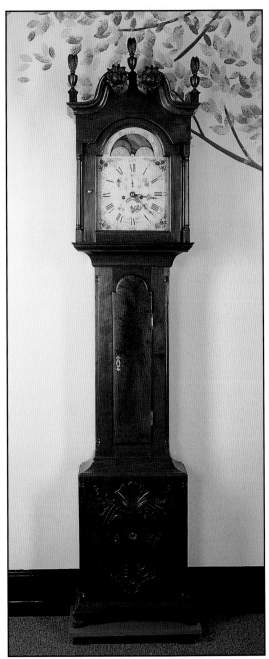

Figure 51. Tall case clock; the eight-day movement is dated 1797 and signed by George Hoff (1733-1816) and John Hoff (1776-1818), clockmakers in Lancaster Borough. The case may be the work of Jacob Hiestand (1767-1834), a farmer and cabinetmaker in Mount Joy Township, Lancaster County. Made for his first cousin John Hiestand (1766-1858) of East Hempfield Township. The Chippendale case boasts carved rosettes, fluted quarter-columns on the waist, and relief-carving on the base. The finials are accurate replacements. Massive, yet beautifully proportioned, this clock demonstrates the high quality of furnishings that some eighteenth century Mennonites enjoyed. *Paint, iron, brass, steel, walnut, tulipwood, and hard pine, 104" x 12" x 23.75". Collection of Toad Hall.*

Figure 52. Detail of base of tall case clock owned by John Hiestand (1766-1858). This exquisite shell and foliate design was executed in relief carving and exhibits influences of both Lancaster Borough carvers and carvers working in the town of Manheim, Lancaster County. *Collection of Toad Hall.*

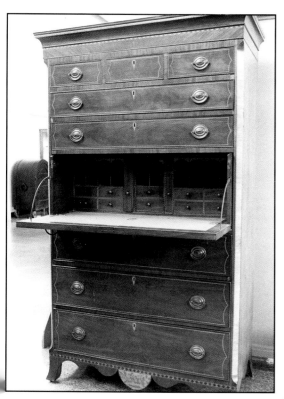

Figure 53. Federal high chest of drawers with a desk drawer, by an unknown cabinetmaker probably working near Manheim, Lancaster County, c. 1800 to 1815. This stylish high chest is constructed of mahogany with line inlay decoration in contrasting woods. The center of the skirt exhibits an elaborate floral vignette executed in marquetry. The name of the original owner, Christian Hiestand (1792-1877) appears inside the case. This costly piece of furniture was undoubtedly a gift from Christian's parents, John Hiestand (1766-1858) and Barbara (Hershey) Hiestand. In 1814 they constructed a two-and-a-half-story stone farmhouse for Christian on a portion of their 391 acre tract just north of Landisville in East Hempfield Township. The Hiestands worshiped at the Landisville Mennonite Meetinghouse (fig. 18). *Mahogany, mahogany veneers, holly, and other wood inlays, 71.75" x 22.75" x 45.25". Photograph courtesy of Hershey Museum.*

Other pieces of relief-carved case furniture from the Lancaster and Manheim schools of carved furniture can also be traced to Mennonite ownership, particularly families that resided in the prosperous townships that surrounded the Borough of Lancaster. The clockcase previously described was executed in the Chippendale style that was gradually falling out of favor by the end of the eighteenth century. The newer Federal style, with its lighter lines, French feet, and delicate wood inlay, rapidly gained in popularity, even among the rather conservative Mennonite community. The high chest-desk combination (fig. 53) is an elaborate example of the changing taste of the Mennonite and broader community. This exquisitely inlaid piece of case furniture is believed to have been built for Christian Hiestand (1792-1877) prior to his marriage to Catharine (Hiestand) Hiestand (1798-1877). Christian married his second cousin, who was the daughter of Jacob Hiestand (1767-1834), the joiner of Mount Joy Township.[5] Christian's high chest is constructed of mahogany and boasts elaborate wood inlay. The demi-lune drop on the skirt exhibits a sophisticated and naturalistic floral design. The owner of this piece, Christian Hiestand, was a farmer, distiller, and bank director. At the time of his death in 1877, he was among the wealthiest members of the Lancaster Mennonite community.

The skilled leather worker who produced the sidesaddle shown in figure 54 was not born into a Mennonite family. Instead, Henry Hoffman (1813-94) joined the church after his marriage to Catherine Hiestand (1824-96), the daughter of Christian and Catherine (Hiestand) Hiestand. Henry continued his father Christian Hoffman's leather-working business in East Hempfield Township, Lancaster County, and by 1860 employed seven workers producing saddles, harnesses, hames, and traces.[6] Hoffman's shop was located about a mile and a half east of Landisville along the Harrisburg Pike (fig. 55). This side saddle with its tooled floral designs was decorated with colored dyes. A note accompanying it states that it was made in 1844 for Katie Nissley. Decorated side saddles were typically given to young Mennonite women prior to their marriage as part of their outfitting for married life. The saddle shows no evidence of wear, likely because Katie Nissley's spouse owned a pleasure carriage. Such carriages were coming into common use by the Lancaster Mennonites about this time.

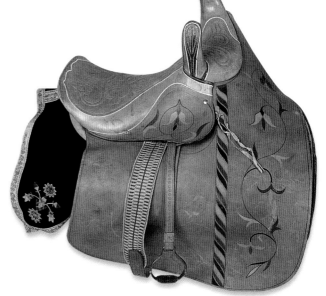

Figure 54. Sidesaddle, made by Henry Hoffman (1813-94) working in East Hempfield Township, Lancaster County, c. 1844. Saddler Henry Hoffman was the son-in-law of Christian Hiestand (1792-1877), the owner of the high chest shown in figure 53. Crafted for a young Mennonite woman, Katie Nissley, in 1844. Hoffman decorated the seat with an elaborately stitched floral design. On the side flaps he used a tooled tulip and vine decoration enlivened with colored stains. The stirrup straps are punch-decorated in a star pattern. The wool blanket was further enhanced with floral decoration stitched with wool embroidery flosses. *Leather, wool, tow fabric, and iron, 25.5" x 23" x 27". Collection of the Hershey Museum.*

SADDLES & HARNESS,
Made in the newest Fashion by
Henry Hoffman,
East Hempfield, Lancaster Co.
On the Lancaster and Harrisburg Turnpike, opposite the 5th mile Stone.

Figure 55. Sidesaddle label. Here Henry Hoffman advertises "Saddles and harness in the newest fashion." His shop stood on the south side of the Old Harrisburg Pike just west of Bowman Road in East Hempfield Township. *Wove paper and ink on leather. Collection of the Hershey Museum.*

We have examined a number of pieces of hardwood furniture with decoration, sulphur, wood inlay, and carving that can be traced to Mennonite ownership. Many families owned less costly furnishings as well. In most regions of Europe softwood cabinetry was painted with an overall ground color and then decorated utilizing additional colors and designs. The Mennonites of Pennsylvania frequently owned numerous pieces of painted softwood furniture as well as hardwood pieces. Except for chests, painted pieces are rarely inscribed; hence they are difficult to document. In the Bamberger family one member has been identified as a cabinetmaker and decorator. Examples of his work are seen in figure 56 and 93.

John Bamberger (1780-1861) was a great-grandson of Christian Bamberger (d. 1742). John and his wife Anna Maria Musser (1787-1861) farmed a portion of the Christian Bamberger tract in Warwick Township, about one mile north of the town of Lititz in Lancaster County. John supplemented his farming by doing a small amount of cabinetmaking. More information on Bamberger appears in a later chapter (figs. 91-93). The chest over drawers shown in figure 56 is the only recorded example of a chest by Bamberger having drawers. The decoration, however, is typical of Bamberger's stippled surfaces, as is the large heart that encloses the date and name of the owner.

John Bamberger's eldest brother Christian (1778-1834) produced a small but impressive group of fraktur drawings. He was born on the Bamberger homestead, and about the time of his marriage, c. 1811, he and his wife Barbara Reist (1772-1848) moved northward to North Cornwall Township, Lebanon County, Pennsylvania, where they occupied a farm that was owned by his parents, John and Maria (Reist) Bamberger. Christian's wife Barbara was the daughter of Abraham and Elizabeth (Kauffman) Reist, whose 1775 clothespress is seen in figure 49. Christian and Barbara farmed a large plantation in North Cornwall Township. They had two children, both of whom died in childhood. Christian produced a small quantity of fraktur drawings, all dating from 1823 to 1832. All are of a similar format with brightly colored tulips, hearts, and birds artfully intertwined (fig. 57). Some of his work is inscribed for the recipient, and his fraktur pieces are frequently signed and dated. The children who received these colorful drawings appear to have been the children of neighboring farmers, some of whom likely worked as hired boys and girls on the Bamberger farm. One recipient, Catherine Westenberger (1820-48), who received her drawing at age twelve,[7] is buried in the tiny Bamberger family cemetery.

Figure 56. Chest over drawers, attributed to John Bamberger (1780-1861), working in Warwick Township, Lancaster County, made for Elizabeth Herr, dated 1825. Although Bamberger's chests typically lack drawers, the stippled painted surfaces and the heart design, exhibited here, are found on all of his recorded examples. The whimsical carved half-turnings that flank the drawers may, however, be unique to this chest. *Tulipwood, paint, and iron, 31" x 23" x 50". Collection of Dr. and Mrs. Donald M. Herr.*

Figure 57. Fraktur drawing, signed by Christian Bamberger (1778-1834), working in present-day North Cornwall Township, Lebanon County, for Hanna Schmidt, dated 1832. Bamberger's bird and floral compositions are a jubilant mix of tulips, birds, and hearts. All recorded examples appear to be presentation pieces. The inscription inside the heart translates as follows: "This picture belongs to Hanna Schmidt in Lebanon Township in Lebanon County 1832". Christian Bamberger's signature appears in the lower left corner. *Ink and watercolor on wove paper, 10" x 12". Collection of the Dietrich American Foundation. Photograph by Will Brown.*

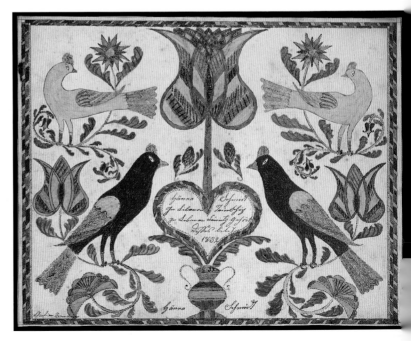

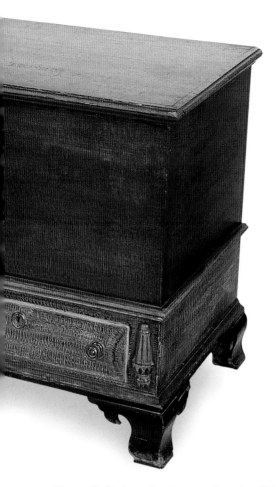

Other fraktur drawings exist that can be attributed to descendants of Christian Bamberger (d. 1742). The drawing shown in figure 58 bears the signature of Elias Brubacher (1789-1847). He was a first cousin of Christian Bamberger, the fraktur artist. Elias Brubacher, a bachelor, probably drew this *Bild*, or picture, about 1820. He later gave it to his niece, Magdalena Eby (b. 1817), who pasted it in her 1840 New Testament as a remembrance of her uncle.

Another notable fraktur artist among the Bamberger clan is Jacob Nolt (1798-1852) of West Earl Township, Lancaster County. Nolt had a large farm along the banks of the Conestoga River. He created a group of imaginative and appealing bird drawings. A descendant recalled that they were created during a period of illness. Recorded examples bear the dates 1834 to 1837. Many are inscribed for the recipient in either English or German (figs. 59, 211, and 212).

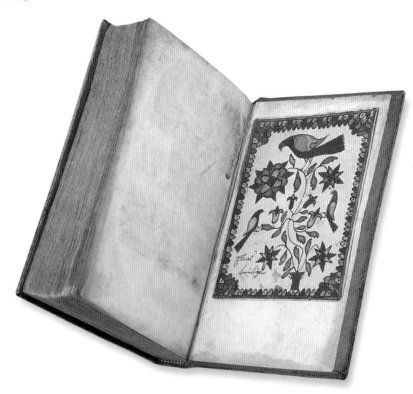

Figure 58. Fraktur drawing, attributed to Elias Brubacher (1789-1847), probably Warwick Township, c. 1820. This simple *Bild*, or picture, was a gift to Brubacher's niece Magdalena Eby (b. 1817). Ink and watercolor on wove paper, 5" x 3.75". *Heritage Center Museum Collection through the generosity of the Donegal Chapter of the Daughters of the American Revolution.*

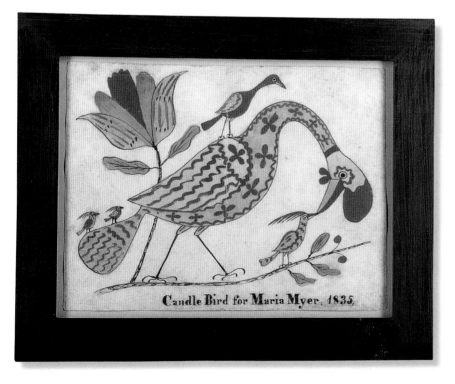

Figure 59. Bird drawing, attributed to Jacob Nolt (1798-1852), working in West Earl Township, Lancaster County. Drawn for Maria Myer, dated 1835. This strange-looking creature, dubbed a "Candle Bird" by artist Jacob Nolt, bears little resemblance to any bird known to inhabit southeastern Pennsylvania. There is little doubt that it was purely the product of Nolt's lively imagination. *Ink and watercolor on wove paper, 5.75" x 7.75". Private collection.*

Among Mennonite families it was common to receive decorated trinket boxes, miniature chests, or document boxes as gifts from one's parents or grandparents. The domed lid document box shown in figure 60 is believed to have been given to Jonas Nolt (1801-65) around his thirteenth birthday. Jonas was the younger brother of Jacob Nolt the fraktur artist. He lived with his parents, Jonas Nolt (1771-1838) and Magdalena (Buckwalter) Nolt, in West Earl Township, Lancaster County. This box was among a large group of similarly decorated boxes that were produced c. 1760 to 1830 by several different persons, all of whom used compasses to create the elaborate snowflake designs.

The miniature chest shown in figure 61 was likely made c. 1810 as a gift for twelve- year-old Abraham Reist (1798-1844) of Penn Township, Lancaster County. Although it is an accurately proportioned miniature chest, the interior lacks a till, suggesting that it was likely intended to function as a document box. Abraham Reist was the namesake grandson of Abraham Reist (1737-1813), the owner of the 1775 clothespress in figure 49. Young Abraham Reist (b. 1798) was reared in the 1774 limestone farmhouse built by his grandparents. He later married Barbara Eby (1802-89).

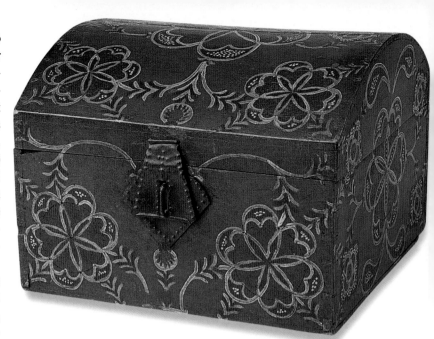

Figure 60. Compass Decorator box, made by an unidentified maker known as the Compass Decorator, for Jonas Nolt (1801-65), living in West Earl Township, Lancaster County, pencil inscription and date 1814. As a teenager Jonas would have kept small treasures and correspondence in his domed-lid box. He later farmed in West Earl Township. *Tulipwood, paint, and tin, 8" x 10.75" x 11". Collection of Winterthur Museum.*

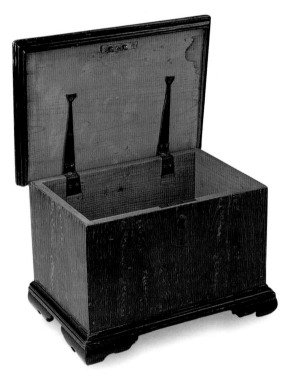

Figure 61. Miniature chest, by an unknown cabinet-maker likely working in Lancaster County, c. 1810, made for Abraham Reist (1798-1844) of Penn Township, Lancaster County. The dovetailed construction, molded bracket base, and strap hinges are features found on full-size chests of this period. The red graining is also original; however, the feet have lost some height. *Pine, paint, iron, and brass, 11" x 11" x 16.50". Private collection.*

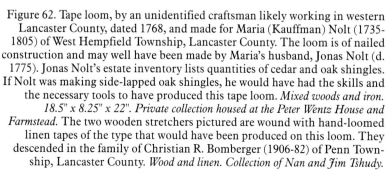

Figure 62. Tape loom, by an unidentified craftsman likely working in western Lancaster County, dated 1768, and made for Maria (Kauffman) Nolt (1735-1805) of West Hempfield Township, Lancaster County. The loom is of nailed construction and may well have been made by Maria's husband, Jonas Nolt (d. 1775). Jonas Nolt's estate inventory lists quantities of cedar and oak shingles. If Nolt was making side-lapped oak shingles, he would have had the skills and the necessary tools to have produced this tape loom. *Mixed woods and iron. 18.5" x 8.25" x 22". Private collection housed at the Peter Wentz House and Farmstead.* The two wooden stretchers pictured are wound with hand-loomed linen tapes of the type that would have been produced on this loom. They descended in the family of Christian R. Bomberger (1906-82) of Penn Township, Lancaster County. *Wood and linen. Collection of Nan and Jim Tshudy.*

Figure 63. Woman's cap, by an unknown needleworker probably working in Warwick Township, Lancaster County, c. 1762, made for the wedding of Elizabeth Bucher (c. 1744-1806) of Warwick Township to Abraham Huber. This cap is finely quilted and quite similar to the cap seen in figure 250. *Handloomed cotton fabric, 6.5" x 4" x 6". Collection of the Lititz Historical Foundation, Inc.*

Figure 64. Wedding handkerchief, stitched by Feronica Schneider (1767-1856) of Rapho Township, Lancaster County, in 1787. Feronica's handkerchief exhibits all the traits of the typical Pennsylvania German wedding handkerchief, employing cross-stitched motifs that are oriented towards all four sides of the fabric square. Feronica's name is spelled out around the border, and a large case alphabet surrounds the central box design. *Linen fabric and silk flosses, 20.5" x 21". Collection of Mary Ann McIlnay.*

The object appearing in figure 62 is a tape loom. Although simply constructed it is incise-decorated with the use of a compass and is inscribed, "Maria Noltin 1768." The tape loom was used by Pennsylvania German women and children to produce narrow bands of colorful fabric tape. These tapes would be used as ties on clothing and bedding and as hanging loops on towels. This was typically the only form of weaving done in a Pennsylvania German household. The weaving of yard goods required a massive loom and was the product of professional weavers. The owner of this tape loom, Maria (Kauffman) Nolt (c. 1735-1805), was the granddaughter of Christian Bamberger (d. 1742). She was married to Jonas Nolt (d. 1775), a farmer in West Hempfield Township, Lancaster County.

The descendants of Christian Bamberger (d. 1742) also produced a wide array of decorated textiles that are representative of the textile forms that many Mennonite women produced. Many of them are outstanding in terms of design and quality of needlework. Several of their textile objects are widely regarded as icons of Pennsylvania German folk textiles. The quilted cap shown in figure 63 is the earliest textile object that has been associated with this family. According to tradition it is the wedding cap of Elizabeth Bucher (c. 1744-1806), and was worn at her 1762 wedding to Abraham Huber (1731-90). Eighteenth-century Pennsylvania German women, of most denominations, commonly wore caps. This tradition of wearing head coverings continues today among the Mennonites, Amish, and other conservative groups. Elizabeth Bucher was the daughter of 1737 Swiss immigrant Hans Martin Bucher and his wife Elizabeth Bamberger. They lived on a portion of the Christian Bamberger (d. 1742) tract in Warwick Township.

The cross-stitch decorated textile appearing in figure 64 is among the rarest forms of Pennsylvania German needlework, the wedding handkerchief. Twenty-one examples are known, and most appear to have been stitched by young Mennonite women living in northwestern Lancaster County in the last decades of the eighteenth century. The needleworker who created this example, Feronica Schneider (1767-1856), was the daughter of Jacob and Maria (Hershey) Schneider of Rapho Township, Lancaster County. Feronica stitched her wedding handkerchief in 1787 in preparation for her marriage to Benjamin Hershey (1768-1842). In 1791 they built a two-and-a-half-story stone farmhouse in Penn Township, just southeast of the town of Manheim. Benjamin Hershey was a farmer and minister in the Mennonite Church. His farm adjoined the farm of his brother, Christian Hershey, whose clothespress appears in figure 29. Feronica employed a wide variety of cross-stitch motifs, including the alphabet. She started to list the names of her brothers and sisters; but she never finished, as she undoubtedly realized that she wouldn't be able to fit all fifteen of them on her handkerchief. Although she was a proficient needleworker, her designs and texts were carefully copied. Like many Mennonite women of her day, she apparently had no formal education. On a 1796 deed she signed her name with an "X," suggesting that she was unable to read or write.

Young Pennsylvania German women usually stitched a sampler as a means of recording the various motifs that they wished to save for future use in marking their textiles. These samplers were typically asymmetric, and most were never completely filled with motifs (figs. 255, 264, 266, and 267). They were stored in the sewing basket and never displayed. In the nineteenth century, more balanced samplers gained in popularity, with some needleworkers producing both types. The balanced or formal samplers were intended for display, and they frequently survive in their original frames (figs. 67, 265, and 269).

Although the sampler made by Anna Bamberger (1791-1881) has not been located, her cross-stitch decorated tablecloth survives (fig. 65). Anna Bamberger was born in Penn Township near Manheim, the daughter of Joseph Bamberger (1762-1811) and Magdalena (Hershey) Bamberger (1765-1845). Anna's aunt by marriage was Feronica (Schneider) Hershey, who stitched the wedding handkerchief pictured in figure 64. Anna stitched her name and the date of 1809 on her tablecloth. In 1810 she married Martin Nissley (1788-1872), the son of Bishop Samuel and Barbara (Kreider) Nissley of Mount Joy Township, Lancaster County. Upon their marriage Martin and Anna Nissley moved to the farmhouse shown in figure 66, located in Rapho Township, near Sporting Hill. Anna's tablecloth is one of a small group of related tablecloths that are made out of a single loom's width of fabric and then embellished with a row of cross-stitch motifs at either end. Other tablecloths employ a wide, drawn-work band to join two widths of pattern-weave linen fabric with cross-stitch decoration at the ends of the drawn-work band, as seen in figures 71 and 261.

Figure 65. Decorated tablecloth, stitched by Anna Bamberger (1791-1881) of Penn Township, Lancaster County, dated 1809. Anna used silk and cotton embroidery flosses to decorate the ends of her tablecloth, stitching her name, the date, and several floral motifs, including a corner flower motif that appears on the wedding handkerchief of her aunt and close neighbor, Feronica (Schneider) Hershey. Anna used a needle and red cotton thread to stitch the horizontal bands that appear on her tablecloth. *Linen, cotton, and silk, 43" x 66". Private collection.*

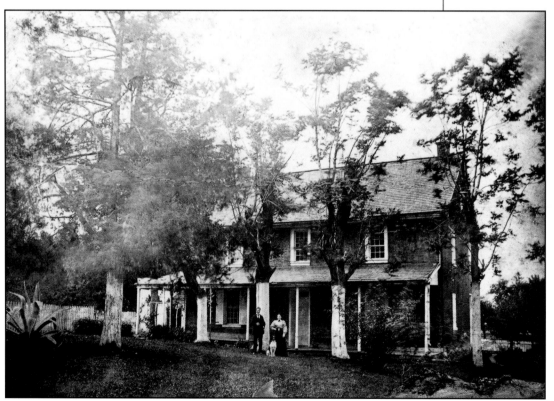

Figure 66. Nissley home, c. 1900 photo, located in Rapho Township. It was in this house that Martin and Anna (Bamberger) Nissley resided after their marriage in 1810. They reared a family of five daughters, who created an outstanding group of cross-stitch-decorated textiles (figs. 67, 68, and 71). In this photo, great-grandson Sem S. Brubaker (1872-1957) and his wife Bertie (Engle) Brubaker pose with the family pet. The house was destroyed by fire in 1907. *Photo in private collection.*

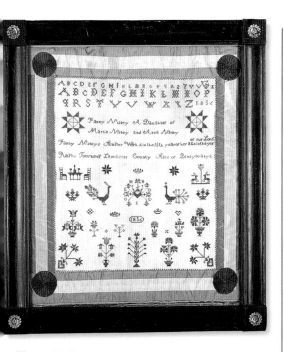

Figure 67. Sampler, made by Fanny Nissley (1821-88), working in Rapho Township, Lancaster County, dated 1836. At age fifteen, Fanny Nissley created this exceptional cross-stitched sampler that she bound with a silk ribbon and corner rosettes. Fanny employed a myriad of traditional Pennsylvania German motifs to fill her sampler. At least two of Fanny's sisters stitched similar pieces. Fanny's sampler still retains the original frame. *Linen, cotton, silk, wood, and brass, 21" x 18". Collection of Dr. and Mrs. Donald M. Herr.*

Figure 68. Decorated towel, made by Fanny Nissley (1821-88), working in Rapho Township, Lancaster County, dated 1839. Most of the motifs that Fanny chose to decorate her towel appear on her sampler (fig. 67), which she had completed three years earlier. The domestic grouping, consisting of a pair of ladderback chairs, a stretcher-base table, and a wine set, were popular motifs among the Mennonites of northwestern Lancaster County (fig. 261). The inscription that is enclosed by a large heart is as follows: "Fanny Nissley/ is My Name Rapho To/ wnship Lancaster County and/ State of Pennsylvania Fany/ Nisley is My name the rose is/ red the lives [sic] are green the days/ are Past which I have seen/ I Mark this Hand/ Toul [sic] the 4/ May." *Plainweave linen, cotton flosses. 56" x 16.5". Collection of Dr. and Mrs. Donald M. Herr.*

Most of the cross-stitch decorated tablecloths in this group can be attributed to Mennonite needleworkers in northwestern Lancaster County. The proportions of Anna Bamberger's table cloth suggest that it was designed to fit a sawbuck table (fig. 19), which was popular in eighteenth century Pennsylvania German households. In the nineteenth century, drop-leaf tables became the preferred style. A drop-leaf table required a cloth that was wider and shorter, such as the tablecloth made by Anna's daughter, Mary Nissley (fig. 71).

Martin and Anna (Bamberger) Nissley had a family of five daughters. All appear to have been highly skilled needleworkers who produced an impressive group of textiles, a few of which can be seen in figures 67, 68, and 71. The cross-stitch motifs that appear on Anna's 1809 tablecloth also appear on the textiles stitched by her daughters. In 1836, fifteen-year-old Fanny Nissley (1821-88) stitched the exceptional sampler pictured in figure 67. She included both small- and large-case alphabets and a variety of classic cross-stitch motifs that were popular among the Mennonite needleworkers of Lancaster County. The silk binding with silk corner rosettes is effectively repeated in the design of the original frame. Although her sampler is balanced, giving it a more formal appearance, close inspection reveals that she employed different motifs similar in scale to achieve that balance and was thus preserving the original intent of the Pennsylvania German sampler, as a means of recording as many different motifs as possible. Three years later, in 1839, Fanny stitched the decorated towel seen in figure 68. Most of the motifs she employed on her towel also appear on her earlier sampler. Two years after completing this towel she married Jacob W. Snyder. They eventually owned her parents' Rapho Township farm. The bookplate and fraktur drawing (figs. 69 and 70) are found in the 1827 New Testament that was likely a gift from Fanny's parents.

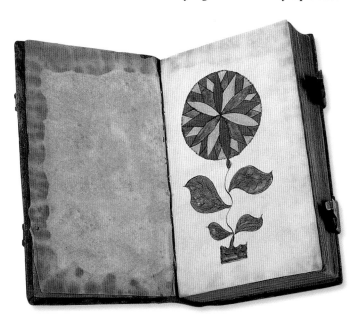

Figure 69. Fraktur drawing, attributed to Heinrich Keyser (b. c. 1776), Rapho Township, Lancaster County, c. 1833. From a folded sheet of paper, schoolmaster Keyser created a two-page fraktur bookplate that was then sewn into the 1827 New Testament owned by Fanny (Feronica) Nissley (1821-88). On the front page he created this lively floral design. *Wove paper, ink, and watercolor, 5" x 2.5". Collection of Dr. and Mrs. Donald M. Herr.*

A decorated tablecloth stitched by Mary Nissley (1824-98), Fanny's younger sister, can be seen in figures 71 and 72. In the overall photograph it is easy to see the evolution in the size of the Pennsylvania German table when comparing it to her mother's (fig. 65). All of the cross-stitch motifs that Mary chose to stitch on her 1843 tablecloth appear on her sampler dated 1840. The vine design that appears in the drawn-work center panel of her tablecloth appears in cross-stitch on her 1841 decorated towel, as well as on her sister Fanny's towel dated 1839 (fig. 68).

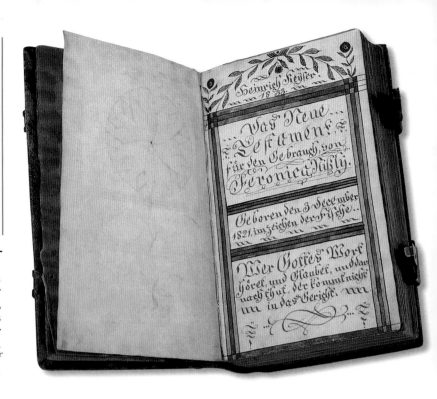

Figure 70. Fraktur bookplate, signed by Heinrich Keyser (b. c. 1776), Rapho Township, Lancaster County, dated 1833. On the second page of decoration, schoolmaster Keyser recorded that the Testament was for the use of Feronica Nissley. He also recorded her birth and then closed with a religious admonition. *Wove paper, ink, and watercolor, 5" x 2.5". Collection of Dr. and Mrs. Donald M. Herr.*

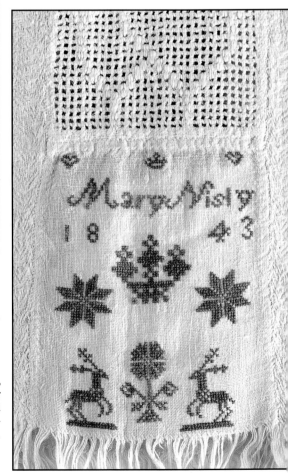

Figure 71. Decorated tablecloth, stitched by Mary Nissley (1824-98) in Rapho Township, Lancaster County, dated 1843. Nineteen-year-old Mary created this tablecloth by joining two loom widths of pattern weave linen fabric. For the center seam she worked a drawnwork band with an undulating vine motif. At either end of the band she inserted a piece of plain weave fabric, which she decorated with cross-stitch motifs. *Pattern weave linen, cotton flosses, 65" x 56.5". Private collection. Nathan Cox Photography.*

Figure 72. Detail of tablecloth stitched by Mary Nissley (1824-98), Rapho Township, Lancaster County, dated 1843. Mary chose prancing stags to adorn this end of her tablecloth. The other end was decorated with cross-stitched birds. Mary's tablecloth is patterned after a similar one stitched by her eldest sister Magdalena Nissley (1814-84) in 1837. *Private collection. Nathan Cox Photography.*

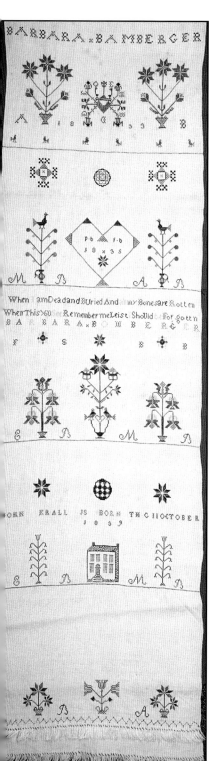

Figure 73. Decorated towel stitched by Barbara Bamberger (1817-88), probably living in North Cornwall Township, Lebanon County, dated 1833, 1835, and 1839. Barbara employed a variety of traditional motifs to create her needlework masterpiece. It is significant to note that it was produced over a period of several years. The daughters of Pennsylvania German farmers were expected to help with work in the house, the gardens, and even the fields. Their free hours were few, so some of their personal projects took months or even years to complete. *Plain weave linen, silk, and cotton flosses, 60" x 15.75". Collection of Dr. and Mrs. Donald M. Herr.*

The Nissley sisters weren't the only talented needleworkers in the Bamberger family. Two highly decorated towels (figs. 73 and 74) were stitched by their second cousins, sisters Mary and Barbara Bamberger. Barbara Bamberger (1817-88) and Mary Bamberger (1822-53) were the daughters of Peter and Fanny (Musser) Bamberger of West Earl Township, Lancaster County. Barbara's towel, stitched at age sixteen in 1833, is considered to be one of the finest decorated towels known. In addition to a wide array of cross-stitch motifs, she also included the initials of her parents and siblings. The initials "AB" may refer to her uncle Abraham Bamberger (1786-1859), a farmer in North Cornwall Township, Lebanon County, in whose home she was likely living as a hired hand. Barbara married John Krall of Lebanon County and, after the birth of their first child, she recorded his birth on her towel.

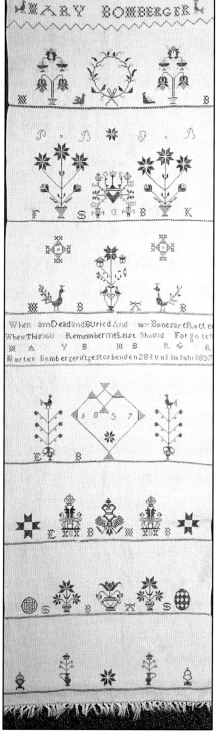

Four years after Barbara stitched her towel, sister Mary Bamberger, at the age of fifteen, crafted an equally elaborate textile. Mary anglicized her name to Bomberger and used both English and German text on her towel. The German text memorialized her nine-year-old brother Marten Bamberger, who died in 1837, the year that she made her towel. This towel was quite likely stitched in North Cornwall Township, Lebanon County. Another towel survives, stitched by a third Bamberger sibling, Elizabeth (1825-1916), in 1845. She used red and gray wool embroidery flosses to create a free-form design. Elizabeth's efforts were not nearly as successful as her elder sisters' and certainly suggest Elizabeth likely received her needlework instruction from a different teacher, most likely her mother. Elizabeth remained in West Earl Township, Lancaster County, where she married Jacob Stauffer (1824-1909), whose milking coat is shown in figure 225.

Figure 74. Decorated towel stitched by Mary Bamberger (1822-53), probably living in North Cornwall Township, Lebanon County, dated 1837. Mary Bomberger borrowed a number of motifs from her sister Barbara's towel, including the popular "OEHBDDE" motif, a stylized heart surrounded by the initials standing for, "O edel Hertz bedenk dein Ende" or "O noble heart, consider your end." Mary also included the initials of her parents and siblings. The initials "BK" represent Barbara (Bamberger) Krall, the maker of the towel shown in figure 73. The initials of her three deceased siblings, Martin, Methuselah, and Susanna, were all stitched in brown silk thread. *Plain weave linen, cotton, and silk flosses, 56" x 16". Collection of Dr. and Mrs. Donald M. Herr.*

The sampler seen in figure 75 is something of a departure from the traditional cross-stitch decoration that was popular among the Mennonites of Pennsylvania. The needleworker Fianna Landis (1818-1900) employed brightly colored wool embroidery flosses in place of the traditional silk and cotton threads. Most of the motifs she chose were traditional ones that were executed in cross-stitch. The house and pine tree motifs appear on a towel stitched by her mother Anna Long (1800-85) in 1816. A few of the motifs Fianna used, notably the eagle and the pitcher with coxcomb, are free-form designs that were embroidered using chain stitch. Fianna Landis is also known to have produced two decorated towels dated 1832 and 1835, utilizing chain-stitched free-form designs, similar to the towel stitched by her younger sister, Maria Landis (fig. 76).

The towel stitched by Maria Landis (1828-89) in 1843 is representative of a small group of free-form decorated towels that were produced in northern Lancaster County during the 1830s and 1840s, primarily by young Mennonite women. Unlike counted cross-stitch motifs, free-form decoration was created by the use of a pattern or tracing. Not surprisingly, this small group of towels seems to have been the product of a few interrelated families scattered across Lancaster County, from Earl Township in the northeast to Mount Joy Township in the northwest. Maria Landis was the daughter of "Rich" Benjamin Landis (1791-1849) and Anna (Long) Landis (1800-85), Mennonites residing in Manheim Township. In 1845, two years after completing this towel, Maria Landis married Levi G. Getz (1827-96), a farmer. They lived near McGovernville, East Hempfield Township, Lancaster County.

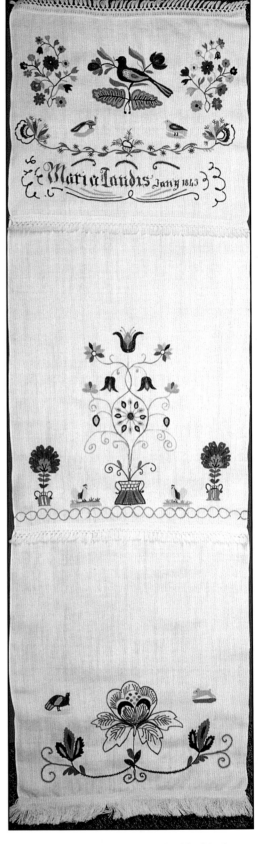

Figure 76. Decorated towel, stitched by Maria Landis (1828-89), living in Manheim Township, Lancaster County, dated 1843. Maria's use of chain-stitched designs, executed in wool threads, creates motifs that are far more naturalistic in appearance than are the traditional cross-stitched designs. She stitched her name and the date in fraktur-style lettering, which is rarely seen on Pennsylvania German textiles. *Plain weave linen and wool, 62.5" x 18.5". Collection of Eugene and Vera Charles.*

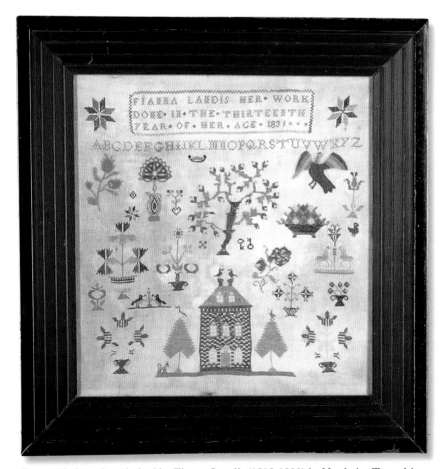

Figure 75. Sampler stitched by Fianna Landis (1818-1900) in Manheim Township, Lancaster County, dated 1831. Fianna's colorful sampler incorporated traditional Pennsylvania German motifs and nouveau designs. The use of brightly colored wool embroidery threads also signals a change in needlework traditions. The towel in figure 76 was stitched by her younger sister Maria Landis and is an even further departure from the centuries-old cross-stitch needlework style. *Plain weave linen and wool, 16.75" x 16.25". Collection of Eugene and Vera Charles.*

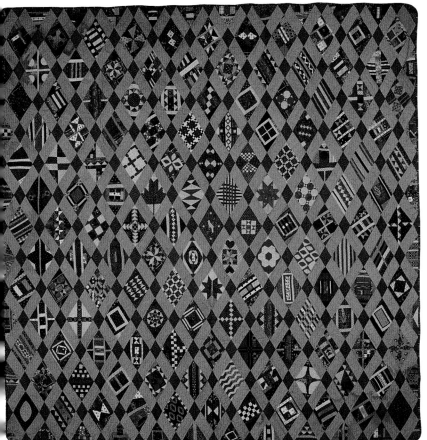

Figure 77. Sampler quilt, attributed to Fanny S. Bucher (1841-1910), living in Warwick Township, Lancaster County, dated 1860. The quiltmaker utilized thousands of bits of fabric to create a bold mosaic of quilt patterns. Each block is unique. Her choice of a diamond format for her blocks greatly complicated her work. In 1861 she married Simon B. Snyder (1836-1907), a farmer in Clay Township, Lancaster County. Their eldest daughter, Barbara B. Snyder (1862-1922), produced a related quilt seen in figure 294. *Cotton top, cotton batting, cotton whole cloth backing, 84" x 84". Private collection.*

While decorating textiles with cross-stitch motifs was a tradition that Mennonite women brought with them from their Swiss, German, and Dutch homelands, the quilting tradition was borrowed from their English neighbors in Pennsylvania. The quilt seen in figure 77 is a Sampler quilt. It is dated 1860 and is believed to have been made by Fanny S. Bucher (1841-1910), whose initials are stitched on a corner of the quilt. Fanny was reared on the Warwick Township homestead that her great-great-grandfather received from his father-in-law Christian Bamberger (d. 1742). Fanny was the daughter of Joseph Bucher (1820-94) and Anna (Shenk) Bucher (1820-42), farmers who were members of the Hess Mennonite congregation. Fanny's quilt is intricately pieced, utilizing fabric patches as small as one-quarter inch in width, each patch different from the rest. Her quilt is one of a small group of related Sampler quilts produced in northern Lancaster County in the 1860s and 1870s. Fanny's quilt is unusual in the use of the diamond format for her patches. A related quilt created by her eldest daughter Barbara can be seen in figure 294.

Quilting skills were also used in quilting whole-cloth petticoats, such as the example seen in figure 78. This elaborately stitched petticoat is one of three that have survived from the wardrobe of Fanny S. Bucher, the maker of the sampler quilt previously discussed. This petticoat, the most elaborate example, may well have been part of Fanny's wedding outfit for her 1861 marriage to Simon B. Snyder (1836-1907). Simon's parents were members of Middlecreek Church of the Brethren, and eventually Simon and Fanny Snyder joined the Brethren church as well.

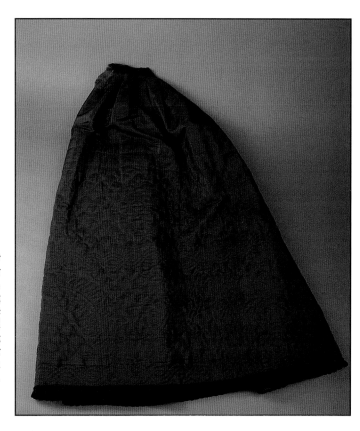

Figure 78. Petticoat, attributed to Fanny S. Bucher (1841-1910), living in Warwick township, Lancaster County, c. 1860. An elaborately quilted example. Fanny employed many of the same quilting patterns in stitching her petticoat that were commonly used to decorate quilts. The quilted petticoat was not a traditional clothing form among the Mennonites, but was borrowed from their Quaker neighbors, who wore them at a much earlier date. *Cotton, 41" x 35". Private collection.*

The pieced ball seen in figure 79 is attributed to Anna H. Bomberger (1843-1901), a close neighbor of Fanny S. Bucher. Anna was the daughter of Mennonite Bishop Christian Bomberger (1818-98) and Catherine (Hess) Bomberger (1819-75), who farmed a portion of the Christian Bamberger (d. 1742) homestead in Warwick Township. Anna used eighty-six pieces of fabric, and considerable skill, to piece this tiny round ball. Small pieced balls such as this example were frequently used as pin cushions or simply for decoration, as the hanging loop would suggest.

The Palatine custom of decorating Easter eggs survived among the Pennsylvania Germans.[8] While typically eggs were submerged in onion-skin dyes and then when dry were scratch-decorated, the example shown in figure 80 was decorated using ink and water colors. This goose egg is dated May 15, 1890, and was decorated by eighteen-year-old Haydn Bomberger (1872-1958), the son of Christian H. Bomberger (1848-1916) and Elizabeth S. (Hess) Bomberger, who were farmers in southern Penn Township, Lancaster County.

We have examined a sampling of the objects made, used, or owned by one Mennonite family, the descendants of Christian Bamberger (1682-1742), a 1722 Mennonite immigrant to rural Lancaster County. Although they are representative of the types of objects that many other Pennsylvania German families owned, many of the Bamberger family's objects rank among the finest known examples of Mennonite decorative arts. They suggest that some members of this family were highly skilled craftspeople, while others possessed both the desire and the wealth to purchase fine domestic furnishings.

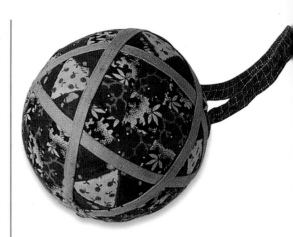

Figure 79. Pieced ball, attributed to Anna H. Bomberger (1843-1901), living in Warwick Township, Lancaster County, c. 1860. A number of similarly pieced balls are known. Most appear to have been created in northwestern Lancaster County, c. 1830-1900. The sheer challenge of stitching together tiny patches to create a sphere appears to be likely motivation for the creation of these eccentric pieced balls. *Cotton fabrics and unidentified stuffing, 2.5" x 2.5" x 2.5". Private collection.*

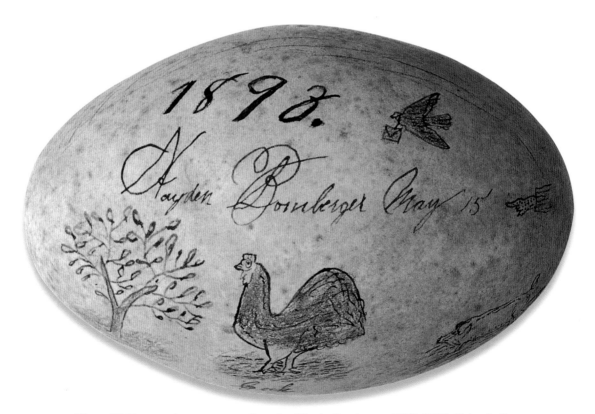

Figure 80. Decorated goose egg, attributed to Haydn Bomberger (1872-1958), living in Penn Township, Lancaster County, dated May 15, 1890. Haydn chose to decorate his egg with objects that appeared on his father's Penn Township farm. The tree, cock, and pig are identified as such underneath his drawings of them. He was a nephew of Anna H. Bomberger, who made the pieced ball seen in figure 79. *Goose egg, ink, and water color, 3" x 3" x 6". Collection of Nan and Jim Tshudy.*

Craftsman in Wood: Cabinetmakers and Turners

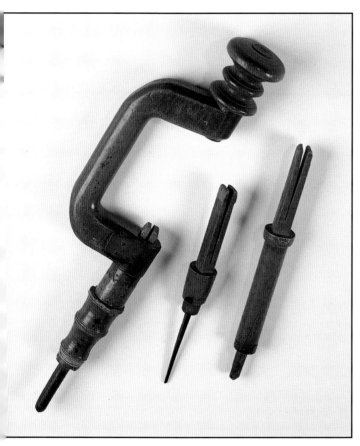

Figure 81. Brace with bits, marked "RL" for Rudolph Landes (1732-1802), cabinetmaker working in Bedminster Township, Bucks County, c. 1770-1802, dated 1770. This woodworking tool descended in the family of Rudolph Landes. One of the bits matches the diameter of holes that Landes drilled in his spooling wheel (fig. 82). *Cherrywood, pewter, tin, 17.25" x 2.25" x 4.5"; the bits: 10" x 1.25", 9" x 1". Collection of the Mennonite Heritage Center, Harleysville, Pennsylvania. Nathan Cox Photography.*

The Mennonite communities of eastern Pennsylvania were well established by the mid-eighteenth century. The affluent farm owners and millers, as well as their less-prosperous tenant farmers, all required wood craftsmen to build the furnishings for their houses. Their choice of furnishings was influenced by their Swiss-German cultural traditions, as seen in some of their earlier furniture (figs 27, 28, and 48). As acculturation occurred, the Pennsylvania Mennonites were quick to embrace furniture styles and forms that were part of the tradition of their English neighbors. Furniture forms that were unknown in their Swiss and German homelands, such as dough troughs, corner cupboards, and chests of drawers, soon became accepted if not indispensable objects in their Pennsylvania households. Some traditional furniture forms remained popular, including the chest and the massive clothespress, but they increasingly acquired the stylistic details that were popular in the surrounding Anglo community (fig. 29).

Unfortunately for researchers, few Pennsylvania German cabinetmakers signed their products. Among those who did sign their wares, a few can be identified as members of the Mennonite community. The earliest documented woodworker among the Franconia Mennonite community was Rudolph Landes (1732-1802). In 1749 Rudolph Landes left the village of Ober Florsheim in the Palatinate, Germany, and traveled to Philadelphia. Settling in Bedminster Township, Bucks County, he married Sarah Oberholtzer and became one of the first deacons in the Deep Run Mennonite congregation.[1] Rudolph's namesake grandson, Rudolph Landes (1789-1852), was an accomplished fraktur artist (fig. 199) in the Bucks County community. It is uncertain when the elder Rudolph Landes began his cabinetmaking career; but one of his tools, the brace with bits seen in fig. 81, is dated 1770. That Landes was a cabinetmaker is certain, for a 1786 receipt records that he was paid for making a coffin.[2] He also owned a turning lathe and produced a flax wheel and a spooling wheel (fig. 82), both stamped with his initials, "RL." The spooling wheel is dated 1787. His skill as a cabinetmaker is evidenced in the mortice-and- tenoned frame of the spooling wheel and the scrolled cutouts of the base. These details are quite often found on the massive Pennsylvania German weaving looms built in the eighteenth century, and it is highly likely that Rudolph Landes built looms as well.

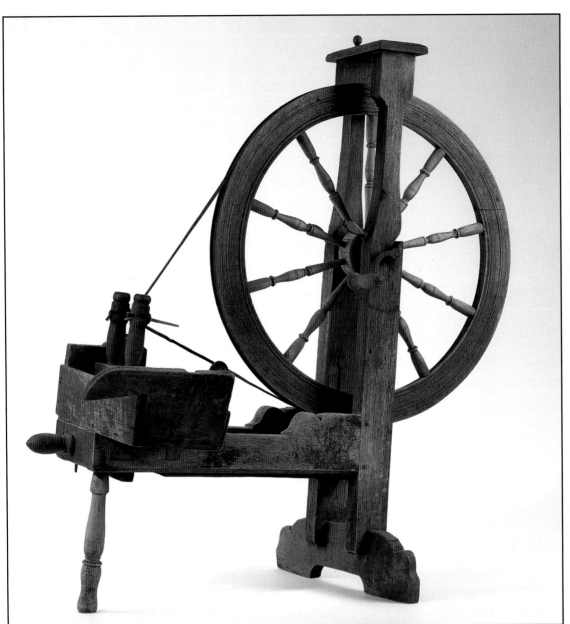

Figure 82. Spooling wheel signed "RL" for Rudolph Landes (1732-1802), working in Bedminster Township, Bucks County, c. 1770-1802, dated 1787. The scrolled foot and side boards of this wheel reflect the Germanic training of the cabinetmaker, Rudolph Landes. *White oak, maple, iron, 43.5" x 19.75" x 43". Private collection. Nathan Cox Photography.*

Figure 83. Drawing of spooling wheel in the ledger of Abraham Overholt (1765-1834), working in Plumstead Township, Bucks County, 1790-1833. Cabinetmaker Overholt likely apprenticed with Rudolph Landes. He copied the form and detail of Landes' spooling wheel (fig. 82) and in 1821 built the example seen in figure 86. *Laid paper. Private collection. Nathan Cox Photography.*

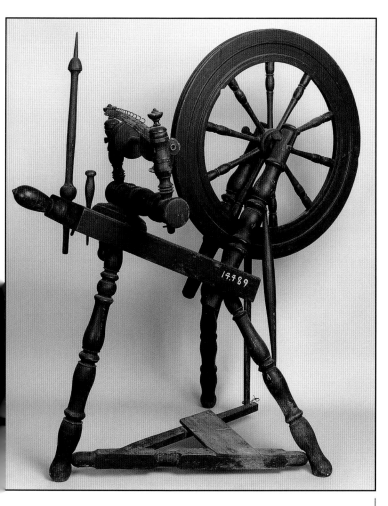

A second turner and cabinetmaker who worked in the Bucks County community was Abraham Overholt (1765-1834).[3] Overholt, who was born in Plumstead Township, Bucks County, was a nephew of Rudolph Landes (1732-1802), to whom he was certainly apprenticed. Abraham's drawing of a spooling wheel (fig. 83), and his completed wheel (fig. 86), were copied in detail from the wheel made by Rudolph Landes in 1787 (fig. 82). Overholt kept a ledger beginning in 1790 and continuing until 1833, shortly before his death. In addition to cabinetmaking, Abraham operated a sizable farm beginning in 1794. The flax wheel seen in figure 84 is dated 1790 and is one of the seven that he recorded making in that year. Overholt's name stamp and date appear in figure 85. He employed a star punch for additional decoration. The spooling wheel (fig. 86) is strikingly similar to the example made by Rudolph Landes (fig. 82) more than thirty years earlier. Overholt's spooling wheel was sold to Jonas Frey on December 20, 1821, for $4. Abraham Overholt's ledger records that in addition to producing textile tools, he made such items as painted high-post bedsteads, walnut butter boxes, dough tray tables, painted kitchen cupboards with and without glass, a walnut table with drawers, milk cupboards, walnut chests of drawers, a painted water bench, walnut cradles, a chest with three drawers painted blue with red moldings, a trundle bed, a little walnut chest, clock cases, tea tables, and rolling pins. Overholt's ledger clearly indicates that he produced both hardwood cabinetry and softwood pieces and that he invariably painted his softwood production. Abraham Overholt and his wife, Margaret Wismer (1771-1846), are both buried in the Deep Run Mennonite Cemetery in Bedminster Township, Bucks County.

Figure 84. Flax wheel, stamped "AOH" for cabinetmaker Abraham Overholt (1765-1834), working 1790-1833 in Plumstead Township, Bucks County, dated 1790. The brown paint on this spinning wheel may well be original, for Overholt's ledger records that much of the softwood furniture that he produced was painted brown. *Mixed woods, paint, iron, 34.75" x 19" x 33". Collection of the Mercer Museum of the Bucks County Historical Society.*

Figure 85. Stamped mark on flax wheel, "AOH" for Abraham Overholt (1765-1834), working 1790-1833 in Plumstead Township, Bucks County, dated 1790. This is a detail of the signature appearing on the wheel in figure 84. Overholt used a star punch to highlight his initials and the date. *Collection of the Mercer Museum of the Bucks County Historical Society.*

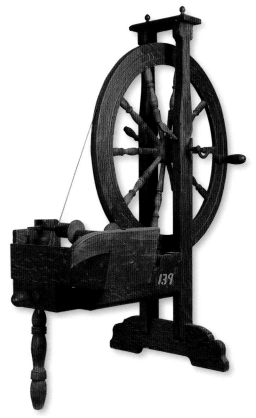

Figure 86. Spooling wheel, stamped "AOH" for Abraham Overholt (1765-1834), working 1790-1833 in Plumstead Township, Bucks County, c. 1821. Overholt's ledger records the sale of this wheel to Jonas Frey in 1821. In 1897 Frey's widow sold the piece to Dr. Henry C. Mercer. Overholt's drawing of the construction of this wheel is seen in figure 83. White oak, maple, iron, 44.75" x 19.75" x 41". *Collection of the Mercer Museum of the Bucks County Historical Society.*

One of the best known cabinetmakers to have worked in Lancaster County was a Mennonite house carpenter named Johannes (John) Bachman (1746-1829). Bachman was born in Lancaster County, the son of Hans and Anna (Miller) Bachman or Baughman. It isn't known to whom Bachman was apprenticed, but by 1769 he began keeping his cabinetmaking ledger and continued to do so until 1828.[4] His ledger, written entirely in German script, gives a rare insight into the production and clientele of an eighteenth century craftsman.

In 1770 Johannes Bachman was living in West Lampeter Township on property owned by Christian Herr (d. 1772), who became one of his first clients. Bachman recorded that on March 2, 1770, "I have made an English bedstead for Christian Herr." A generation later he would build a walnut clothespress, quite similar to the example in figure 87, for his former landlord's namesake son, Christian Herr (1772-1846). Although the bed has been lost, the clothespress is still treasured by a descendant.

Figure 87. Clothespress, signed John Baughman, c. 1790, working in Pequea Township, Lancaster County. The cabinetmaker Johannes Bachman (1746-1829) employed architectural elements in the design of this wardrobe. Bachman, who built furniture as well as millwork for new houses, was well versed in the current architectural trends. *Walnut, tulipwood, brass, and iron, 82" x 30.25" x 86". Collection of Dr. and Mrs. Donald M. Herr.*

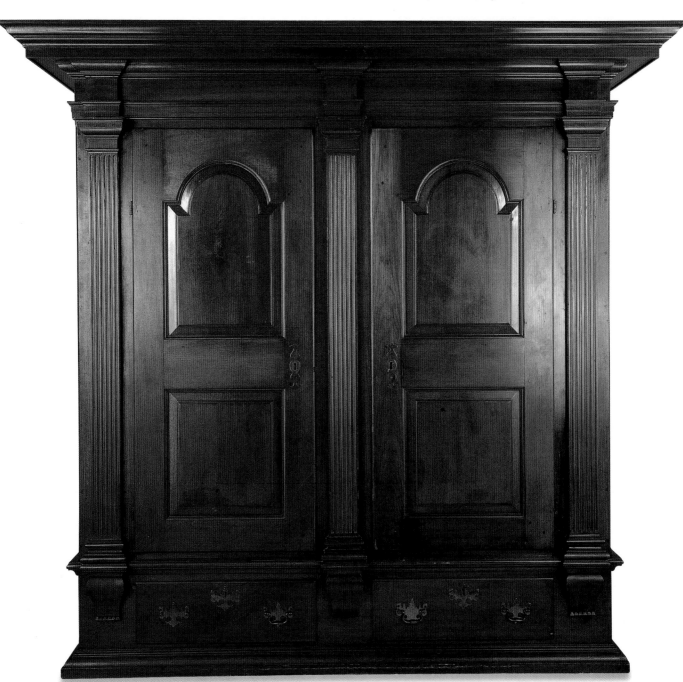

On April 9, 1771, Johannes Bachman married Mary Rohrer (b. 1749), the daughter of John Jacob Rohrer, a 1732 Swiss immigrant who settled in West Lampeter Township.[5] In 1780 Bachman purchased land in Conestoga Township, now in present-day Pequea Township. Johannes Bachman spent the rest of his life working in Pequea Township, where he trained his sons, John Bachman (1775-1849) and Jacob Bachman (1782-1849), in the cabinetmaking trade.

In his fifty-nine-year career, Johannes Bachman built a variety of furniture forms including clothespresses, chests of drawers, blanket chests, milk cupboards, kitchen cupboards, clock cases, tilt-top tables, corner cupboards, bedsteads, drop-leaf tables, desks, and coffins. He also made woodwork for the interiors of houses, several of which are still standing. Bachman's most popular item was the bedstead. He crafted 400 of them. Cabinetmakers in rural Pennsylvania frequently also served as undertakers. Johannes Bachman recorded the production of 376 coffins. Some of his descendants have continued in the undertaking business to this day.

Of the thousands of pieces of furniture built by Bachman, only a few can today be positively attributed to his workshop. These examples of his cabinetmaking demonstrate that Bachman was a skilled woodworker whose case furniture is handsomely proportioned and detailed. The clothespress signed by Bachman (fig. 87) exhibits strong architectural detailing. The prominent boxed cornice, fluted pilasters with molded capitals and plinth blocks, and the swelled brackets reflect Bachman's experience as a house carpenter. Probably constructed about 1790, this clothespress, or *"gleyder schrank"* as Bachman called it, was one of the twenty that he built.[6] The prices charged by Johannes Bachman suggest that he made both softwood and hardwood clothespresses and that most of his painted softwood examples were produced in the 1770s.

Christian Forrer (1737-83), the clock maker, purchased four softwood clothespresses on March 29, 1774, a few days after he bought a 212-acre tract of land in Newberry (present-day Fairview Township), York County, Pennsylvania. In 1774 Forrer left Lampeter Township for York County, where he operated a tavern and a ferry on the Susquehanna River.

Johannes Bachman's cabinetmaking shop was located just a few miles south of Lancaster Borough along the western edge of the 1710 Pequea settlement. Not surprisingly, most of his customers were Mennonite families of the third and fourth generations in Pennsylvania, families that were building and furnishing their substantial stone and brick farmhouses. In 1797 Johannes was joined by his eldest son, John Bachman (1775-1849), in the cabinetmaking trade. Within a few years son Jacob (1782-1849) would also enter the trade. Ultimately, each operated his own shop, and the brothers continued to supply the Pequea Township community with quality cabinetry for a generation after the death of their father.

John Bachman (1775-1849) was married to Esther Greider (b. 1780), and their eldest child, Jacob Bachman (1798-1867), followed in the cabinetmaking tradition established by his grandfather. After Jacob's 1822 marriage to Barbara Kendig, they moved to East Lampeter Township, where he established his cabinetmaking business. Jacob Bachman's ledger, kept from 1822 to 1862, was recorded in English[7] and contains a vast array of furniture forms and of farm and household tools that were manufactured by Jacob Bachman. This list illustrates the diverse objects that rural cabinetmakers were capable of producing. Jacob Bachman's shop served a far wider clientele than had his grandfather's shop. In addition to Mennonites, his clients included English people and other Pennsylvania Germans, including a sizable number of Amish customers.

The daybook listings of Jacob Bachman for the years 1822 to 1861; the spelling is as it appears in the original: "Kitchen dresser, corner cupboard, stand, baureau, high case of drawers, dining table, breakfast table, family table, high post bedstead, low post bedstead, doughtrough, wash trough, (window) sash and frames, chest, cherry desk, shutters, column bureau, benches, open dresser, boxes and a lamp stand, picture frames, mehackeny desk, french bedstead, quilting frame, sign, painting chairs, wood chest, spitting box, milk cupboard, flower boxes, cradle, bee boxes, bonnet box, wash machine, feating trug, roling pin, saltbox, bookcase, pulles, heakel boxes, meal chest, pairing machine, small wagon, mahackeney clock case, sleigh, close press, toilet table, framing two slates, knife box, candle box, churn stand, trough for cider mill, axe handle, knife handles, swift, election boxes, nail box, sampler frame and glass, lap board, rusian secretary, souing table, shoemaker bench, shoebox, clamb, shelf for clock, trunk, sadler bench and board, cabage box, cole rake, looking glass frame, door frames, tunnel bedstead, sideboard cupboard, sink, coffin, painting two oil cloths, crock lids, dressing bureau, wal(nut) washstand with marble slap, octogon wal(nut) bedstead, towl rack, drying boards, and a bench table."

Jacob Bachman's son Christian (1827-1901)(fig. 88) joined his father in the cabinetmaking shop, and they worked together until his 1855 marriage to Barbara Buckwalter. After his marriage Christian moved to Strasburg, Pennsylvania, where he opened his own cabinetmaking shop. The chest of drawers in figure 89 was crafted by Christian Bachman early in his career. The fluted corner posts and turned feet are elements of the Federal style and would have been considered to be old-fashioned by many of his contemporaries. Christian's adherence to earlier styles suggests the conservative influence of his father, Jacob Bachman (1798-1867), in whose shop he was likely working.

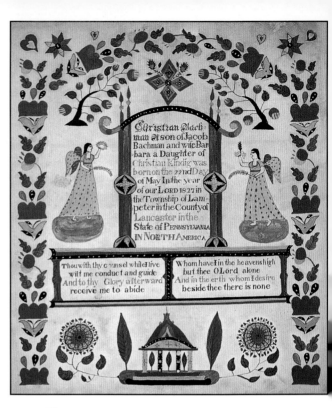

Figure 88. Fraktur birth record attributed to Eli Haverstick, c. 1834, working in East Lampeter Township, Lancaster County. This colorful hand-drawn fraktur records the birth of Christian Bachman in 1827. Christian Bachman (1827-1901), like his father Jacob Bachman (1798-1867), became a prominent cabinetmaker in eastern Lancaster County. *Wove paper, watercolor, ink, 11.75" x 9.75". Collection of the Heritage Center Museum.*

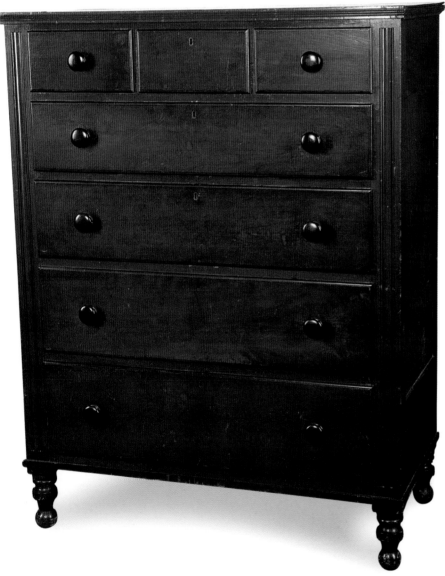

Figure 89. Chest of drawers, signed Christian Bachman, c. 1845 to 1855, working in East Lampeter Township, Lancaster County. Christian Bachman (1827-1901) crafted this chest of drawers in the Federal style, employing fluted corner posts with turned legs. It was likely built early in his career while he was still working in the shop of his father, Jacob Bachman (1798-1867). *Cherry, tulipwood, 55" x 22.5" x 42.5". Collection of Dr. and Mrs. Donald M. Herr.*

Figure 90. Copy book, signed by John Bamberger (1780-1861), residing in Warwick Township, Lancaster County, dated c. 1795-1802. The Federal eagle above the landscape on the left was directly copied from an image appearing on United States coinage between 1795 and 1807. The portrait of George Washington (1732-99) was likely copied from a published engraving. It is a reminder that General Washington was a popular figure even among the pacifist Swiss-German Mennonites. *Watercolor and ink on laid paper, 13.5" x 16.75". Private collection.*

In his Strasburg cabinetmaking shop, Christian Bachman expanded his furniture offerings to include a broad range of styles. He renamed his business Bachman and Sons in c. 1880, after sons Frank and Ellis joined his shop. Christian Bachman, who served as a school director and notary public, retired from the cabinetmaking trade in 1897. His son, Ellis Bachman (1856-1933), carried the Bachman family woodworking tradition into the twentieth century.

Not all cabinetmakers were full-time craftsmen, however. Some farmers supplemented their income by making furniture during the winter months when they were free from field work. John Bamberger was born in Warwick Township, Lancaster County, on November 22, 1780, the second son of John Bamberger (1750-1818) and Maria (Reist) Bamberger (1758-1831).[8] John's elder brother Christian Bamberger (1778-1834) was a farmer and fraktur artist (fig. 57) in Lebanon County. The brothers were reared on a portion of the Bamberger tract that was patented to their great-grandfather, Christian Bamberger, in 1735 (fig 43). Although John Bamberger was a lifelong farmer, an 1815 tax list indicates that his 142-acre farm included a stone one-story dwelling and a two-story stone joiner's shop measuring twenty four feet by sixteen feet.[9]

John Bamberger is remembered as a man of many talents. His school copybook contains several ink and watercolor drawings (fig. 90), a fraktur motto, and ink renderings of a tall case clock (fig. 91) and a chest of drawers. In addition to farming, he did house carpentry, operated a lime kiln, and served as a school director. One of the Bamberger farm ledgers survives (fig. 92), covering the years 1831 to 1848. It documents the production of a limited amount of cabinetry. The chest seen in figure 93 bears Bamberger's signature on the underside of the bottom board. When it was discovered, it confirmed the author's suspicion that a group of similarly decorated chests were indeed the work of John Bamberger (fig. 56). The ledger entry (fig. 94) documents the purchase of a chest by Jacob Eitenier in 1835 for $3.50.

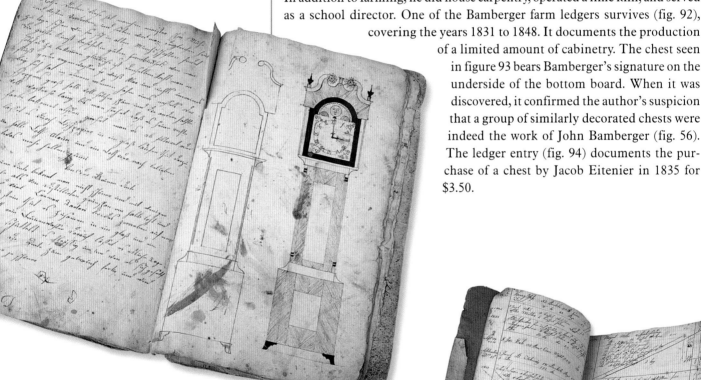

Figure 91. Copybook leaf, attributed to John Bamberger (1780-1861), residing in Warwick Township, Lancaster County, drawn c. 1800. Bamberger, an aspiring cabinetmaker, began to draw a sketch of a tall case clock on the left; apparently unhappy with the overall proportions, he redrew the case, shortening the height of the hood. The style of the case that Bamberger drew reflects the transition from the Chippendale to early Federal style that was occurring in the rural Lancaster County community at this time. *Ink on laid paper, 13.5" x 8.25". Private collection.*

Figure 92. Farm ledger kept by John Bamberger (1780-1861), residing in Warwick Township, Lancaster County, covering the years 1831 to 1848. Bamberger recorded the names of his accounts in English, but the items sold or purchased in German script. The records indicate that he was largely preoccupied with the operation of his 142-acre farm but still found time to make a few pieces of furniture. *Ink on wove paper, 13" x 15.5". Private collection.*

The purchaser, Jacob Eitenier (c. 1774-1844), probably bought the chest as a gift for his wife Maria (Hoffer) Eitenier. Although the chest was dated 1789 to record Maria's birth, it was apparently constructed and painted by Bamberger in 1835. Most of the chests with Bamberger attributions that are known to the author are dated in the 1820s, prior to the advent of his surviving ledger. It is likely that the bulk of his production occurred in the 1820s. From 1831 to 1847 he built only seven full-size chests, one small chest, and one clock case.[10] The distinctive heart design that Bamberger invariably painted on the front panels of his chests was probably inspired by the work of an earlier chest decorator who worked in northern Lancaster County. Perhaps Bamberger was trained by this currently unidentified artisan.[11] Although the scope of Bamberger's production is unknown, descendants recalled, "He made all the furniture for his three daughters when they went to housekeeping and made the cases for huge grandfather's clocks for his two sons."[12] His paint-decorated chest fulfilled a need in the conservative rural community of northern Lancaster County. The boldly decorated chests of the Pennsylvania Germans peaked in popularity late in the eighteenth century. By the 1830s Bamberger was the only Lancaster County cabinetmaker still decorating and inscribing his chests in the traditional manner. It is perhaps significant that the last chest that he recorded making in 1847 was sold for fifty cents less than the others, suggesting that it was likely undecorated, thus signaling the end of the need for Bamberger's paint-decorating skills.

Figure 94. Ledger entry written by John Bamberger (1780-1861), working in Warwick Township, Lancaster County, dated 1835. The account titled "Jacob Eitenier" records that Bamberger charged him for one and one-half peck of timothy seed and levied a charge for making cider. The last entry reads "made for him a chest 3.50." The chest made by Bamberger for Eitenier is seen in figure 93. *Ink on wove paper. Private collection.*

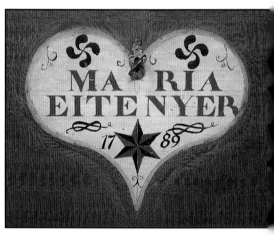

Figure 95. Detail of paint decoration on a chest signed by John Bamberger (1780-1861), working in Warwick Township, Lancaster County, c. 1835. The bold heart decoration typically used by Bamberger encloses the owner's name and date, painted in English block lettering. The two-toned six-pointed star and the swastikas are also standard elements of his decoration (fig. 56). *Pine, paint, iron, and brass. Collection of the Lancaster Mennonite Historical Society.*

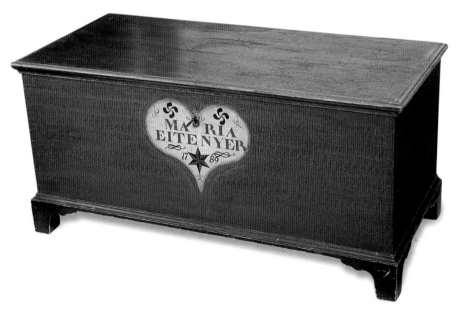

Figure 93. Chest signed by John Bamberger (1780-1861), made in Warwick Township, Lancaster County, c. 1835. This chest exhibits cabinetry detailing and paint decoration that is identical to a group of chests dated 1821-31 that can be firmly attributed to Bamberger. This example was likely commissioned as a gift for Maria Eitenier, the middle-aged wife of Jacob Eitenier of Warwick Township. The date of 1789 commemorates the birth of Maria. *Pine, paint, iron, and brass, 22.75" x 23" x 49". Collection of the Lancaster Mennonite Historical Society.*

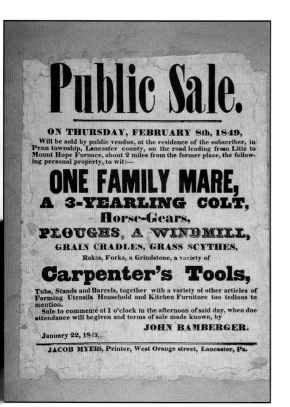

Figure 96. Public sale broadside for the auction of the farm equipment, livestock, etc. belonging to John Bamberger (1780-1861) of Penn Township, Lancaster County. Sale to be held on February 8, 1849. Printed by Jacob Myers, working on West Orange Street, Lancaster City. At this time Bamberger was retiring from farming and cabinetmaking; notice the prominence accorded his carpenter tools. *Ink on wove paper, 13" x 10". Private collection.*

In 1849 he retired from farming and carpentry, selling his tools at public auction (fig. 96). He turned his farm over to his youngest son, Jacob Bamberger (1824-85), who had recently married. On November 16, 1861, John Bamberger died on the Warwick Township farm where he was born. He was laid to rest in the family cemetery that overlooked his farm.

John Bamberger was a widely respected member of the Warwick community; and, although he was a Mennonite, his circle of close friends included Christian H. Rauch (1788-1866), the Moravian musician, surveyor, author, and Justice of the Peace. Upon Bamberger's death Christian Rauch's brother, John William Rauch (1790-1862), a confectioner, baker, and poet in the nearby village of Lititz, composed a verse in memory of their friend John Bamberger. Rauch's memorial was published in *Der Volksfreund und Beobacter*, a weekly newspaper published in Lancaster City.

While John Bamberger was quietly producing cabinetry in Lancaster County, another cabinetmaker, Abraham Latschaw (1799-1870), was being trained in Colebrookdale Township, Berks County, on the western fringe of the Franconia Mennonite community. In 1822 Abraham Latschaw traveled with his parents, Isaac Latschaw (1774-1857) and Susannah (Kindig) Latschaw (1782-1859), to the young Mennonite settlement in Waterloo County, Ontario. Unlike John Bamberger, whose father owned nearly 900 acres in the same community (fig. 34) but had no sons willing to leave their comfortable homes, the entire Latschaw family boldly trekked northward to occupy Canadian lands. Abraham Latschaw, like Bamberger, also created a few frakturs (fig. 97). Latshaw's exquisite work is regarded as the finest fraktur ever produced in the Waterloo County settlement. He is believed to have made a few frakturs while still in Pennsylvania, but all of his known Canadian examples were produced in 1822 and 1823, shortly after his arrival in the community.[13]

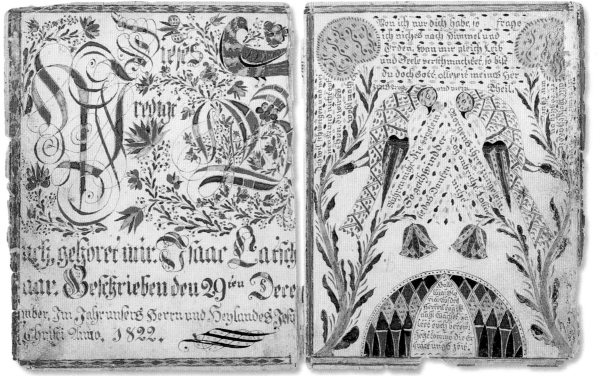

Figure 97. Fraktur bookplate, attributed to Abraham Latschaw (1799-1870), working in Mannheim, Waterloo County, Ontario, dated December 29, 1822. This superb example was drawn by Abraham Latschaw for his brother Isaac Latschaw (1812-81) in the year of their arrival in Canada. Although Latschaw was a highly skilled fraktur artist, he seems to have abandoned his fraktur art at an early date, preferring to concentrate on cabinetmaking. *Paper, watercolor, and ink, 7.75" x 6.25". Collection of the Joseph Schneider Haus, Kitchener, Ontario.*

As a cabinetmaker Abraham Latschaw was far more prolific, fortunately signing some of his examples. He produced furniture in traditional Pennsylvania German forms such as clothespresses (fig. 98), employing paint decoration in the form of graining on softwood examples and some rather elaborate wood inlay on some of his hardwood furniture production (fig. 99). The style and detailing of his cabinetry reflect the conservative taste of Latschaw as a craftsman and undoubtedly mirror the old-fashioned sensibilities of his clientele as well. The clothespress seen in figure 98, with its stepped construction, molded backet base, and rat-tail hinges, is eighteenth century in form but was actually crafted well into the second quarter of the nineteenth century. The finely detailed clock case (fig. 99) constructed in rural Ontario about 1850, far away from the urban design centers of Philadelphia, Baltimore, or New York, exhibits skillfully executed inlay and marquetry. The decorative elements that Latshaw employed - -including the carved keystone, inlaid rosettes, and fan inlay on the crest of the door— were all details that had peaked in popularity in Latschaw's Pennsylvania homeland decades earlier.

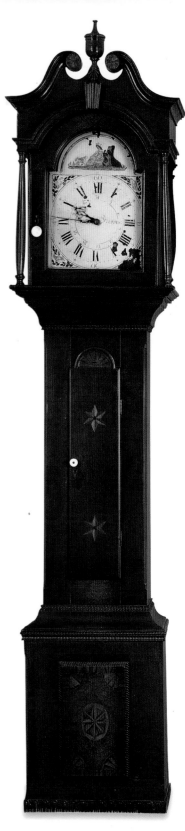

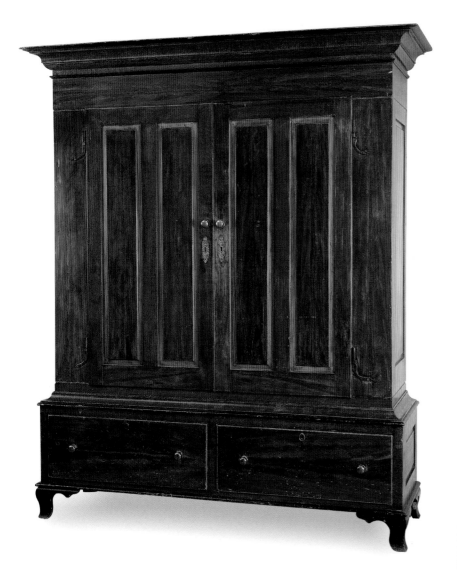

Figure 98. Clothespress, attributed to Abraham Latschaw (1799-1870), working in Wilmot Township, Waterloo County, Ontario, c. 1835 to 1850. An outstanding example of a Pennsylvania German furniture form produced in Ontario. Latschaw grained this piece to simulate hardwood, carefully matching the drawer fronts so they appear to have been cut from a single board. *Pine, paint, iron, and brass, 82.25" x 70.5" x 24.75". Collection of the Joseph Schneider Haus, Kitchener, Ontario.*

Figure 99. Tall case clock, movement by Samuel Kepner working c. 1807-26 in Montgomery County, Pennsylvania. The case is attributed to Abraham Latschaw (1799-1870), working in Waterloo County, Ontario, c. 1850. This clock case is a monument to the cabinetry skills of Abraham Latschaw, exhibiting carved details on the hood, finely executed inlay on the rosettes and waist door, and a sophisticated marquetry panel on the base section. *Movement: iron, brass, and paint. Case: Cherrywood with inlays, porcelain, 95" x 13" x 21". Collection of the Rev. Mr. and Mrs. Ward M. Shantz. Photograph courtesy of the Joseph Schneider Haus.*

Abraham Latschaw left his mark on the decorative arts of the Mennonites of Ontario. Reared in Pennsylvania, he carried both fraktur and cabinetmaking traditions to his new homeland. In Canada he met and married his wife, Catharine Bauman (1802-43). They had a family of four children. The Canadian historian Ezra E. Eby recorded that Latschaw "was a carpenter and cabinetmaker by trade and many an old clock case is to be found in this county (Waterloo) that was made by 'Abe' Latschaw."[14]

A group of Mennonite cabinetmakers created distinctive cabinetry in rural Somerset County, located in southwestern Pennsylvania. This furniture is known as Soap Hollow furniture. The craftsmen who created these colorful stencil-decorated furnishings lived in a small valley in northern Somerset County, near Johnstown. The valley, known as Soap Hollow, took its name from soapmaking, the cottage industry for which the region was famous.

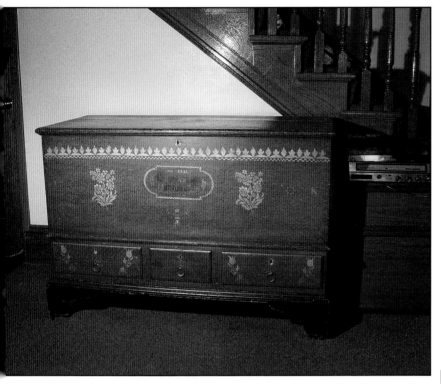

Figure 100. Chest over drawers, marked "1851 BARBARA HOCHSTETLER," also signed "JK," attributed to Jacob Knagy (1796-1883) working in Summit Township, Somerset County, Pennsylvania. A conservative craftsman, Jacob Knagy employed eighteenth century detailing such as the bracket base and lip-molded drawer fronts on his cabinetry. His use of gold stencil decoration was innovative, particularly the border design which crowns the front panel. *Photograph courtesy of Charles R. Muller.*

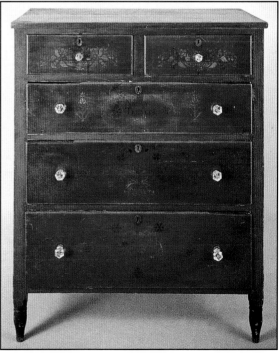

Figure 101. Chest of drawers, dated 1866, marked "NANCY TRESLER," attributed to Jacob Knagy (1796-1883) working c. 1841-1870s in Summit Township, Somerset County, Pennsylvania. This is a typical example of Knagy's cabinetry. He favored lip-molded drawer fronts, an earlier construction detail that is not found on Soap Hollow chests of drawers. He also employed brass keyhole escutcheons, while Soap Hollow examples feature inlaid unpainted wooden diamonds. Knagy typically placed the owner's name and the date in a central cartouche as seen on this example. *48" x 20" x 40". Photograph courtesy of Conestoga Auction Company, Inc.*

While the cabinetmakers of Soap Hollow have become famous for their stencil-decorated furniture, another Mennonite craftsman, Jacob Knagy (1796-1883) was working in southern Somerset County. He was employing similar decoration on his furniture as early as 1841 (fig. 100). A number of chests of drawers survive which are attributed to Knagy (fig. 101). His chests of drawers typically feature two half-width drawers above three graduated drawers. The cornerposts terminate in turned feet which were painted black. The stenciled motifs used by Knagy include tulips, stars, and flower baskets. These decorations he typically applied in gold and black on all the drawer fronts. In addition, the owner's name and the date were frequently enclosed in a cartouche that was stenciled in the center of an upper drawer front. Jacob Knagy and his son Elias Knagy (1832-1906) crafted furniture for the substantial Amish and Mennonite communities of southern Somerset County and northern Garrett County, Maryland. Jacob's stencil decorations may have inspired a younger generation of cabinetmakers who were working about thirty miles to the north in the small valley known as Soap Hollow.

In Conemaugh Township, Somerset County, nine cabinetmakers have been identified by signed examples of their stencil-decorated cabinetry. All lived and worked along the road that transverses the three-mile valley. The documented cabinetmakers and their known periods of production, based on signed and dated examples include: John Sala (1819-82) working 1850 to 1874; Tobias Livingston (1821-91) working in 1853; Jeremiah Stahl (1830-97) working 1866 to 1871; Christian C. Blauch (1828-99) working 1854 to 1859; Peter K. Thomas (1838-1907) working 1861 to 1867; David K. Livingston (1841-1930); John K. Livingston (1842-1912); John M. Sala (1855-1912); and Edward Schrock (1856-1924).[15]

These cabinetmakers working in Soap Hollow created distinctive furniture forms with equally distinctive surface decoration. Their furniture production was as innovative as it was conservative. Innovative elements include their scrolled ocean-wave backboards (fig. 102), their extensive use of stencil-decoration on drawer fronts, corner posts, end panels, skirts, and backboards, as well as their practice of boldly stenciling the cabinetmaker's name across the fronts of much of the furniture that they crafted (fig. 105).

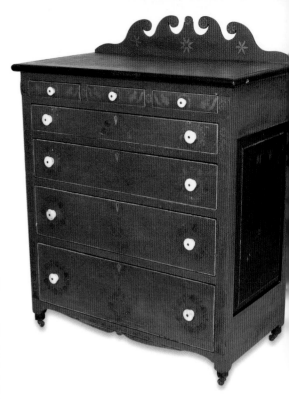

Figure 102. Chest of drawers, dated 1871, signed by John K. Livingston (1847-1912) working in Soap Hollow, Conemaugh Township, Somerset County, Pennsylvania, marked "1871, MW" on the endpanel. This cabinet is also marked "MANUFACTURED BY JOHN K. LIVINGSTON" on the rail located between the first and second full drawer. Although it is the only known example of Livingston's work, it exhibits all the typical features of a Soap Hollow chest of drawers: the red and black paint enhanced with the use of stenciled gold decorations, the scrolled backboard, the inlaid diamond-shaped wooden keyhole surrounds, and the distinctive shape of the skirt. The legs have been shortened. *Cherry, poplar, and porcelain, 51.5" x 20.75" x 40.5". Collection of Charles and Brenda Muller.*

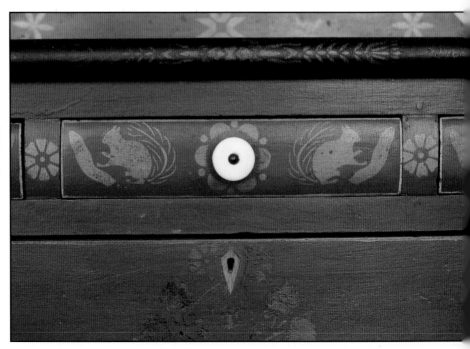

Figure 103. Detail of chest of drawers seen in figure 102. The squirrel stencils are an unusual design. The unpainted inlaid wooden escutcheon is a typical feature of Soap Hollow cabinetry. *Photograph courtesy of Charles R. Muller.*

Figure 104. Stack of Soap Hollow chests, all made in Conemaugh Township, Somerset County, Pennsylvania, between 1861 and 1884. All display common characteristics of Soap Hollow chests: the black and red paint combinations, the shaped bracket foot, the slight drop in the center skirt, and the diamond-shaped inlaid escutcheons. From top: 1) marked "S.T., 1861" and "MFD BY PKT," made by Peter K. Thomas (1838-1907); 2) marked "1861, J.S.R."; 3) marked "L.L., 1866," and "MANUFACTURED BY JEREMIAH STAHL," made by Jeremiah Stahl (1830-97); 4) marked "J.S., 1884" and MANUFACTURED BY C.C.B.," the maker was Christian C. Blauch (1828-99). These chests were formerly in the collection of the late Robert B. Myers. *Photograph courtesy of Charles R. Muller.*

The basic forms which they produced were chests, one-drawer stands, and chests of drawers. This furniture was exceedingly conservative in both form and construction details. The classic Soap Hollow chest of drawers was actually a Federal style of furniture that was widely popular by 1815. In this secluded valley of Somerset County cabinetmakers continued to produce the form with only minor concessions to the changing fashions of their times. As late as 1874, during the height of popularity of Victorian style furniture, Soap Hollow craftsmen were still building Federal style chests of drawers with turned feet. Their use of an inlaid diamond-shaped keyhole escutcheon, also a Federal detail, continued to appear on their furniture as late as 1893 (fig. 104).[16] Similarly, the use of the straight, shaped-bracket base, which is also seen on the 1893 chest, is a cabinetry detail that was already out of fashion among rural Lancaster County cabinetmakers by the 1820s. Clearly the style of Soap Hollow furniture evolved slowly, and is reflective of the conservative tastes of the Amish and Mennonite farmers who populated the region and supported the cabinetmakers.

The craftsmen who produced Soap Hollow furniture were Mennonites. John Sala (1819-82), the earliest and most prolific maker also served as an undertaker for the community, building 329 coffins. Sala, who was of Lutheran ancestry, married Magdalena Miller, a Mennonite, and joined her church. Cabinetmakers Tobias, David K., and John K. Livingston were of English ancestry but were assimilated by an overwhelmingly Germanic community. Others, like Christian C. Blauch (1828-99), were descended from old Mennonite families. Christian Blauch, the great-grandfather of Christian C. Blauch, left Lancaster County and purchased lands in 1767 at "the Glades" in Somerset County. He is recorded as one of the first Mennonite settlers to have arrived in Somerset County.

Perhaps the most defining characteristic of Soap Hollow furniture is the use of the phrase "Manufactured by [maker's name]" which appears across the fronts of much their cabinetry. Its use appears to be unique to the Soap Hollow community. The most common color combination found on their furniture features a red ground color with a black base and moldings. The stencil decoration was usually applied in gold paint, but occasionally silver was also utilized. Stencil designs were employed in a wide array, including stars, tulips, flower baskets, birds, squirrels, and rearing horses. On some of their later examples, decals were used in addition to freehand decoration.

The cabinetmakers of Soap Hollow crafted sturdy, decorated folk furniture, which remained a popular and significant expression of the material culture of this remote valley for nearly fifty years. Today, a century after its production has ceased, this furniture is still treasured by descendants of the original owners, as well as by collectors who consider it to be among the most original and significant examples of Pennsylvania German cabinetry.

Figure 105. Detail of chest over drawers seen in figure 104. On this example crafted by Jeremiah Stahl in 1866, the maker's name was stenciled on the skirt located just below the drawers. The reeded trimboards, which surround the drawers, are also typical Soap Hollow features. *Photograph courtesy of Charles R. Muller.*

Chapter Six
Boxes and Birds:
The Painted Woodenwares of the Mennonites

While cabinetmakers fulfilled the need for household furniture, some woodworkers specialized in the manufacture of small household wares, such as salt boxes, tape looms, document boxes, and miniature chests. These objects were frequently given to teenagers and young adults in preparation for marriage and the establishment of households of their own. Hardwood pieces were seldom painted. However, some were brightened by the application of a red wash. Softwood boxes were typically painted and occasionally personalized with the addition of the recipient's name and the date. Additional painted decoration in the form of flowers, geometrics, or architectural motifs complete the surface, creating objects that were treasured keepsakes.

Figure 106. Tape loom, dated 1794, attributed to John Drissel (1762-1846), working 1790-1817 in Lower Milford Township, Bucks County, made for Elisabeth Stauffer. The inscription, lettered in fraktur, translates as follows: "Faithfulness must contemplate alone. In the rose valley beyond the grave numberless roses grow. There also is the field of lilies, there in that new Heaven. There everything will bloom according to its kind, there will be ripe figs, and there the grapes will bear the sweet new wine." *Mixed hardwoods, paint, 21" x 12.75". Collection of the Philadelphia Museum of Art: Gift of Susanne Strassburger Anderson, Valerie Anderson Readman, and Veronica Anderson Macdonald from the estate of Mae Bourne and Ralph Beaver Strassburger.*

One small group of decorated woodenwares is signed by a craftsman named John Drissel (1762-1846). Born in Bucks County, Pennsylvania, John Drissel is believed to be the son of John Ulrich Drissel (d. 1817), a carpenter and a Mennonite who resided in Lower Milford Township, Bucks County.[1] The younger Drissel produced woodenwares from 1790 until 1817, when he inherited his father's plantation in Lower Milford Township. He is known to have produced highly decorated tape looms, salt boxes, a writing box, a slide-lid box, and spoon racks (figs. 106-108). Drissel frequently used bold tri-lobed tulips and striped borders for his decoration, and he carefully added the owner's name in either fraktur or English block lettering. All of his recorded wares bear the names of young Mennonite men or women in his Bucks County community.

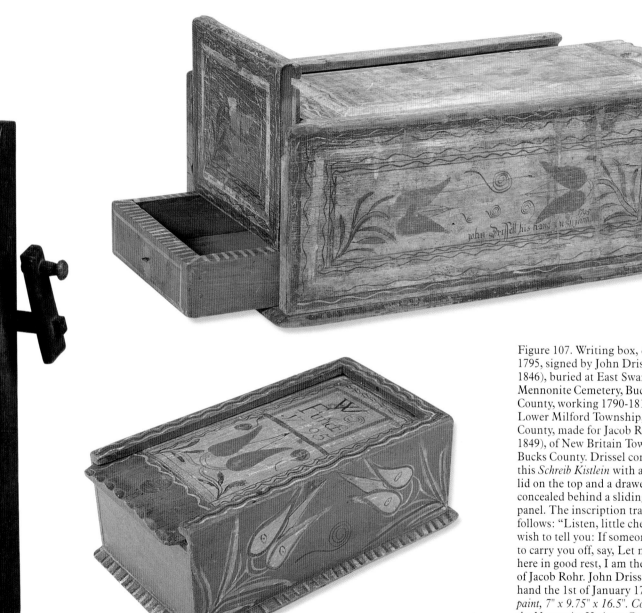

Figure 107. Writing box, dated 1795, signed by John Drissel (1762-1846), buried at East Swamp Mennonite Cemetery, Bucks County, working 1790-1817 in Lower Milford Township, Bucks County, made for Jacob Rohr (1772-1849), of New Britain Township, Bucks County. Drissel constructed this *Schreib Kistlein* with a sliding lid on the top and a drawer that is concealed behind a sliding end panel. The inscription translates as follows: "Listen, little chest, what I wish to tell you: If someone comes to carry you off, say, Let me stay here in good rest, I am the property of Jacob Rohr. John Drissel his hand the 1st of January 1795." *Pine, paint, 7" x 9.75" x 16.5". Collection of the Mennonite Heritage Center, Harleysville, Pennsylvania. Nathan Cox Photography.*

Figure 108. Slide-lid box dated 1795, attributed to John Drissel (1762-1846), working 1790-1817 in Lower Milford Township, Bucks County, made for W. Funck. This colorful document box exhibits Drissel's favored motifs, trilobed tulips and striped borders. *Pine, paint, 4" x 6" x 10.5". Collection of Richard S. and Rosemary Machmer.*

A far more elusive craftsman was working in the Lancaster County region from the 1830s to the 1850s. Unlike Drissel, who frequently signed his products, this woodworker apparently signed none of his wares. The boxes that he produced have become famous among collectors of Pennsylvania German folk art and have been known for years as Weber boxes (fig. 109), with a loose attribution to a man named Jacob Weber of Fivepointville, Brecknock Township.[2] My research has shown that the craftsman's name was not Jacob Weber but rather Jonas Weber (1810-76), who worked in East Earl Township and later Leacock Township, Lancaster County.

Born in East Earl Township, the son of Abraham, a miller, and Mary (Witwer) Weber, Jonas likely began carving small birds and making small boxes by 1835. He married Anna Horst (1808-50) about 1836, and by 1838 the couple was living on an eighty-acre farm in Leacock Township, adjoining the farm of Anna's parents, Joseph and Magdalena (Weber) Horst. Anna's father, Joseph Horst (1774-1856), was a minister at Hershey Mennonite Meetinghouse, located a short distance from their home.

Jonas Weber's woodenware production was likely intended to supplement his rather meager income as a tenant farmer. In the ledger of Anna Weber (1796-1876), a seamstress living in West Earl Township, we find the following note: "14 cents for a box from Henry Weber that his brother Jonas made on the first of January 1839."[3] Based on Anna's record, it appears that Jonas' family helped to distribute his wares. This is further supported by the ledger of his father, Abraham Weber (1783-1852).[4] Abraham moved to a farm near Fivepointville, in Brecknock Township about 1842. His ledger, which covers the years 1842 to 1852, records the sale of twenty wooden objects doubtless manufactured by his son Jonas. The prices that he charged ranged from four cents for a miniature chair to thirty cents for his larger size miniature chest. The author has seen a number of Weber chests and spice boxes with the original sale price written in pencil on the bottoms of the objects. These prices perfectly correspond to the prices recorded in his father's ledger. The forms of the woodenware recorded in Abraham's ledger include two sizes of miniature cradles (fig. 110), a seed chest, a flour chest, pepper chests (fig. 112), chairs, a trunk, a box, a sewing chest, and four sizes of chests (fig. 113). All of these items were produced in miniature, as evidenced by their prices.

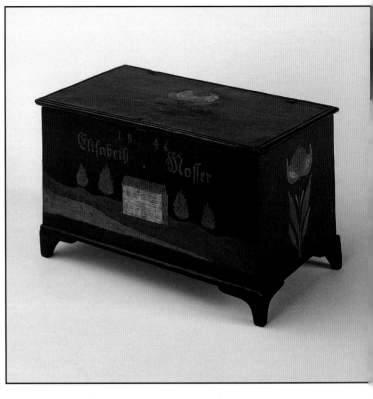

Figure 109. Miniature chest, dated 1846, attributed to Jonas Weber, working c. 1835-55 in Leacock Township, Lancaster County, made for Elisabeth Mosser (1843-1921). Elizabeth was only three years old when she received this chest, probably from her parents, Jacob and Anna (Bowman) Musser. Jacob Musser was a second cousin of Jonas Weber, the maker. *Pine, tin, and paint, 6" x 5.75" x 10.5". Collection of Mr. and Mrs. Richard Flanders Smith. John Herr, photographer.*

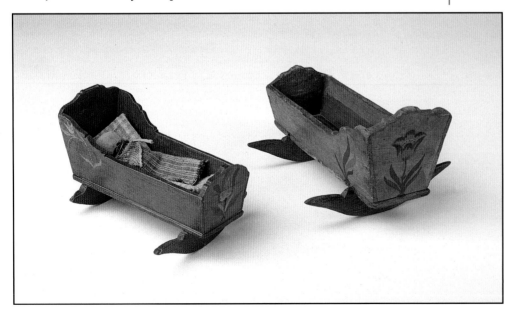

Figure 110. Left, miniature cradle, c. 1847, attributed to Jonas Weber, working c. 1835-55 in Leacock Township, Lancaster County, pencil inscription showing ownership by Fanny S. Bucher (1841-1910) of Warwick Township, Lancaster County. Fanny's father, Joseph Bucher (1820-94), was a first cousin of Jonas Weber. A smaller cradle with Weber's typical floral decoration. *Pine, paint. 4.25" x 5.25" x 6.75". Private collection.*

Right, Miniature cradle, c. 1850, attributed to Jonas Weber, working c. 1835-55 in Leacock Township, Lancaster County. A larger cradle in yellow paint: Weber frequently used yellow on medium-sized boxes, but, it is seldom found on his cradles. *Pine, paint, 4.75" x 6.5" x 8.25". Collection of Richard S. and Rosemary Machmer.*

Most of Weber's boxes are decorated with his trademark design of a house flanked by two large trees. The larger examples frequently have the name of the recipient and the date painted on the front panel (fig. 109). He used both pine and poplar to construct his objects, and all pieces were carefully joined using a series of tiny wooden pegs. The bracket feet that appear on many of his larger chests were carved as were the birds on pedestals (fig. 114) that he created in several sizes. The comb box (fig. 111) is a rare form; the scrolling on the backboard is closely related to that seen on his miniature cradles (fig. 110). This comb box was owned by his brother and next door neighbor, Isaac Weaver (1812-1905). It descended together with a spice box, miniature chest, cradle, and two carved birds to a great-grandson.[5]

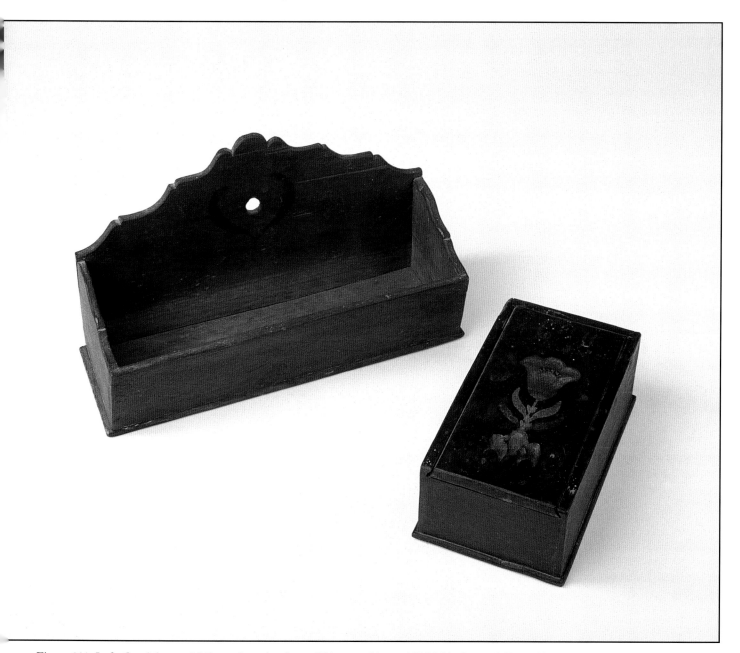

Figure 111. Left: Comb box, c. 1840, attributed to Jonas Weber, working c. 1835-55 in Leacock Township, Lancaster County. Pencil inscription records ownership of Isaac Weaver (Weber) (1812-1905), Jonas' brother and next-door neighbor. Although this is an uncommon form, it possesses all the same construction details as are commonly seen on Weber's cradles and chests. Sparingly decorated, it is probably one of Weber's earlier pieces. *Poplar, paint, 6" x 4" x 11". Private collection.*

Figure 112. Right: Spice box, c. 1852, attributed to Jonas Weber, working c. 1835-55 in Leacock Township, Lancaster County. "CM" painted on lid; box has pencil inscription for Catherine Musselman 1852 on the bottom. This form of slide-lid box with interior dividers was called a "pepper chest" in Abraham Weber's ledger. The lid has gouge-carved finger holds and is decorated with one of Weber's typical floral motifs. *Pine, paint, 2.5" x 4" x 7". Collection of Eugene and Vera Charles.*

A great-granddaughter of Jonas, who owned a small bird (fig. 114), a miniature cradle, and a sewing chest (fig. 113), recalled that her great-grandfather had made the items in about 1850 from the scraps left after building his barn.[6] This tradition may be quite accurate, for in 1850 Weber purchased the farm that he had rented for more than a dozen years, and he likely added new buildings. The 1850 agricultural census, in addition to detailing his farm production, notes that he produced about $25 worth of items of homemade manufacture. If his sales of woodenware generated all of that income, then it is likely that he produced several hundred items in the previous year.

In May of 1850 Jonas's wife, Anna, died, leaving him to care for five young children, aged five to twelve. It appears that his production dropped off sharply after 1850. Perhaps the strain of being a single parent had taken its toll. Two years later his father died, and the inheritance that Jonas received may well have ended the necessity of additional income from his woodenware production. At any rate, the latest dated Weber object that I have recorded bears the date 1851.[7]

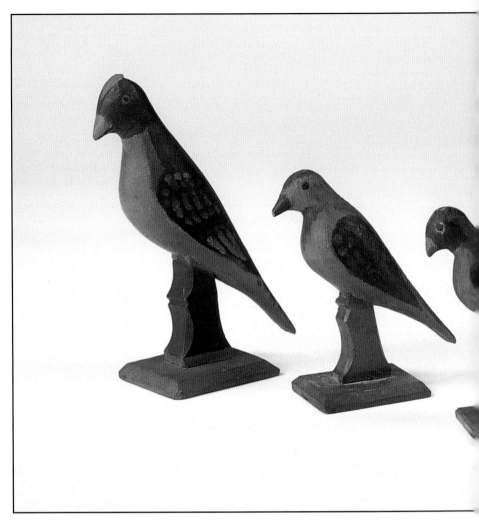

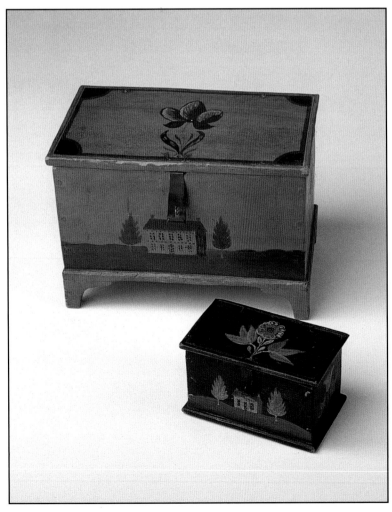

Figure 113. Rear: Sewing chest, c. 1850, attributed to Jonas Weber, working c. 1835-55 in Leacock Township, Lancaster County. Made for Weber's daughter Maria (1838-1922), it was used as a sewing chest by her daughter and granddaughter. This chest is typical of Weber's craftsmanship. Weber made boxes from 4 to 10.5 inches in length. The smaller examples have no feet, whereas the larger ones have carved, and occasionally turned, feet. *Pine, tin, paint. 5" x 4.5" x 7.25". Private collection.* Front: Trinket chest, c. 1848, attributed to Jonas Weber, working c. 1835-55 in Leacock Township, Lancaster County. A pencil inscription records ownership by Maria Weaver (1841-52), niece of Jonas Weber. Maria died in a diphtheria epidemic at the age of ten, just two days after it claimed the life of her thirteen-year-old sister Elizabeth. Maria's trinket chest, the smallest size made by Weber, originally sold for five cents. Weber decorated this box with a one-story house; his larger chests usually have a two-story structure, but a few examples even boast a three-story house. *Pine, tin, paint, 2.25" x 2.25" x 4". Private collection.*

Figure 114. Grouping of three birds on pedestals, attributed to Jonas Weber, working c. 1835-55 in Leacock Township, Lancaster County. Weber carved birds in several sizes. Each has a flat base with a champfered edge that is attached to the pedestal using a single wooden peg. He painted his birds with the same colors that he used to decorate his cradles and boxes. Left: *Pine, paint, 1.5" x 4". Collection of the Rothman Gallery, Franklin and Marshall College.* Center: Attributed to Jonas Weber for his daughter Maria (1838-1922). Maria's granddaughter stated that Weber made this bird about 1850 from scraps left over when he built his barn. *Pine, paint. 1" x 2.5". Private collection.* Right: Attributed to Jonas Weber, c. 1837, for Henry H. Stoner (1825-94) of West Earl Township, Lancaster County. *Pine, paint, 1" x 2.5". Private collection.*

In his retirement years, Weber bought a small farm north of Blue Ball in East Earl Township. It was there on Friday evening, November 17, 1876, he was found dazed but conscious after having been kicked in the forehead by his horse.[8] He died the next day and was buried in the Horst family cemetery beside his wife Anna, a short distance from the Leacock Township home that they had shared.

Jonas Weber is best known for his skillfully crafted wooden boxes with their detailed paint decoration. About the time that Weber retired from the production of his woodenwares, in the mid-1850s, another Lancaster County farmer, Joseph Lehn, was already beginning the production of his own line of paint decorated woodenwares.

Joseph Lehn was born in Manheim Township, Lancaster County, on January 6, 1798, the son of Abraham and Maria (Long) Lehn.[9] When Joseph was only two years old, his father died. His mother eventually married a widower, Daniel Erb (1760-1837) of Warwick Township, Lancaster County. On April 4, 1817, Joseph Lehn (fig. 115) married Elizabeth Erb (1792-1865), his eldest step-sister. They settled on a small farm in Elizabeth Township, Lancaster County. Elizabeth was a Mennonite, whereas Joseph Lehn's family were members of the United Brethren denomination. Descendants recalled that they attended both churches.[10] Later in life, Joseph Lehn joined the Mennonite Church.

Figure 115. Tintype photograph of Joseph Lehn, c. 1875, in a gutta-percha case. This photograph was taken on the front porch of the house that Lehn built in 1849, by an unknown photographer working in Elizabeth Township, Lancaster County. *3.75" x 3.25". Collection of Mr. and Mrs. Clarence E. Spohn.*

Although he farmed his Elizabeth Township property for many years, "farming never appealed to Lehn and even before all the children were grown he had decided upon another career."[11] Lehn's new career was barrel-making. It is reported that by 1856 Lehn was producing barrels. This is confirmed by his surviving ledger covering the years 1856 to 1876 (fig. 116).[12] Although Lehn is credited with the production of coopered wares and a wide variety of turned wooden objects (fig. 117), his ledger records only the production of a number of staved pieces but none of the turned examples that he is known to have produced. Tradition says that some of Lehn's earliest products were given as gifts to relatives. This could account for their absence in his ledger.

The finely executed title page seen in figure 116 suggests that Lehn was a competent scrivener as well as a talented woodworker and decorator. The bookplate (fig. 118) appearing in the Mennonite catechism that he presented to his son Henry Lehn (1823-62) in 1843 could be the work of Joseph Lehn, but it is more likely that his son Henry created it. Among the earliest documented woodenware produced by Joseph Lehn is the miniature chest seen in figure 119. It is one of three similar chests that were produced for Lehn's grandchildren. All three were children of his daughter Catherine (1818- after 1900) and

Figure 116. Ledger, Joseph Lehn (1798-1892), Elizabeth Township, Lancaster County, covering the years 1856 to 1876. The title page, written by Lehn, reads "Joseph L. Lehn his day book 1856." *Wove paper and ink, 7.5" x 6". Collection of the Historical Society of the Cocalico Valley.*

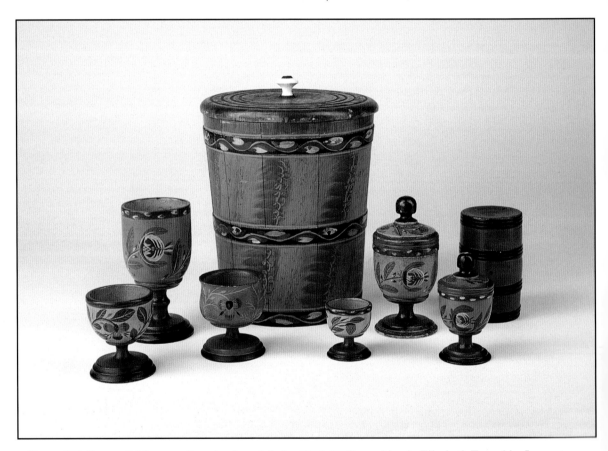

Figure 117. Group of objects attributed to Joseph Lehn (1798-1892), working in Elizabeth Township, Lancaster County, c. 1855-90. These examples are typical of Lehn's range of forms and decorative techniques. Woods used include poplar, mulberry, and white oak. Turned pieces measure 2 to 5.25 inches in height, and the sugar stand is 9.25" x 7.5". Left to right: footed master salt, yellow ground color with clover motif. *Collection of Eugene and Vera Charles.* Goblet, salmon ground color with pomegranate motif. *Collection of Eugene and Vera Charles.* Footed master salt, blue ground color with clover motif. *Private collection.* Sugar stand, staved construction with metal bands, turned lid, ochre graining. The stand exhibits the decoration that Lehn typically applied on his buckets and sugar stands. This example was made for Fanny F. Hess (b. 1871), the daughter of Jonas H. Hess (1841-1919). *Private collection.* Footed master salt, salmon ground color with strawberry motif. *Collection of Eugene and Vera Charles.* Saffron box, salmon ground color with pomegranate motif, strawberry vine on the lid. Among Lehn's most popular form, saffron boxes provided airtight storage for the herb saffron, which was popular among Pennsylvania German cooks. *Collection of Heritage Center Museum through the generosity of Elizabeth Furlow Sinclair.* Small saffron box, exhibiting the same decoration as the preceding example. This vessel was made for Fanny F. Hess (b. 1871), the daughter of Jonas H. Hess (1841-1919), a Mennonite minister in Warwick Township, Lancaster County. *Private collection.* Miniature barrel, a wood turning with a removable lid, painted to simulate the construction of a staved barrel. A novelty form that could be used for storage. *Collection of Eugene and Vera Charles.*

Figure 118. Bookplate in *Christliches Gemuths Gesprach* (Christian Spiritual Conversation on Saving Faith), made for Henry Lehn (1823-62), dated 1843. The book was printed in 1836 by Johann Bar, working in Lancaster City. The inscription in the book, a Mennonite catechism, is translated: "This little book belongs to me Henry Lehn, I have received it from my father Joseph Lehn 1843." Although his fraktur may have been penned by Joseph Lehn (1798-1892), it is more likely the work of his son Henry Lehn, a music teacher, who is believed to have drawn several other frakturs. *Wove paper, leather, brass, ink, and watercolor, 5" x 3". Private collection.*

her husband, John B. Graybill. The three chests are dated 1858 and each has a paper ownership label glued to the inside of the lid, inscribed in fraktur lettering with fanciful flourishes. Between 1856 and 1876 Lehn's ledger records the sale of only twelve boxes and four chests. Although numerous miniature chests and sewing chests survive and are attributed to Lehn, only a few have decoration that is closely related to his 1858 chests. Most of the chests were decorated using decalcomania, with some additional freehand decoration, and were likely produced in the 1880s, when Lehn is known to have employed decals on his turned woodenwares as well.

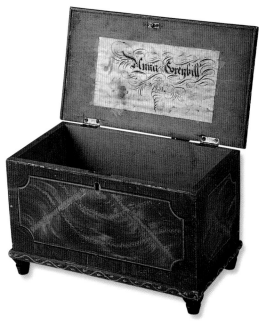

Figure 119. Miniature chest, attributed to Joseph Lehn (1798-1892), working in Elizabeth Township, Lancaster County, dated 1858. Joseph Lehn made this miniature chest, which is certainly among his earliest decorated pieces, for his granddaughter, Anna Greybill. The fine grain-painted decoration shown here differs from most of Lehn's later examples, which are typically painted with a solid background and then decorated using freehand decoration and decals. *Pine, iron, brass, paint, wove paper, and ink, 6.5" x 6" x 10.5". Collection of Mr. and Mrs. Dennis Cox.*

It is Lehn's brightly painted turned wares that are the best-known products of his wood shop (figs. 117 and 120). They have long been sought for their pleasing forms and decoration. Lehn's ledger indicates that he had a lathe in his possession by May of 1856 and, although it fails to record the production of any small turned vessels, the author has seen several pieces with ownership inscriptions dating as early as 1858. It appears likely that Lehn produced turned wares as early as the 1850s, but the bulk of this production was from the late 1870s until 1890.

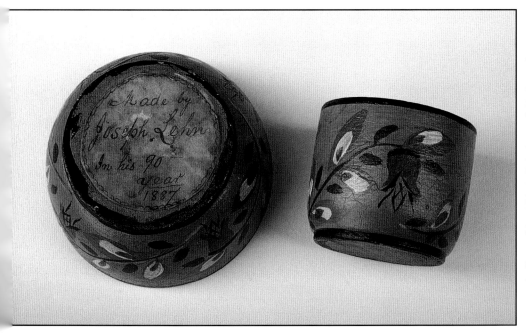

Figure 120. Cup and saucer, signed by Joseph Lehn (1798-1892), working in Elizabeth Township, Lancaster County, dated 1887. The paper label reads: "Made by Joseph Lehn in his 90th year 1887." Starting in the mid-1880s, Lehn began the use of paper labels to identify his workmanship. Although his handwriting is still steady, his decoration is less detailed than on earlier examples. Larger pieces produced in his later years typically received decal decoration, in addition to hand-painted decoration. This example boasts a tulip motif. *Wood, paint, paper, ink, cup, 1.5" x 2"; saucer, 1.25" x 3". Collection of Dr. and Mrs. Donald M. Herr.*

Beginning in the mid-1880s Lehn began to affix paper labels to the bottoms of his turned wares (fig. 120). Already in his late eighties, Lehn was justifiably proud that he could still produce high-quality handcrafts. Jacob N. Brubacher (1838-1913) visited Lehn several times, and on one occasion reported, "He is now ninety years old. It is quite a pleasure to talk with him. He seems to enjoy spiritual conversation. His memory is very good. He repeats poetry and passages of scripture quite readily. He is very devoted in worshipping the Lord. His desire seems to be to lead a life well pleasing to Him. He is a great lover of peace, saying very little of the faults of others. He is daily employed (1888) in making boxes, buckets, etc., which are finished so very tastefully, that but few can equal. Every person that sees his work is tempted to buy. . . . Brother Lehn is in every respect a remarkable man."[13] Joseph Lehn's admirer, J.N. Brubacher, was a minister and bishop in the Mennonite Church. He later produced turned wares that copied Lehn's forms.

The miniature chair seen in figure 121 is one of the more unusual woodenware forms that has been attributed to Lehn. Several similar chairs are known. Their colors and style of decoration appear to be the work of Joseph Lehn. He is believed to have employed, at various times, at least two other workers to help decorate some of his wares: John Sechrist and a chair maker named William C. Heilig (1833-97). Heilig's floral motifs vary considerably from Lehn's. He favored more naturalistic designs, frequently using six-petal flowers that resemble violets. Many chairs with similar decoration have been seen by the author. Only a few of them were signed by Heilig.[14] Perhaps the only objects that can be firmly attributed to Joseph Lehn are his earliest pieces, produced for family members, and his latest production, turned wares with handwritten paper labels. Lehn's death occurred on September 16, 1892. He was buried at Hammer Creek Mennonite Cemetery, a short distance from his home. During the last thirty-five years of his life, Joseph Lehn, a master cooper, turner, and paint decorator, produced a body of distinctive folk objects that continue to inspire craftsmen and delight collectors to this day.

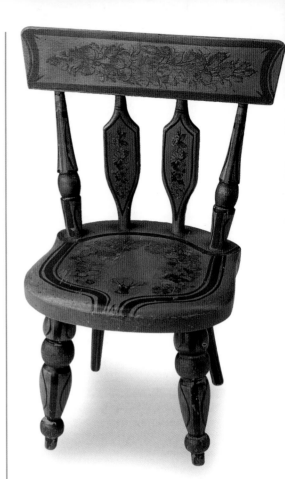

Figure 121. Miniature chair, attributed to Joseph Lehn (1798-1892), working in Elizabeth Township, Lancaster County. One of the more unusual forms attributed to Lehn, this chair is painted in Lehn's typical salmon ground and then decorated using freehand techniques as well as decals. *Pine, paint, decals, 13.25" x 7.5" x 7.25". Collection of Dr. and Mrs. Donald M. Herr.*

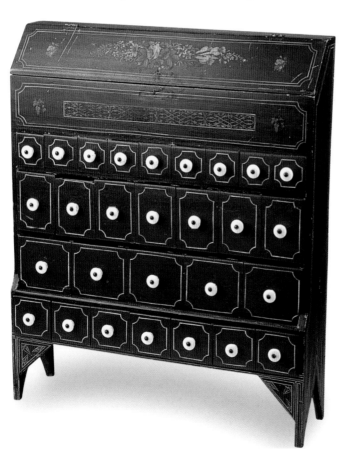

Figure 122. Seed chest, attributed to Joseph Lehn (1798-1892), working in Elizabeth Township, Lancaster County. This chest was used in a general store in the village of Rothsville, Warwick Township, Lancaster County. This is the largest Lehn seed chest recorded. It contains twenty eight drawers; other examples by Lehn have from eight to twenty drawers. All known examples are decorated using both freehand and decal decorations. *Pine, paint, porcelain knobs, 26" x 5.75" x 22". Acquired by the Heritage Center Museum through the generosity of the James Hale Steinman Foundation.*

Figure 123. Group of turned woodenware. Left to right: Sewing clamp with pin cushion, made by Jacob N. Brubacher (1838-1913), working in Rapho Township, Lancaster County, dated 1912 and stamped "JNB." This sewing clamp was made for Martha Newcomer (b. 1912) in the year of her birth. The sewing clamp was used to secure a piece of fabric to the sewing table while the needleworker stitched on it. *8" x 2.5". Collection of the Lancaster Mennonite Historical Society.* Saffron box, made by Jacob N. Brubacher (1838-1913), working in Rapho Township, dated 1910 and signed "JNB," made for Joseph H. Gochnauer (1844-1930) of East Hempfield Township, Lancaster County. This saffron box is typical of Brubacher's form and finish. Jacob N. Brubacher was a prominent minister and bishop in the Mennonite Church. After his retirement from farming he produced a variety of lathe-turned objects whose forms were inspired by his friend Joseph Lehn (1798-1892). *Cherry wood. 6" x 2.5". Private collection.* Saffron box, made by John B. Bucher (1860-1942), working in northern Lancaster County, dated 1933 and signed "JBB." John B. Bucher also served as a Mennonite minister. An acquaintance of both Lehn and Brubacher, he continued the production of saffron boxes into the 1930s, imitating Lehn's form and decoration. The decoration on this example, strawberry and pussy willow, are the motifs most frequently seen on Bucher's turnings. *Pine, paint, varnish, 5" x 2". Private collection.*

One of Joseph Lehn's acquaintances was Bishop Jacob N. Brubacher (1838-1913) of Mount Joy, Pennsylvania. Brubacher's youngest son recalled that as a lad of about eight years old (c. 1880) he accompanied his father on a visit to the aged woodworker. Lehn demonstrated for them the process of turning woodenware on his lathe.[15] When J.N. Brubacher retired from farming, he took up wood turning as a hobby. The item that he most frequently produced was a lidded container used to store the herb saffron. These vessels were locally known as saffron boxes and were also among Joseph Lehn's most popular woodenware forms. Although Brubacher borrowed the form of Lehn's saffron box, he never imitated Lehn's paint decoration, preferring instead to shellac his pieces (fig. 123).

One of J.N. Brubacher's responsibilities as a bishop in the Mennonite Church was to perform wedding ceremonies. It is said that he would present a saffron box to each couple that he married. Brubacher would usually stamp his initials "JNB" and the date on the bottoms of his turnings, most of which are dated 1910 through 1913. Although he utilized a variety of woods for his turnings, cherry seems to have been a favorite. The wooden sewing clamp in figure 123 is one of Brubacher's rarer forms. A similar example with paint decoration is dated 1867 and attributed to Lehn. Brubacher's woodenware production ceased with his death in 1913; however, a grandson named Jacob E. Brubaker (1897- 1981), who also served as a minister in the Mennonite Church, revived his grandfather's wood turning tradition, and during his retirement years created numerous saffron boxes and other turnings.

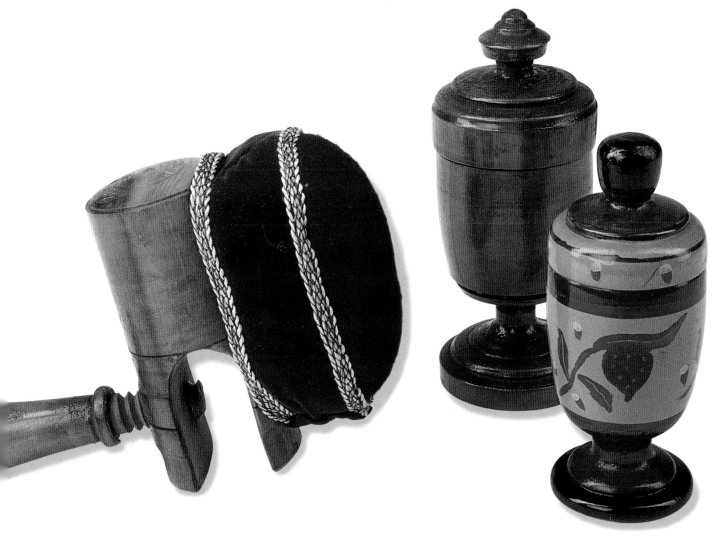

Another wood turner who worked briefly in northern Lancaster County was John B. Bucher (1860-1942). Bucher was born in Warwick Township, Lancaster County, the son of Jonas W. and Ann (Bollinger) Bucher. John's father, Jonas Wittwer Bucher, was a first cousin of the famous woodworker Jonas Weber (1810-76) of Leacock Township. During much of his life John B. Bucher farmed and sold fertilizer in northern Lancaster County. He was an acquaintance of Joseph Lehn, and a few weeks prior to Lehn's death John was ordained as a minister at the Hammer Creek Mennonite Meetinghouse where both he and Lehn were members. John B. Bucher also was well acquainted with Jacob N. Brubacher (1838-1913), and like Brubacher he developed an interest in woodturning in his retirement years. He also produced turned saffron boxes inspired by Joseph Lehn's. His examples were usually paint-decorated in a strawberry and pussy willow pattern (fig. 123). His turnings are heavy, and his painted decoration lacks the refinement of Lehn's work. Usually his initials "JBB" and the date can be found stamped on the underside of the bases of his turnings.

A few miles to the north of the Hammer Creek community was the home of Peter Brubacher (1816-98) of Clay Township, Lancaster County. Peter was a grandson of Abraham Brubacher (1731-1811), a 1749 immigrant who settled in Clay Township, where he was both schoolmaster and minister for the Indiantown Mennonite congregation. Abraham's farm was later owned by his son Abraham Brubacher (1774-1850), who like his father served as a minister in the community. Abraham Brubacher, the younger, donated a corner of his farm for the erection of the first Indiantown Mennonite Meetinghouse in 1819. It was on this farm that Peter Brubacher was born in 1816. Peter later farmed on a 112-acre farm to the north of the meetinghouse. In addition to farming, he carried on the trade of shoemaking,[16] but he is best known for the wooden horses that he carved for each of his fifteen grandchildren (fig. 124).

Figure 124. Toy horses, attributed to Peter Brubacher (1816-98), working in Clay Township, Lancaster County, c. 1870-95. Peter Brubacher, a shoemaker, is said to have carved fifteen horses, one for each of his grandchildren. He would carve the body from one piece of wood; the legs were carved separately, then attached using wooden pins. Spotted horse: on this example Brubacher also carved the detail of the mane; the ears are of tin. *Softwood, paint over gesso, tin, horse hair, 9.5" x 2" x 10.5". Collection of Mr. and Mrs. Richard Flanders Smith. Black horse: pine, paint over gesso, tin, horsehair, 8" x 2" x 10.75". Private collection.*

Opposite page: Figure 125. Wood carvings, attributed to David B. Horst (1873-1965), working c. 1935 to 1943 in Waterloo County, Ontario, Canada. These are typical examples of the barnyard animals that Horst was known for carving. Carved horse, carved from a single block of wood, with watercolor decoration applied to the base. *Basswood, watercolor, 4" x 1" x 4.25". Private collection.* Carved rooster: the oddly shaped base is actually a scrap piece that remained after Horst cut out the profile of the bird using a coping saw. Both carvings were found near Hinkletown, Lancaster County, and were likely brought back from Ontario by visiting relatives. *Basswood, wire, watercolor, 4" x 1.25" x 2.75". Private collection.*

Brubacher first carved the body of the horse, then carved the legs from different pieces of wood, attaching them with wooden pegs. The ears were either cut from tin or leather, and a horse hair tail was added. The carving was covered with gesso, and then it was ready for the final coat of paint. Although he was a competent folk carver, Brubacher apparently created his horses exclusively for the enjoyment of his family and never sold his carvings. Peter Brubacher and his wife, Nancy Weaver (1817-93), are buried in the cemetery at the Indiantown Mennonite Church, on the corner of the farm where he was born.

Compared with the simple, bold carvings of Peter Brubacher, the carvings of David B. Horst (1873-1965) (fig. 125) exhibit far more detail. Widely regarded as one of Ontario's premier woodcarvers, David B. Horst was born in Elgin County, Ontario. His father Samuel Horst was born in East Earl Township, Lancaster County, and migrated to Ontario about 1870. There Samuel joined the Mennonite settlement in Waterloo County that had been established nearly seventy years earlier. Samuel Horst met and married Magdalena Brubacher, a granddaughter of Abraham Brubacher, whose first cousin, Peter Brubacher (1816-98) carved the horses seen in figure 124.

David B. Horst, a farmer and Mennonite deacon, began his carving career in 1935 after a stroke had left him partially disabled. After the death of his wife, he eventually moved to a small cottage on the edge of the Village of St. Jacobs, Ontario, where he decorated his large front window with his woodcarvings. Horst carved a variety of farm animals and birds (fig. 125), which he sold to visitors, charging from fifty cents to $1.50.[17] After completing a carving, he would sometimes paint the base and add stipple decoration to the body of the animal; however, he left many carvings unpainted. His most ambitious work was a likeness of King George V on horseback, intricately carved and painted. He refused all offers to buy it, preferring to keep his masterpiece. David B. Horst created most of his carvings between 1935 and 1943. An imaginative body of folk carvings, Horst's work exemplifies not only his skill but an artistic tradition as well.

A small group of objects (fig. 126) exist that are attributed to Frank B. Nolt (1905-74), a conservative Mennonite who farmed in Earl Township, Lancaster County. Although his comb boxes are dated 1936 and 1937, they reflect a tradition in form and decoration that had been popular about sixty years earlier. Nolt's incised roosters and paint decoration add a memorable quality to his handcrafts. The horse and bird carvings, although not nearly as detailed as the work of David B. Horst, nonetheless reflect the skill and traditions of Frank Nolt, an untrained woodcarver.

While many woodworkers created objects for the enjoyment of children, a few children crafted their own possessions. The toy steam engine and threshing machine seen in fig. 127 was built about 1909 by John L. Hess (b. 1897), a lad of eleven or twelve years of age. The son of Menno

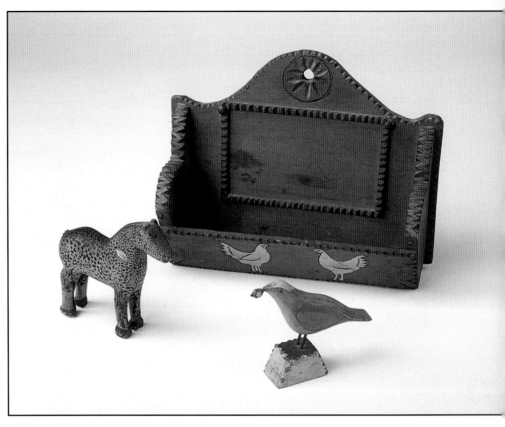

L. and Annie (Leaman) Hess of Mount Joy Township, Lancaster County, John L. Hess was reportedly inspired by a brother-in-law who operated a similar threshing rig. Young John, who had an aptitude for woodworking, built his machine from scrap lumber, endowing it with a movable piston and flywheel. He painted his creation carefully, indentifying his steam engine as a "CASE." In his adulthood, Hess expanded his woodworking interests, specializing in timber framing barns and tobacco sheds.

Figure 126. Wooden objects, attributed to Frank B. Nolt (1905-74), working near Hinkletown, Earl Township, Lancaster County, c. 1920-40. Carved horse: probably intended as a toy, this simple carving illustrates the enduring popularity of homemade toys among the Mennonite population of rural Lancaster County. *Pine, paint, 4.25" x 1" x 4.25". Collection of Nan and Jim Tshudy.* Comb box: decorated with chip and gouge carving, it is reminiscent of the tramp art work that was popular fifty years before this piece was crafted. Inscribed "Frank Nolt 1937." *Pine, paints. 7.5" x 3" x 9.25". Collection of Nan and Jim Tshudy.* Carved bird on base: while the bird holding a berry is reminiscent of the fraktur drawings of Jacob Nolt (1798-1852) (fig. 212), carved birds on pedestals were being carved in this community a century earlier by Jonas Weber (1810-76), (fig. 114). *Pine, paint, and nails; 3.25" x 1" x 4". Collection of Nan and Jim Tshudy.*

Figure 127. Toy threshing machine, built by John L. Hess (b. 1897), c. 1909 while residing in Mount Joy Township, Lancaster County. John L. Hess, a talented farm boy, built his model "CASE" steam engine and threshing machine at the age of eleven or twelve. *Pine, paint, copper, and tin, 9.25" x 8.5" x 42". Private collection.*

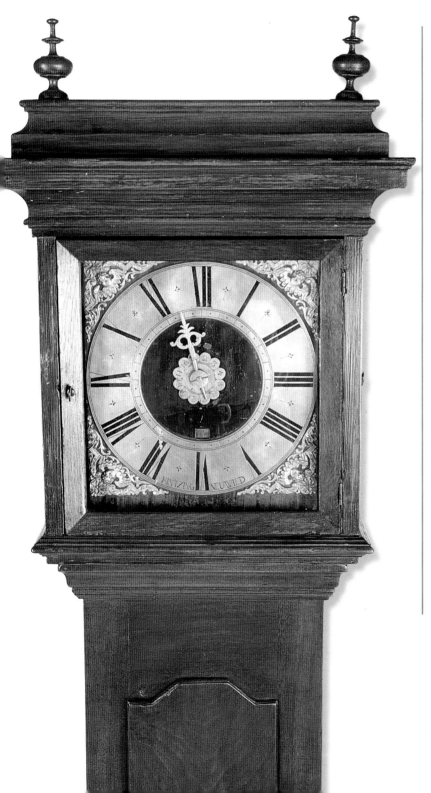

Among many Pennsylvania German house-holds there is perhaps no domestic object more highly regarded than the imposing family grandfather clock. More properly called a tall case clock, this clock form was first developed in England in 1658 by Ahaseurus Fromanteel, a Dutch clockmaker. Within a few years, a number of clockmakers in London and continental Europe were building such clocks to satisfy the brisk demand for this new form. In the first decades of the eighteenth century tall case clocks were being built by several Philadelphia makers, including the famous Dunkard printer Christopher Sauer (1693-1758).

In rural Pennsylvania, where clock movements were scarce, German Mennonite clockmakers found a ready market for their clocks. Although Pennsylvania as a British colony had very little trade with Germany, a surprising number of German tall case clock movements found their way to southeastern Pennsylvania. Christian Kintzing (1707-1804), a Mennonite, and a miller in the village of Neuwied, Germany, made the clock seen in figure 128 about 1730. It was probably owned by William Rittenhouse (1691-1774), the grandson of William Rittenhouse (1644-1708), the famous papermaker and the first Mennonite minister in America.[1] Typically an imported clock movement was housed in a wooden case that was made by a Pennsylvania cabinetmaker. However, this example has a wooden hood that also was crafted in Germany. Sometime after its arrival in Pennsylvania, the lower portions of the wooden case were added by a cabinetmaker, likely one working in Germantown, Pennsylvania.

Figure 128. Thirty-hour clock movement, built c. 1730 by Christian Kintzing (1707-1804), clockmaker at Neuwied, Germany. The single hour hand is a feature found on seventeenth century clocks. The hood portion of the case was crafted in Germany. The balance of the case (fig. 9) was built in Pennsylvania, c. 1730-40. *Oak, pine, iron, pewter, and brass, 88" x 9" x 17.25". Collection of Toad Hall.*

One Swiss Mennonite clockmaker became famous during his lifetime in eighteenth century Germany for his production of tall case clocks. Hans Jacob Möllinger (1695-1763) was born at Duhren near Sinsheim, Germany, the son of Vincenz Möllinger (1668-1748) and Veronica Maylin. The Möllinger family had left the Oberland region of Canton Bern, Switzerland, in the 1670s because of the persecution of the Anabaptists. Settling in the Palatinate, Germany, they lived as tenant farmers, helping to rebuild the land after the destruction of the Thirty Years' War.

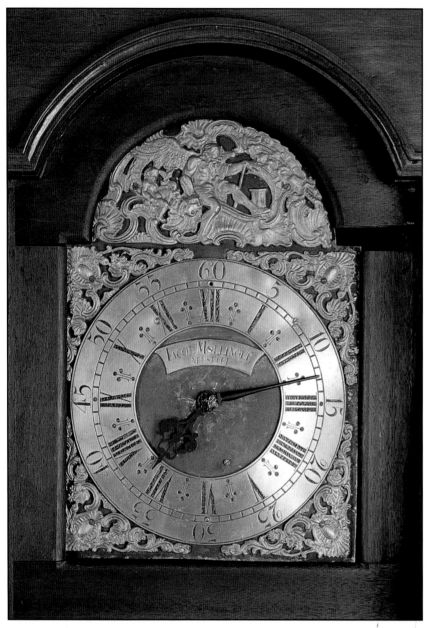

Figure 129. Thirty-hour clock movement, built c. 1760 by Hans Jacob Möllinger (1695-1763) of Neustadt, Germany. The arched iron dial was painted blue. The applied chapter ring and spandrels are of pewter. A casting of Father Time appears on the arch top. This style of dial is considered to be German, but it also was produced in Pennsylvania by several eighteenth century clockmakers. *Iron, pewter, and brass. Dial measures 14.5" x 10.5". Private collection.*

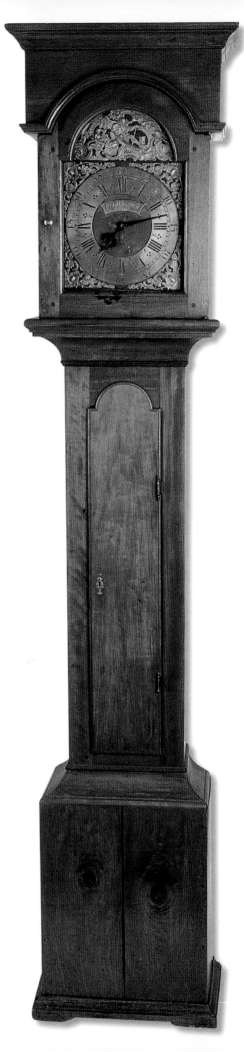

Figure 130. Thirty-hour clock and case, movement built c. 1760 by Hans Jacob Möllinger (1695-1763) of Neustadt, Germany (fig. 129). The case was built c. 1760-70 by an unknown cabinetmaker, likely working in Lancaster County, Pennsylvania. It is of the Queen Anne style with a flat-top hood. The bracket base has been shortened in height. The hood has wedged dovetail construction. *Walnut, brass, and glass. 83.5" x 10" x 19". Private collection.*

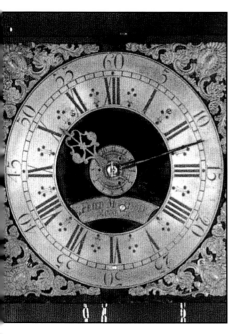

Figure 131. Thirty-hour clock movement, built c. 1750-70 by Friedrich Möllinger (1726-78), working in Mannheim, Germany. The pewter nameplate is inscribed "FRIED MOLLINGER MANNHEIM." The small brass dial is an alarm-setting device. The pewter chapter ring and spandrels are identical to those appearing on some clocks built by his father, Hans Jacob Möllinger (fig. 129). *Iron, pewter, and brass. Dial measures 10.75" x 10.75". Private collection.*

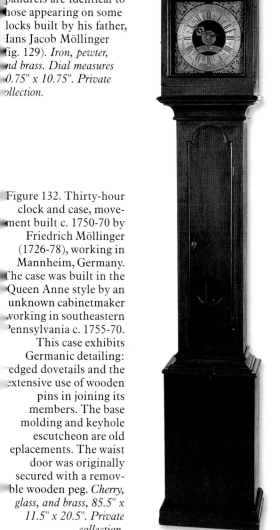

Figure 132. Thirty-hour clock and case, movement built c. 1750-70 by Friedrich Möllinger (1726-78), working in Mannheim, Germany. The case was built in the Queen Anne style by an unknown cabinetmaker working in southeastern Pennsylvania c. 1755-70.

This case exhibits Germanic detailing: wedged dovetails and the extensive use of wooden pins in joining its members. The base molding and keyhole escutcheon are old replacements. The waist door was originally secured with a removable wooden peg. *Cherry, glass, and brass, 85.5" x 11.5" x 20.5". Private collection.*

Hans Jacob married Margarethe Wurzer (d. 1741), and they settled in the village of Neustadt an der Haardt. About 1725 Hans Jacob Möllinger began making clocks, a career that he would follow until his death in 1763. In addition to the manufacture of movements for tall case clocks, Möllinger also built large tower clocks for use in churches, town halls, and castles throughout the Palatinate. However, it is his thirty-hour movements that found their way to Pennsylvania (fig. 129). His clock movements are fitted with square or arched iron dials, usually painted black or red. Mounted on the dial is a pewter chapter ring displaying the numerals, and a pewter name plate marked "JACOB MÖLLINGER NEUSTATT." In the four corners are mounted cast pewter spandrels, baroque in inspiration. His movements have two brackets on the rear side that allow them to be hung from spikes driven into the backboard of the case. In this manner, the clock could also be hung directly on the wall, without a case, functioning as a wag-on-the-wall clock. When funds were available, the owner could subsequently enclose the works in a wooden clock case (fig. 130).

The avenue that Möllinger used to export his movements is unknown; however, his sister Esther (b. 1703) married Jacob Bossert, and they emigrated to Pennsylvania in 1726, providing a close contact in the colony of Pennsylvania. Equally intriguing is the relationship between the thirty-hour movements made by George Hoff (1733-1816), a colonial clockmaker in Lancaster Borough, and the movements made by the Möllingers of Germany. Hoff was trained as a clockmaker in the village of Grunstadt, located about twenty miles from the Möllinger shop at Neustadt. He arrived in Pennsylvania in 1765, two years after the death of Hans Jacob Möllinger, and was soon a prominent clockmaker in the Lancaster Borough. Hoff's thirty-hour movements share many similarities to Möllinger movements. Some of the pewter spandrels and chapter rings appearing on his dials are identical to those found on movements by Hans Jacob and his son Friedrich Möllinger (1726-78), which suggests that Hoff may either have purchased parts directly from the Möllingers or that both Hoff and the Möllingers purchased parts from a common source in Germany.

The death of Hans Jacob Möllinger in 1763 did not end the production of Möllinger clocks. His widow, Elisabeth Sinzenich (1714-90), retained his employees and continued to run the workshop until 1787, when she turned the business over to their son, Elias Möllinger. Elisabeth marked her clocks "JACOB MÖLLINGER, widow." Joseph Möllinger (1715-72), the youngest brother of Hans Jacob, was also a prolific clockmaker, whose clock movements occasionally are found in Pennsylvania. Additionally, three of the sons of Hans Jacob Möllinger followed in their father's trade—Friedrich (1726-78), Johannes (1739-1815), and Elias—although none of them achieved the fame that was accorded their father.

Friedrich Möllinger (1726-78), the eldest son of Hans Jacob, was living in the city of Mannheim by 1751, working at the clockmaking trade. He and his wife were members of the small Mennonite congregation at Mannheim, where his uncle Martin Möllinger was minister. While he is known to have built thirty-hour movements for tall case clocks (fig. 131), his clocks are rare. Perhaps he was preoccupied with his duties as the clockmaker for the Elector Karl Theodor, the ruler of the Palatinate from 1742 to 1799. Karl Theodor, a Catholic, who was regarded as an enlightened ruler, relaxed some of the restrictions that had been placed on the Palatine Mennonites. He appointed this young Mennonite clockmaker, Friedrich Möllinger, as warden over the clocks in his castle at Mannheim.

The brothers Christian and Daniel Forrer were among the earliest clockmakers to work in Lancaster County, Pennsylvania. They were born near Langnau, Canton Bern, Switzerland, the sons of Daniel Fuhrer (d. 1747) and Anna Engel (d. 1740).[2] Their father, Daniel Fuhrer, was a barber and a surgeon who owned a sizable farm named Lohren near the village of Mett. After the death of their father, the young sons, Daniel Forrer (1734-80) and Christian Forrer (1737-83), were apprenticed to Jean Francois Guillerat of Delemont, in the Jura region of Switzerland. In 1754, after completing their clockmaking apprenticeships, they traveled to Pennsylvania accompanied by their only sister, Christina Forrer (1729-99), and twenty-seven Mennonites from the Jura mountains. They arrived in Philadelphia on October 1, 1754, aboard the ship *Phoenix*. It appears that they immediately settled in Lampeter Township, Lancaster County, joining another Forrer family that had already been in residence for more than thirty years.

Christian and Daniel Forrer operated their clock shop in the village of Lampeter, where they signed their clock dials "C & D FORRER." Their partnership was apparently short-lived, for in 1762 Daniel sold his Lampeter Township lands to his brother Christian. Daniel Forrer (1734-80) moved to Frederick, Maryland, where he worked as a clockmaker and a silversmith.[3] He likely died without issue as the fraktur bookplate from his family Bible (fig. 133) descended in the family of his sister Christina (Forrer) Witmer (1729-99) of Lampeter, Pennsylvania.[4]

The clocks made by Christian Forrer (1737-83), after the dissolution of his partnership are usually engraved in script, "Christian Forrer Lampeter" (fig. 134). The majority of Christian Forrer's clocks are eight-day movements, and they typically have arched brass dials. The cases that house his works are frequently of high-quality cabinetry, exhibiting carving or inlay (fig. 28), although some housed in simpler cases have also been recorded. Of the two Forrer brothers, Christian was by far the more prolific clockmaker. He operated his shop in Lampeter until the spring of 1774, when he purchased 212 acres in Fairview Township, York County, Pennsylvania. Selling his Lampeter lands, he moved to York County, where he is said to have operated a farm, a tavern, and a ferry that traversed the Susquehanna River. He also continued to make clocks, though likely far fewer than he had made in Lampeter. Upon his death in 1783, his inventory included clockmaker's tools and one unfinished clock. His widow, Elizabeth (Kendig) Forrer (1735-1802), the granddaughter of Martin Kendig, the leader of the 1710 Mennonite group that had settled in Pequea, Lancaster County, later married Jacob Erisman (d. 1792) of Rapho Township, Lancaster County. After the death of her second husband, Elizabeth Erisman moved to Page County, Virginia, joining three of her sons, who had also relocated to Virginia.

Figure 133. Fraktur bookplate, drawn by an unknown artist working at the Ephrata Cloister in Lancaster County, Pennsylvania, c. 1755-60. Made for the Bible of clockmaker Daniel Forrer (1734-80) of Lampeter, Lancaster County. The piece is inscribed: "This Bible belongs to me DANIEL FORER, Jeremiah XVII, verses 7 and 8 Blessed is the man who trusteth in the Lord, and whose hope the Lord is. For he shall be as a tree planted by the waters, and that spreadeth out her roots by the river, and shall not see when heat cometh, but her leaf shall be green, and shall not be careful in the year of drought, neither shall cease from yielding fruit." This fraktur is by far the finest bookplate known to have been penned at the Cloisters. Long ago removed from Forrer's Bible, it was later owned by his sister Christina (Forrer) Witmer (1729-99). After her death it passed to her stepson John Witmer (1754-1828). *Laid paper, ink, watercolor, 15" x 12". Private collection.*

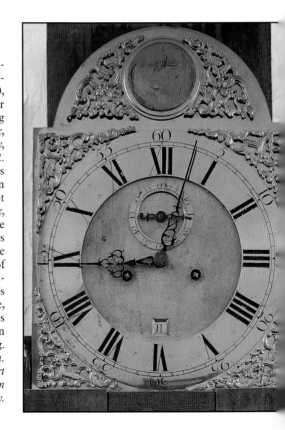

Figure 134. Eight-day clock movement, built c. 1760, by Christian Forrer (1737-83), working in Lampeter, Lancaster County, c. 1755 to 1772. The arched brass dial is engraved in English script "Christian Forrer, Lampeter." The center of the dial is matted. The spandrels are of cast brass. Although the dial is English in style, the case (fig. 28) is purely Germanic in form and detailing. *Brass, iron. Collection of Robert C. Wenger. Nathan Cox Photography.*

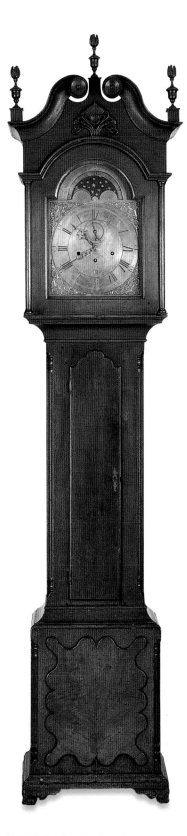

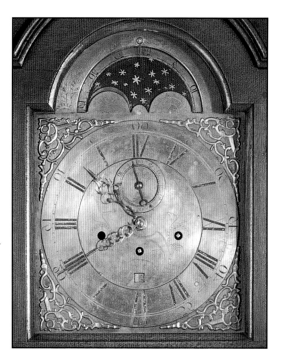

Figure 135. Eight-day clock movement, built c. 1790 by Samuel Stauffer (1754-1825), working in Manheim, Rapho Township, Lancaster County, from c. 1783 to 1794. The arched brass dial has brass spandrels. Stauffer engraved a foliate design in the center field and across the top of the arch. The moon dial is painted to resemble a starry night. He signed the dial, engraving it in English script, "Samuel Staufer Manhm No.25." *Brass, iron, and paint. Collection of Margaret and Lawrence Skromme. John Herr, photographer.*

The town of Manheim in northwestern Lancaster County was originally laid out in 1762 by the flamboyant German ironmaster and glassmaker, "Baron" Henry William Stiegel. The town founder built his brick mansion on the square and his glass factory on the edge of town. By the time of the American Revolution, Manheim had developed into a lively commercial center. The Mennonite population of Lancaster County was largely agrarian; although they did business in the cities and towns, they preferred to dwell in the countryside. For the few who were full-time craftsmen, there was good reason to move into the towns. Still, most resisted. The village of Manheim was, however, able to attract several young Mennonite craftsmen, who later became important clockmakers.

Samuel Stauffer (1754-1825) was born in Warwick Township, Lancaster County, the son of Jacob Stauffer (1713-75), a 1732 immigrant from the Palatinate, and his wife Magdalena Hess. In 1769 Samuel moved with his parents to Donegal Township, Lancaster County, and on June 4, 1776, he was married to Elizabeth Haldeman (b. 1759). Samuel appears on the Donegal tax list for 1779, where the assessor noted that he was "out of his reason," alluding to a mental incapacity that would plague him for the rest of his life.

It is not certain when Samuel began his clockmaking career. But by 1783 he was living in Manheim, where he had purchased lot 282, located on the east side of Prussian (Main) Street, about a half block south of the square. His clockmaking shop was located in a portion of his two-story brick house that measured twenty-six feet by thirty feet. As was the custom of many towns-people, he also owned an "out lot." His lot of twelve acres was situated outside of town and afforded him a place to have animals and an orchard and to grow some crops. It is uncertain who taught Samuel Stauffer the art of clockmaking, but perhaps it was the master clockmaker George Hoff (1733-1816) of Lancaster, who witnessed the receipt of a payment made by Stauffer in June 1785, suggesting Stauffer's presence in Hoff's West King Street clockshop. Judging by the style of Stauffer's clock dials, it is certain that he was producing clocks by the mid-1780s. He manufactured clocks in the German style, having thirty-hour movements with an iron dial and applied pewter spandrels and chapter rings. He also built eight-day movements in the English style (fig. 135), with finely engraved arched brass dials having moon wheels, and applied brass spandrels and chapter rings. Stauffer numbered his movements, the highest number recorded being fifty-one.

Figure 136. Eight-day clock and case, movement built c. 1790 by Samuel Stauffer (1754-1825), working in Manheim, Rapho Township, Lancaster County. The case was constructed c. 1790 by an unknown Lancaster County cabinetmaker in the Chippendale style with a swan's-neck pediment, carved flame finials, quarter-columns on the waist and base, an applied turtle-shaped panel on the base, and a molded bracket base. The applied foliate and fan carving on the hood is an unusual feature. *Walnut, glass, and brass, 101" x 10.5" x 21". Collection of Margaret and Lawrence Skromme. John Herr, photographer.*

Clocks signed by Samuel Stauffer are scarce. The few that are known to the author are all housed in fine walnut cases in the Chippendale style (fig. 136). It is likely that some of his cases were the work of Phillip Bretz, a cabinetmaker who lived in Rapho Township, and who seems to have been closely connected to Stauffer.[5] The clockmaking career of Samuel Stauffer was short-lived, however, for in February 1794, after an inquisition of lunacy, the court in Lancaster declared him to be a lunatic and awarded legal guardianship (fig. 137) to his older brother Christian Stauffer (1736-1808), a miller in Warwick Township. This action signaled the end of his clockmaking career. On May 9, 1795, his nephew and fellow Manheim clockmaker, Christian Eby (c. 1768-1803), submitted a bill (fig. 138) "for finishing an eight day clock being the property of Samuel Stauffer." Nothing more is known concerning the nature of Stauffer's illness, but he never regained control of his real estate. His brother Christian paid the quit rents on his Manheim property until Christian's death in 1808, after which Samuel's son Christian Stauffer (1783-1855) continued to pay them.[6] Although Samuel Stauffer died on June 7, 1825, his clockmaking tradition had been passed on to two of his nephews, Christian and Jacob Eby.

Opposite page: Figure 139. Eight-day clock movement, built c. 1800 by Christian Eby (c. 1768-1803), working c. 1794-1803 in Manheim, Rapho Township, Lancaster County. The painted-iron dial with floral decoration represented an innovation in clockmaking. The white dial was far easier to read than were pewter and brass examples. It became popular in rural Pennsylvania by the 1790s. Christian Eby painted his own dials. Some, such as this example, bear an elaborate signature. The movement is a rare musical example that plays ten tunes. *Iron, brass, and paint, 21" x 15". Collection of the Heritage Center Museum.*

Figure 137. Wallpaper document box with documents, made c. 1795, possibly in Manheim, Rapho Township, Lancaster County. Inscribed in ink "Samuel Stauffer's Deeds + +". This box was the repository of records pertaining to clockmaker Samuel Stauffer (1754-1825), after Samuel was declared to be mentally incompetent in 1794. The papers contain links to clockmakers George Hoff and Christian Eby and cabinetmakers Phillip Bretz and Emanuel Deyer. *Hand printed wallpaper over pressed board, homespun linen thread, laid paper, ink. Box measures 2.5" x 9.25" x 10.25". Private collection.*

Figure 138. Receipt from Christian Eby, dated May 9, 1795. This receipt documents the end of the clockmaking career of Samuel Stauffer (1754-1825) of Manheim, as his nephew clockmaker Christian Eby (c. 1768-1803) receives payment for finishing an eight-day clock, for the guardians of "Samuel Stauffer, lunatic." Stauffer was obviously unable to complete his last clock movement. *Laid paper and ink, 4.5" x 8". Private collection.*

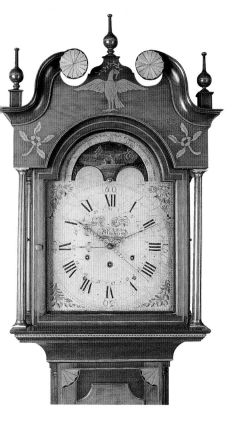

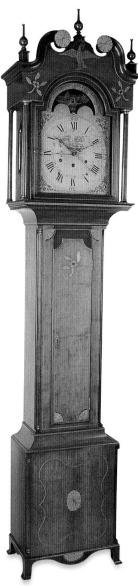

Magdalena Stauffer (c. 1744-c.1799), an elder sister of the clockmaker Samuel Stauffer, married a Mennonite named John Joseph Eby (1741-83). The Ebys were prominent millers in Warwick Township but eventually moved to Windsor Township, York County, Pennsylvania. In 1792 their son Christian Eby (c. 1768-1803) first appears on the Manheim tax roll. By 1795 he had purchased lots 333 and 334 on Prussian Street, about one block north of the home of his uncle Samuel Stauffer. It is highly likely that Christian Eby learned the clockmaking trade from Samuel Stauffer, for their movements share a number of similar details. It is known that he was making clocks by himself at least as early as March 1794, when he bought strikers, weights, and sheet iron from Mathias Long (1752-1824), the Manheim blacksmith.[7] Although his career probably lasted only about a decade, a number of thirty-hour and eight-day movements bearing his name have survived. A highly skilled clockmaker, Eby crafted the movement seen in figure 139, which is an eight-day musical clock that plays ten tunes. It is housed in an outstanding inlaid Federal case that was likely made in one of several cabinet shops that were operating in Manheim. Christian Eby's clocks typically have a white painted dial with floral decoration. From the inventory taken after his death in 1803, it is clear that he possessed the materials and tools necessary, and he was certainly painting his own dials. Most clockmakers did not, however, but instead purchased the finished dials. Christian Eby apparently didn't marry until after the age of thirty, when he married a Lutheran woman named Maria Butler. Their only child, Johannes (1803-04), was born just a few months prior to Christian Eby's death in the fall of 1803.[8]

The clock movements crafted by Christian's younger brother Jacob Eby (c. 1776-1828) are quite similar to the elder Eby's. Jacob Eby probably apprenticed with his brother Christian Eby, since his uncle Samuel Stauffer had ceased clockmaking nine years earlier. Jacob doesn't appear on the tax lists until 1803, the year of his brother's death. Evidently Jacob was working with his brother Christian, and by 1805 he was occupying lots 333 and 334, continuing to reside and operate the clock shop at his late brothers' residence. He continued there until his death in 1828. Apparently all the clocks made by Christian and Jacob Eby were made in the same Manheim clockshop located on Main Street, about a half block north of the town square. In 1815, the Eby residence and clockmaking shop was described as a one-story dwelling, partially of brick, measuring thirty-six feet by twenty-six feet. Jacob Eby's career spanned more than twenty-five years. Many of his clock movements are housed in finely inlaid Federal cases that were built in Manheim's cabinetmaking shops. Jacob's eldest child, George Eby (b. 1803), also trained as a clockmaker and continued in that craft until 1840. He left the clockmaking trade at a time when competition from inexpensive, mass-produced New England shelf clocks was rapidly decreasing the demand for the traditional tall case clocks. Ironically, George Eby became a merchant, quite possibly selling the New England shelf clocks that helped to end the Eby family's clockmaking tradition.

Figure 140. Eight-day clock and case. The movement was built c. 1800 by Christian Eby (c. 1768-1803), working c. 1794-1803 in Manheim, Rapho Township, Lancaster County. The clockcase was made c. 1800 in an unknown cabinetmaker's shop, likely located in or near Manheim, Rapho Township. Although the case is predominantly Federal in detailing the fluted quarter-columns on the waist and base are remnants of the Chippendale style. The line inlay and the fan-shaped and oval inlays are decidedly high-style in origin, whereas the eagle and floral inlays are folk forms that reflect the Germanic origin and sensibilities of the cabinetmaker. *Cherrywood with contrasting wood inlays. 107.5" x 12" x 25.25". Collection of the Heritage Center Museum through the generosity of Gloria G. Schrantz, Mary Jane Mann, Harry B. Hartman, Richard Snyder, Nancy Neff Tanger, Wilson McElhinny, Ken and Susan Stoudt, Michael and Kathleen Frantz, John W.W. Loose, Linda and Michael McKee, Marian Conybeare, John J. Snyder, Jr., Evelyn R.G. Snyder, Constance McCullough, Patricia T. Herr, Mary Forry, Willis Shenk, Caroline S. Nunan, and John and Carol Pyfer.*

Chapter Eight
Blacksmithing

Figure 141. Ledger, 1796-1803, kept by John Herr, working in Eden Township, Lancaster County. Herr's ledger records farming as well as blacksmithing activities. His smithwork, typical of rural smiths, involved making tools, repairing old tools, and horseshoeing. *Laid paper, 8.25" x 7". Collection of John and Inta Tannehill.*

The European settlers who arrived in southeastern Pennsylvania found the area to be rich in iron ore deposits. Numerous iron furnaces were built, and ironmasters of predominantly English background produced a variety of cast ironwares including the five-plate stoves that were so popular among their Pennsylvania German neighbors. The further refinement of cast iron produced the far less brittle bar iron that would be used by local blacksmiths to produce farm and kitchen tools, house and wagon hardware, horseshoes, and an endless array of finely wrought wares.

Although blacksmithing was a specialty trade numerous eighteenth century farmers possessed the basic tools of the trade and doubtless produced wares for their own use as well as for their neighbors' use. Many eighteenth century inventories of Mennonite farmers and others include a listing of blacksmith's tools, although they are frequently not identified as blacksmiths in contemporary records, such as tax lists. Blacksmithing and other trades were practiced by these farmers in the winter months when they were free from most of their agrarian duties. This second trade also provided them with an additional income source. Ultimately, as they cleared more of their acreage and increased the numbers of their livestock they had less spare time to devote to sideline trades. Hence, many restricted themselves to farming.

Most blacksmiths did not sign their wares, but fortunately for researchers a small percentage of them did. Several blacksmiths can be identified among the Lancaster County Mennonite community. The production of the five blacksmiths discussed here—John Herr, Jacob Landis, John Long, and Henry and Cyrus Hersh—spans a period from 1790 to 1914. By the mid-nineteenth century, factories were mass-producing nails, housewares, kitchenwares, and horseshoes, all in direct competition with the rural blacksmith. Although the role of the blacksmiths was changing, they continued to produce specialized tools and custom hardware, and they did horseshoeing well into the twentieth century.

John Herr (1771-1854) was born in Manor Township, Lancaster County, to David and Christiana (Martin) Herr, prosperous Mennonites. John Herr's great grandfather Abraham Herr owned 600 acres of land in Manor and Lancaster Townships. His uncle Emanuel Herr was the owner of the elaborate 1768 sulphur-inlaid clothespress in the collection of Winterthur Museum. In addition to farming, John Herr plied his blacksmithing trade first in Eden Township, and later in Manor Township. His ledger for the years 1796-1803 survives (fig. 141). It documents a small amount of his output, which produced plow irons, a hammer, boring tools, sharpening shears, and steeling axes. It is significant that he chose to keep his ledger in English rather than German, as this reflects the Anglo character of his Eden Township community.

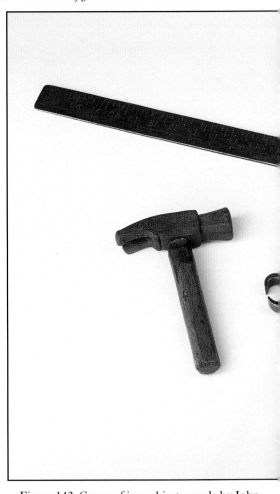

Figure 142. Group of iron objects, made by John Herr (1771-1854), Eden Township, Lancaster County. Claw hammer, c. 1790-1830, signed "J HERR" and punch-decorated with a series of semicircles used to form a pyramid. *Iron and wood. 5" L. Collection of John and Inta Tannehill.* Pincers, signed "J HERR" and dated 1792. *Iron,*

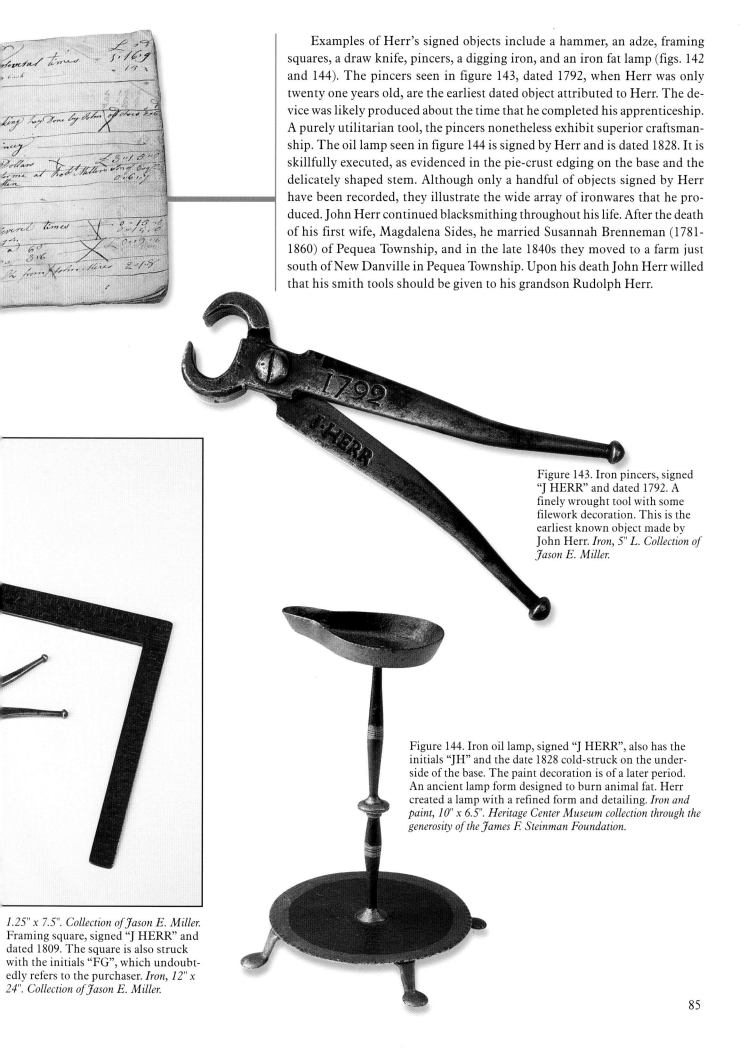

Examples of Herr's signed objects include a hammer, an adze, framing squares, a draw knife, pincers, a digging iron, and an iron fat lamp (figs. 142 and 144). The pincers seen in figure 143, dated 1792, when Herr was only twenty one years old, are the earliest dated object attributed to Herr. The device was likely produced about the time that he completed his apprenticeship. A purely utilitarian tool, the pincers nonetheless exhibit superior craftsmanship. The oil lamp seen in figure 144 is signed by Herr and is dated 1828. It is skillfully executed, as evidenced in the pie-crust edging on the base and the delicately shaped stem. Although only a handful of objects signed by Herr have been recorded, they illustrate the wide array of ironwares that he produced. John Herr continued blacksmithing throughout his life. After the death of his first wife, Magdalena Sides, he married Susannah Brenneman (1781-1860) of Pequea Township, and in the late 1840s they moved to a farm just south of New Danville in Pequea Township. Upon his death John Herr willed that his smith tools should be given to his grandson Rudolph Herr.

Figure 143. Iron pincers, signed "J HERR" and dated 1792. A finely wrought tool with some filework decoration. This is the earliest known object made by John Herr. *Iron, 5" L. Collection of Jason E. Miller.*

Figure 144. Iron oil lamp, signed "J HERR", also has the initials "JH" and the date 1828 cold-struck on the underside of the base. The paint decoration is of a later period. An ancient lamp form designed to burn animal fat. Herr created a lamp with a refined form and detailing. *Iron and paint, 10" x 6.5". Heritage Center Museum collection through the generosity of the James F. Steinman Foundation.*

1.25" x 7.5". Collection of Jason E. Miller. Framing square, signed "J HERR" and dated 1809. The square is also struck with the initials "FG", which undoubtedly refers to the purchaser. *Iron, 12" x 24". Collection of Jason E. Miller.*

Some blacksmiths produced a full range of wrought iron products, while others like "Schmidt" Jacob Landis were known for their specialty production. Born in East Hempfield Township, "Schmidt" Jacob Landis (1780-1848) was the son of John Landis (1748-1823) and Anna (Bear) Landis. His father, John Landis, was a farmer and woodworker who manufactured wooden grain shovels, shaking forks, and yarn winders.[1] Jacob Landis learned the art of blacksmithing and in 1805 moved to Manheim Township with his wife Elizabeth Kauffman (1781-1859). The property that they occupied was owned by Elizabeth's father, Isaac Kauffman (1748-after 1820), a well-to-do farmer in East Hempfield Township (fig. 145). Their six-acre tract in Manheim Township was located at the busy intersection of Reading Road and the road to Lititz and included a blacksmith shop. This site eventually became the crossroads village of Landis Valley and today is the core of the Landis Valley Museum, a Pennsylvania Historic and Museum Commission property.

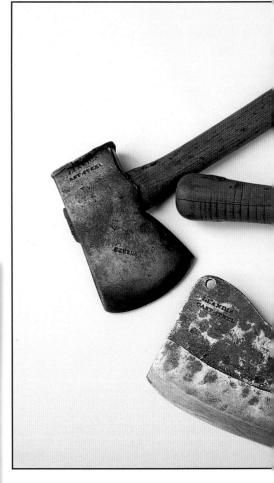

Figure 145. Fraktur family record, attributed to Christian Strenge (1757-1828), working in East Hempfield Township, Lancaster County, c. 1790. Th[e] colorful fraktur records the family of Isaac Kauffma[n] (b. 1742) and his wife, Elizabeth (Brubacher) Kauffman (b. 1748). Isaac's fourth child, Elizabeth (1791-1859), became the wife of "Schmidt" Jacob Landis, the blacksmith of Landis Valley. *Laid paper, ink, and water color, 12.25" x 15.5". Heritage Center Museum through the generosity of Henry Kauffman.*

Figure 146. Oil painting on canvas, by an unidentified folk artist, working c. 1860. This painting depicts the farmstead occupied by "Schmidt" Jacob Landis from 1805 until his death in 1848, as seen from the south, located at Landis Valley, Manheim Township, Lancaster County. The brick house on the left was enlarged by Jacob Landis about 1828. He constructed the brick one-and-a-half story house c. 1842 as his retirement dwelling. He built the stone bank barn in 1814. Both brick structures survive and are on the grounds of the Landis Valley Museum. *Canvas, oil paint, wood, 24.75" x 36". Collection of the Landis Valley Museum (PHMC). Nathan Cox Photography.*

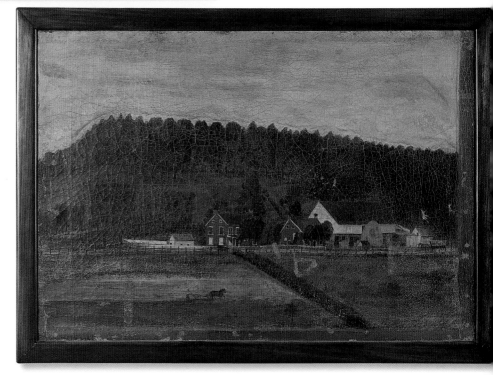

Working as a blacksmith, Jacob Landis prospered. In 1820 he received title to the property seen in figure 146. In addition to blacksmithing, Landis also farmed, served as a township supervisor, and was a founder of the Reading Road Mennonite Meetinghouse. Judging from the surviving examples of "Schmidt" Jacob Landis's work, it appears that his production consisted largely of edged tools (figs. 147 and 148). There are felling axes, goosewing axes, broadaxes, post-hole axes, a hatchet, a drawing knife, a scythe anvil, and a number of meat cleavers that survive with his mark. His son "Devil" John Landis (1805-61) also learned the blacksmithing trade and was remembered as an edge-tool manufacturer. It is likely that they worked in the same shop, and may even have shared the same "J LANDIS" tool stamp. The tool box seen in figure 149, which is mounted on the Conestoga wagon (fig. 13), is clearly stamped "JO LANDIS." This wagon was built for the Shreiner family, close neighbors of the Landises, and may well have been ironed by "Devil" John Landis. Jacob Landis continued his smithwork as late as 1843, when he moved from his brick farmhouse to the small brick house he had built for his retirement (fig. 146). Upon his death in 1848, he became the first burial in the cemetery adjoining the Reading Road Mennonite Meetinghouse at Landis Valley.

Figure 147. Group of iron objects, all signed "J LANDIS", attributed to Jacob Landis (1780-1848), working in Manheim Township, Lancaster County, c. 1805-43.
A. Hatchet head, stamped, "J LANDIS CAST STEEL," also stamped "J SHERTZ." This hatchet was originally made by Jacob Landis. The cutting edge was likely later re-steeled by John Shertz, a blacksmith who worked in Lancaster Borough from 1857 to 1880. *Iron, steel, and wood. 13" x 6" x 1". Collection of Jason E. Miller.*
B. Pair of meat cleavers, stamped "J LANDIS CAST STEEL," c. 1830. This pair of cleavers, unusually small and graceful in form, descended together with their leather sheaths. Both retain their original wooden handles. *Steel and wood, 4" x 13" x 1.25". Collection of Jason E. Miller.*

Figure 148. Iron objects, signed "J LANDIS," attributed to Jacob Landis (1780-1848), working in Manheim Township, Lancaster County, c. 1805-43. Left: Post-hole axe, stamped "J LANDIS CAST STEEL," c. 1805-10. The gracefully shaped lower edge of the axe head is more typical of eighteenth century smithwork. This suggests that the example was forged early in Landis' career. *Iron, steel, and wood, 3.75" x 9.75" x 1". Private collection.* Right: Scythe anvil, signed "J LANDIS," c. 1805-43. This tool was commonly known as a *Dengelschtock*, and was carried into the fields by farmworkers. After it was driven into the top of a fence post, the broad end functioned as an anvil to help repair damaged scythe blades. *Iron, 10" x 1.25" x 1". Private collection.*

Figure 149. Tool box mounted on a Conestoga Wagon, signed "JO LANDIS," possibly made by "Devil" John Landis (1805-61) of Manheim Township, Lancaster County. This box is mounted on the wagon seen in figure 13. *Wood, iron. Collection of the Landis Valley Museum (PHMC). Nathan Cox Photography.*

Another specialized trade within the craft of blacksmithing is locksmithing. John Long (1787-1856) of Manheim Borough was trained as a locksmith and was probably apprenticed to Mathias Long (1752-1824), an immigrant from Wittenstein, Germany, and a skilled blacksmith who operated a shop in the village of Manheim, Lancaster County. About 1811, John Long married Peggy Lindemuth, the daughter of Peter Lindemuth, a tavern owner in Mount Joy, Pennsylvania. They moved to the property of the widow of Jacob Druckenmiller (1756-1806), another Manheim blacksmith.[2] As late as 1822 he was still occupying the Druckenmiller shop, but by 1831 he was at another Manheim location and the tax list identifies him (for the first time) as a locksmith. Nothing is known about the wares that Long produced during his years in Manheim; however, he is famous for a series of decorative oil lamps that he produced late in his blacksmithing career. In 1839 he left his wife and children in Manheim and moved a few miles away to the village of Sporting Hill in Rapho Township.

John Long spent the last seventeen years of his life living in Sporting Hill with the family of another blacksmith, Emanuel Long (1789-1875), his wife Anna Hernley, and their six children (figs. 150 and 153). The Long family was Mennonite, and it was in this setting that John Long created a series of exquisitely wrought and decorated oil lamps (fig. 152). The lamps are constructed of iron with a swinging brass lid. The lid is usually inscribed with the name of the recipient, the date, and John Long's signature, and it has a brass finial in the shape of a songbird. Some examples also boast punched star decoration and additional chased decoration on the lid and the bird finial. Recorded examples of Long's lamps are dated from 1841 to 1855. The recipients seem to be equally divided between male and female, and they typically received their lamps in their late teens to early twenties. It appears that they were a part of the *Aussteier*, or outfitting that was received in preparation for marriage. A few other decorated iron objects can also be attributed to the skillful hands of John Long (fig. 151), including a sewing clamp made for Harriet Long (1828-1914), the daughter of his landlord, Emanuel Long (figs. 150 and 153). John Long died at Sporting Hill on August 14, 1856. His son George Long (1818-90) followed in his father's trade and also became a locksmith working in Manheim Borough. John Long's legacy is a group of exceptional iron oil lamps that many collectors consider to be among the finest examples of Pennsylvania German smithwork.

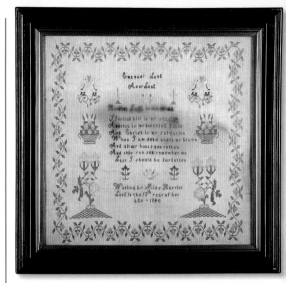

Figure 150. Sampler, made by Harriet Long (1828-1914), working in Sporting Hill, Rapho Township, Lancaster County, dated 1840. Harriet Long stitched her sampler at age twelve, proudly recording that she was the daughter of Emanuel and Anna (Hernley) Long of Sporting Hill. Her family shared their home with John Long, the blacksmith who made for Harriet the sewing clamp seen in figure 153. *Linen fabric, silk, and cotton threads, 17" x 17.5". Collection of the Hershey Museum.*

Figure 151. Objects made by John Long (1787-1856), working in Sporting Hill, Rapho Township, Lancaster County, active 1839-56. Both examples exhibit two sizes of punched stars in their decoration.
A. Betty lamp, signed by John Long, dated 1848. This oil lamp is inscribed for Fanny M. Erisman (1822-1913), a neighbor of Long, who married John Becker (1821-52) in 1848. It was likely commissioned as a gift from her parents in preparation for her marriage. *Iron and brass, 8" x 4" x 2.5". Private collection.*
B. Flesh fork, attributed to John Long, c. 1840-48, working in Rapho Township, Lancaster County. Although unsigned, this wrought fork has the name Fanny M. Erisman incised in script on the handle. It also was owned by Fanny M. Erisman (1822-1913). *Iron, 11.5" x 1.75". Collection of Eugene and Vera Charles.*

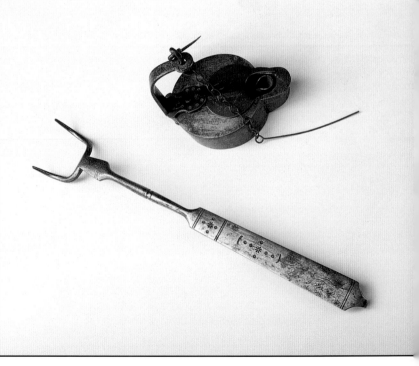

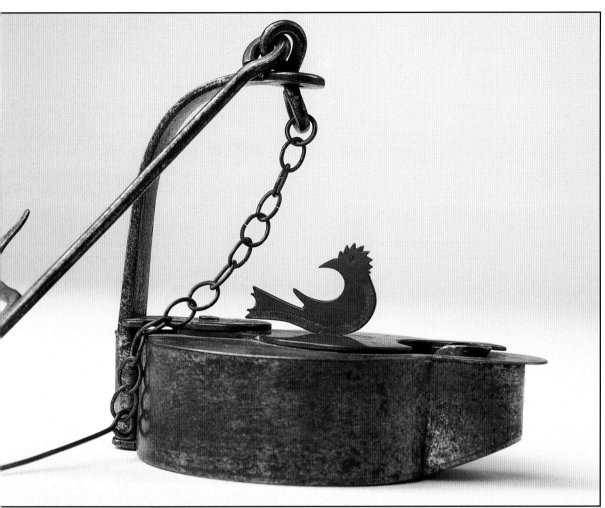

Figure 152. Side view of the Betty lamp, signed by John Long, working in Rapho Township, dated 1848. The profile of the bird finial is the typical form employed by Long on most of his oil lamps. Although bird finials appear on both European and Pennsylvania prototypes, the beauty of Long's finials is unsurpassed. His lamps are regarded as icons of the Pennsylvania German blacksmith's art. *Iron and brass, 8" x 4" x 2.5". Private collection.*

Figure 153. Sewing clamp attributed to John Long, working in Rapho Township, Lancaster County, c. 1840-45. The sewing clamp was a standard accessory of the Pennsylvania German needle worker. When slipped over the edge of the work table, the clamp secured the fabric. A fabric cushion fastened to the top held pins and needles. This example has the name Harriet Long incised in script along one side. The thumbscrew is decorated with the two sizes of stars that are frequently found on John Long's work. The owner, Harriet Long (1828-1914), was the daughter of Emanuel Long, John Long's landlord. She received this sewing clamp prior to her October 1845 marriage to Benjamin Brubaker (1821-91). The brass bowl at the top of the clamp would have originally held a straw-filled cushion that was sewn to the brass base. *Iron and brass, 5" x 2.75". Private collection.*

The brothers Cyrus Hersh (1832-94) and Henry S. Hersh (1833-1917) began their career as blacksmiths about the time that John Long's career ended. Their father Peter Hersh (1805-35) was a blacksmith who lived in Strasburg Township, Lancaster County. He was killed when a still that he was working on exploded. Cyrus was only three years old when his father died. He learned the trade of blacksmithing from Jacob Johnson, a young blacksmith in Pequea Township with whom he was living from 1850 to 1854. About 1856 he married Catherine Hertzler (1831-94). They moved to Manheim Township, where he carried on the blacksmithing trade until 1864, when they left the township.[3] They eventually settled in West Donegal Township, where he continued blacksmithing until his death in 1894. Cyrus's son Benjamin F. Hersh (1858-1943) learned the trade from his father and continued to work in the smithshop for many years.

The New Danville blacksmith shop of Henry S. Hersh can be seen in figure 154. Henry and his young bride, Ann (Shaub) Hersh (1832-1918), moved to this site in 1855. Henry S. Hersh was a blacksmith, wheelwright, and a carriage builder. Much of his ironware was signed and occasionally it was dated (fig. 155). His ironwork was of a high quality. The wagon hasp (fig. 155) is dated 1894, but the sunflower terminus is reminiscent of Conestoga Wagon hardware that had been produced a century earlier.[4] In 1898 Henry retired from the business (fig. 156). His son Albert S. Hersh (1857-1941) continued to operate the shop until 1938. Albert did blacksmithing, horseshoeing, and carriage building. He is known to have built sleighs, market wagons, surreys, and Jenny Linds. Henry S. Hersh died in 1917 and is buried nearby at the New Danville Mennonite Cemetery.

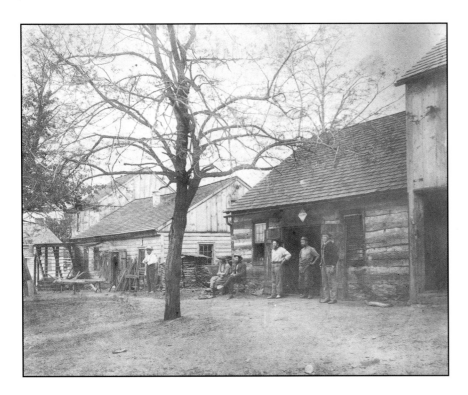

Figure 154. Photo of the blacksmith shop of Henry S. Hersh, located in the village of New Danville, Pequea Township, Lancaster County, c. 1878. In this photo, blacksmith Henry S. Hersh (1833-1917) stands in front of the left door leading into his log smith shop. His son Albert S. Hersh (1857-1941) stands in the center of the doorway wearing his leather apron. The frame building to the left is his carriage building shop. Between the two shops is a stack of layered split wood pieces that will be fashioned into spokes for wooden wagon wheels. The log smith shop still stands today, although it has been converted into a garage. *Photo courtesy of Mrs. Mary K. Wenger.*

Figure 156. Photo of Henry S. Hersh, blacksmith at New Danville, Pequea Township, c. 1900. This photo was taken about the time of Hersh's retirement from blacksmithing. His son Albert S. Hersh had taken over the operation of the blacksmith shop and the carriage building business. *Photo courtesy of Mrs. Mary K. Wenger.*

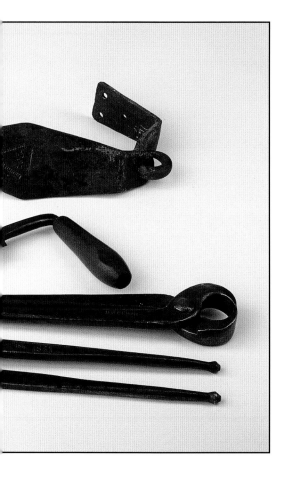

Figure 155. Group of iron objects, all signed "HS HERSH," made by Henry S. Hersh (1833-1917), working in New Danville, Pequea Township, 1855 to 1898.
Upper left: Broadaxe head, stamped "HS HERSH". *Iron and steel. 9.5" x 8". Collection of Jason E. Miller.*
Middle: Drawknife, signed "HS HERSH." This was a popular woodworking tool that was used in conjunction with the Schnitzelbank, or shaving bench, to form rungs and spokes. *Iron and wood. 5.5" x 15". Collection of Jason E. Miller.*
Lower: Pair of pincers, both marked "HS HERSH." One example has copper inlay worked into the letters. *2.5" x 12.5". Collection of Jason E. Miller.*
Upper right: Double tree hasp, signed "HS HERSH," dated 1894. This hasp was made near the end of Hersh's career. It was likely made for use on a Conestoga wagon and retains some salmon paint, the typical color of a Conestoga's running gear. Hersh employed the traditional sunflower design but also used his name stamp to create a triangular design for additional decoration. *Iron, 3.5" x 12". Eugene and Vera Charles.*

Cyrus F. Hersh (1855-1949) was also taught the art of blacksmithing in his father's New Danville shop. He began working in the blacksmith shop of Henry S. Hersh in 1871, at age sixteen. In 1879, the year following his marriage to Mary Ann Irvin, they moved to Strasburg, Lancaster County, where he operated his own smithshop until 1914. Cyrus did general blacksmithing and a great deal of horseshoeing. He is probably the maker of the dough scraper seen in figure 157. A group of these gracefully executed scrapers has been found in Lancaster County signed "C HERSH." Several bear dates from 1876 to 1881. The earlier examples produced prior to 1879 employed a number set that appears to be the same as the set used by his father, Henry S. Hersh. The latest recorded example (fig. 157) displays a different style in the date numerals, as it would have been made after Cyrus opened his own shop in Strasburg and had acquired his own number set. Although Hersh was quite capable of producing fine iron wares, he was working at a time when competition from inexpensive manufactured goods made it impractical for smiths to continue to produce traditional forms. Cyrus Hersh, like many of his peers, was forced to rely on horseshoeing as his principal trade. Hersh recalled that he "shod as many as ten horses in half a day."[5] After closing his shop, he was employed in various carriage building shops. Later in life he served as the sexton at East Chestnut Street Mennonite Church in Lancaster City, where he was a member.

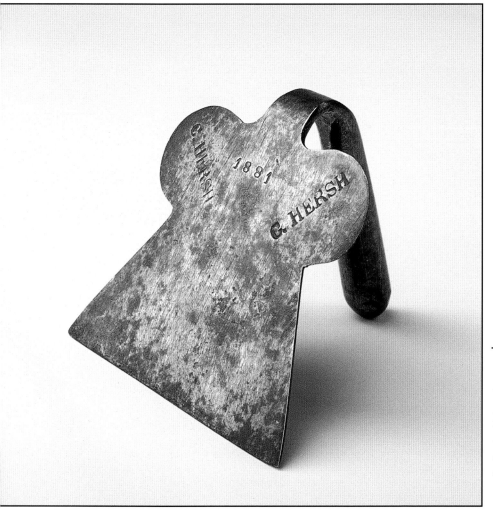

Figure 157. Dough scraper, attributed to Cyrus Hersh (1855-1949) working in Strasburg, Lancaster County, stamped "C HERSH" twice, dated 1881. Hersh is believed to have produced a number of these scrapers early in his blacksmithing career. *Iron, 3.5" x 4.25". Collection of Jason E. Miller.*

Chapter Nine
Redware Pottery

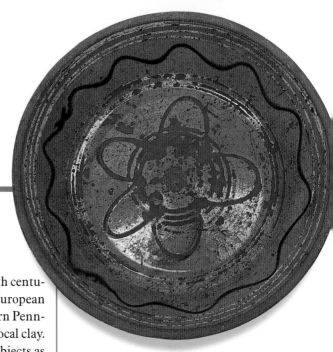

The rural Pennsylvania Germans of the eighteenth and nineteenth centuries were quite familiar with redware pottery. Widely used in their European homeland, this utilitarian ware was quickly duplicated in southeastern Pennsylvania, where arriving immigrants found abundant supplies of the local clay. These potters produced an array of cooking and storage vessels and objects as diverse as roof tiles, inkwells, fat lamps, and children's toys. The vast majority of their production, however, consisted of simple forms that were left undecorated. These wares were inexpensive, and as a result were heavily used, with few early examples surviving intact.

Redware production in Pennsylvania continued unabated throughout most of the nineteenth century until it was ultimately replaced by stonewares. While redware pottery was widely used for cooking, baking, and storage needs, the tablewares used by most Pennsylvania Germans by the early nineteenth century consisted of imported English pottery or "Queensware," as it is often referred to in household inventories. These wares were produced in England for the American market, and largely consisted of hand-decorated, and later transfer-printed pottery. These white-bodied imported ceramics, represented the "fine china" of the household and as such were treasured by their owners. The lowly redwares found in the kitchen and cellar were used, broken, and discarded.

Local potters were capable of producing pleasing forms, unusual glazes, and outstanding surface decoration. These skills were often reserved for presentation pieces that were given to friends and family. Unfortunately, few potters signed their wares, making positive attributions difficult. Among the Mennonites of Pennsylvania only a few individuals have been identified as redware potters. Moreover, pottery making was frequently a part-time trade, and for that reason many potters are not identified as such in tax lists and other contemporary records.

Archeological excavations at Mennonite homesteads in eastern Pennsylvania have yielded large quantities of locally made redware shards. A surprising number of shards were decorated using two or three colors of slip. This large redware bowl (fig. 158) is a rare survival of eighteenth century domestic pottery. The two-color slip decoration is typical of the modest decoration that was once commonly found on local redwares. This bowl was owned by the Mylin family of West Lampeter Township, Lancaster County, and likely dates from the second half of the eighteenth century. The Mylin ancestor, Martin Meylin (c. 1665-1749), was among the first Mennonite settlers to arrive at Pequea, Lancaster County, in 1710. In 1724 Martin requested a grant of 100 acres in Lancaster County, in order to manufacture brick and (roof) tiles. Perhaps this bowl was a product of the Meylin family's clay manufacturing efforts.

Figure 158. Redware bowl, descended in the Mylin family of West Lampeter Township, Lancaster County, by an unknown potter, c. 1750-1800. This glazed bowl was decorated using two colors of clay slip. Wares such as this were common utilitarian forms in Germany, as well as in southeastern Pennsylvania during the eighteenth century. *Red clay, clay slip, 3" x 13". Collection of the Lancaster County Historical Society.*

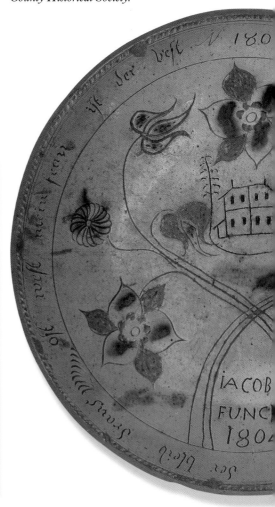

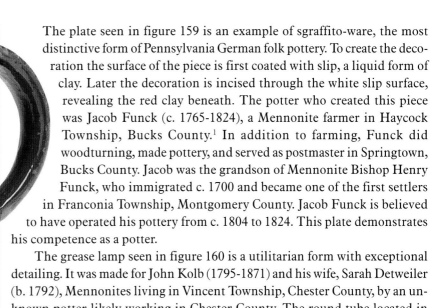

The plate seen in figure 159 is an example of sgraffito-ware, the most distinctive form of Pennsylvania German folk pottery. To create the decoration the surface of the piece is first coated with slip, a liquid form of clay. Later the decoration is incised through the white slip surface, revealing the red clay beneath. The potter who created this piece was Jacob Funck (c. 1765-1824), a Mennonite farmer in Haycock Township, Bucks County.[1] In addition to farming, Funck did woodturning, made pottery, and served as postmaster in Springtown, Bucks County. Jacob was the grandson of Mennonite Bishop Henry Funck, who immigrated c. 1700 and became one of the first settlers in Franconia Township, Montgomery County. Jacob Funck is believed to have operated his pottery from c. 1804 to 1824. This plate demonstrates his competence as a potter.

The grease lamp seen in figure 160 is a utilitarian form with exceptional detailing. It was made for John Kolb (1795-1871) and his wife, Sarah Detweiler (b. 1792), Mennonites living in Vincent Township, Chester County, by an unknown potter likely working in Chester County. The round tube located in the font contained the wick, the small loop at the apex of the handle likely held a wire pick that was used to advance the wick, and the collar farther down the column caught the drippings from the wick. The yellow slip decoration on the brown overall glaze creates a lamp that is both functional and attractive, and it was likely intended as a presentation piece.

Figure 160. Redware grease lamp, descended in the John Kolb (1795-1871) family of Vincent Township, Chester County, by an unknown potter likely working in Chester County, Pennsylvania, c. 1800-40. It is a more refined example of the lamp form seen in figure 144. The potter who crafted the lamp employed white slip over a brown glaze. Exhibiting little evidence of use, this lamp may well have been given as a wedding gift to a young bride, in keeping with an old Pennsylvania German custom. *Red clay, white slip, manganese, 7.25" x 4.75" diameter. Collection of the Mennonite Heritage Center, Harleysville, Pennsylvania. Nathan Cox Photography.*

Figure 159. Sgraffito plate, signed by Jacob Funck (c.1765-1824), working in Haycock Township, Bucks County, c. 1804-24, dated 1804. Jacob Funck chose to scratch the image of a house on his plate, a design that is exceedingly rare on decorated pottery. The border inscription translates as follows: "In the dish stands a house. He who would pilfer-keepout. East, west, my wife is the best [in the year] 1804 Jacob Funck 1804." *Red clay, white slip, copper oxide, 2.25" x 11" diameter. Collection of the Philadelphia Museum of Art: Purchased: John T. Morris Fund.*

The slip-decorated plate seen in figure 161 is believed to be the work of Benjamin Bergey (1797-1854), a potter and a sawmiller in Rockhill Township, Bucks County. Bergey, a Mennonite, is thought to have made redware pottery c. 1820 to 1840, including this impressive example. Using white slip, he chose to decorate his plate with a large pelican seated on a floral vine, creating a bold example of folk pottery. Benjamin Bergey, who was born in Franconia Township, Montgomery County, was a part of the larger Pennsylvania German community of Bucks and Montgomery Counties that produced a wealth of finely decorated redware pottery. Bergey and his wife, Elizabeth Hendricks (1801-95), are buried in the Rockhill Mennonite Cemetery.

Although typically potters spent most of their days throwing quantities of undecorated pie plates and crocks, occasionally they were commissioned to produce special gifts. This skillfully executed cat (fig. 162) was crafted by an unknown potter as a wedding gift for a young Mennonite couple in 1847. The recipients were Susanna Swartley (1829-1904) of New Britain Township, Bucks County, and her groom, Jacob K. Alderfer (1825-80), of Lower Salford, Montgomery County. Most redware animal forms were produced purely for decoration. This figural cat is a functional piece that was likely intended for the storage of cookies or candies. The head, which is threaded onto the body, provides a lid for the canister.

Figure 162. Redware cat jar, made by an unknown Bucks County potter, given as a wedding gift to Susanna Swartley (1829-1904) of New Britain Township, Bucks County, in 1847, at her marriage to Jacob K. Alderfer of Lower Salford, Montgomery County, Pennsylvania. This skillfully sculpted cat has a removable head that allows for storage of cookies or candies; the piercings represent whiskers and allow for limited ventilation. *Red clay, yellow lead glaze, 11.75" x 8" x 5". Collection of the Mennonite Heritage Center, Harleysville, Pennsylvania. Nathan Cox Photography.*

Figure 161. Slipware plate attributed to Benjamin Bergey (1797-1854), working in Rockhill Township, Bucks County, working c. 1820 to 1840, inscribed "EB." Bergey chose to decorate his redware plate with an image of a pelican plucking its breast, an ancient Christian image that is frequently seen on Pennsylvania German fraktur. *Red clay, clay slip, copper oxide, 2.5" x 13.25" diameter. Collection of the Philadelphia Museum of Art. Photograph by Graydon Wood, 1993.*

While no member of the Lancaster Mennonite Community has been identified as a redware potter, several descendants of Lancaster County families rank among the most prominent potters to have worked in Markham and Waterloo Counties, in Ontario, Canada. Jacob Bock was a Mennonite from Lancaster County who settled in Waterloo County, where he is known to have produced redware in the 1820s.[2] Bock is the earliest documented potter in the Waterloo region. A second potter with Lancaster County ties is "Potter Sam" Eby. "Potter Sam" was born in Waterloo County on August 18, 1805, the year after his parents, George and Barbara (Wenger) Eby, arrived in Canada.[3] He is remembered as the first child of European ancestry to be born on the 60,000-acre German Company Tract that had been purchased by the Mennonites in Waterloo County. Nothing is known concerning redware production by "Potter Sam," as he apparently didn't sign any of his wares.

Two of Ontario's most highly regarded folk potters were the brothers William K. Eby (1831-1910) and Cyrus Eby (1844-1906). The Eby brothers undoubtedly learned the art of pottery making from their father, "Potter Sam" Eby. Cyrus Eby and his wife, Sarah Ann Heise (b. 1841), settled in Markham County, Ontario, where he is believed to have created the decorated storage jar seen in figure 163. This jar has an attractive olive glaze and is decorated with an eight-pointed star, drawn in two colors of slip. Within a few years of opening his Markham County pottery, Cyrus moved north to Chippawa Hill in Bruce County, Ontario, where he continued to make pottery.[4]

Figure 163. Earthenware storage jar attributed to Cyrus Eby (1844-1906), working in Markham County, Ontario, Canada, c. 1862-67, signed by Eby. The yellow and brown slip decoration consisting of an eight-pointed star and a pair of birds is reminiscent of Pennsylvania prototypes. *Clay, yellow, and brown slip, 9.5" x 6" diameter. Collection of the Joseph Schneider Haus, Kitchener, Ontario. John Herr, photography.*

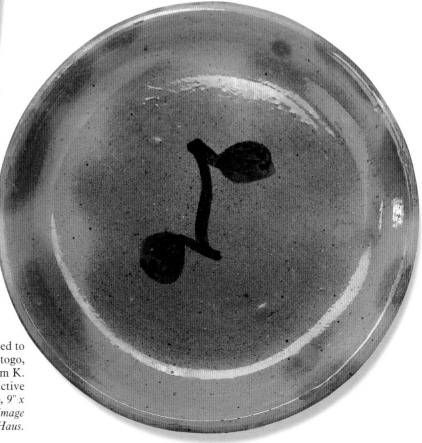

Figure 164. Earthenware pie plate attributed to William K. Eby (1831-1910), working in Conestogo, Waterloo County, Ontario, c. 1875-1900. William K. Eby was known for his pie plates with a distinctive cherry motif applied in brown slip. *Red clay, slip, 9" x 1.5" diameter. Collection of Dave and Sandy Moore. Image courtesy of the Joseph Schneider Haus.*

William K. Eby (1831-1910) opened his first pottery in Markham in 1855, but two years later he moved to the village of Conestogo in Waterloo County. Here he established a successful pottery that he continued to operate for nearly fifty years. Although his production largely consisted of plain utilitarian wares, it is the decorated wares that he created for family and friends (figs. 164-166) that have attracted the attention of pottery collectors. His mottled pie plates with their distinctive cherry design represent a late survival of the tradition of slip-decorated pie plates that were widely made by earlier Pennsylvania German potters. William Eby also produced a small amount of redware in a deep-green glaze (fig. 165). Most of these pieces, like the miniature harvest ring, were manufactured for family members. The sugar bowl (fig. 166) is an unusual example. The light color of the clay contrasts sharply with the dark-green stick decoration. Eby was a talented potter who created a diverse group of redwares. His death in 1910 marked the end of an era, the demise of a folk pottery tradition.

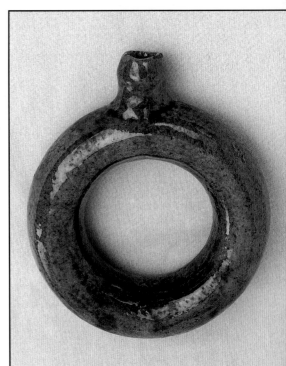

Figure 165. Harvest ring attributed to William K. Eby (1831-1910), working in Conestogo, Waterloo County, Ontario, c. 1875. A miniature example of a storage vessel that was filled with liquid refreshment and carried into the fields by farm workers. Eby was known for the rich green glazes that he used on specialty wares that he produced for his family and friends. *Red clay, green glaze, 6.5" x 5.5" diameter. Collection of the Joseph Schneider Haus, Kitchener, Ontario. John Herr, photography.*

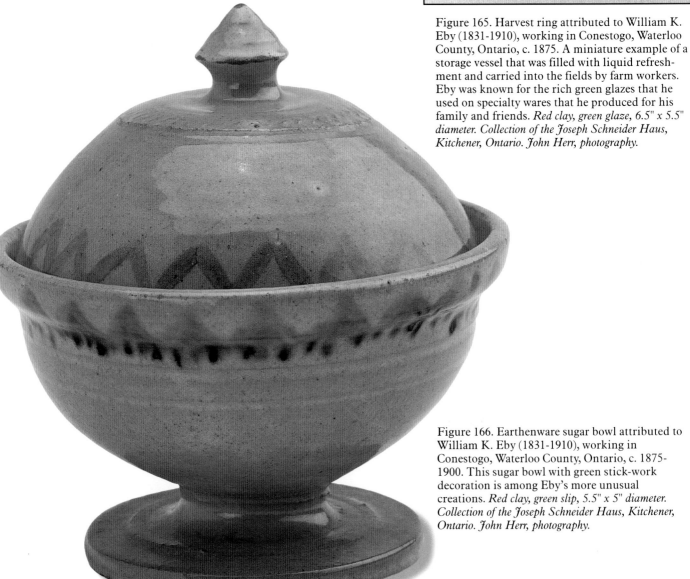

Figure 166. Earthenware sugar bowl attributed to William K. Eby (1831-1910), working in Conestogo, Waterloo County, Ontario, c. 1875-1900. This sugar bowl with green stick-work decoration is among Eby's more unusual creations. *Red clay, green slip, 5.5" x 5" diameter. Collection of the Joseph Schneider Haus, Kitchener, Ontario. John Herr, photography.*

Fraktur Artists

Figure 167. Fraktur bookplate, c. 1755, by an unknown artist working at the Ephrata Cloister in Lancaster County. This bookplate, originally bound in a 1748 Ephrata *Martyrs' Mirror*, was penned for Carl Christophel (d. 1767) a c. 1718 immigrant who served as a deacon in the New Danville Mennonite congregation. *Ink on laid paper, 14" x 18.75". Heritage Center Museum collection through the generosity of Irene Walsh and Dr. Warren Robbins.*

The Germans and Swiss who arrived in Pennsylvania carried with them numerous folk art traditions. The most distinctive of these art forms is their paper art known as fraktur. The word "fraktur" has come to represent a diverse group of ink and watercolor drawings that were executed on paper. Actually, the word derives from the name of a type font that was commonly used by printers in all Germanic regions of Europe. This same printers' font was employed in Pennsylvania by the German printers on all of the German-language books, broadsides, and printed fraktur forms that they produced.

While the practice of hand-illuminating manuscripts was widespread in medieval Europe, this tradition survived among the Swiss and German peasantry in the form of decorated baptismal wishes. These small certificates were often presented to the newly baptized child by their baptismal sponsors. Other recorded European fraktur forms included decorated book-ownership inscriptions (bookplates), and *Vorschriften* (handwriting examples). These fraktur traditions were carried to Pennsylvania, where schoolmasters continued to make handwriting examples and bookplates for their young scholars. However, the European baptismal wish did not survive in Pennsylvania but instead evolved to become the *Geburts und Taufschein*, or birth and baptismal certificate, which soon became the most popular fraktur form among the Pennsylvania Germans.

Fraktur art experienced a tremendous rebirth in its New World setting, where it was created by schoolmasters, ministers, and enterprising itinerants. By the 1780s, printing presses were turning out printed fraktur forms with hand-drawn wood block decoration. This greatly expedited fraktur production, as artists purchased the forms, hand-colored them, and then added the birth and baptismal records in fraktur lettering. Despite the advantages of the printed forms, hand-drawn fraktur continued to be created for generations.

Many of the Mennonites who arrived in Pennsylvania were familiar with the fraktur traditions of their Swiss and German homelands. A few frakturs survive (figs. 4 and 6) that were brought along by immigrant families arriving in southeastern Pennsylvania. These continental examples may have directly inspired some Pennsylvania artists. It is also likely that a few immigrant schoolmasters may have produced fraktur both in Europe and Pennsylvania. The New Year's greeting seen in figure 168 was created in 1753 by an immigrant named Ulrich Stoller for Jacob and Anna Witmer, Mennonites living in Lampeter Township, Lancaster County. Stoller arrived in Philadelphia in September 1749 on the ship *Phoenix*. Also on board was Hans Jacob Witmer. It is probable that this is the same Jacob Witmer who received the fraktur penned by Stoller four years later. The style of Stoller's New Year's greeting is typical of early Pennsylvania examples, in that the decoration was clearly sec-

ondary to the text. The decoration is rather subdued when compared to the bold decoration that is frequently seen on fraktur produced generations later during the zenith of fraktur production.

The earliest group of documented Pennsylvania fraktur was produced at the Ephrata Cloister in Lancaster County, Pennsylvania, from c. 1744 to c. 1760, under the leadership of Conrad Beissel (1691-1768). Beissel established the Cloister on the banks of the Cocalico Creek in 1732 after a split with the Dunkards. His new group came to be known as the Seventh Day Baptists, and he established celibate and married orders within the community. By the mid-1740s a paper mill and a printing press were in operation by the Cloister brethren. Conrad Beissel himself is credited with establishing a writing school that was operated by the sisters. This school produced dozens of beautifully illuminated manuscript books, as well as the great wall charts that were used in the Cloister buildings.

The fraktur that was produced at Ephrata during this period is regarded by many people as the finest fraktur ever created in Pennsylvania. The work is characterized by perfectly formed fraktur capital letters that were completely infilled with minute textures and patterns, accompanied by highly stylized bird and floral designs. Nearly all the fraktur created during this golden period was solely for the use of Cloister members; however, the two-page bookplate (fig. 133) is an exception. The fraktur's owner, Daniel Forrer, a clock maker in Lampeter, Lancaster County, had no known connection to the Cloister. The artist who executed this superb example was certainly one of the same unidentified sisters who created the manuscript volumes that were used by the Cloister members.

In 1745 a group of Mennonites from the Franconia community approached the Cloister brethren with a request to republish the *Martyrs' Mirror*, a massive volume that chronicles the history of early Christian and later Anabaptist martyrs. It was first printed in 1660 in the Dutch language. Cloister Prior Peter Miller translated the work into German, and fourteen others labored three years to produce 1,300 copies of the book. Although it bears the printing dates of 1748 and 1749, it is believed that the volume was not available until 1751. Some of these copies were personalized with the addition of a fraktur bookplate (figs. 36 and 167).[1] Approximately twenty of these bookplates are known to the author. Nearly all were inscribed for Mennonite owners who were living in Lancaster County. These bookplates appear to be the work of several different artists, and most bear dates in the 1750s.

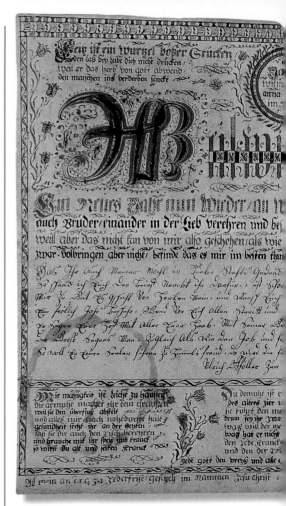

Figure 168. New Year's greeting, dated 1753, signed by Ulrich Stoller. One of the earliest known Pennsylvania frakturs to have been produced outside of the Ephrata Cloister, this fraktur illustrates the continuation of the Palatine tradition of giving New Year's greetings. The recipients, Jacob and Anna Witmer, were residents of Lampeter Township, Lancaster County. *Ink on laid paper, 12" x 15". Private collection.*

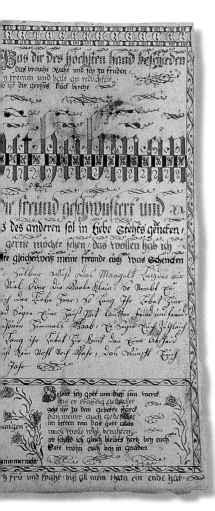

Although the Ephrata community was closely related to the Dunkard Church, it also drew its membership from many other denominations. A considerable portion of the Ephrata group had previously held memberships in the Mennonite congregations in Lancaster County. Consequently, many families among the Lancaster County Mennonites had children, siblings, or even parents who had been attracted by the charms of the charismatic founder, Conrad Beissel, and joined his utopian settlement on the Cocalico. A close relationship persisted and the Cloister Press printed a number of important Mennonite devotional, theological, and historical works for their Mennonite neighbors.

Among the most important Colonial schoolmasters in Pennsylvania is Christopher Dock (1698-1771).[2] Dock taught sporadically from 1718 to 1771 at the Salford and Skippack schools in Montgomery County, Pennsylvania. Believed to have been a Mennonite, Dock likely introduced the *Vorschrift* form into this community. Although no pieces of signed fraktur have been discovered, the *Vorschrift* (fig. 169) can be firmly attributed to Dock, based on its comparison to some documented examples of his handwriting. The basic composition of this *Vorschrift*, including the text and decoration, was later copied and expanded by a host of schoolmaster artists.

Figure 169. *Vorschrift* or writing example, c. 1750-60, attributed to Christopher Dock (1698-1771), working in Montgomery County, Pennsylvania. Dock may well have been the first schoolmaster in Pennsylvania to pen *Vorschriften* for his students. The basic format of this piece was copied by a host of later fraktur artists in the Franconia and Lancaster regions. *Ink and watercolor on laid paper, 7.75" x 12.25". Collection of the Mennonite Heritage Center, Harleysville, Pennsylvania. Nathan Cox Photography.*

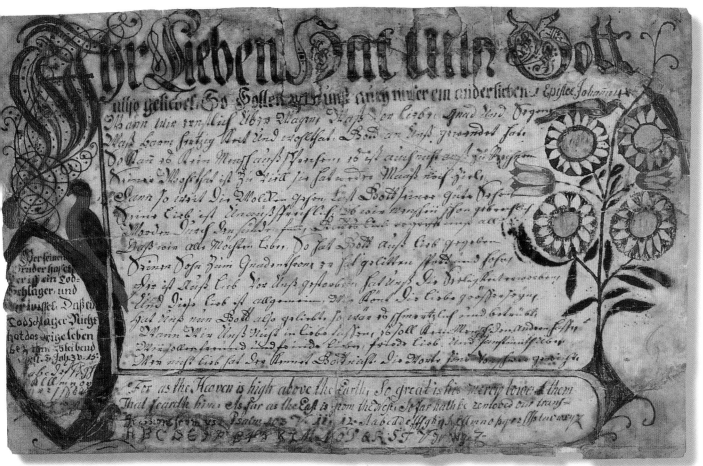

One of Dock's greatest contributions was his *Schul-Ordnung*, a teaching guide that was printed by Christopher Sauer, Jr., in 1770. Written twenty years earlier, Dock's work reveals the insight of a kind and thoughtful schoolmaster. As a teacher opposed to strict punishment, Dock proposed instead a system of rewards as incentives for good work and behavior. Schoolmaster Dock wrote that he liked to reward children by giving them a "certificate" or "a flower drawn on paper or a bird." Dock's words document the reason for the creation of a large portion of the Pennsylvania German fraktur that survives to this day. The *Vorschriften*, or handwriting examples, and the *Bilder*, or pictures (small presentation pieces), as well as the manuscript music booklets, were most frequently penned as gifts from the schoolmaster to his young pupils. In some cases it also appears that schoolmasters would purchase a quantity of books, sell copies to the parents of their students, and then personalize them by adding a colorful fraktur bookplate. As books were costly, the book and its decoration were a gift from the parents to their child; however, the schoolmaster both conceived of the gift and negotiated its purchase.

One of the earliest fraktur artists to have worked in Lancaster County, outside of the Ephrata Cloister, was a Mennonite schoolmaster and farmer named Hans Jacob Brubacher (c. 1726-1802). [3] Brubacher, like his father, Hans Jacob Brubacher (d. 1755), lived in Providence Township, Lancaster County, along the southern edge of the Pennsylvania German settlement, in Lancaster County. His fraktur production spanned fifty years, 1751-1801. His fraktur style, among the most distinctive of any Pennsylvania artist, is highly geometric in format. This could well reflect Brubacher's training at his father's weaving loom, as many Pennsylvania German weavers were masters at weaving complex geometric-patterned yardage. However, the younger Brubacher did not follow his father's craft, but instead he farmed and taught school.

Brubacher's earliest fraktur examples exhibit restrained use of color (figs. 15, 170, and 171) and convey an almost medieval sense of order and simplicity. It is likely that Brubacher ceased teaching about 1770, as his acreage had expanded and his farming was probably more profitable than was his teaching career. Of the dozen school-related frakturs, such as writing examples and presentation pieces, currently identified as Brubacher's work, all are dated between 1760 and 1769. For the next twenty years only one example of his work is known. In 1789, then his mid-sixties, Brubacher became revitalized as an artist, probably because he had turned his farming operation over to his son.

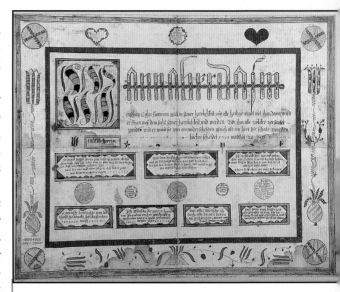

Figure 171. New Year's greeting, dated January 1, 1766, signed by Hans Jacob Brubacher (c. 1726-1802) working 1751-1801 in Providence Township, Lancaster County. This "New Year's letter," as Brubacher calls it, was presented to Maria (Bowman) Herr (1738-1815), the wife of Christian Herr (1732-1815). The capital "W" within the box begins the Biblical text of Matthew, Chapter, 25, verse 31. Directly below appears the entire text of the Lord's Prayer inside a circle measuring only one inch in diameter. *Ink and watercolor on laid paper, 14.75" x 18.5". Collection of the Lancaster Mennonite Historical Society.*

Figure 170. *Vorschrift*, dated February 1764, signed by Hans Jacob Brubacher (c. 1726-1802), working 1751-1801 in Providence Township, Lancaster County, Pennsylvania. This writing example was produced early in Brubacher's career. It contains an illumination of a Biblical text; it lacks the alphabets and numerals traditionally found on this form. Brubacher inscribed it, "This *Vorschrift* belongs to me Johannes Schenck, Jacob Brubacher." The recipient Johannes Schenck (c. 1755-1836), received a second fraktur from Brubacher thirty-five years later (fig. 172). *Ink and watercolor on laid paper, 7.75" x 9.75". Private collection.*

The fraktur that Brubacher created in his retirement years is markedly different from his earlier production. While it was still strongly geometric in format, Brubacher employed strong colors to brighten his fraktur. At this point in his life the fraktur forms that he produced were primarily New Year's greetings and large religious texts that were generally illuminations of verses from the Book of Psalms. These pieces were frequently drawn on a full sheet of paper and were given to or perhaps commissioned by Brubacher's friends and neighbors. The two examples seen in figures 172 and 173 were penned for a husband and wife, Johannes Schenck (c. 1755-1836) and Magdalena (Stauffer) Schenck (b. c.1762), who were neighbors and co-worshipers with Brubacher at the New Providence Mennonite Meetinghouse.

Figure 172. Religious text, dated March 14, 1799, signed by Hans Jacob Brubacher (c. 1726-1802), working 1751-1801 in Providence Township, Lancaster County. Fraktur produced by Brubacher after 1790 tends to be colorful. The double row of hearts appearing on this example may be unique. The text of this fraktur comprises ten verses from the Book of Psalms. The recipient was Johannes Schenck (c. 1755-1836), a prominent Mennonite farmer in Providence Township and a former student of Brubacher's (fig. 170). *Ink and watercolor on laid paper, 13" x 16". Private collection. Nathan Cox Photography.*

Figure 173. Religious text, dated September 3, 1799, signed by Hans Jacob Brubacher (c. 1726-1802), working 1751-1801 in Providence Township, Lancaster County. This bold example of Brubacher's work displays the brilliantly colored geometric formats that were favored by Brubacher on his later pieces. Brubacher copied eight verses from the Book of Psalms and inscribed the fraktur, "this letter belongs to the lawful wife of Johannes Schenck named Magdalena Schenck in the year 1799 the 3rd day of September, to God alone the glory." The recipient Magdalena (Stauffer) Schenck (b. c. 1762) was the wife of Johannes Schenck (c. 1755-1836), who received the fraktur in figure 172. *Ink and watercolor on laid paper, 12.75" x 15.25". Private collection.*

Although Brubacher's art was attractive and highly distinctive, it appears to have influenced only a few other artists. One unidentified artist who worked among the Mennonites of Conestoga Township (fig. 246) seems to have inherited his Cubist leanings.[4] The impressive fraktur portrait seen in figure 174 is believed to be an example of the work of John Moyer, who was active in the 1760s and 1770s as a schoolmaster in Tinicum and Bedminster Townships, Bucks County, Pennsylvania. This drawing is a rare example of folk portraiture on fraktur. The subject, Frederick II, King of Prussia, was a popular figure among the Pennsylvania Germans. They named taverns, and even the town of King of Prussia, in his honor. Currently little is known about the artist Moyer, but he may prove to have been an important influence on later Bucks County fraktur artists.

An artist working in Manor Township, Lancaster County, whose identity remains a mystery, has been dubbed the "Manor Township Artist." This penman created a distinctive body of fraktur between 1768 and 1804, an example of which is seen in figure 175. His compositions employ little color, and his decoration of angels, doves, and human forms is drawn in a minute scale. He produced both bookplates and birth records, of which nearly all known examples were made for his Mennonite neighbors. Although his name has been forgotten, his art was cherished for generations, and it spawned at least one nineteenth century imitator.

Figure 175. Birth record and handwriting example dated February 2, 1792, attributed to "the Manor Township artist," made for Johannes Hostetter (1787-1854). This fraktur is typical of the artist's busy and playful format. Although it is primarily a birth record, the artist calls it a *Vorschrift*, or handwriting example. This artist, who is as of yet unidentified, created a number of these birth records for his Mennonite neighbors in Manor Township, Lancaster County. *Ink and watercolor on laid paper, 7.5" x 12.25". Collection of Miriam Lefever.*

Figure 174. Fraktur portrait, c. 1763, attributed to John Moyer, schoolmaster, active 1760s and 1770s in Tinicum and Bedminister Townships, Bucks County, Pennsylvania. Possibly the artist chose to memorialize Frederick II, King of Prussia, because of his sympathetic treatment of Mennonites who had settled in Prussia. Curiously, the heart motif located in the center of the tulip appears to have a pin pricking it. Perhaps it was intended to symbolize the kind heart of King Frederick. On the reverse side of the drawing is the inscription "Abraham Landes his picture." *Ink and watercolor on laid paper, 15.75" x 12.75". Collection of the Mennonite Heritage Center, Harleysville, Pennsylvania. Nathan Cox Photography.*

Figure 176. *Scherenschnitte* or scissors cutting, c. 1795, attributed to Jacob Botz (working 1775-1805), made for Elisabeth Wissler (b. 1784) of Manor Township, Lancaster County. Botz was skilled in the delicate art of scissors cutting. *Watercolor and ink on laid paper, 7.75" x 6.25". Private collection. Nathan Cox Photography.*

Another fraktur artist who also worked in Manor Township, Lancaster County, was Jacob Botz, a schoolmaster who produced a small body of fraktur between 1775 and 1805. Most of his work has pen and ink decoration applied to elaborate scissors cuttings such as the example seen in figure 176. Although Botz's church affiliations are unknown, he lived in a rural farm community that was predominantly Mennonite; hence most of his fraktur was made for children of the neighboring Mennonite farmers.

Among the most versatile and influential fraktur artists was John Adam Eyer. A Lutheran schoolmaster from Bucks County, John Adam Eyer (1755-1837) was a highly skilled and innovative fraktur artist.[5] He began his teaching career in 1779 and for most of the next decade taught in the Mennonite schools at Perkasie and Deep Run, both located in Bucks County. Eyer is believed to have originated two important fraktur forms, the *Vorschrift* booklet and the music booklet. The latter form was immensely popular among the Franconia Mennonites (fig. 197), although not nearly as popular in the Lancaster community. Both forms were probably introduced to the Lancaster Mennonites in the winter of 1788-89 when Eyer taught at a school in Strasburg Township, Lancaster County. It was there that he penned the bookplate seen in figure 177 for a young Mennonite student named John Denlinger. In 1791 schoolmaster Christian Alsdorff created a nearly identical bookplate for a music booklet produced at the Earl School in northeastern Lancaster County,[6] and by 1797 schoolmaster Christian Strenge, teaching at East Petersburg, had also copied Eyer's form and fraktur decoration.[7] Although only eleven Lancaster County music booklets have been recorded, nearly 165 survive from the Franconia Mennonites.

Figure 177. Bookplate, dated December 22, 1788, attributed to John Adam Eyer (1755-1837) for his student Johannes Dentlinger in Strasburg Township. This bookplate was originally mounted in the front of a small manuscript music booklet, a form that Eyer introduced to the Lancaster County community when he taught in Strasburg Township in the winter of 1788-89. *Ink and watercolor on laid paper, 3.75" x 6.75". Private collection.*

Although the Cloister is credited with having produced the earliest fraktur in Pennsylvania, its art seems to have had minimal influence on later fraktur artists. Its press, however, had a profound influence on fraktur production. Beginning in the early 1780s, the Cloister Press printed a variety of birth and baptismal certificates, house blessings, and spiritual labyrinths, frequently bearing the names of their purchasers, Heinrich Otto or Heinrich Dulheuer. The bird and floral woodblock borders found on these certificates inspired a host of copyists for both printed and hand-drawn frakturs. The birth and baptismal certificate in figure 178 was ordered by Heinrich Dulheuer, an eccentric preacher and scrivener who claimed to be acting as a land agent for European Mennonites and who was seeking to purchase large tracts of land in Ohio for their eventual resettlement.

In 1784, about the time that Dulheuer was having certificates printed at Ephrata, he reported that he "was living by Peter Musselman Senior near Lancaster."[8] Peter Musselman Senior (c. 1737- after 1808) was a resident of East Hempfield Township, Lancaster County, and a Mennonite. Therefore, it is not surprising that many of Dulheuer's birth and baptismal certificates record Mennonite births, as Dulheuer was briefly living with and traveling among them, pedaling his fraktur certificates and inscribing them for the recipients. By June 15, 1786, he had left the Lancaster community and was engaged in printing a German-language newspaper in Baltimore.

One of the most highly regarded fraktur artists to have worked among the Mennonites of eastern Pennsylvania is Andreas Kolb (1749-1811).[9] Kolb was born at Skippack, Montgomery County, Pennsylvania. He was a grandson of Martin Kolb, a 1707 immigrant and a preacher at the Skippack Mennonite Meetinghouse. Andreas Kolb is believed to have attended the school that was conducted there by Christopher Dock (fig. 169). It was likely there that Kolb developed his skills in writing and fraktur art. By 1785 the bachelor Kolb was drawing fraktur and teaching school. He is known to have taught in Montgomery, northern Bucks, southern Lehigh, and Chester counties, Pennsylvania. As an artist he was unusually versatile, producing a variety of fraktur forms and employing a myriad of decorative motifs: tulips, trees, birds, hearts, angels, and even coffins (fig. 179). His art exhibits some influences from John Adam Eyer, a contemporary schoolmaster. Kolb in turn influenced a number of artists, some of whom settled in Lincoln County, Ontario.

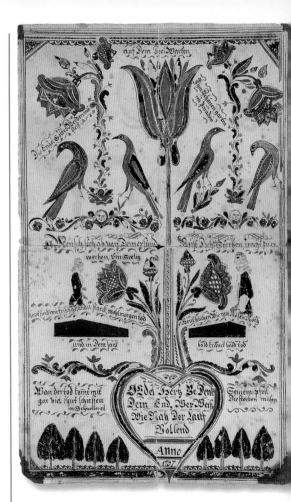

Figure 179. Teaching piece, dated 1797, attributed to Andreas Kolb (1749-1811), working c. 1784-1810 in Montgomery, Bucks, Chester, and Lehigh counties, Pennsylvania. This unusual composition includes a woman and a man, each standing above a coffin, and the following text: "The angels of God diligently watch over your soul in the beautiful garden of Paradise. Man, refrain from sinning. Prepare to die. Concern yourself with achieving a blessed end. Today we are fresh, healthy and strong, tomorrow dead and in the coffin. Today we blossom red like roses. Soon sick, soon dead. When death comes with its arrows, it shoots many and these must die quickly. Oh noble heart, think upon thy end. Who knows how soon our walk will end, Anno 1797." *Ink and watercolor on laid paper, 13.5" x 8.25". Collection of the Germantown Mennonite Corporation.*

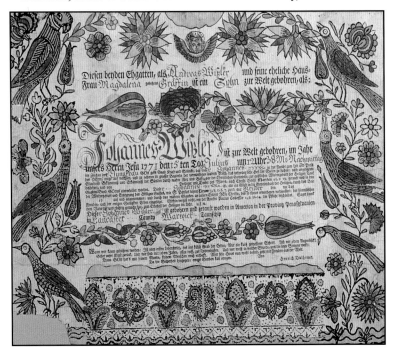

Figure 178. Birth and baptismal certificate, printed c. 1784 at the Ephrata Cloister for Heinrich Dulheuer. While the border decoration is block-printed, the hand drawn decoration that divides the text is attributed to Johann Heinrich Otto (c. 1733-99). Dulheuer added the fraktur lettering, which records the birth of Johannes Wissler on July 15, 1771, in Warwick Township, Lancaster County. He was the son of Andreas Wissler and Magdalena (Groff) Wissler. As on many Mennonites' birth certificates, no baptism is recorded, as thirteen-year-old Johannes would not receive baptism until he reached adulthood. *Ink and watercolor on laid paper, 13" x 16.50". Collection of Mr. and Mrs. John W. Wissler.*

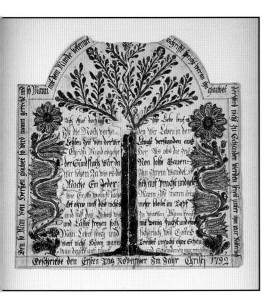

Figure 181. Religious text, dated November 1, 1792, probably by Samuel Meyer (1767-1844), working c. 1784-99 in Bucks County, Pennsylvania, and c. 1804-1830s in Lincoln County, Ontario. The gravestone-like form of this fraktur is rarely encountered but is an obvious reminder of man's mortality. The branches of the tree display two faces, Adam and Eve, while a serpent descends between them. This fraktur was likely penned in Bucks County for Anna (Bechtel) Meyer (c. 1770-1832), who had married Samuel Meyer in 1789. In 1800 they settled in Lincoln County, Ontario, where Samuel taught at the Clinton School. Ultimately, this fraktur descended to a great-great-granddaughter. *Ink and watercolor on laid paper, 7.5" x 7.5". Collection of Joanne Hoover.*

Note to the reader: there is no Figure 180.

One of the more elusive fraktur artists is Samuel Meyer (1767-1844), a Bucks County schoolmaster who is likely to have been the first Pennsylvania German to carry the fraktur tradition into Canada. Samuel was the son of Preacher Jacob Meyer (1730-78) of Hilltown Township, Bucks County, Pennsylvania, and a minister at what is now the Blooming Glen Mennonite congregation. Samuel was orphaned at the age of ten, when his parents died of yellow fever. He likely received his education at several schools. It is documented that he attended two sessions taught by John Adam Eyer.[10] Samuel left Eyer's class at Deep Run, Bucks County, in March of 1784, just after his seventeenth birthday.

Family tradition asserts that Samuel began his teaching career at age sixteen, but in all likelihood it commenced in 1784 at age seventeen. Just three months after leaving the tutelage of Eyer, Samuel executed a rather sophisticated fraktur handwriting example, probably in preparation for teaching his first school class. The *Vorschrift* is the only example signed by Meyer, and thus the only positively attributed piece. Other examples (figs. 181 and 182) can be attributed to him based on ownership and stylistic details. Another early example that I attribute to Meyer is a 1789 illuminated text drawn for Magdelena Bechtel (1773-1816),[11] a sibling (?) of Meyer's wife Anna Bechtel.

The unusual gravestone-shaped religious text seen in figure 181 is dated 1792, and it exhibits Samuel Meyer's fully developed fraktur style. Meyer's fraktur decoration bears close similarities to the work of Andreas Kolb. In 1800 Samuel and Anna Meyer left their Bucks County home for the young Mennonite settlement in Lincoln County, Ontario. There they joined Samuel's cousin, Reverend Jacob Moyer (1767-1833), and his wife Magdalena Bechtel, who had arrived the previous year. Samuel Meyer is believed to have been the earliest schoolmaster to serve the Lincoln County community, a position that he continued to fill for several decades. It's probably not a coincidence that the two earliest known Canadian fraktur examples (fig. 182) were both penned in 1804 for Magdelena Meyer (1794-1834),[12] the eldest child of schoolmaster Samuel Meyer. Both pieces are exceptional examples of his work and typify the high quality of fraktur that artists often reserved for their family members.

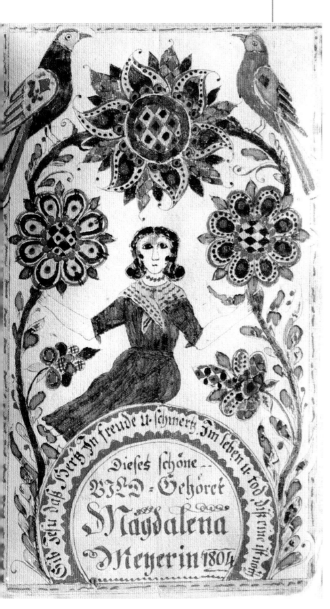

Figure 182. Presentation fraktur, dated 1804, probably by Samuel Meyer (1767-1844), working c. 1804-1830s in Lincoln County, Ontario. This fraktur, among the earliest Canadian examples known, is certainly by the same hand as figure 181. The naturalistic drawing of a young woman wearing a neckerchief is most unusual and is perhaps a portrait of the recipient, Magdalena Meyer (1794-1834), the eldest daughter of schoolmaster Samuel Meyer. This unusual fraktur may well have been a gift to celebrate Magdalena's tenth birthday. *Ink and watercolor on laid paper, 6.5" x 3.75". Collection of the Jordan Historical Museum of the Twenty, Vineland, Ontario. Photograph by Lawrence Moyer.*

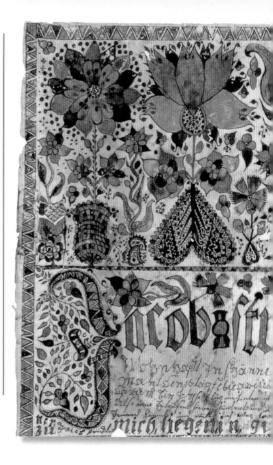

Ist is indeed ironic that one of the most important fraktur artists to work among the pacifist Mennonites was a former Hessian soldier named Christian Strenge (1757-1828). When the Revolutionary War ended, Strenge chose to settle in Lancaster County rather than return to his native Germany. He earned his living as a schoolmaster and by 1793 was teaching in a log church in East Hempfield Township.[13] Although he was a member of the German Reformed Church, most of his students were the sons and daughters of prosperous Mennonite farmers who lived in East Hempfield and the adjoining Manheim Township (figs. 145 and 183). Strenge is regarded as a master fraktur artist whose immaculate German script and fraktur art spawned several imitators.

Migrating Pennsylvania Germans in search of inexpensive lands carried their folk art traditions far beyond "Penn's Woods." By 1733 a group of fifty-one Swiss-Germans from Lancaster County, Pennsylvania, had settled in the Massanutten region of Shenandoah County, Virginia.[14] Among this group of settlers was Abraham Strickler (d. 1746). Jacob Strickler, a direct descendant of Abraham, was born in 1770 in present-day Page County, Virginia. Although it is unknown who taught Jacob Strickler the art of fraktur, in 1794 he penned the elaborate example seen in figure 184. Strickler's whimsical art is obviously a deeply personal expression. By 1801, Strickler was teaching in the community, and it is also thought that he may have served as a preacher among the Mennonites at Massanutten.

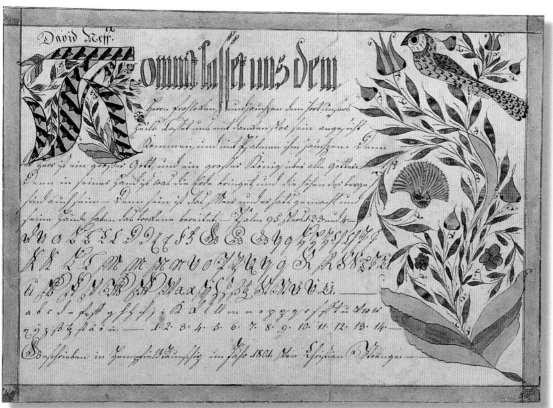

Figure 183. *Vorschrift*, dated 1801 and made for David Neff, signed by Christian Strenge (1757-1828), working c. 1787-1820 in East Hempfield Township, Lancaster County. Strenge, a former Hessian soldier, became a schoolteacher in East Hempfield Township after the end of the Revolutionary War. Although a member of the German Reformed Church, Strenge taught at a school attended largely by Mennonites, including David Neff. The distinctive bird is his signature motif. This example includes the text of Psalm 95, verses 1 through 3, as well as the upper- and lowercase alphabets and the numerals one to fourteen. *Ink and watercolor on laid paper, 7.5" x 10.5". Collection of the Heritage Center Museum, through the generosity of V. Ronald Smith.*

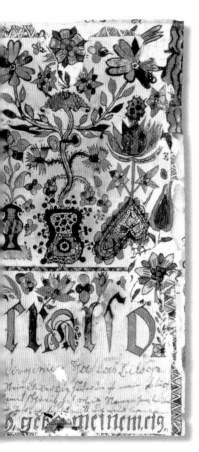

Figure 184. *Vorschrift*, dated February 16, 1794, signed by Jacob Strickler (1770-1842), working c. 1787-1815 in Shenandoah (now Page County), Virginia. Strickler is believed to have been a Mennonite preacher who penned a small but diverse group of fraktur pieces. Because of Strickler's isolation from the main body of fraktur art in Pennsylvania, his work is quirky and decidedly original. The text includes a variation of a verse that has been found on several Pennsylvania German textiles: "The paper is my field and the pen is my plow, that is why I am so clever. The ink is the seed wherewith I write my name Jacob Strickler." This photo was taken prior to restoration. *Ink and watercolor on paper, 12.25" x 16.25". Collection of Winterthur Museum.*

The large family record (fig. 185) was drawn by a presently unidentified artist who worked primarily in Manor and Conestoga Townships, Lancaster County, Pennsylvania. He has been called the "Johannes Schopp Artist," and most of his work, consisting of small presentation pieces and birth records, was produced in the 1790s. The family record that is illustrated is unusual because of its size, which well exceeds the standard 13-by-16-inch sheet of paper. On this example, the artist recorded the birth of the husband, Abraham Miller, in the large heart on the left. His wife Barbara Havecter is on the right. Their clasped hands, representing their marriage, appears in the intersection of the two hearts. Abraham's arm leads upwards to a sheaf of wheat, symbolizing his trade, that of a grist miller. The couple's children appear in the smaller hearts. The undulating floral vines and soft color palette are typical of this artist's work. The Miller family were Mennonites, as were most, if not all, of this artist's clientele.[15]

Figure 185. Family record, c. 1800, attributed to "the Johannes Schopp Artist" (active c. 1790-1802) for the family of Abraham Miller (b. 1756) and Barbara (Havecter) Miller (b. 1758), both born in Manor Township, Lancaster County. The sheaf of wheat at the top of the piece represents Abraham Miller's occupation, that of a grist miller. *Ink and watercolor on laid paper, 17.5" x 17.5". Collection of Eugene and Vera Charles.*

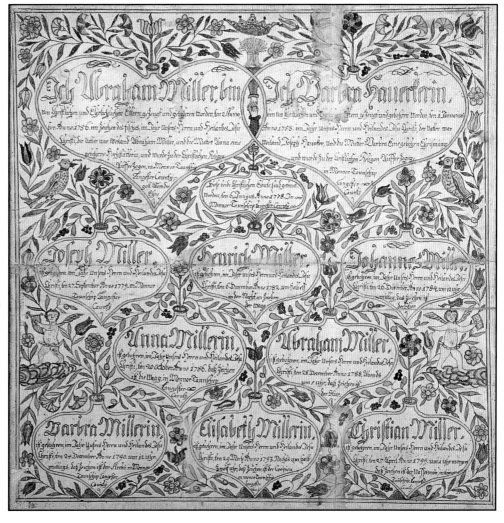

For years, one of the great masters of fraktur art was known only as "the Earl Township Artist." He was eventually identified as Christian Alsdorff (c. 1760-1838), a schoolmaster who taught in schools in East Earl and East Hempfield Townships, Lancaster County, Pennsylvania, and in New Hanover Township, Montgomery County and Lower Paxton Township, Dauphin County, Pennsylvania.[16] Alsdorff, who wrote only in German, wrote in a steady, flowing script. His fraktur letters are so heavily embellished that they are frequently difficult to read. His fraktur decoration is rich and diverse (figs. 186-189) and owes much to the influences of the brothers John Adam (fig. 177) and John Frederick Eyer.

Figure 187. *Vorschrift* booklet, dated October 30, 1792, attributed to Christian Alsdorff (c. 1760-1838), working 1790-1824. These pages were originally stitched between paper covers to form a booklet. The inscription within the circle reads: "This writing example note booklet belongs to Peter Guh (Good) outstanding writing student in the Earl School in Lancaster County the 30th of October, 1792." Alsdorff was an accomplished artist and scrivener. On this piece he borrowed the flower within the star motif and the gentleman in colonial garb from John Adam Eyer, a contemporary schoolmaster who greatly influenced Alsdorff's art. *Ink and watercolor on laid paper, 7.75" x 12.75". Collection of the Rothman Gallery, Franklin and Marshall College.*

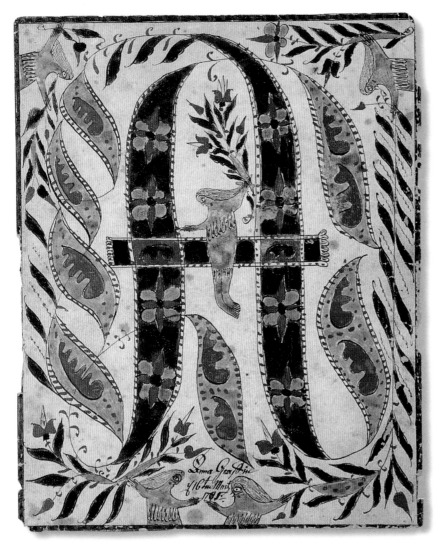

Figure 186. Fraktur drawing, dated Mar. 16, 1791, attributed to Christian Alsdorff (c. 1760-1838), working 1790-1824. This piece was made in West Earl Township, Lancaster County, for Anna Groff (b. 1780), daughter of a wealthy Mennonite farmer, Marx Groff (1757-1827), and his wife Feronica Meyer. One of Alsdorff's earliest and most original creations, this drawing is an illumination of the letter "A" surrounded by a host of female angels. Two years later Anna also received a *Vorschrift* booklet from her schoolmaster, Christian Alsdorff. Her cross-stitched thread case can be seen in figure 258. *Ink and watercolor on laid paper, 7.5" x 6.25". Collection of the Lancaster Mennonite Historical Society.*

Although it isn't known whether Alsdorff was a Mennonite, it appears that more than ninety-five percent of his fraktur art was produced for Mennonite friends and students. It is curious to note that the two earliest dated frakturs attributed to Alsdorff were penned for the children of two wealthy Mennonite farmers who resided on adjoining farms near Farmersville, West Earl Township.[17] Perhaps it was Joseph Horst (1723-1804) and his neighbor Marx Groff (1757-1827) (fig. 186) who first brought Alsdorff to the Mennonite community to instruct their children and grandchildren.

Figure 188. Bookplate, dated May 18, 1793, attributed to Christian Alsdorff (c. 1760-1838), working 1790-1824. This bookplate was penned in Earl Township, Lancaster County, for Abraham Martin as a gift from his father. It was tipped into a 1785 *Ausbund*, a book of Anabaptist martyr hymns. The Martin family carried it along to Waterloo County, Ontario, c. 1820. *Ink and watercolor on laid paper, 6.5" x 4". Private collection.*

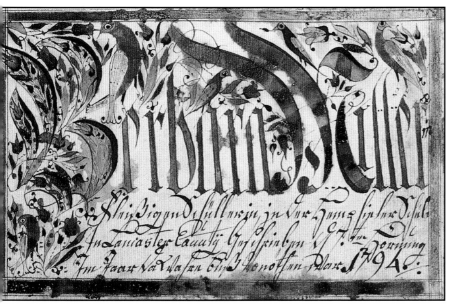

Figure 189. Manuscript music booklet, dated February 7, 1794, attributed to Christian Alsdorff (c. 1760-1838), working c. 1792-96 in East Hempfield Township, Lancaster County. Drawn for Barbara Miller, "an outstanding student in the Hempfield School," this music booklet is a form that Alsdorff borrowed from a contemporary schoolmaster, John Adam Eyer. This bookplate is followed by nine pages of handwritten music (fig. 190). *Ink and watercolor on laid paper, linen tape, 3.75" x 6.5". Collection of Eugene and Vera Charles.*

About 1805 Alsdorff left his East Earl Township home and purchased a farm in Lower Paxton Township, Dauphin County, Pennsylvania. Here he taught school, as evidenced by several surviving *Vorschriften.* In 1810 Alsdorff, with his wife and children, relocated to Buffalo Township, Perry County, Pennsylvania, and in 1821 they moved northward to Walker Township, Juniata County, Pennsylvania. It was in Juniata County that Alsdorff spent the last seventeen years of his life. It is unlikely that he taught school during this period, but a small quantity of his fraktur birth records has been recorded. These were penned for members of the Weber, Stauffer, and Shirk families, all Mennonite families that had relocated to Juniata County from the Earl Township region in Lancaster County where Alsdorff had begun his teaching career decades earlier.

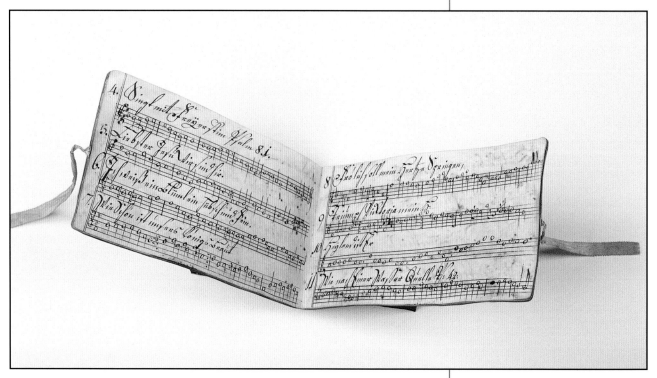

The finely detailed and colorful frakturs created by Alsdorff between 1790 and 1824 served as inspiration for several Lancaster County and Canadian artists. The style of his popular handwriting examples continued to inspire imitators as late as 1852, when David Weaver (fig. 219) penned a pair of *Vorschriften* that mimicked the format and bird and floral decoration that had been in use by Alsdorff fifty years earlier. It is a tribute to a beloved schoolmaster and the enduring appeal of his brilliant fraktur art.

The most prolific Mennonite fraktur artist to have worked in the Lancaster community was a schoolmaster named Abraham Brubaker. He was born in Conoy Township, Lancaster County, in 1760, the son of the late John Brubaker (c. 1732-60). By 1789 he was teaching at a school kept at the Mellinger Mennonite Meetinghouse, where he penned a *Vorschrift* written largely in English. The use of English was unusual on eighteenth century fraktur from the Lancaster region; however, Brubaker's classroom was located a short distance east of Lancaster Borough along the King's Highway (Lincoln Highway), the main road to Philadelphia. It was probably considered necessary that his students learn English, as many of their fathers owned horse teams and Conestoga wagons, and regularly traveled to Philadelphia.

Figure 190. Interior of music booklet, dated February 7, 1794, attributed to Christian Alsdorff (c. 1760-1838), working 1790-1824. Schoolmasters such as Alsdorff were expected to teach singing in addition to reading, writing, and arithmetic. The music booklet was an extremely popular form among the Franconia Mennonites; in Lancaster County it was rarely produced. The fraktur bookplate for this piece can be seen in figure 189. *Ink and watercolor on laid paper, 3.75" x 13". Collection of Eugene and Vera Charles.*

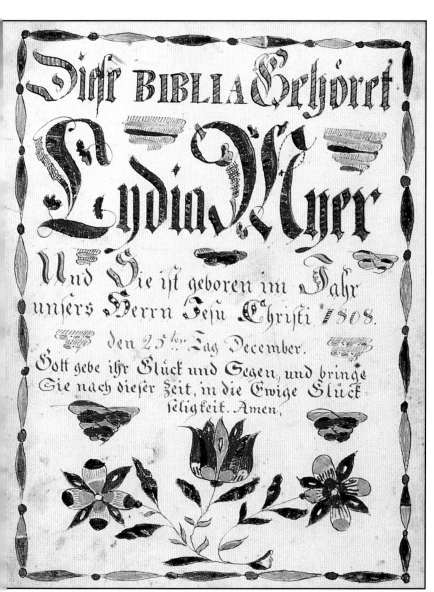

Figure 191. Bookplate and birth record, c. 1820-25, attributed to Abraham Brubaker (1760-1831), working c. 1789-1829 in East Lampeter and Upper Leacock Townships, Lancaster County. This bookplate was originally mounted in a large family Bible that was presented to Lydia Myer. It records her birth on December 25, 1808. Among the Mennonites, particularly in Lancaster County, fraktur bookplates often doubled as birth records. They were frequently presented to teenage children by their parents or grandparents. *Ink and watercolor on wove paper, 12" x 9". Private collection.*

Figure 192. *Vorschrift*, dated June 20, 1826, attributed to Abraham Brubaker, working c. 1789-1829 in East Lampeter and Upper Leacock Townships, Lancaster County. This writing example was executed for John Downer (Dohner) of East Lampeter Township, who likely attended the school taught by Brubaker at Mellinger Mennonite Meetinghouse just east of Lancaster Borough. Brubaker frequently used English on his fraktur. On his later examples he typically employed yellow as the predominant color, replacing the mottled brick orange and olive greens of his earlier production. *Ink and watercolor on wove paper, 7.25" x 12.25". Collection of the Rothman Gallery, Franklin and Marshall College.*

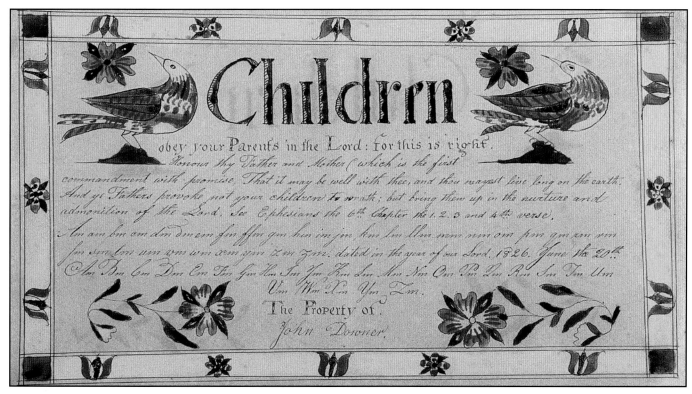

Brubaker's identity as an artist had remained a mystery for many years, with his earlier production being attributed to "the Huber Artist." Later examples were attributed to John Landis. It was David Johnson, a scholar researching Lancaster County schoolmasters, who finally pieced together the biography of Brubaker, and who recognized the scope of his work. To complicate matters, Brubaker's earliest fraktur was decorated using clear strong colors—reds and blues. Late in the 1790s his color palette shifted to favor more somber colors—olive, browns, and brick colors, all with an applied glazing that presented a mottled appearance. Late in Brubaker's career he returned to the stronger colors he had once favored, but now with a penchant for the color yellow (figs. 192 and 193).

Brubaker's teaching career spanned forty years. In addition to teaching in East Lampeter Township, Brubaker also taught in Upper Leacock Township, Lancaster County, where his students included both Amish and Mennonite children. After his death in 1831, Brubaker was buried in the Mellinger Mennonite Cemetery in East Lampeter Township, Lancaster County. For a few years after Abraham Brubaker's death, someone in the community, perhaps a son, continued to make some fraktur that closely copied Brubaker's color and decoration.[18]

Another Mennonite schoolmaster who was a contemporary of both Alsdorff and Brubaker was a former weaver named David Meyer (before 1758-after 1824). Meyer operated a weaving shop at his one-and-a-half-story log house, which still stands along Lititz Pike in Manheim Township, Lancaster County, Pennsylvania. Beginning in 1794 he is listed as a schoolmaster, a trade that he would follow for thirty years. Despite Meyer's long tenure as schoolmaster, only about a half-dozen examples of his fraktur have been recorded.[19] All of his recorded examples are rather sparsely decorated *Vorschriften* (fig. 194). His simple floral borders were inspired by the work of Christian Strenge and Abraham Brubaker.

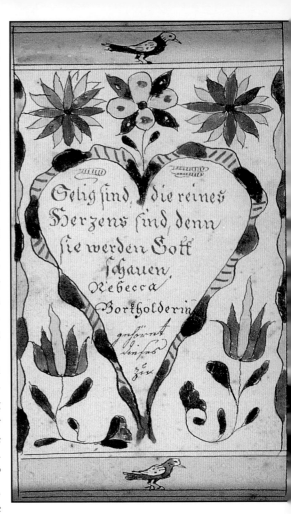

Figure 193. Presentation piece, c. 1828-30, attributed to Abraham Brubaker (1760-1831), working c. 1789-1829 in East Lampeter Township and Upper Leacock Townships, Lancaster County. Brubaker was nearly seventy when he penned this small presentation fraktur for Rebecca Burkholder. In 1828 she received a copybook by Brubaker's hand, and in 1829 he executed three bookplates for other Burkholder children. These are some of the last fraktur produced by Abraham Brubaker. *Ink and watercolor on wove paper, 5.75" x 3.25". Private collection.*

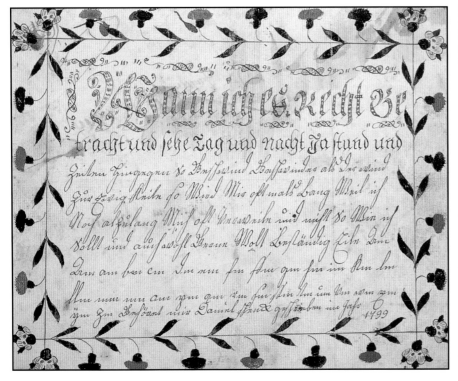

Figure 194. *Vorschrift*, dated 1799, attributed to David Meyer (bef. 1758 c. - aft. 1824), working 1794-1824 in Manheim Township, Lancaster County. This simply decorated religious text was penned by schoolmaster Meyer for his student Daniel Schenck (b. c. 1791), the son of Christian Shenk (1756-1804), a Mennonite and a wealthy farmer in Manheim Township. Meyer's fraktur decoration was typically limited to simple floral vine borders. *Ink and watercolor on laid paper, 6.25" x 73.75". Collection of the Lancaster Mennonite Historical Society.*

Mennonite Bishop Jacob Gottschall (1769-1845) is believed to have served as a schoolmaster in Franconia Township, Montgomery County, Pennsylvania, prior to his ordination to the ministry in 1804. Although only a few fraktur have been attributed to him, the example seen in figure 195 displays Gottschall's steady hand and immaculate script. As a decorator he pales when his work is compared to the vibrant creations of his sons, Martin and Samuel Gottschall (figs. 213-215).

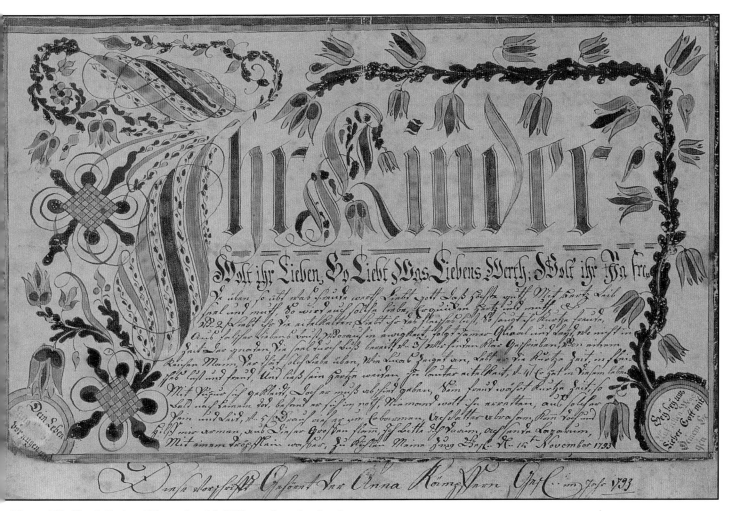

Figure 195. *Vorschrift*, dated November 15, 1793, attributed to Jacob Gottschall (1769-1845), working 1792-93 in Franconia Township, Montgomery County, Pennsylvania. This *Vorschrift*, executed for Anna Kemperer at the Skippack School, is of a typical format used by many fraktur artists working in the Franconia region of eastern Pennsylvania. Jacob Gottschall taught school prior to being selected as a preacher and bishop in the Mennonite Church. Although he was a highly skilled penman, he seems to have created few frakturs. *Ink and watercolor on laid paper, 7.75" x 12.75".* *Collection of the Mennonite Heritage Center, Harleysville, Pennsylvania. Nathan Cox Photography.*

David Kulp (1777-1834), who worked as a schoolmaster in Bedminster, Hilltown, and Plumstead Townships, Bucks County, Pennsylvania, was a fine penman and a highly skilled decorator. His work was previously attributed to the "Brown leaf artist."[20] Kulp taught c. 1801-1818 and produced a substantial number of manuscript music booklets, bookplates, and small presentation pieces (figs. 196-198). All of his fraktur art is flawlessly executed with myriad tiny brown leaves that were his trademark. His style of decoration is closely related to the work of Rudolph Landes (fig. 199), who may well have studied under David Kulp. Kulp had been a student of the master fraktur artist John Adam Eyer (1755-1837). In addition to teaching school, Kulp also practiced the weaving trade. He continued to follow weaving and farming after his c. 1820 retirement from the classroom. David Kulp and his wife Mary (Landis) Kulp (1789-1872) both repose in the Deep Run Mennonite Cemetery.

Figure 197. Bookplate, dated February 5, 1815, attributed to David Kulp (1777-1834), working c. 1801-18 in Bucks County, Pennsylvania. This bookplate is mounted in a manuscript music booklet handwritten by Kulp for Sarah Oberholtzer, a "singing scholar in the Deep Run School," in Bedminster Township, Bucks County, Pennsylvania. The style of the bookplate relates closely to examples that were penned earlier by John Adam Eyer, Kulp's schoolmaster. *Ink and watercolor on laid paper, 4.25" x 7.75". Collection of the Mennonite Heritage Center, Harleysville, Pennsylvania. Nathan Cox Photography.*

Figure 196. Bookplate, dated February 7, 1814, attributed to David Kulp (1777-1834), working c. 1801-18 in Bedminster, Hilltown and Plumstead Townships, Bucks County, Pennsylvania. This bookplate was drawn for Jacob Kolb and exhibits the "brown leaves" and exacting symmetry that characterized his work. *Ink and watercolor on laid paper, 6.75" x 3.75". Collection of the Mennonite Heritage Center, Harleysville, Pennsylvania. Nathan Cox Photography.*

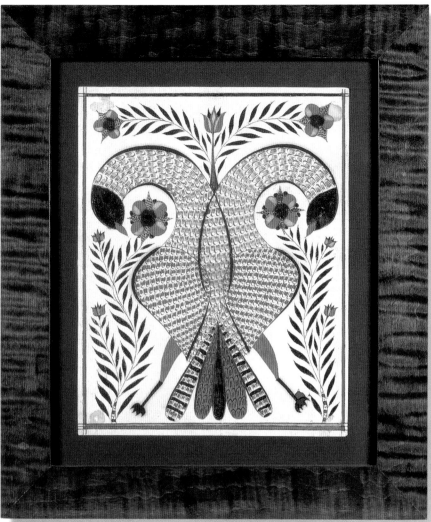

Figure 198. Fraktur drawing, c. 1810, attributed to David Kulp (1777-1834), working c. 1801-18 in Bucks County, Pennsylvania. This exceptionally vibrant depiction of a double-headed bird is a masterpiece of Kulp's fraktur art. Although the motif is uncommon in Pennsylvania German folk art, it was widely used in Germanic regions of Europe. *Ink and watercolor on laid paper, 7.75" x 6.5". Photograph courtesy of Christie's Images.*

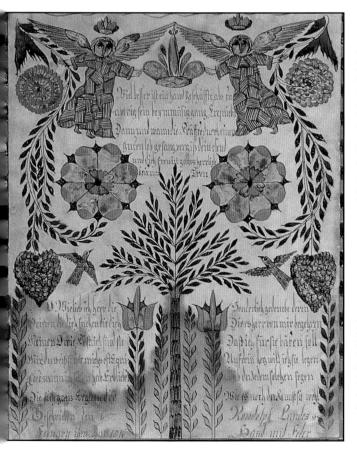

Only a few fraktur are known to have been created by Rudolph Landes (1789-1852), a schoolmaster who taught at schools in Hilltown and New Britain Townships, Bucks County, Pennsylvania, from 1812 to 1818. Landes was named for his grandfather, Rudolph Landes (1732-1802), the wood turner (figs. 81 and 82) who worked in Bedminster Township, Bucks County. The religious text seen in figure 199 is a masterful example of Landes' careful fraktur art. Although his work is quite similar to the fraktur of David Kulp, Landes' designs are less rigid, and he seems to have been more adventuresome as an artist.

Figure 199. Religious text, dated February 6, 1816, signed by Rudolph Landes (1789-1852), working c. 1814-16 in Hilltown and Bedminster Townships, Bucks County, Pennsylvania. Landes's fraktur art closely resembles the work of David Kulp, a contemporary schoolmaster who may well have instructed Rudolph Landes. *Ink and watercolor on woven paper, 9.5" x 7.5". Collection of the Heritage Center Museum.*

The majority of small presentation frakturs were prepared by schoolmasters who then presented them to their deserving scholars. A few examples were given from one student to another student, or even exchanged among relatives (fig. 201). This colorful drawing was a present from Jacob Klemens to his cousin, Catharina Hunsberger. If Klemens was the artist, he possessed a steady and skilled hand. It was also possible that he commissioned a schoolmaster to create the drawing for a favorite cousin. The drawing seen in figure 202 was presented to Henry Letterman from Bedminster Township, Bucks County, c. 1830, quite likely as a gift from his schoolmaster. Both of these fraktur examples are representative of the high quality of fraktur art that was still being produced by Mennonites in Bucks County well into the second quarter of the nineteenth century.

The bookplate seen in figure 200 was penned in the conservative Mennonite community of the Weaverland Valley in East Earl Township, Lancaster County. The artist currently is known as "the Weaverland Artist." He produced a small group of bookplates, religious texts, and at least one *Vorschrift*, all dating 1822-24. His fraktur art is closely related to the work of Abraham Latschaw (1799-1870), the fraktur artist (fig. 97) who had recently settled in Waterloo County, Ontario. This suggests that "the Weaverland Artist," like Latschaw, was likely trained in the Eastern Berks County, Pennsylvania, region. His bookplates most often appear in the 1820 edition of the Lancaster Mennonite hymnal, *Unpartheyisches Gesang=Buch*. The artist favored hearts, stars, and songbirds on his colorful bookplates.

Figure 200. Bookplate, dated 1823, made by an anonymous artist called "the Weaverland Artist," working c. 1822-24, in Earl or East Earl Township, Lancaster County, Pennsylvania, for Barbara Martin. Working briefly among the Mennonite families of the Weaverland Valley, this artist penned a small group of similar bookplates. In the vast majority of fraktur examples, their decoration is largely unrelated to their text. But this artist encircled his star motif with a text relating to the morning star and flanked his paired birds with a verse concerning the morning songs of the little birds. *Ink and watercolor on wove paper, 7.5" x 4". Private collection.*

Figure 201. Presentation fraktur, dated 1825, by an anonymous artist, inscribed, "This beautiful picture which I received as a gift from my cousin Jacob Klemens, belongs to me Catharina Hunsberger in Hiltaun 1825." The artist, working in Hilltown Township, Bucks County, Pennsylvania, created a lively composition that is reminiscent of the work of Andreas Kolb (1749-1811). *Ink and watercolor on wove paper, 7" x 8". Collection of the Mennonite Heritage Center, Harleysville, Eastern Pennsylvania. Nathan Cox Photography.*

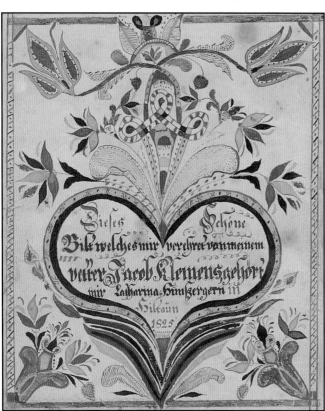

Figure 202. Fraktur drawing, c. 1830, by an anonymous artist working in Bedminster Township, Bucks County, Pennsylvania. The recipient of this drawing, Henry Letterman, likely received these colorful birds from his schoolmaster. *Ink and watercolor on wove paper, 6.5" x 7.25". Collection of the Mennonite Heritage Center, Harleysville, Pennsylvania. Nathan Cox Photography.*

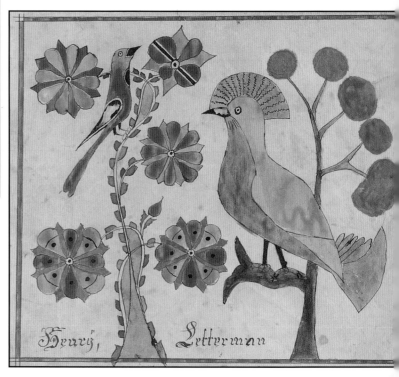

The fraktur seen in figures 203 and 204 are the work of Carl Fredrich Seybold, an immigrant schoolmaster who arrived in Philadelphia on December 11, 1806, on the ship *Fair American*. Seybold initially taught school in Northampton County, Pennsylvania, but later moved to Lancaster County. Schoolmaster Seybold was frequently called upon to record births and deaths in Mennonite family Bibles (fig. 203). He also penned a number of Mennonite birth records (fig. 204). Most follow the format of this example, which was certainly inspired by the decorations found on the cast-iron jamb stoves that were produced in southeastern Pennsylvania in the 1750s. It is easy to imagine Seybold as a poor schoolmaster, living in a tenant house in Manor Township, with an outdated five-plate stove in his stove room. He sits on the corner bench at the table, carefully drawing his fraktur birth certificates. Taking his inspiration from the molded decoration of the five-plate stove, he borrows the striped columns, the arch, the tulips, the circular and heart forms, and the swag with tassel. Although the stove and its decoration are relics of the German Baroque taste of mid-eighteenth century Pennsylvania, Seybold's resulting fraktur was rather contemporary for the mid-1830s, when it was created. The Greek Revival style was popular in architecture, furniture, and other decorative arts of the period. Fraktur art was not immune to popular trends in design (fig. 218), as Seybold, Samuel Bentz, and other artists of the period frequently employed architectural formats with classical design elements in their fraktur drawings. While it was clear that earlier Seybold was not a Mennonite, and in fact had aspired to join Frederick Rapp's Harmonist Society in Beaver County, Pennsylvania,[21] once in Lancaster County he settled comfortably among the Mennonites of Manor Township, perhaps even joining their denomination.

Figure 203. Family Bible record, c. 1835 and 1844, attributed to Carl Frederich Seybold (active c. 1820-46) for the family of Martin R. Mayer (1798-1873) and Elizabeth (Mosser) Mayer of Manheim Township, Lancaster County. The architectural format is typical of Seybold's work. Each heart encloses a birth record of one of the Mayer children. Seybold recorded the couple's baptism in 1823, the year following their marriage. He also noted Martin Mayer's ordination as a minister for the Mennonite congregation at Landis (the Landis Valley Meetinghouse). The Martin Mayer family lived in the 1797 David Mayer house seen in figure 31. *Ink and watercolor on wove paper, 15.50" x 9.50". Collection of the Lancaster Mennonite Historical Society.*

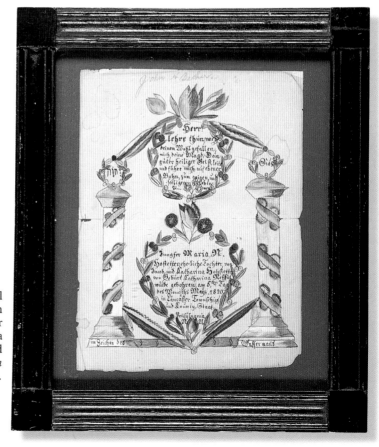

Figure 204. Birth record, c. 1835, attributed to Carl Frederich Seybold, for Maria N. Hostetter, born May 5, 1820, in Lancaster Township, Lancaster County. This fraktur was likely presented to Maria during her teen years by her parents, Jacob and Catherine (Neff) Hostetter. *Ink and watercolor on wove paper, 10" x 8". Private collection.*

The colorful presentation fraktur seen in figure 205 is an exceptional example of the work of David Herr (1771-after 1828). Herr worked as a schoolmaster in Strasburg Township, Lancaster County, where he penned a small number of fraktur drawings. Most of his examples are centered around a large bird perched on a branch. He typically signed his fraktur by placing his initials "D" and "H", on either side of the drawing, concealed in foliage. The illustrated example is dated 1828, and is the only dated example known.

The work of David Herr was obviously a source of inspiration for the artist who penned the presentation fraktur seen in figure 206. This artist is believed to be Christian S. Herr (1812-80) of Lancaster Township, Lancaster County. Herr may well have taught school prior to his ordination as a Mennonite minister in 1842. Although this example bears only initials, other examples survive that include his full name. The Herr family name is quite common in Lancaster County, and the two artists, David and Christian Herr, were not closely related. There does appear to have been a connection between the two men, however, as a David Herr drawing descended through the Christian S. Herr family and remains in their possession.

Figure 206. Presentation fraktur, dated 1834, attributed to Reverend Christian S. Herr (1812-80), working in Manor Township, Lancaster County. This drawing was presented to nine-year-old Joseph Charles (1825-99), the son of John and Fannie (Witmer) Charles. Obviously inspired by the work of David Herr (fig. 205), this curious drawing features a female form facing what appears to be a body wrapped in a shroud, having a timepiece for a face. A none-too-subtle reminder of the brevity of life. The artist's initials "CH" appear along the left border. *Ink and watercolor on wove paper, 5" x 7.5". Private collection.*

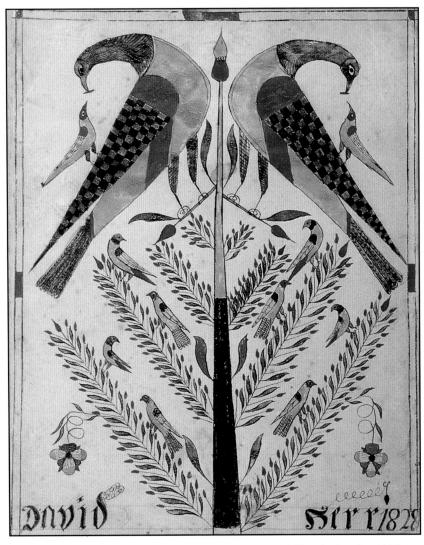

Figure 205. Fraktur drawing, dated 1828, signed by David Herr (1771-after 1828), working c. 1820s in Strasburg Township, Lancaster County, Pennsylvania. Schoolmaster Herr penned a small group of bird drawings that were likely intended as gifts for his young students. This bird tree drawing, perhaps his most outstanding example, boasts a dozen birds. *Ink and watercolor on wove paper, 7.5" x 6.25". Collection of Dr. and Mrs. Donald M. Herr.*

While many fraktur artists are known by only a few examples of their work, and obviously were only briefly active as artists, others enjoyed long and productive careers that allowed their art to flourish and evolve. In some instances their early works bear little resemblance to their later efforts. Isaac Z. Hunsicker (1803-70) is an excellent example of an artist whose fraktur changed with the times. Hunsicker was born in Montgomery County, Pennsylvania. He penned the skillfully drawn *Vorschrift* (fig. 207) in 1830. This handsome piece conforms stylistically to the *Vorschriften* that had been widely produced in the Franconia region since the 1750s.

Figure 207. *Vorschrift*, dated 1830, signed by Isaac Z. Hunsicker (1803-70), working c. 1820s-1868, in Montgomery County, Pennsylvania, and Waterloo County, Ontario. Isaac Hunsicker was a schoolmaster and accomplished fraktur artist who taught among the Mennonites in Montgomery County, where he executed this handwriting example. He was a fastidious penman who continued to produce fraktur long after he relocated to Ontario (fig. 208). *Ink and watercolor on wove paper, 8.25" x 13.25". Collection of the Mennonite Heritage Center, Harleysville, Pennsylvania. Nathan Cox Photography.*

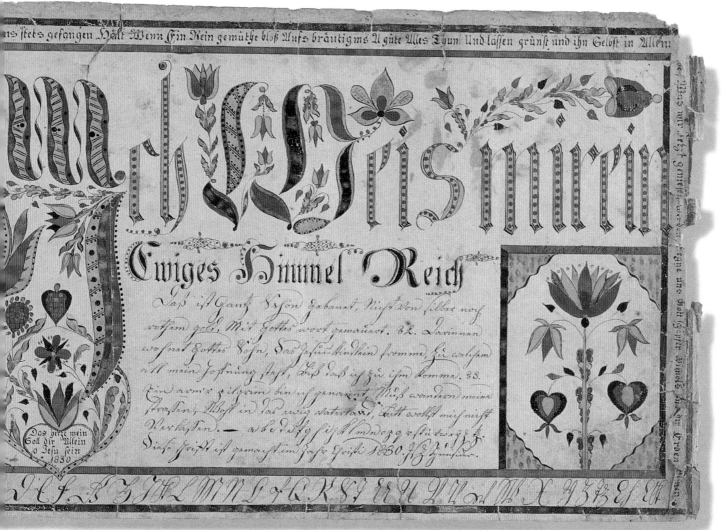

Figure 208. Motto, dated 1861, signed by Isaac Z. Hunsicker (1803-70), working c. 1820s-1868, in Montgomery County, Pennsylvania, and Waterloo County, Ontario. The motto is inscribed "live piously and virtuously" and was inspired by continental German prototypes. Hunsicker created this example in Berlin (Kitchener), Ontario. Although superbly executed, it bears little similarity to frakturs that he drew in Pennsylvania decades earlier (fig. 207). *Ink and watercolor on wove paper 11.75" x 12.25". Collection of the Joseph Schneider Haus, Kitchener, Ontario.*

Within a few years after producing this fraktur, schoolmaster Hunsicker moved northward, settling in Waterloo County, Ontario. Here he found employment as a schoolmaster, continuing to teach and draw fraktur. The fraktur he drew did not include the *Vorschrift*, whose popularity was already rapidly fading in Pennsylvania. The availability of printed copybooks and the institution of the Pennsylvania public school system in 1834 quickly ushered in the end of the era of school-related fraktur. Although numerous *Vorschriften* were carried to both the Niagara Peninsula and Waterloo settlements by emigrating Mennonite families, the form seems to have seldom been produced in the Canadian settlements.

In his first few years in the Waterloo settlement, Hunsicker penned birth records and bookplates that were embellished with some of the traditional fraktur art that was popular in his Pennsylvania homeland. Hunsicker is perhaps unique among fraktur artists, for although he left Pennsylvania in the early 1830s he continued to visit his home community, and he produced numerous bookplates for his relatives and former neighbors in Montgomery County.[22] The fraktur that Hunsicker created after 1860 was markedly different from his earlier production (fig. 208). Gone were the traditional stylized floral decorations. Instead, Hunsicker employed geometric-patterned borders that mimicked the borders of printed broadsides. However, all of his work was still executed in his nearly flawless fraktur lettering. The illustrated motto (fig. 208) was inspired by a continental prototype. The anthropomorphic lettering demonstrates Hunsicker's great skill and artistic flair. Only the tiny faces peering from the four corners of the piece are reminiscent of the fraktur of Hunsicker's Montgomery County, Pennsylvania, homeland.

The Bucks County Mennonites who settled on the Niagara peninsula in Lincoln County, Ontario, carried with them the rich fraktur traditions of their Bucks County schools. The quantity and quality of their fraktur production is unmatched by the other Pennsylvania German settlements in Ontario. The presentation fraktur seen in figure 209 was drawn by an anonymous artist who was probably teaching at the Clinton School in Lincoln County, Ontario, in 1833. Although this fraktur is closely related to the work of Samuel Meyer (fig. 182), it also relates to even earlier works by John Adam Eyer and Andreas Kolb. The bold graphics and brilliant colors declare it to be equal with the best of Pennsylvania frakturs and demonstrate that the fraktur tradition not only survived but thrived in its adopted Canadian homeland.

Figure 209. Presentation fraktur, dated 1833, by an anonymous artist, working at the Clinton School in Lincoln County, Ontario. The inscription reads as follows: "This picture belongs to Rebecca Moyer, Clinton Canada 1833." The bold graphics of this colorful fraktur are reminiscent of earlier Canadian examples as well as prototypes from Bucks County, Pennsylvania. *Ink and watercolor on wove paper, 9" x 7". Collection of the Joseph Schneider Haus, Kitchener, Ontario.*

The drawing appearing in figure 210 is one of a nearly identical pair that were owned by Peter Guth (Good) and his wife Catharina (Zimmerman) Guth (1810-1893). Although the artist is unidentified, it is tempting to think that it might be the work of Christian Good (1779-1838), a Mennonite preacher in their district who reportedly gave fraktur baptismal certificates to the young people who received his instruction and baptism.[23] In 1834 the Goods had been married for two years and were at a point in life at which many young Mennonites typically made the decision to join their church. The resulting frakturs possess strong and unusual graphics, consisting almost entirely of tulips and *Schesstern* (hex signs). The recipients, Peter and Catharine Good, are buried at Lichty's Mennonite Cemetery in Caernarvon Township, Lancaster County.

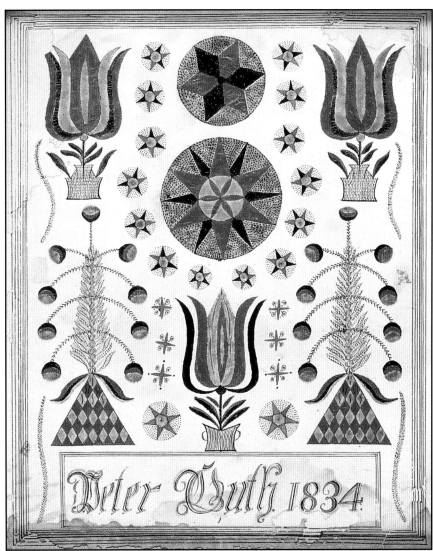

Figure 210. Presentation fraktur, dated 1834, by an unknown artist probably working in Brecknock Township, Lancaster County, made for Peter Guth (Good) (1800-63). This bold and graphic drawing is one of a nearly identical pair drawn for Peter and Catharina (Zimmerman) Guth, two years after their marriage. Perhaps the artist was Christian Good (1779-1838), a local Mennonite preacher, remembered for making certificates for the young people whom he baptized and who were received as members in the church. Peter Guth, the recipient, became a shopkeeper and founder of the town of Goodville in eastern Lancaster County. *Ink and watercolor on wove paper, 10" x 8". Collection of Mr. and Mrs. Richard Flanders Smith.*

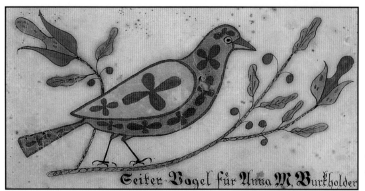

Figure 211. Presentation fraktur, c. 1835, attributed to Jacob Nolt (1798-1852), active 1834-37 in West Earl Township, Lancaster County, Pennsylvania. Jacob Nolt, a farmer and a member at Metzler's Mennonite Meetinghouse, created a small group of exotic bird drawings for young children in his community. This drawing he inscribed in fraktur lettering, "a cider bird Anna M. Burkholder." *Ink and watercolor on wove paper, 4" x 7.5". Collection of the Lancaster Mennonite Historical Society.*

Figure 213. Bookplate, dated 1834, attributed to Samuel Gottschall (1808-98), active c. 1834-35, in Franconia Township, Montgomery County, Pennsylvania. The bachelor miller and farmer Samuel Gottschall created a small group of brilliantly decorated fraktur. This bookplate he penned for his own copy of *Zions Harfe.* It is inscribed, "This songbook belongs to me Samuel Gottschall, written in the year 1834." *Ink and watercolor on laid paper, 6.25" x 3.5". Collection of the Mennonite Heritage Center, Harleysville, Pennsylvania. Nathan Cox Photography.*

While the vast majority of fraktur was produced by schoolmasters and itinerant artists, a far smaller group of examples was penned by farmers or tradesmen. These few individuals did not draw fraktur for financial gain or because it related to their field of work. Instead, their fraktur art was drawn and given just for the pleasure of it. Perhaps it is their art that represents the purest form of fraktur folk art: an untrained artist, unmotivated by financial gain, occasionally creating his or her art for the pleasure that it provides.

The whimsical bird drawings seen in figures 59, 211, and 212 are the creations of just such an artist. Jacob Nolt (1798-1852) was a prosperous Mennonite farmer who owned a 100-acre farm along the banks of the Conestoga River in West Earl Township, Lancaster County. He was the son of Jonas and Magdalena (Buckwalter) Nolt of West Earl Township. Jacob married Barbara Hurst (1806-81), the daughter of Christian Hurst, Jr., who moved to Stark County, Ohio, in 1837. Jacob and Barbara Nolt raised a family of eleven children and attended Metzler's Mennonite Meetinghouse. For some reason Jacob Nolt, a thirty-six-year-old farmer with a growing family, became motivated to create a group of bird drawings for young relatives and neighborhood children. A descendant recalled that he had penned them during a period of illness. Dated examples are recorded from 1834 to 1837, when his fraktur "binge" ceased as quickly as it had started.

Figure 212. Presentation fraktur, dated 1836, attributed to Jacob Nolt (1798-1852), active 1834-37 in West Earl Township, Lancaster County. On this lively example the artist printed his own name in on English style lettering and decorated the birds using his trademark, lobed crosses. *Ink and watercolor on wove paper, 6.5" x 8.25". Collection of Eugene and Vera Charles.*

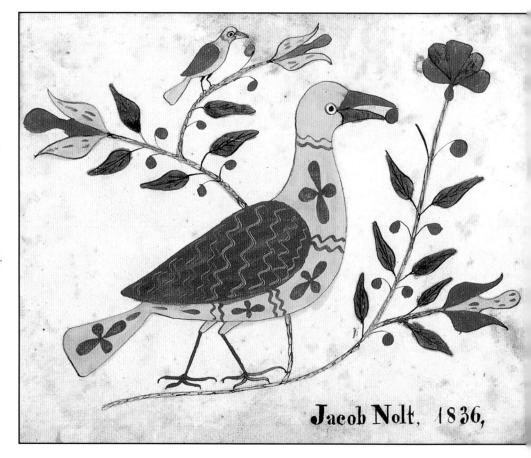

Regardless of his impetus, Jacob Nolt's charmingly naïve bird drawings doubtless pleased their young recipients, as many of them were preserved between the pages of their family Bibles. Nolt decorated his birds with lobed crosses and frequently drew the birds with berries in their beaks. Nolt's fraktur art inspired a niece, Susanna W. Nolt (1827-1867), to try her hand at fraktur drawing (fig. 220).

The fraktur artworks of Samuel Gottschall (1808-98) and his brother Martin are widely regarded as among the best examples of Pennsylvania German fraktur. These two bachelor brothers were the sons of Bishop Jacob Gottschall (fig. 195), and together they operated a mill on the Perkiomen Creek at Salford, Montgomery County, Pennsylvania. Their artwork is similar, making positive attributions difficult.[24] Their fraktur is highly stylized, with deep, rich colors that were glazed in gum arabic (figs. 213-215). Their V-waisted ladies in striped petticoats are highly distinctive. Some of Samuel's larger compositions are complex and intriguing. Birds, women, tulips, hearts, and peering faces co-mingle to form a dramatic example of fraktur art.

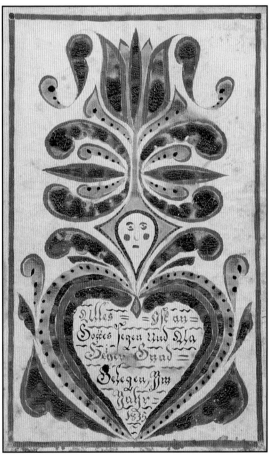

Figure 214. Presentation fraktur, dated 1835, attributed to Samuel Gottschall (1808-98), active c. 1834-35, in Franconia Township, Montgomery County. The small face peering out from above the heart is a motif that was frequently employed by schoolmaster Andreas Kolb (1749-1811). Gottschall's use of bold motifs executed in rich deep colors created frakturs that rank among the most highly regarded examples of Pennsylvania German folk art. *Ink and watercolor on wove paper, 6.25" x 3.5". Collection of the Mennonite Heritage Center, Harleysville, Pennsylvania. Nathan Cox Photography.*

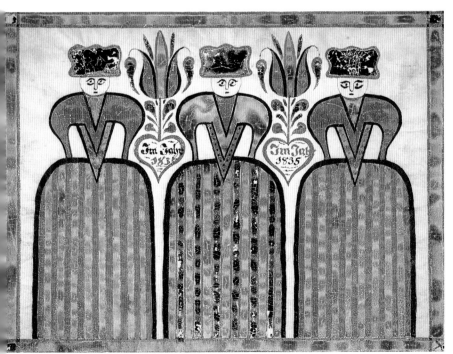

Figure 215. Drawing of three ladies, dated 1835, attributed to Samuel Gottschall (1808-98), active c. 1834-35 in Franconia Township, Montgomery County. This highly unusual fraktur drawing is a superb example of the whimsical nature of Gottshall's art. The V-waisted women with their striped petticoats appear to be unique to the work of Samuel and his bachelor brother Martin Gottschall. *Ink and watercolor on wove paper, 6" x 8.5". Collection of H. Richard Dietrich, Jr. Image Courtesy of Philadelphia Museum of Art. Photograph by Lynn Rosenthal.*

Little fraktur was created by Mennonite women. Most fraktur was school-related, and for many rural Pennsylvania Germans schooling was reserved for their sons. Young women frequently received little education and thus had less opportunity to experiment with fraktur art. Catharine L. Landis (1831-1900) is an exception to the rule. She was the daughter of prosperous Mennonite farmers in East Lampeter Township, Lancaster County, Christian S. and Mary (Landis) Landis. In her mid-teen years she attended a school taught by Christian B. Hartman, "Professor of Penmanship." Hartman, a fraktur artist, instructed young Catharine. Her resulting copybook still survives.[25] Catherine's hands were skilled. Her floral decorations are reminiscent of the work of Hartman and schoolmaster Abraham Brubaker (1760-1831). Catharine was too young to have known Brubaker, but it is probable that her parents were taught by Brubaker. Catharine may have had access to their *Vorschriften*.

While Landis' fraktur production was limited, she is known to have penned a birth record for her brother, John L. Landis (b. 1832), as well as at least three birth records that record her own birth (fig. 216). Catharine was also schooled in the more traditional feminine domestic arts, as evidenced by her cross-stitched sampler (fig. 217). She stitched her "sambler" [sic] in her sixteenth year, using wool embroidery flosses. The majority of her needlework motifs were traditional Pennsylvania German patterns; however, the asymmetrical floral motifs represented the "new wave" of motifs that was just then entering the vocabulary of young Mennonite needleworkers. In about 1851 Katie Landis married Christian S. Risser (1825-1910), who was later ordained as preacher and as the bishop to serve the Hammer Creek Mennonite congregation. It appears likely that Katie's fraktur production ceased upon her marriage. Christian and Katie, who raised a family of six children, are buried in the Hammer Creek Mennonite Cemetery, Elizabeth Township, Lancaster County, Pennsylvania.

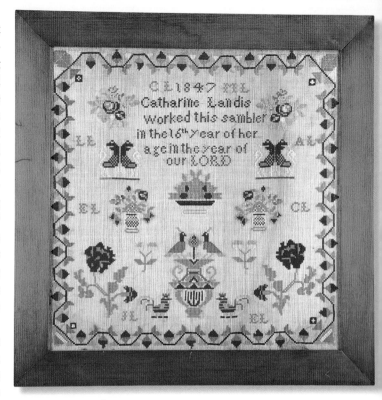

Figure 217. Sampler, dated 1847, stitched by Catharine L. Landis (1831-1900) in East Lampeter Township, Lancaster County. Fraktur artist Catharine L. Landis also was skilled in the needle arts, a far more common art form among young Mennonite women. She inscribed her sampler "CL 1847 ML/Catherine Landis worked this sambler [sic] in the 16th year of her age in the year of our LORD / LL AL EL CL JL EL." The initials flanking the date are those of her parents Christian S. and Mary R. (Landis) Landis; the other initials represent her siblings and herself. This style, the mirror-image sampler, became popular among Mennonite girls in the second quarter of the nineteenth century, when it was borrowed from their English neighbors. This form of sampler was intended for display, and Catharine's retains its original frame. *Wool embroidery flosses on linen cloth, cherry wood, glass, 17.25" x 17.25", excluding frame. Private collection.*

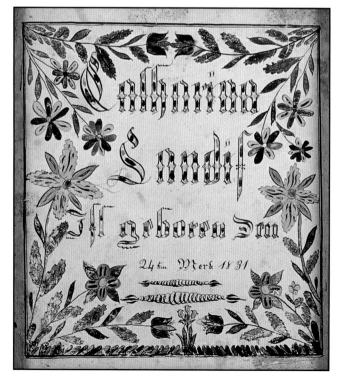

Figure 216. Birth record, c. 1845-51, attributed to Catharine L. Landis (1831-1900), active c. 1845-51 in East Lampeter Township, Lancaster County. This birth record is one of at least three examples penned by Catharine that record her own birth. *Ink and watercolor on wove paper, 8" x 7.25". Private collection.*

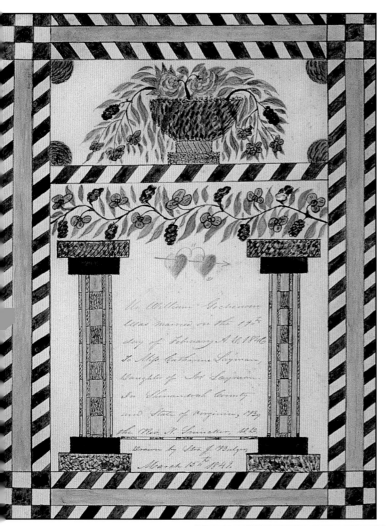

The *Vorschrift*, or handwriting example, appeared in both the Franconia and Lancaster communities by the 1750s. Judging from surviving examples, it is clear that the form was never as popular among the Lancaster County Mennonites as it was among their distant relatives to the east in Montgomery, Bucks, and Lehigh Counties. It is noteworthy, however, that the *Vorschrift* apparently made its final appearance among the Germans of Pennsylvania in Earl Township, Lancaster County.

The conservative schism led by Jacob Stauffer (1796-1861) in 1845 created the Stauffer or Pike Mennonites, whose Meetinghouse was located in Earl Township, Lancaster County. Much of the latest fraktur penned by Lancaster County Mennonites was made by the families of this group. The *Vorschrift* in figure 219 is one of two similar examples penned by David Weaver (1818-84) on February 28, 1852. Two earlier *Vorschriften* by Weaver are both dated 1843, and all four were made for members of the Weber (Weaver) families.[26] The artist, David Weaver, was obviously familiar with the *Vorschriften* of Christian Alsdorff, for he borrowed the general format and numerous details from Alsdorff's work. David Weaver later served as a deacon in the Rissler branch of the Pike Mennonites. It is fitting that the last group to abandon the *Vorschrift* tradition should be members of the most conservative branch of the Mennonite Church.

Figure 218. Marriage certificate, dated March 15, 1849, signed by Stro. J. Bolger working in Shenandoah County, Virginia. The architectural format of this piece is reminiscent of fraktur birth records that were being produced by Samuel Bentz and Carl Frederick Seybold (fig. 204) in eastern Pennsylvania ten to twenty years earlier. This colorful example records the marriage of William Gochenour and Catharine Layman on February 19, 1846. Both are descended from families that originally settled in Lancaster County, Pennsylvania, prior to immigrating to the Shenandoah Valley of Virginia. *Ink and watercolor on wove paper, 10" x 7.75". Collection of the Landis Valley Museum, Pennsylvania Historic and Museum Commission.*

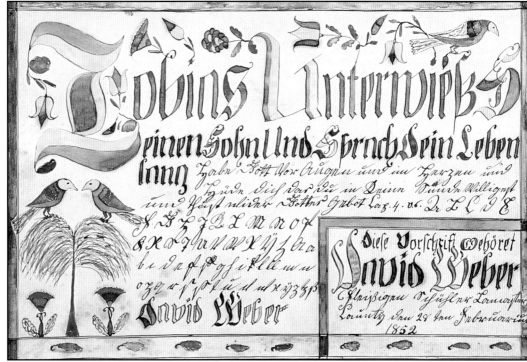

Figure 219. *Vorschrift*, dated February 28, 1852, attributed to David Weaver (1818-84), active c. 1843-52 in Earl Township, Lancaster County, Pennsylvania. This *Vorschrift* was penned for David Weber, "an outstanding student in Lancaster County"; the artist, David Weaver was a schoolmaster who also served as a deacon in the Rissler Church, a conservative branch of the Stauffer Mennonites. Weaver produced his handwriting example, copying the style of Christian Alsdorff (c. 1760-1838), who had earlier taught in the Earl Township community. The *Vorschrift* rapidly faded from use after the introduction of the public school system in Pennsylvania in 1834. This example is the latest dated Pennsylvania German *Vorschrift* currently known. *Ink and watercolor on wove paper, 7.75" x 12.75". Private collection.*

Susanna W. Nolt (1827-67) was born in West Earl Township to John and Esther (Wenger) Nolt. Susanna was niece of the fraktur artist Jacob Nolt (1798-1852), who created the bird drawings in figures 59, 211, and 212. As a young girl Susanna was the recipient of one of her Uncle Jacob's colorful birds. It was likely the work of her uncle that inspired Susanna to create the drawing (fig. 220) for her younger brother, John W. Nolt (1843-1913). The simple free-hand and compass-work drawing is dated April 14, 1855, John's twelfth birthday. Susanna is also known to have penned a second drawing in 1855, inscribed in neat fraktur lettering. At about age thirty, Susanna married George W. Martin, and then she probably ended her fraktur production.

Perhaps the best documented of all Mennonite fraktur artists is a diminutive Mennonite maiden, Anna Weber (1814-88).[27] Anna was born in the Weaverland Valley in northeastern Lancaster County, Pennsylvania, the daughter of John and Catherine (Gehman) Weber of Earl Township. In 1825 Anna and her family made the 500-mile trek to Waterloo County, Ontario. It wasn't until about 1855 that Anna created her first drawings, comprising of colorful birds with a striped border. Anna, who was a slow learner, had a reputation for being eccentric and temperamental. Her fraktur art served as an outlet for her abundant creativity (figs. 221 and 222). Anna drew peacocks, sheep, turkeys, horses, and dogs, often decorated in geometric patterns. Her color palette favored violet, blue, and rose. Anna marked most of her production with her name, the date, and sometimes the recipient. Anna's works are quite individualistic and possess a naivete that gives her simple drawings a timeless appeal.

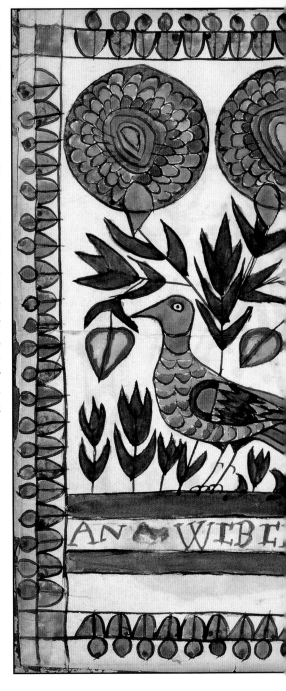

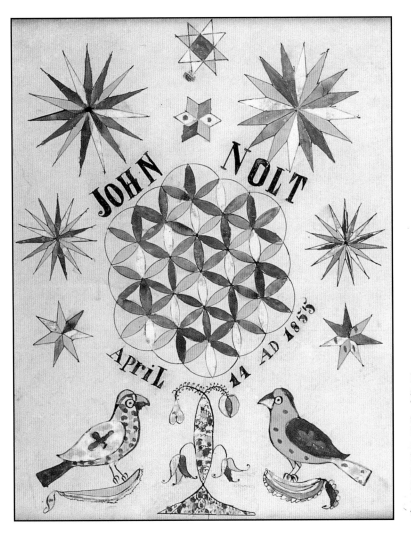

Figure 220. Presentation drawing, dated April 14, 1855, attributed to Susanna W. Nolt (1827-67), active in West Earl Township, Lancaster County, Pennsylvania. It is a late expression of fraktur art among the Mennonites of Pennsylvania; Susanna employed a compass to construct the central geometric motif of her gift. This drawing was presented to her younger brother, John W. Nolt (1843-1913), on his twelfth birthday. Susanna borrowed the lobed-cross designs seen on her birds from the bird drawings of her recently deceased uncle, Jacob Nolt (1798-1852) (figs. 59, 211, and 212). *Ink and watercolor on wove paper, 8.75" x 7.25". Private collection.*

Figure 221. Bookplate, dated 1872, signed by Anna Weber (1814-88), active 1866-88 in Waterloo County, Ontario, Canada. Anna drew this bookplate in her copy of the *Paradiesgartlein* printed in 1872. It is an early example of her work, known for its charmingly naïve depictions of birds, flowers, horses, and even sheep. The pastel colors that she favored are also characteristic of her work. Born in Earl Township, Lancaster County, Pennsylvania, Anna traveled to Ontario at age eleven with her parents. She is among Ontario's most celebrated folk artists. *Ink and watercolor on wove paper, 9" x 5.25". Collection of the Joseph Schneider Haus, Kitchener, Ontario. John Herr, photographer.*

Fraktur bird drawing, c. 1835 attributed to Jacob Nolt (1798-1852), working in West Earl Township, Lancaster County. *Ink and watercolor on wove paper, 3.25" x 4". Collection of the Landis Valley Museum, Pennsylvanai Historic and Museum Commission.*

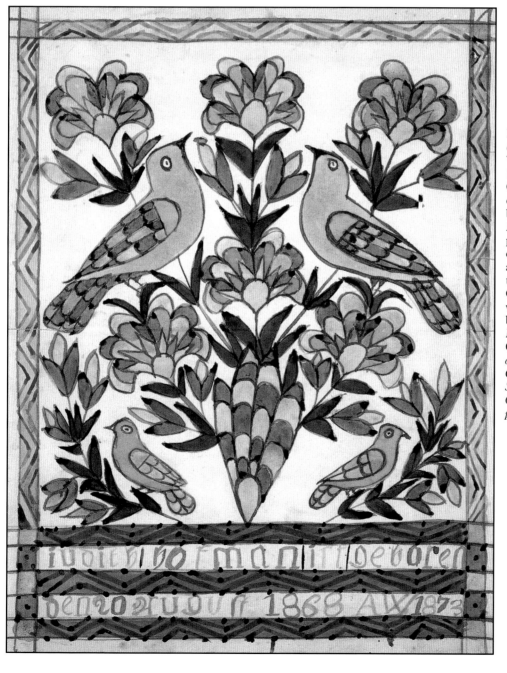

Figure 222. Birth record, dated 1873, signed by Anna Weber (1814-88), active 1866-88 in Waterloo County, Ontario. This lively composition records the birth of Judith Hoffman on August 20, 1868, and was presented to the five-year-old as a gift. Anna's fraktur art demonstrates the tenacity of the Pennsylvania German folk traditions that were transplanted to, and blossomed in, the fertile Mennonite settlements of Ontario. *Ink and watercolor on wove paper, 9" x 7". Collection of the Joseph Schneider Haus, Kitchener, Ontario. John Herr, photographer.*

Chapter Eleven
Homespun Textiles

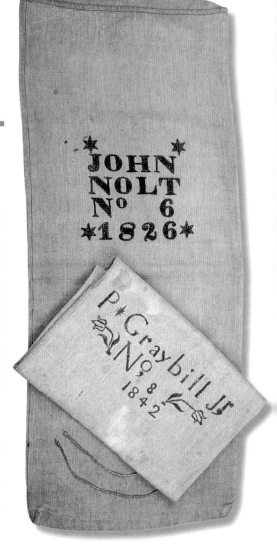

The production of folk textiles once consumed a major portion of the duties of the female members of a typical Pennsylvania German family. To provide for their textile needs, an average family planted about two acres of flax, the plant that would ultimately be processed into tow and linen thread. The flax had to first be planted, then harvested, then flailed, dew retted, broken, scutched, and hetcheled. This was accomplished with the entire household assisting in the process.[1] Finally the combed flax was ready to be spun into thread by the nimble fingers of the women of the household. Young women were taught the art of spinning at an early age, well before entering their teen years. This was an important task, as the production of a fine and uniform thread was a critical element in the creation of fine textiles.

Figure 223. Grain bags. One is stamped "JOHN NOLT No 6 1826"; Nolt was a resident of West Hempfield Township, Lancaster County. The other is stamped "Peter Graybill Jr. No 8 1842"; Peter Graybill, Jr. (1817-94) was a farmer in Manheim Township, Lancaster County. Grain bags were woven from linen tow or hemp thread to withstand the rigors of transporting grain to the mill. The farmer's name allowed him the assurance that his grain wouldn't be switched and that the flour he received would be his own. *Linen, hemp, and ink, 52" x 21" and 50" x 20". Private collection.*

Figure 224. Carved bag stamp used by John Hess (1791-1831), Elizabeth Township, Lancaster County, unknown carver. Hess likely acquired his stamp about 1813, the year of his marriage to Elizabeth Risser. John and his bride moved to the farm that his father, Preacher John Hess (1768-1830), had purchased for him. Hess used his stamp to mark his grain bags (fig. 223). Beginning about 1840, wooden stamps were rapidly replaced by tin stencils. *Pine, 6" x 1" x 16". Private collection.*

Linen cloth provided most of the clothing (fig. 225) and bedding needs (fig. 226) of the Pennsylvania German family. Wool was also necessary for the production of the woolen yarns that were used in the manufacture of certain clothing items such as petticoats and stockings (fig. 252), as well as the warm coverlets that decorated the Pennsylvania German bed. Most rural families maintained a small flock of sheep to provide them with the raw wool that they required. In addition to wool, cotton thread was also desirable for certain textile needs. Because cotton could not be grown in the cold Pennsylvania climate, it had to shipped into urban markets from southern states. While raw cotton was processed by Pennsylvania spinners, it remained a scarce textile until inexpensive factory-woven cotton yardage became readily available in the nineteenth century.

Figure 225. Man's outfit, linen milking coat c. 1820, worn by Jacob Stauffer (1824-1909) of West Earl Township, Lancaster County. Homespun linen man's shirt c. 1830-50, initialed "CU" below neck opening, Lancaster County. Commercially woven *Halsduch* (neckerchief) c. 1850, likely worn by Martin Rudy (1826-76) of Warwick Township, Lancaster County. Although the clothing shown is of mid-nineteenth century origins, rural clothing styles changed so slowly that this same style of clothing was worn a century earlier. The traditional pullover shirt is still worn by the Nebraska Amish of Mifflin County, Pennsylvania, with only minor changes in detailing. *Coat: piece-dyed homespun linen with hand-loomed linen tapes for closures, 36" x 22.75" with 26" sleeves. Shirt: homespun linen, handsewn, with needlelace faggoting at the base of the neck, 38.5" x 26" with 20.5" sleeves. Neckerchief: mill-made cotton fabric with two selvage edges and two handsewn edges, 23" x 23.5". Private collections.*

Figure 226. Homespun linens, an assortment of colored pattern-woven linens, all made in Lancaster County, c. 1800-50. Top: neutral and blue plaid, woven in 1834 by Joseph Andrews (1792-1873), weaving in East Lampeter Township. *Homespun linen, 23.5" x 33.25". Collection of the Lancaster Mennonite Historical Society.* Blue and rust check yardage, by unknown weaver for the family of John H. Hess (1828-1913) and Elizabeth H. (Brubaker) Hess of Warwick Township. *Homespun linen, 19.5" x 46". Private collection.* Brown and neutral check yardage, by an unknown weaver for Anna F. Hostetter (1849-1936) or her mother Catherine (Franck) Hostetter (1807-86) of Penn Township, Lancaster County. *Homespun linen, 66" x 69". Private collection.* Blue and neutral plaid feather tick, with hand-loomed blue and white linen tapes, by an unknown weaver for "EB" living in northern Lancaster County. *Homespun linen, 79" x 58". Private collection.*

While nearly every Pennsylvania German family raised flax and processed the fibers into thread, the actual weaving of the fabric was left to the professional weaver. The only weaving that routinely occurred in the average Pennsylvania German household was the creation of narrow woven tapes (fig. 245). These were produced by women and children on the table loom or tape loom (figs. 62 and 106). The family supplied the weaver with the numerous skeins of homespun thread that were required to produce their textile yardage. While a limited amount of yarn was home-dyed, most was dyed either by the weaver or the blue-dyer.

There were many skilled weavers among the Mennonite immigrants who settled in Pennsylvania. The earliest settlers of Germantown were linen-weavers of Dutch and north German ancestry. They were soon joined by Swiss Mennonites, who also had professional weavers among their number. Melchior Brenneman (d. 1737), who arrived in Lancaster County in 1717, was a direct descendant of an earlier Melchior Brenneman (b. c.1631), who was exiled from Canton Bern, Switzerland, in 1671. In addition to farming a large tract of land that Melchior (d. 1737) had acquired from William Penn, he also practiced the weaving trade. Melchior's son, Melchior (1718-94), grandson Jacob (1753-1838), and great-grandson John Brenneman (1787-1843) all farmed the Brenneman lands in Pequea Township near New Danville. Additionally, all four men carried on the weaving trade (figs. 228 and 232). While none of the Brenneman weavers of New Danville made the transition from traditional handweaving to weaving on the new style Jacquard loom (fig. 240), a collateral descendant, Martin B. Breneman (1803-89), wove numerous Jacquard coverlets in Washington Township, York County, Pennsylvania, continuing the long Brenneman weaving tradition as late as 1861.[2]

Figure 227. Plain weave blanket, hand-loomed with dark blue and red wool yarns, c. 1820-50, owned by Nancy Weber (1817-93), perhaps woven by her uncle Christian Weber (1785-1854), "a weaver of fine linens" in West Earl Township, Lancaster County. This boldly patterned blanket may well have been part of the "outfitting" that Nancy received prior to her marriage to Peter Brubacher (1816-98) (fig. 124). Nancy was the daughter of John and Salome (Meyer) Weber of West Earl Township and a niece of the seamstress Anna Weber (figs. 248 and 249). *Wool yarn, 92" x 88". Collection of Dr. and Mrs. Donald M. Herr.*

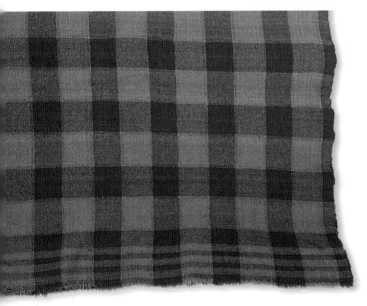

Figure 228. Wool blanket. This twill-weave blanket was woven c. 1800-40, probably by Jacob Brenneman (1753-1838) or his son, John Brenneman (1787-1843); both operated weaving shops at New Danville, Pequea Township, Lancaster County. It remains in the possession of a descendant. Three colors of wool yarn, light blue, dark blue, and rust, were used in the manufacture of this center-seam blanket. When new, the blanket likely had a fringe. *Wool yarn, 72" x 68". Private collection.*

Figure 229. Wool blanket, a twill-weave blanket woven c. 1840-60 for the family of Deacon Daniel S. Burkholder (1833-1915) and his wife Anna (Weaver) Burkholder of West Earl Township, Lancaster County. The brilliant red and blue yarns used in the production of this blanket were likely commercially spun and dyed, creating a bold bed covering. *Wool yarn, 76.5" x 74". Collection of Sam and Kathy McClearen.*

Figure 230. Weaver's patterns, drawn by Christian Dienner (1811-59), working c. 1830-50 in Caernarvon Township, Lancaster County. Christian Dienner, an Amish immigrant from the Alsace, France, drew these patterns of the fabrics that he encountered when visiting in homes. He often recorded the name of the family by each draft of their textile. Dienner would later use his patterns to produce coverlets and other textiles for his Amish and non-Amish clients. *Ink on wove paper, 13" x 16.5". Private collection.*

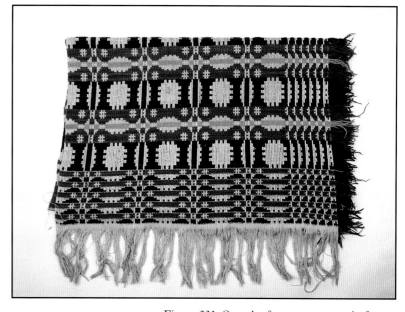

Figure 231. Coverlet fragment, woven in four colors, overshot, with a cotton warp and a wool weft, c. 1830-50, attributed to Joseph Andrews (1792-1873), weaving in East Lampeter Township, Lancaster County. Geometric-patterned coverlets became popular among the Mennonites late in the eighteenth century. By the 1830s they were fading in popularity as the more elaborate Jacquard-type coverlets came into favor. *Wool, cotton, 96" x 37". Collection of the Lancaster Mennonite Historical Society.*

Figure 232. Group of homespun table cloths; these center-seam geometric-weave tablecloths were all woven for Mennonite families living in Lancaster County, Pennsylvania, c. 1800-60. They demonstrate the variety of complicated geometric weaves that were utilized on their best tablecloths. All the examples are stitched with the owners' initials in counted cross-stitch. Left to right: Dated 1858, initialed "AH" for Anna F. Hostetter (1849-1936) woven with a pine tree border and field, half-inch-wide needlelace center seam, Penn Township. *Linen, 69" x 48". Private collection.* Pine tree border with snowball field, initialed "MB CL EL." Landis family of East Lampeter Township, c. 1820-50. *Linen, 68" x 65". Private collection.* Snowball pattern, initialed "FG" for Feronica Groff (1787-1845), daughter of Marx and Feronica (Meyer) Groff of West Earl Township, c. 1797-1808. *Linen, 72" x 52". Private collection.* Goose-eye pattern, initialed "MH" for Mary Habecker (1818-1906), the daughter of Jacob and Eve Habecker, Manor Township, c. 1830. *Linen, 70" x 58.5". Private collection.* Diamond and Lozenge pattern, initialed "JDL" for John D. Landis (1843-78), son of Christian B. and Fanny (Denlinger) Landis of East Lampeter Township, c. 1840-60. *Linen, 65" x 53". Private collection.* Squared geometric pattern, initialed "CHH", for Christian Henry Hess (1852-1913), son of Christian and Susanna (Brenneman) Hess, possibly woven by his great-grandfather, Jacob Brenneman (1753-1838), a weaver in Pequea Township, c. 1810-40. *Linen, 68" x 60". Private collection.* Goose-eye weave, initialed "MM" for Martin Mayer (1798-1873), son of David and Elizabeth (Rohrer) Mayer, Manheim Township, c. 1800-22. *Linen and cotton, 78" x 60". Private collection.*

In Bedminster Township, Bucks County, Pennsylvania, Jacob Wismer (d. 1787), a 1709 immigrant to Pennsylvania, also established a line of farmer-weavers. His son Henry Wismer (c. 1730-1806), grandson Abraham Wismer (1756-1844), and great-grandson Abraham Wismer (1791-1859) all occupied the same farm and weaver's shop. Fortunately for researchers, the ledgers recording their weaving production still survive (fig. 233). Abraham Wismer, Jr. recorded weaving woolen coverlids [sic], linsey, checks, stripes, and flannel yardage. The coverlets that he produced (fig. 234) were traditional geometric patterns, as the Wismers, like the Brennemans, never made the transition to a Jacquard loom, which produced the more pictorial form of coverlets (figs. 239, 241, 242, and 243). These coverlets became fashionable among the Pennsylvania Mennonites in the 1830s.

Figure 233. Weaver's pattern, from the account book of Henry Wismer, (c. 1730-1806), working 1768-1800 in Bedminster Township, Bucks County, Pennsylvania, pattern dates c. 1790. Henry's ledger contains a record of his farming, distilling, and weaving accounts. *Ink on laid paper, 12.25" x 7.5". Collection of the Mennonite Heritage Center, Harleysville, Pennsylvania. Nathan Cox Photography.*

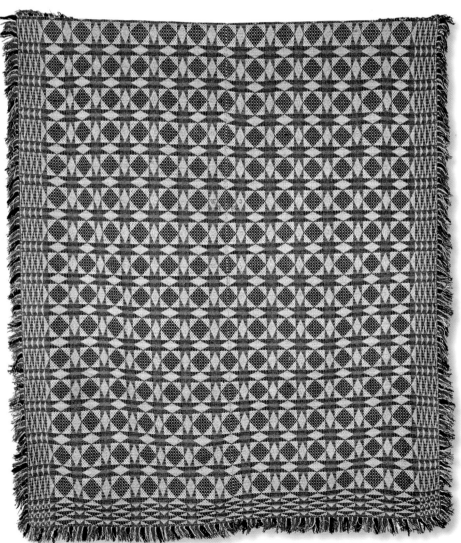

Figure 234. Star and Diamond pattern coverlet, initialed in cross-stitch "CW 1831," attributed to Abraham Wismer, Jr. (1791-1859), working c. 1813-after 1830 in Bedminster Township, Bucks County. Star and Diamond coverlets were popular among Pennsylvania Germans. This four-color example was produced on a multiple-shaft loom. In 1816 Wismer wove two "Coverlids" [sic] for a charge of $1.50 apiece. *Wool and cotton yarn, 93" x 81". Collection of the Mennonite Heritage Center, Harleysville, Pennsylvania. Nathan Cox Photography.*

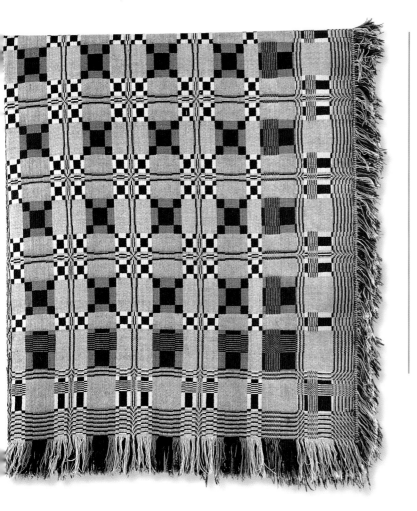

The skills and equipment possessed by weavers varied considerably. All that was required to produce plain-weave fabrics in white, checks, or plaids (figs. 225-228), was a simple two-or four-harness loom and rudimentary weaving skills. These plain-weave fabrics filled most of the farm needs (fig. 223), clothing needs (fig. 225), and bedding needs (fig. 226) of the typical family. The colorful checks and plaids were frequently used for the topmost layers of bedding: bolsters, pillowslips, ticking, and blankets (figs. 226-229). Plain-weave white linen was used for sheets, chaff bags (straw-filled mattresses), and clothing items. However, to produce the elaborate geometric patterns that the Pennsylvania Germans reserved for their tablecloths, toweling, and coverlets (figs. 232, 234, 235, and 236) required a highly skilled weaver working on a loom that possessed as many as forty harnesses. These sophisticated pattern-weaves represent the finest examples of hand-loomed textiles that Pennsylvania German weavers were capable of producing.

Figure 235. Double-weave coverlet, by an unknown weaver, c. 1800-40, for the family of Jacob C. and Hannah (Rittenhouse) Clemens of Towamencin Township, Montgomery County, Pennsylvania. Although double-weave is often considered to be an English weave structure, the Mennonite Wismers of Bucks County recorded producing them by the 1790s. The reverse side of this coverlet appears in figure 236. *Wool and cotton yarn, 93" x 84". Collection of the Mennonite Heritage Center, Harleysville, Pennsylvania. Nathan Cox Photography.*

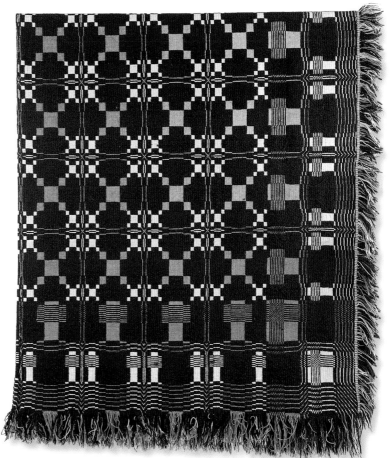

Figure 236. Double-weave coverlet, by an unknown weaver, c. 1800-40. This is the reverse side of the coverlet seen in figure 235. *Collection of the Mennonite Heritage Center, Harleysville, Pennsylvania. Nathan Cox Photography.*

When Peter Andreas (Andrews) (1764-1857), a Mennonite and a weaver from Bavaria, arrived in Lancaster County in 1782, he settled on a small farm in East Lampeter Township, where he taught his sons the weaving trade. His son Joseph Andrews (1792-1873) also practiced weaving, producing both plain-weave and geometric fabrics (figs. 226 and 231). While Jacob Andreas (1797-1873), a younger brother of Joseph, also learned the weaving craft from his father, he instead chose to enter the teaching field. Jacob taught in the years c. 1815-24 at subscription schools in Manor, Elizabeth, and Warwick Townships, Lancaster County. A small number of fraktur *Vorschriften* and presentation pieces survive that can be attributed to Jacob Andreas (figs. 237 and 238). Andreas' fraktur is delicately executed, and the majority of his fraktur examples feature paired birds. Like many schoolmasters Andreas was single, as the meager pay that schoolmasters received was rarely adequate to support a family.

Figure 237. Fraktur drawing, dated 1822, attributed to Jacob Andreas (1797-1873), schoolmaster teaching in Manor and Warwick Townships, Lancaster County, c. 1815-24. Schoolmaster Andreas (Andrews) presented this drawing to a student, John Seitz, in Manor Township. The paired doves carry a banner that reads, "Hoping for better times April 5, 1822." A few years later Andrews took up weaving (fig. 239). *Ink and watercolor on wove paper, 5.5" x 7.5". Private collection.*

In 1824, at age twenty-seven, Jacob Andreas married Fanny Funk (1806-82), the daughter of the weaver Henry Funk and Barbara (Herr) Funk of Manor Township. It appears that by 1826 Jacob Andreas had returned to the loom, working in Manor Township, quite likely with his father-in-law, Henry Funk. About 1835 Jacob acquired a Jacquard attachment for his loom and commenced the weaving of Jacquard coverlets (fig. 239).

Figure 238. *Vorschrift*, c. 1823, attributed to Jacob Andreas (1797-1873), schoolmaster in Manor, Elizabeth and Warwick Townships, Lancaster County, working c. 1815-24. Andreas penned this handwriting example for Anna Eby (1815-79), daughter of Hannes and Maria (Witwer) Eby of Warwick Township. Hannes Eby was a prominent Mennonite miller who constructed a schoolhouse on his Warwick Township farm. Eby played an important role in the decision of the Lancaster County Mennonites to aid their brethren who had purchased encumbered lands in Waterloo County, Ontario. This resulted in the formation of the German Company, and the ultimate relocation of dozens of Lancaster County Mennonites to the Waterloo region in the 1803-25 period. *Ink and watercolor on wove paper, 7.75" x 12.25". Collection of Dr. and Mrs. Donald M. Herr.*

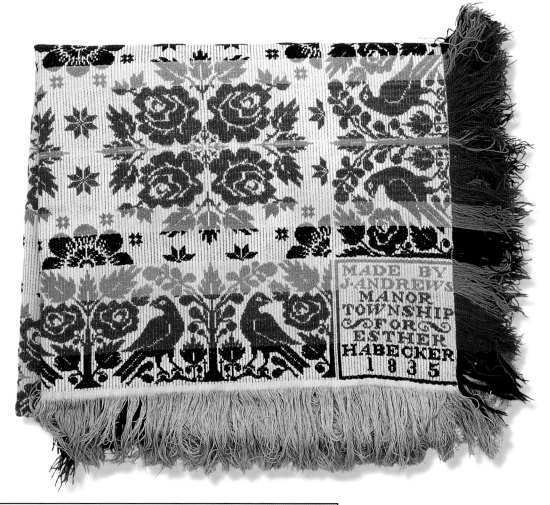

Figure 239. Jacquard coverlet, dated 1835, woven for Esther Habecker (1816-98), by Jacob Andrews (Andreas) (1797-1873), weaving c. 1826-38 in Manor Township, Lancaster County. About 1826 Andrews retired from teaching and began his weaving career, working with his father-in-law, Henry Funk. Andrews purchased a Jacquard attachment for his loom c. 1835 and created this four-color coverlet. The Rose and Dove pattern of this coverlet is the only Jacquard pattern that Andrews appears to have used. Curiously, the paired birds of the Rose and Dove pattern repeat the common theme of his earlier fraktur drawings (figs. 237 and 238). Esther Habecker, the recipient, was the daughter of Christian and Elizabeth (Kauffman) Habecker, of Manor Township. She received her coverlet just prior to her 1835 marriage to Ephraim Rohrer (1811-91). *Wool and cotton yarn, 100" x 85". Private collection.*

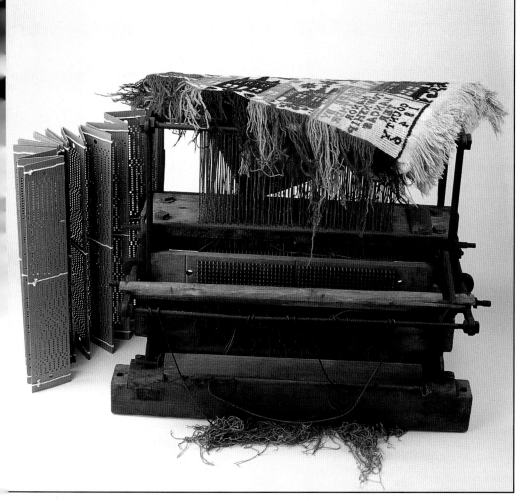

Figure 240. Jacquard-type weaving apparatus, probably made and used by Joseph Lauser, c. 1850, in Schaefferstown, Lebanon County, Pennsylvania. This weaving attachment, when mounted above a conventional loom, read a series of punch cards (seen on the side), and these cards programmed the loom to select a series of threads. This allowed the production of elaborate curvilinear patterned textiles (figs. 239, 241, 242, and 243). When mounted on the loom, the loom height would exceed nine feet. This often necessitated the removal of a portion of the ceiling. *Mixed woods, iron, wire, and threads, 22" x 19.5" x 29". Private collection. Contemporary cards are from the collection of the Heritage Center Museum through the generosity of Family Heirloom Weavers.*

The Jacquard loom was invented by Joseph-Marie Jacquard in France in 1806. It allowed a series of punchcards (fig. 240) to essentially program a handloom, enabling the creation of far more naturalistic designs than had previously been possible. Jacquard coverlets frequently include cornerblocks with the name of the weaver, the date, location, and the owner's name (figs. 239, 241, 242, 243, and 244). When Jacquard coverlets appeared in rural Pennsylvania in the 1820s, they soon rendered the traditional geometric-patterned coverlets obsolete. Few Mennonite weavers of Lancaster County made the transition to the costly new equipment. Jacob Andrews, as his name is spelled on his coverlets, was one of the weavers who successfully made this transition. His career was short-lived, as all recorded examples date from 1835 to 1838. In the spring of 1839, he moved back to East Lampeter Township to assist his father on his farm.

It appears that Jacob Andrews was working with another Mennonite weaver, Jacob F. Witmer (1813-1900) prior to his departure to East Lampeter Township. Both weavers appear to have shared the same cards and yarns. Witmer apparently purchased Jacob Andrew's loom, continuing to supply coverlets to the Manor Township community until 1851, when he removed to Medina County, Ohio. Witmer's coverlets are dated from 1837 to 1851. As a result of his longer period of production, his coverlets are far more numerous than are Andrews' examples. On some of his coverlets Witmer employed the more unusual schoolhouse border (fig. 241). Both men wove their coverlets for a clientele that was predominantly Mennonite.

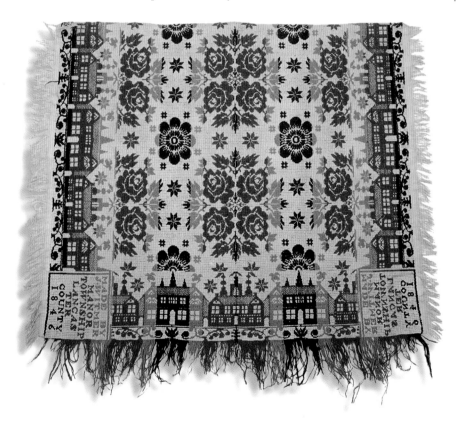

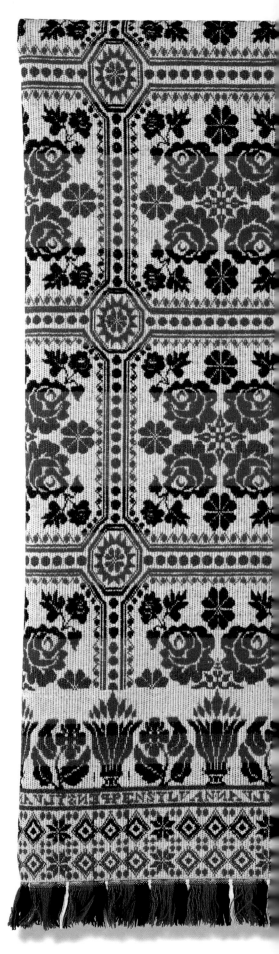

Figure 241. Child's coverlet, dated 1846, woven by Jacob F. Witmer (1813-1900), weaving c. 1837-51 in Manor Township, Lancaster County. Jacob Witmer used a hand loom with a Jacquard attachment to weave this crib-size coverlet, with the schoolhouse border. Jacob probably learned the art of weaving from his father Peter Witmer, who also was a weaver. It is highly probable that Jacob worked with the weaver Jacob Andrews (1797-1873). beginning in 1837 and continuing the association until the spring of 1839, when Andrews quit weaving. In 1851, Jacob F. Witmer and his wife Mary (Sauder) Witmer moved to Medina County, Ohio. *Wool and cotton yarn, 46.5" x 41.75". Collection of Dr. and Mrs. Donald M. Herr.*

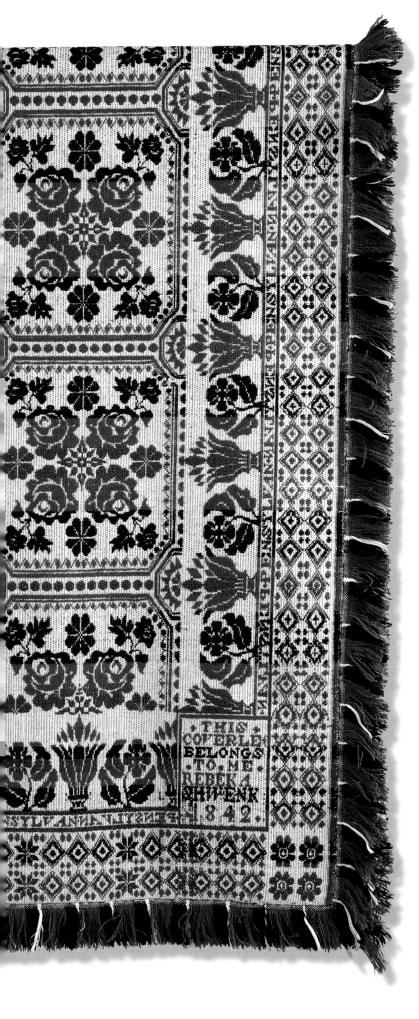

Upon Jacob Andrews' return to East Lampeter Township, he resumed teaching school to supplement his farming income. He continued to produce a few fraktur, primarily birth records and presentation pieces, until his retirement from teaching in 1854. In 1852 Jacob Andrews was ordained as a preacher for the Strasburg Mennonite congregation, a position that he filled for twenty-one years. He was remembered as having been able to preach in both English and German, and "he traveled extensively among the churches in other counties and states and in Canada."[3] After a colorful career as a schoolmaster, fraktur artist, coverlet weaver, and Mennonite preacher, Jacob Andrews died in 1873; he was buried in the Strasburg Mennonite Cemetery.

Among the Franconia Mennonites of eastern Pennsylvania were a number of weavers producing Jacquard coverlets. Among them were weavers Samuel B. Musselman (1802-74), Samuel Hunsberger (1800-73), Michael Kauffman (1806-46), John Kaufman (1812-63), and Aaron Zelner (1812-93).

The coverlet seen in figure 242 was woven for Rebeka Shwenk in 1842; it is attributed to Samuel B. Musselman (1802-74). Likely the most prolific coverlet weaver to have worked in Bucks or Montgomery County, Mussleman is believed to have woven more than 1,000 coverlets during a career that spanned twenty-three years.[4] By 1837 he was weaving in Lower Milford Township, Bucks County, Pennsylvania. Although his first coverlets were center-seamed, by 1838 Musselman had acquired a larger loom and was manufacturing one-piece coverlets. Mussleman wove in a variety of patterns, and he often numbered his coverlets. By 1847 Samuel B. Musselman had relocated to Hilltown Township, Bucks County, where he continued to weave until 1859.

Figure 242. Jacquard coverlet, dated 1842, attributed to Samuel B. Musselman (1802-74), weaving c. 1834-47 in Lower Milford Township, Bucks County, and c. 1847-59 in Hilltown Township, Bucks County, Pennsylvania. A prolific weaver, Samuel B. Musselman is said to have woven about 1,000 coverlets during his career. This colorful example was woven for Rebeka Shwenk. It is woven in one piece, as Musselman had acquired a larger loom in 1838 and did not need to sew a center-seam as did most weavers. He and his wife Elizabeth (Landes) Musselman are buried in the Line Lexington Mennonite Cemetery in New Britain Township, Bucks County. *Wool and cotton, 102.75" x 85". Collection of the Mennonite Heritage Center, Harleysville, Pennsylvania. Nathan Cox Photography.*

Coverlet weaver John Kaufman (1812-63) began his coverlet production in 1837 in Hilltown Township, Bucks County.[5] He wove the four-color example seen in figure 243 in 1840, employing an unusual rooster pattern for the border design. Like most weavers, Kaufman wove coverlets in two sections with a hand-sewn center seam. It is interesting to note that Kaufman ceased weaving in 1848, the year following the arrival of Samuel B. Musselman in the Hilltown Township community where Kaufman worked. It is certain that coverlet purchasers would have preferred Musselman's one-piece coverlets to the old-style two-piece production of Kaufman. Faced with new competition and lagging sales, John Kaufman may well have decided to retire his loom.

The coverlets woven by Aaron Zelner (1812-93), born in Plumstead Township, Bucks County (fig. 244), clearly demonstrate how the transfer of textile traditions can occur between distant communities with little change in the end product. Zelner produced Jacquard coverlets in his native Plumstead Township from 1839 to 1845. In 1847 he joined the northward migration, settling in South Cayuga Township in Ontario's Niagara peninsula. By 1853 he had moved again, this time opening a weaving shop in Berlin (Kitchener), Waterloo County, Ontario.[6] Here Zelner remained until 1864, when he made his final move to Kent County, Michigan. The coverlet woven by Zelner in Bucks County in 1840 exhibits a rose and oak leaf border, the same border that he used in 1860 on the coverlet that he wove for Mary Ann Groff living in Waterloo Township, Ontario. Aaron Zelner's craft had successfully survived distant moves and two decades of changing fashions, with little impact on his woven product.

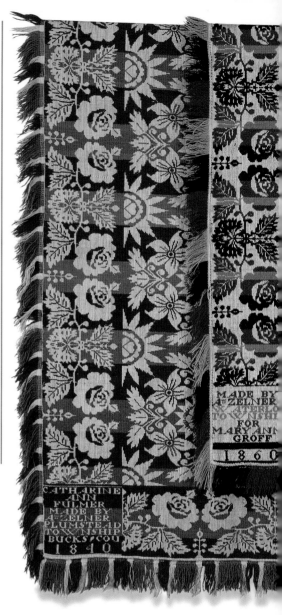

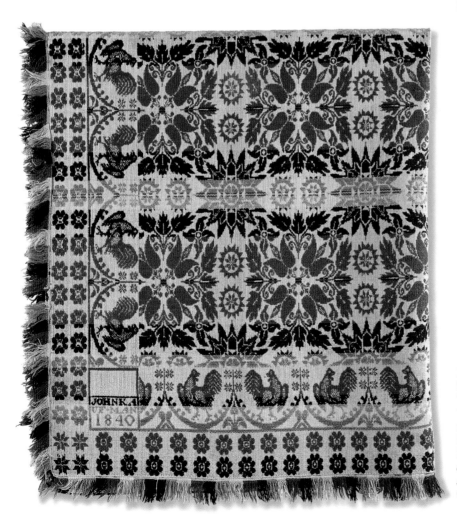

Figure 243. Jacquard coverlet, dated 1840, signed by John Kaufman (1812-63), weaving in Hilltown Township, Bucks County, Pennsylvania, c. 1837-48. This four-color, center-seam coverlet boasts an unusual rooster border. Kaufman and his wife Susanna (Angelmoyer) Kaufman are buried at the Blooming Glen Mennonite Cemetery. *Wool and cotton yarn, 80.5" x 78". Collection of the Mennonite Heritage Center, Harleysville, Pennsylvania. Nathan Cox Photography.*

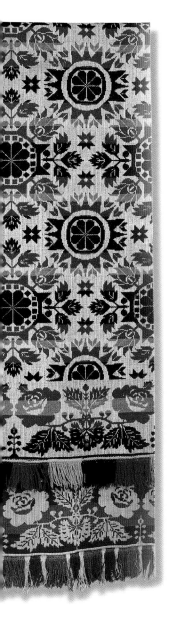

Figure 244. Jacquard coverlets, dated 1840 and 1860, both woven by Aaron Zelner (1812-93), weaving c. 1839-45 in Plumstead Township, Bucks County, Pennsylvania, and c. 1847-after 1860 in Waterloo County, Ontario, Canada. Utilizing the same Jacquard card to create the borders, these coverlets were woven by Zelner twenty years and 500 miles apart. The first coverlet was woven in 1840 for Catharine Ann Fulmer, Plumstead Township, Bucks County. The second was woven in 1860 for Mary Ann Groff, in Waterloo County, Ontario. *Wool and cotton yarn, 87" x 84.25". Collection of Kitty Bell and Ron Walter. Wool and Cotton yarn, 87" x 83". Collection of Robin Walker. Image courtesy of Joseph Schneider Haus, Kitchener, Ontario.*

Jacquard coverlets with personalized name-blocks were treasured by their recipients and often were sparingly used. As a result of their veneration, they have survived in relatively large numbers. Since most examples include the name of the owner and the date, it is often possible to document the age at which they were received. It is clear that among the Mennonites of Pennsylvania these coverlets were typically given by the parents to their teen-aged daughters and sons, as a part of their "outfitting" in preparation for their eventual marriage. Most persons received their coverlets between the ages of sixteen and twenty-two, with female recipients far outnumbering male recipients. This was obviously a matter of varying family custom, as in some families every child received one, in others only the daughters would receive a coverlet.

Among the Mennonites the heyday of Jacquard coverlet production and ownership stretched from 1835 to 1860. Another generation of youth would continue to receive coverlets, but these were no longer hand-loomed by the local weaver; rather they were produced in the large coverlet factories, such as Philip Schum's (1814-80), Lancaster Carpet, Coverlet, Quilt, and Yarn Manufactory, located in Lancaster City, Lancaster County, Pennsylvania. These one-piece coverlets usually featured an overall medallion pattern and lacked the ownership block of the earlier Jacquard coverlets. The appearance of these competitively priced coverlets signaled the end of hand-loomed coverlet production. As other mill-made textiles became rapidly available after 1850, we see the homespun textile traditions rapidly eroding. It appears that among the Mennonites of Lancaster County little spinning or hand-weaving was done after 1860. The few weavers who had survived myriad developments that continually threatened their textile craft were forced to shift their production to the creation of rag carpeting. A popular floor covering in the second half of the nineteenth century, rag carpeting continued to be used by the Old Order Mennonite and Amish throughout the twentieth century, providing a handful of weavers with the opportunity to continue their age-old craft for generations beyond the end of the homespun textile era.

The creation of homespun textiles was truly a group effort, involving the entire family in harvesting and processing the fiber into thread. It was the professional weaver, however, who transformed those threads into the delicately patterned linen tablecloths and the brilliantly colored woolen coverlets that were so popular among Pennsylvania German housewives. Ironically, it was their plain-woven white linen cloth, the simplest product of the weaver's loom, that afforded the needleworker her greatest means of self expression. Armed with only a needle and thread, a skilled needleworker could transform her bolts of homespun linen fabric into carefully constructed clothing (fig. 225) or a myriad other functional and decorative domestic textile forms (figs. 256, 258, 259, 260, and 262).

Figure 245. Group of hand-loomed tapes, woven c. 1850-75 by an unidentified Mennonite family living in West Earl Township, Lancaster County. The production of narrow tapes was the only weaving that occurred in a typical Mennonite household. The weaving of yard goods was left to professional weavers. These tapes were used on clothing (fig. 225), bedding, and towels. They were woven by women or children on a tape loom (fig. 106). *Linen, and cotton, 6.25" x 1.5" diameter. Collection of Nan and Jim Tshudy.*

With mothers or grandmothers by their sides, young girls were invariably taught the skills of plain sewing and decorative needlework as well. A knowledge of knitting skills was also important for the creation of some clothing and accessories (figs. 252 and 253). These skills were taught to young women to prepare them for their eventual role as wife, mother, and homemaker. However, not all women chose to marry. These maiden siblings or aunts were often referred to as spinsters. Traditionally these unmarried women played important roles within the Mennonite community, often functioning as caregivers and needleworkers. For single women, the sewing arts provided one of the few means of financial support available to them. As professional seamstresses, they honed their sewing skills to perfection, frequently mastering unusual stitches and techniques.

While most professional needleworkers lived and died in obscurity, the names are known of two nineteenth century Mennonite women who spent decades working as seamstresses. Both Christina Hess and Anna Weber were born in the 1790s. Each lived with her parents until her parents' deaths. They both subsequently shared a household with an unmarried sibling, supporting themselves with their needleworking skills.

Christina Hess (1790-1854) was born in Conestoga Township, Lancaster County, a few miles from the home of her great-grandfather, Hans Hess (c. 1683-1733), a 1717 immigrant from the Palatinate. She lived near Conestoga Center with her parents, John Hess (c. 1754-1813) and Elizabeth (Mosser) Hess (1760-c.1823) (fig. 246), in a one-story log house measuring 30 feet by 28 feet. After the death of her father in 1813, and the subsequent division of his lands among her brothers, Christina lived with her widowed mother, together with her bachelor brother, John Hess (c. 1780-1825), a blacksmith, and her maiden sister, Elizabeth (c. 1785-1850), who also was a seamstress. Ultimately, after John's death in 1825, Christina and Elizabeth occupied a seventeen-acre farm, where they spent their remaining years. While the scope of Christina's needleworking is unknown, at least three decorated towels have survived that can be attributed to her skillful hands. These towels, dated 1815, 1816, and 1818, give ample evidence that by age twenty-five, Christina already was highly skilled. Her towels exhibit a half-dozen unusual embroidery stitches that are seldom seen on Pennsylvania German towels (fig. 247). The towel that she stitched in 1816 for Anna Herr indicates that Christina was already commercially marketing her sewing skills. The 1850 census records the occupations of Christina Hess and her sister Elizabeth as seamstresses. This confirms that the sisters had continued to support themselves into their sixties, through the production of customized needlework.

Figure 247. Miniature towel, dated 1815, made by Christina Hess (1790-1854), working in Conestoga Township, Lancaster County. As a professional seamstress, Christina Hess was showcasing her skills when she stitched this miniature towel using satin, whip, and seed stitches. Her drawnwork bands are also masterfully executed. Christina embroidered her full name in German script across the top of her towel. *Linen fabric, cotton and silk threads, 22" x 8.25". Collection of Winterthur Museum.*

Figure 246. Fraktur birth record, c. 1800, penned by an unidentified artist working in Conestoga Township, Lancaster County. This fraktur records the birth of Christina Hess (1790-1854) in Conestoga Township. It also records the birth of her mother Elisabeth Mosser (Musser) in 1760. Christina, who never married, was a professional needleworker who stitched the towel seen in figure 247. *Ink and watercolor on laid paper, 6" x 5.25". Collection of James Keener. Nathan Cox Photography.*

The varied production of Anna Weber (1796-1876) is better documented than are the textile objects that were stitched by the Hess sisters. Anna Weber maintained a series of diaries and ledgers dating from 1827 to 1876 (fig. 249), detailing many of the wares that she produced. Her earliest records begin just after the death of her father, linen-weaver Samuel Weber (1760-1825), of East Earl Township, Lancaster County. In 1829 she began living with her widowed sister, Magdalena (Weber) Shirk (1787-1874). They shared a small property near Akron in West Earl Township. Here Anna would spend nearly five decades supporting herself by her needleworking skills. Anna recorded making and decorating clothing, both men's and women's. She also knitted gloves and stockings, did quilting, made wallpaper boxes, decorated towels, and did Berlin-work on punchcards. In her lengthy career she created thousands of objects, but only a single piece (fig. 248) has been firmly attributed to her skilled hands. The maiden seamstress affectionately known as Anely (little Anna) died in 1876 at the age of eighty, and she was buried in Metzler's Mennonite Cemetery in West Earl Township.

Figure 248. Decorated change pouch, dated 1833, signed by Anna Weber (1796-1876), working in West Earl Township, Lancaster County. Anna Weber, an unmarried Mennonite woman, worked as a professional needleworker throughout most of her life (fig. 249). This change purse was crafted by Anna for her personal use and was decorated using chain stitch. Although she produced thousands of objects in her career, this is currently the only piece that can be firmly attributed to her. *Linen fabric, linen, wool, and cotton threads, 3" x 4.25". Private collection.*

Figure 249. Seamstress ledger, dated 1843-51, kept by Anna Weber (1796-1876), working in West Earl Township, Lancaster County. This is one of a series of ledgers kept by Anna to record her production. Among her many services, she quilted, sewed clothing, knitted gloves, decorated towels, and made wallpaper boxes. *Pressed board, hand-printed wallpaper, ink on wove paper, 12" x 8". Collection of the Lancaster Mennonite Historical Society.*

Professional seamstresses fulfilled a need within the Mennonite community by providing textile products for families that were unable or unwilling to create their own needlework. However, the vast majority of pieces of decorated textiles were produced by the families that used them. Nearly every young girl was taught the basic skills of needleworking by an elder relative, for acquiring those skills was viewed as an essential part of her education process. The mode of needlework instruction, typically mother to daughter, was the most important ingredient in the transmission of folk textile traditions within the Mennonite community. Thus, a woman who was an especially gifted needleworker would be most likely to have trained daughters to be equally skillful needleworkers. It is apparent that some Pennsylvania German families placed great emphasis on needle arts while others were considerably less enthusiastic. For this reason there are groups of exceptional textiles that were created by siblings (figs. 73-76) or multiple generations within the same family (figs. 64, 65, 67, 68, and 71). Perhaps some of this phenomenon could be attributed to sibling rivalry, but I would prefer to view it as the successful transfer of the respect and love for a folk tradition, from one generation to the next.

Figure 250. Women's caps. Cap at left: c. 1730-55, initialed "EA" for Elizabeth Amweg (b. c. 1730-40) of Rapho Township, Lancaster County. A young woman's *Haube* or cap. An accompanying note (c. 1865) states that Elizabeth wore the cap both in Switzerland and Pennsylvania. She was the daughter of Johann Martin Amweg and Barbara (Wissler) Amweg, Mennonites who immigrated in 1737 settling in Rapho Township, Lancaster County. *Cotton, 6.75" x 4" x 5.75". Collection of the Lancaster Mennonite Historical Society.* Cap at right: c. 1762, made by an unknown needleworker likely working in Warwick Township, for the wedding of Elizabeth Bucher (c. 1744-1806) to Abraham Huber (c. 1731-90). Both were Mennonites who lived in Warwick Township. Elizabeth's father, Hans Martin Bucher, immigrated directly from Switzerland, arriving in Warwick Township in 1737. Both caps are similarly quilted. *Handloomed cotton fabric, 6.5" x 4" x 6". Collection of the Lititz Historical Foundation Inc.*

142

Figure 251. Group of women's head coverings, dating c. 1850-1910, by unknown needleworkers in Lancaster County, Pennsylvania. During the eighteenth and early nineteenth centuries, most adult Pennsylvania German women wore head coverings regardless of their religious affiliations. This tradition continues today among conservative branches of the Mennonite Church. Coverings were traditionally made by professional seamstresses. The two examples on the left descended in the family of Feronica (Hostetter) Hershey (1820-93) of Penn Township, dating c. 1830-70, Lancaster County. *Cotton fabrics, 20" x 7" and 25" x 7". Collection of the Lancaster Mennonite Historical Society.* Example on right was worn by Catherine (Garber) Reist (1833-1922), the wife of Henry B. Reist (1832-79) of Mount Joy, Lancaster County. *Cotton, 18" x 6.5". Private collection.*

Figure 252. Group of handknit stockings, dated c. 1840-1900, all knit by Mennonite women living in Lancaster County. On left: homespun wool socks, c. 1840, with cross-stitch initials "FH" for Feronica Hostetter (1820-93), the daughter of Bishop Jacob Hostetter (1774-1865) and Elizabeth (Miller) Hostetter of Penn Township. *Wool, 19" x 5". Collection of the Lancaster Mennonite Historical Society.* In center: handknit wool socks in brilliant red and blue yarns. They were knit c. 1878-1880 by Magdalena (Weaver) Sensenig (1855-1940), the wife of Aaron Sensenig (1854-1916), a bishop in the Stauffer or Pike Mennonite Church. *Wool, 6" x 3". Private collection.* On right: Handknit cotton stockings, made c. 1900 for Frances Hess (1888-1977) by her stepmother Edna (Charles) Hess (1858-1947), the wife of Christian Henry Hess (1852-1913) of West Lampeter Township. *Cotton, 20" x 4.5". Private Collection.*

Figure 253. Knit pin cushion, c. 1875-1900, made by a member of the Gish family, near Elizabethtown, Lancaster County. A talented needleworker with an artistic flair knitted this unusual pincushion. *Wool yarn, unidentified stuffing, 4" x 3". Collection of Sam and Kathy McClearen.*

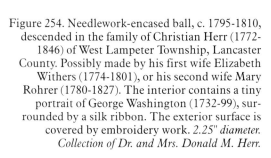

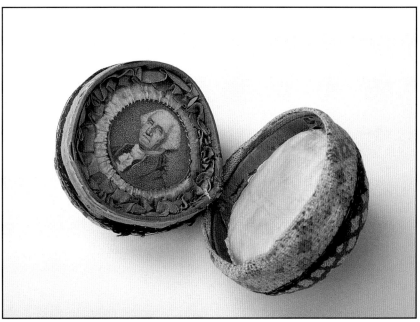

Figure 254. Needlework-encased ball, c. 1795-1810, descended in the family of Christian Herr (1772-1846) of West Lampeter Township, Lancaster County. Possibly made by his first wife Elizabeth Withers (1774-1801), or his second wife Mary Rohrer (1780-1827). The interior contains a tiny portrait of George Washington (1732-99), surrounded by a silk ribbon. The exterior surface is covered by embroidery work. *2.25" diameter. Collection of Dr. and Mrs. Donald M. Herr.*

To create decorated textiles, the needleworker began with a plain-woven piece of homespun linen. On most of her household textiles she would stitch her initials, and often a number to aid in the rotation of her linens. On some she might add a single decorative motif such as a tulip or a star, "just for pretty." Her sampler, or *Namenduch*, would be stitched with an assortment of alphabets, numerals, and decorative motifs (fig. 255). These she would collect from her mother's or grandmother's samplers or from the textiles that her cousins and friends were stitching. The traditional Pennsylvania German sampler was not intended for display but was simply a record of admired motifs that young women would later copy onto the other objects that they decorated. The decorative stitch that was most often employed by Pennsylvania German needleworkers was counted cross-stitch, a stitch that had been used in continental Europe for centuries. Similarly, the research of Tandy and Charles Hersh has demonstrated that some of the popular cross-stitch motifs used by the Pennsylvania Germans had been in use in Switzerland, Germany, and the Netherlands since the early seventeenth century.[7]

The sampler appearing in figure 255 is dated 1750. This random sampler is the second earliest recorded Pennsylvania German sampler, and it shares numerous motifs in common with the Maria Herr sampler of 1732.[8] Both textiles were stitched by young Mennonite women living in Lancaster County and are important links to later textiles. The 1750 sampler was stitched by "LB," who is likely Elizabeth Bear (c. 1732-after 1771), a daughter of Henry and Barbara (Witmer) Bear.[9] Elizabeth was born and reared on the 300-acre tract of land in East Hempfield Township that had been warranted to Henry Bear in 1718. In the mid-1750s, Elizabeth Bear married Henry Brubaker (c. 1729-1820) and they settled on a farm in Manheim Township, Lancaster County. The long, narrow format of Elizabeth's sampler is typical of European prototypes. Later Pennsylvania samplers are wider and are frequently square (figs. 264, 266, 267, and 268). Elizabeth would have used her sampler as a pattern, copying letters and motifs onto other textiles that she might choose to decorate (figs. 256, 257, 258, 259, 260, and 262).

One of the ironies of the history of Pennsylvania German decorated textiles is that while abundant examples exist in all regions of Germanic Europe to suggest that most immigrant families were well acquainted with traditional decorated textile forms, few decorated textiles exist that can be attributed to children or even grandchildren of seventeenth and early eighteenth century German emigrants to Pennsylvania. Only seven Pennsylvania German samplers stitched prior to 1775 have been recorded. Additionally, while more than 1,500 decorated towels have been recorded, only three examples pre-date 1793.[10] These three examples exhibit only a single decorative motif, thus barely qualifying as decorated towels. The paucity of eighteenth century decorated textiles suggests that few of the daughters or granddaughters of early Pennsylvania German immigrants stitched decorative needlework, even though it was a part of their traditional folk culture. In all probability the demands of pioneer life caused a temporary cessation of some folk traditions that were not as necessary for sustaining and advancing the agricultural communities of these early settlers. It was production of textiles and the creation of clothing and bedding that was most important. Any decoration that might be lavished on those objects was desirable, but dispensable.

During the last decades of the 1700s, a rebirth of interest in traditional decorated textile forms occurred among Pennsylvania German needleworkers, including the introduction of a variety of new forms: the wedding handkerchief (fig. 256), the decorated apron (fig. 257), the decorated thread case (fig. 258), decorated pillowslips (fig. 262), and decorated towels (fig. 260). By the

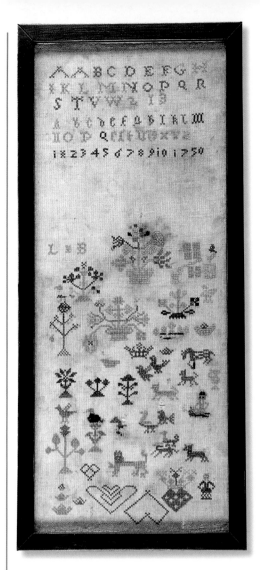

Figure 255. Random-style sampler, dated 1750, initialed "EB," likely for Lisbet (Elisabeth) Bear (c. 1732-after 1771) of East Hempfield Township, Lancaster County. This sampler is the second-earliest recorded Pennsylvania German sampler. In addition the upper- and lowercase alphabets and numerals, the needleworker recorded a wide range of cross-stitched motifs that she could eventually copy on to other textiles. *Linen fabric, silk threads, 16.25" x 6.75". Collection of Dr. and Mrs. Donald M. Herr.*

Opposite page, top left: Figure 256. Wedding handkerchief, dated 1787, made by Barbara Strickler (1762-1805), working in Rapho Township, Lancaster County. A small group of young Mennonite women, living in northwestern Lancaster County, stitched most of the recorded examples of wedding handkerchiefs, which are among the rarest forms of decorated Pennsylvania German textiles. Barbara Strickler, the needleworker who created this exceptional example, worked the following inscription, which translates: "Barbara Strickler. In the year 1787. On this little handkerchief there stands a star. When I eat I am pleasantly full." Barbara married John Lehman (1761-1839), a fuller. They resided in Rapho Township. *Homespun linen, silk threads, 18.5" x 18.5". Collection of the Hershey Museum.*

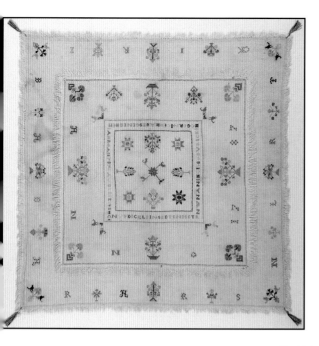

mid-1790s, needleworkers were not only decorating their towels with cross-stitch decoration but also extensively utilizing drawnwork panels to add another dimension of decoration to their textiles (figs. 260 and 271). To create a drawnwork panel, threads were carefully removed from the textile. The remaining threads were bound together to create a gridwork. Using white cotton embroidery flosses, the needleworker would then create designs on the gridwork with the use of darning stitches. When drawnwork towels were hung on the brightly painted doors of the Pennsylvania German stoveroom, the background color would show through and accentuate the delicately stitched open-work panels. The art of drawnwork seems to have been particularly popular among the young Mennonite needleworkers of Lancaster County, who not only stitched many exceptional towels, but incorporated drawnwork panels into their tablecloths as well (figs. 72, 259, and 261).

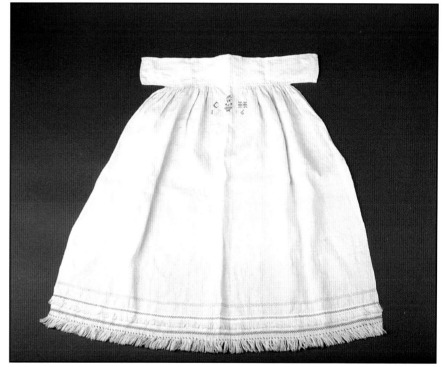

Figure 257. Decorated apron, dated 1786. Needleworker is unknown. Descended in the family of Peter Risser (1818-89) and Catherine (Horst) Risser (1818-91) of Mount Joy Township, Lancaster County. Decorated aprons, a rare form of Pennsylvania German textile, are believed to have been produced as part of a woman's wedding outfit. All recorded examples possessing any provenance have been traced to Mennonite families residing in Lancaster County. This example, like most, is stitched from handspun handloomed cotton yardage; it bears the initials "CH" stitched in silk thread. *Homespun cotton, silk, threads, 26" x 25". Private collection.*

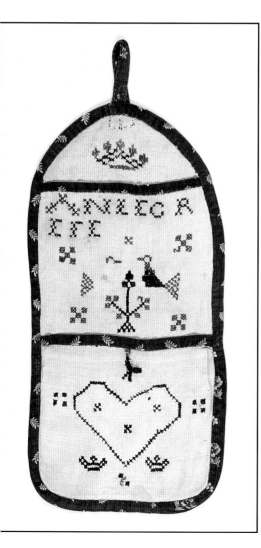

Figure 258. Thread case, c. 1795-1810, stitched by Anle Grefe (Anna Groff) (1780-after 1827). Anna Groff created this thread case to store her embroidery flosses and needles. Cross-stitched examples such as this are a rarity among Mennonite textiles. Anna Groff (fig. 186) was the daughter of Marx Groff and Feronica (Meyer) Groff of West Earl Township. Anna, who never married, is also known to have stitched a small sampler and a decorated towel. *Homespun linen fabric, cotton print binding, cotton and silk threads, 13" x 6". Collection of Dr. and Mrs. Donald M. Herr.*

Among the rarest forms of Pennsylvania German needlework known are the wedding handkerchief (fig. 256) and the decorated apron (fig. 257). The creation of both textiles seems to have been largely confined to Mennonites living in northwestern Lancaster County. Only twelve decorated aprons have been recorded, all dating from 1786 to 1800.[11] It appears likely that they were stitched by only a few families during a short period of time. It is also probable that the apron was a part of the wedding outfit and was a survival of a regional Germanic tradition that was carried to Lancaster County by only a few emigrating families. In some instances the initials that appear on the apron are likely those of the groom rather than the bride. The illustrated example is dated 1786 and is the earliest recorded decorated apron. The identity of "CH" is unknown; however, the object has a long history of ownership by Mennonite families living in Mount Joy Township, Lancaster County.

The decorated handkerchief is a textile form that is nearly as rare as the decorated apron, with only twenty-one examples recorded (figs. 64 and 256).[12] Nearly all examples are dated from 1768 to 1809. The creation of this textile also appears to be largely confined to Mennonite needleworkers living in northwestern Lancaster County. The exceptional handkerchief stitched by Barbara Strickler in 1787 (fig. 256) is the finest example known. Fortunately for historians her great-granddaughter, Dr. Lizzie Cassel, attached a note identifying it as a wedding handkerchief. The inclusion of a decorated handkerchief as part of the wedding outfit has been documented in several Germanic regions of Europe. The maker of this handkerchief, Barbara Strickler (1762-1805), was likely well acquainted with Feronica Schneider (1767-1856), the needleworker who stitched the example seen in figure 64. Both young women attended the Rapho Mennonite Meetinghouse (Hernleys) near Manheim, Lancaster County.

The social life of eighteenth and nineteenth century Mennonites was largely centered around their church community. The organization of their weekly religious services afforded numerous opportunities for young needleworkers to have first-hand exposure to the sewing arts of others within their community. Congregations were organized by the church district and shared their ordained leadership: deacons, preachers, and bishops within their district. While some congregations constructed meetinghouses at an early date, others continued to worship in private homes, some for more than a century prior to building their first meetinghouse. The homes that they worshiped in were typically the larger homes of the community. The services would generally be held on a rotating basis among several households. The Old Order Amish of Lancaster County still observe this practice. This arrangement presents an obvious opportunity for the transfer of folk traditions, or even the latest innovations, from one household to another. My home in Warwick Township, Lancaster County, was built c. 1744 and was likely used for church services for more than a century.[13] The largest room, the stoveroom, has two doors, both of which were fitted with wooden pegs to suspend decorated towels. It is easy to imagine that the young needleworkers who occupied the house took great delight in having their decorated towels and tablecloths prominently displayed during the meetings that were held in their home.

As more meetinghouses were constructed, the pattern of alternating worship services continued. The meetinghouse was used for services only every few weeks. In the days when people walked or rode horseback to meetings, it was thought that by alternating locations it would provide the membership with services held close to their homes at least every few weeks. If they wished to attend services every week, they would be required to travel. This reality also contributed to the diffusion of folk trends within the community, as the

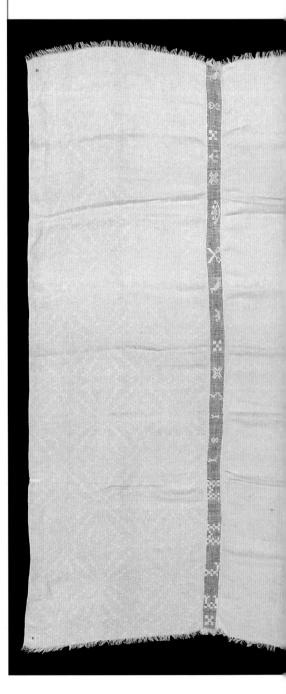

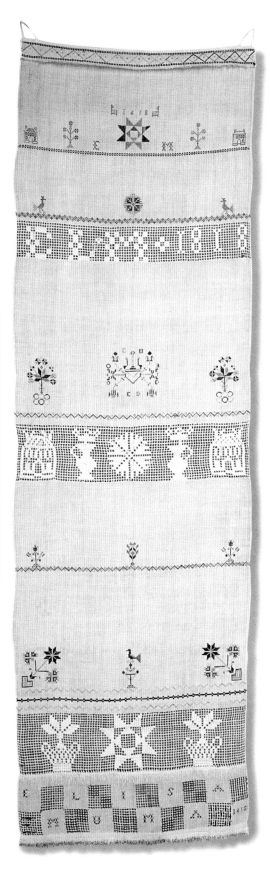

local hosts of the week's services would frequently invite the families who had traveled a distance to accompany them home, where they would provide a meal and plenty of opportunity for social interaction. Considering this regional pattern of co-mingling, it is no surprise that some textile forms and motifs used by Mennonite needleworkers seem to be of localized origins and regionally confined development. Among some Lancaster Conference districts, the custom of alternating services continued into the early 1900s.

Young Mennonite women spent their teen years perfecting their domestic skills, including the sewing arts. They typically "marked" or embroidered their name or initials on the substantial quantity of household textiles that they would require when they commenced housekeeping. Utilitarian towels required hemming along one side, creating a fringe along the bottom edge, and applying hanging loops at the top of the towel. Tablecloths were formed from two looms' widths of yardage and needed to be joined by a sewn center-seam. The ambitious needleworker could create a needle-lace center-seam or insert a drawnwork band (figs. 259 and 261) on her tablecloth. The finest tablecloths would combine cross-stitch decoration with drawnwork skills. Elisa Muma (1799-1836) was only sixteen years old when she stitched her tablecloth (fig. 259). The towel that she created three years later in 1818 exhibits a variety of cross-stitched motifs, as well as boldly executed drawnwork panels (fig. 260). The towel and tablecloth were undoubtedly her finest textiles, and as such they were seldom used. Most young women would stitch only one highly decorated towel; however, a few enthusiastic needleworkers are known to have produced several examples.

Opposite page: Figure 259. Tablecloth, dated 1815, initialed "ELMM" for Elisa(beth) Mumma (1799-1836), of Donegal Township, Lancaster County. This tablecloth is one of a group of similarly constructed table coverings that utilize a wide drawnwork band to join two loom-widths of patterned linen yardage. Their popularity seems to have been confined to a small group of Mennonite needleworkers in northwestern Lancaster County. Elisa was sixteen years old when she created her tablecloth. Three years later she stitched her decorated towel (fig. 260). To create her drawnwork band, she first took plain-weave linen, cutting and removing threads to form a grid. Then she formed the designs using cotton threads and darning stitches. Elisa designed her tablecloth for use in a traditional Pennsylvania German stoveroom, where the table always stood in the front corner next to the corner benches. All of her motifs are designed to be seen from one direction when placed on the table; visitors passing through the room would see the decoration in its proper perspective. Only the children sitting on the bench along the wall, behind the table, would see the wrong side of her needlework, and they would likely be too busy eating to care. *Linen fabric, cotton flosses, 70" x 45.5". Private collection.*

Left: Figure 260. Decorated towel, dated 1818, marked "EM," "ELM," and "ELISA MUMA," for Elisa (beth) Mumma (1799-1836), of Donegal Township, Lancaster County. A skilled needleworker, Elisa was adept at drawnwork (fig. 259) as well as counted cross-stitch embroidery. She executed several motifs, notably the house and snowball design, in both cross-stitch and drawnwork. The three-pronged crown that tops the single-handled pot is the only motif that she borrowed from her tablecloth of 1815. Elisa was the daughter of Jacob and Anna (Kraybill) Mumma of Donegal Township, Lancaster County. She married Jonas Nolt (1796-1848), a farmer in West Hempfield Township, Lancaster County. *Homespun linen fabric, silk and cotton threads, 60" x 17", band measures 2". Private collection.*

Decorated textiles were stitched by Pennsylvania German women of all denominations, but it is clear that young Mennonite women seem to have had a particularly keen interest in the traditional sewing arts. While it is frequently stated that members of the sectarian denominations, Amish, Dunkard, Mennonites, and Schwenkfelders constituted less than ten percent of the Pennsylvania German population, they seem to have produced disproportionately higher numbers of the surviving folk textiles than have their non-sectarian neighbors. In Tandy and Charles Hersh's 1991 landmark study of Pennsylvania German samplers, more than half of the recorded samplers that bear the maker's name can be identified as having been stitched by Mennonite or Amish needleworkers.

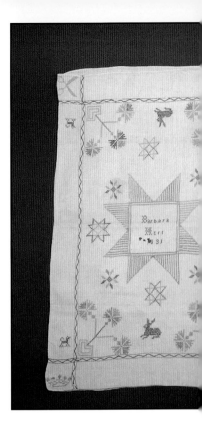

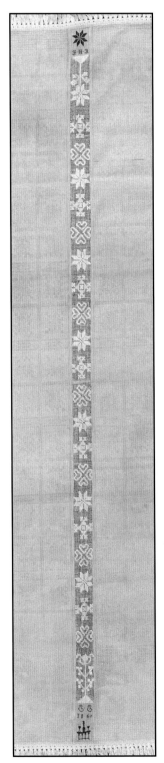

Figure 261. Tablecloth detail, dated 1860, initialed "EHE" and "EE," probably stitched by Elizabeth H. Erb (1844-1927) of Warwick Township, Lancaster County. Elizabeth used a variety of drawnwork motifs to decorate her center panel. She added the square pieces of plain-weave linen at both ends of the drawnwork panel to strengthen the center seam. The pieces also provide a canvas for cross-stitch decorations (figs. 71 and 72). The table, with its wine glasses and a decanter, was a favored motif among Mennonite needleworkers in northwestern Lancaster County. Mary Hess (1815-88), the mother of Elizabeth, stitched a related tablecloth in 1834 at the time of her marriage to Daniel S. Erb. *Linen twill-weave fabric, cotton fringe, cotton threads, 70" x 62.75", band measures 1.75". Private collection.*

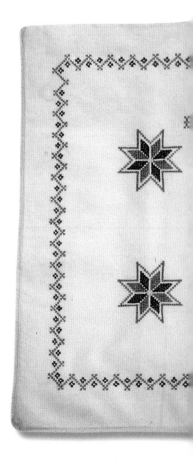

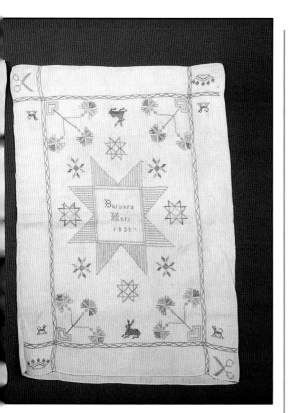

Figure 262. Pair of pillowslips, dated 1831, stitched by Barbara Herr, likely working in Manor Township, Lancaster County. Highly decorated pillowslips are rare among Pennsylvania German textiles. Barbara Herr stitched this pair in counted cross-stitch using silk and cotton threads. She selected some unusual motifs, including the scissors and the oversized rabbits being watched by attentive dogs. *Homespun linen fabric, silk and cotton thread, 24.5" x 17". Collection of Dr. and Mrs. Donald M. Herr.*

The decorated towels and samplers were by far the most frequently decorated textiles to be found in the Pennsylvania German household. Other textile objects were occasionally the recipient of traditional cross-stitch embroidery decoration as well. The thread case seen in figure 258 is a form that was rarely produced by Mennonite needleworkers. The maker of this thread case, Anna Groff (1780-after 1827), was a former student of schoolmaster Christian Alsdorff. As an unmarried woman, she perhaps had more time to experiment and stitch unusual textile forms.[14] This case would have held her embroidery flosses, and likely her needles as well. Anna and her family were members of the Groffdale Mennonite congregation in West Earl Township, Lancaster County.

Other domestic textiles that were seldom highly decorated include sheets, bolster covers, and pillowslips (figs. 262 and 263). The pair of exceptional pillowslips seen in figure 262 are among the most elaborately stitched examples known. They were doubtless inspired by a pair of similarly decorated examples that were stitched five years earlier, in 1826, by Maria Herr, who was most likely an elder sister of Barbara Herr. Barbara outdid her sibling's efforts with the addition of dogs, rabbits, and the grouping of star motifs that surround the large central star. The brilliantly colored pillowslip seen in figure 263 is far simpler in design than are the Herr examples. The maker, Maddy (Magdalena) Shirk, created a bold expression of the Mennonite needleworkers' art, with the use of a strong border and graphic motifs. While highly decorated cross-stitched pillowslips were never common in Pennsylvania German households, the pieced pillowslip tradition experienced great popularity, especially among the Mennonite quilters in Lancaster County (figs. 281-289).

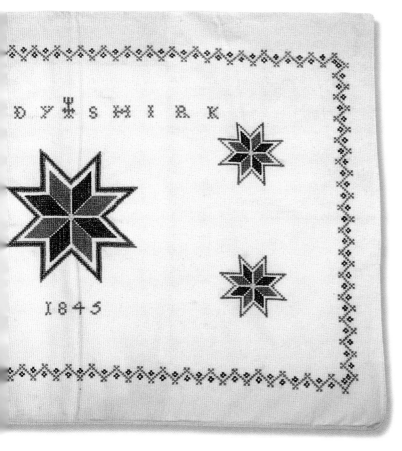

Figure 263. Decorated pillowslip, dated 1845, stitched by Maddy (Magdalena) Shirk, probably in Lancaster County. This is one of a pair of finely decorated pillowslips. Could their owner Maddy Shirk be Magdalena (Weber) Shirk (1787-1874), the widow who lived with her sister Anna Weber (1796-1876), the seamstress (figs. 248 and 249)? Perhaps it is even more likely that Maddy Shirk is actually Mattie W. Shirk (1826-1904), the nineteen-year-old daughter of Magdalena (Weber) Shirk. Young Mattie lived with her mother and her aunt, Anna Weber, marrying at age fifty; she may well have supported herself by doing needlework, as did many unmarried adult women. *Homespun linen fabric, cotton threads, 16" x 24.75". Collection of Dr. and Mrs. Donald M. Herr.*

The traditional role of the sampler in the Pennsylvania German household was ultimately influenced by contact with the Anglo needleworking traditions of their English neighbors. The Mennonites, like the broader Pennsylvania German community, traditionally used the sampler as an object on which to record their assembled collection of alphabets, numerals, and cross-stitch motifs. In their folk tradition the sampler was a functional textile object that was normally kept in the sewing basket or chest and was used for reference when making household textiles. Unlike the decorated towel, they were never intended as an object to be displayed. Their English neighbors, however, practiced an ancient tradition of decorative needlework, creating samplers that were fully intended for display. They also had a tradition of teaching their young women the needle arts in a school setting. Indeed, numerous needlework teachers operated schools in the cities and larger towns of eastern Pennsylvania. Although they are uncommon, some school samplers stitched by Mennonites have been recorded (fig. 265).

When Elisabeth Oberholtzer (1800-79) stitched her random-design sampler in 1817 at her Bucks County home, she incorporated a number of cross-stitch motifs that were in use by her English Quaker neighbors. Although the sampler that she created was still in the traditional form, it demonstrates that non-Germanic influences were already entering the folk textile traditions of the Mennonites. Lydia Freed stitched her sampler at age fifteen in 1826 (fig. 265). Her parents were Mennonites who had moved from Montgomery County, Pennsylvania, into Salisbury Township, Lancaster County. The community that the Freeds arrived in, Salisbury Township, was a region with a large En-

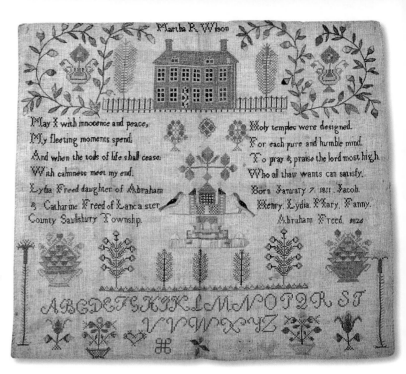

Figure 265. School-type sampler, dated 1826, stitched by Lydia Freed (1811-89), living in Salisbury Township, Lancaster County. This English-style school sampler was stitched by Lydia under the watchful eye of Martha R. Wilson, her instructress in needleworking. It appears that only a small percentage of Mennonite girls attended young ladies' schools to learn the sewing arts. The vast majority were taught needlework skills by their mothers or grandmothers. The Freed family moved from Montgomery County, Pennsylvania, to Salisbury Township, in eastern Lancaster County. Lydia Freed was the daughter of Abraham and Catharine (Eckert) Freed. *Linen, silk threads, 17.5" x 20.5". Collection of the Lancaster Mennonite Historical Society.*

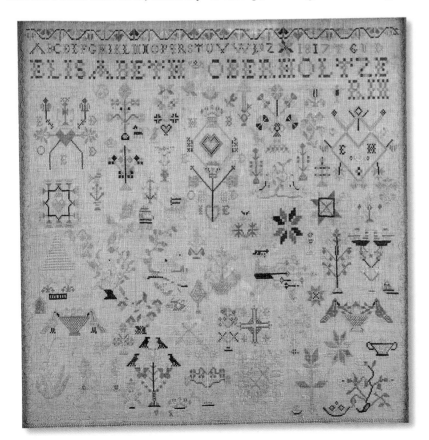

Figure 264. Random-type sampler, dated 1817, stitched by Elisabeth Oberholtzer (1800-79), living in Bedminster Township, Bucks County, Pennsylvania. Stitched by a young Mennonite woman, this sampler includes traditional Pennsylvania German motifs as well as motifs borrowed from the needlework traditions of the neighboring English Quakers. It documents the trans-cultural influences that occurred at relatively early dates, when small Mennonite populations came into regular contact with the predominant Anglo community. Elisabeth was the daughter of Henry and Mary (Nash) Oberholtzer. Her husband, Daniel Gross (1784-1875), was a deacon in the Doylestown Mennonite Congregation. *Linen, silk threads, 21.5" x 21.75". Collection of the Mennonite Heritage Center, Harleysville, Pennsylvania. Nathan Cox Photography.*

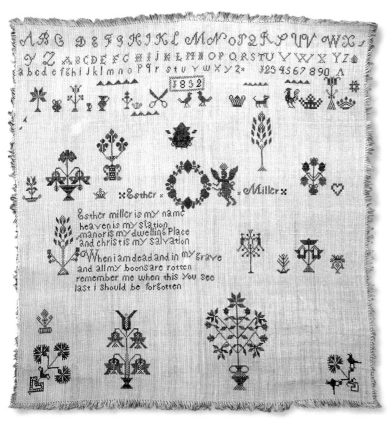

glish population. The sampler that young Lydia Freed stitched, under the instruction of Martha R. Wilson, is a typical example of an English-style school sampler. Although intended for display, this sampler has never been framed. Perhaps its public display was viewed as too prideful for the conservative Freed family. Lydia, who never married, is buried in Lichty's Mennonite Cemetery, East Earl Township, Lancaster County.

Old habits die hard, and perhaps old needlework traditions die even more slowly. As popular Anglo needleworking forms, such as the symmetrical school-type samplers, and needlework pictures continued to enter the repertoire of Pennsylvania German needleworkers, the traditional random-style marking sampler still continued to occupy a prominent spot in their needle arts. The two samplers seen in figures 266 and 267 were both stitched in 1832 by fourteen-year-old Mennonite girls living in Manor Township, Lancaster County. Both needleworkers, Esther Miller (1818-1904) and Elisabeth Neff (1818-65), stitched traditional Pennsylvania German marking samplers. While Esther employed cotton embroidery threads to create her randomly placed motifs, Elisabeth used mostly silk threads and organized her motifs in rows with more care given to their balanced placement. Esther chose to include a popular English rhyme that had entered the tradition of many Lancaster County Mennonite needleworkers: "Esther Miller is my name / heaven is my station / manor is my dwelling Place / and Christ is my Salvation / When I am dead and in my grave / and all my boons [sic] are rotten / remember me when this you see / last [sic] I should be forgotten." It is also significant to note that Esther included the letter "J" in her alphabet. The letter is absent from Elisabeth's sampler and was not traditionally included in the Pennsylvania German alphabet, where "I" was used to represent both "I" and "J." The inclusion of this letter and the English verse are both signs of the gradual assimilation of the Pennsylvania German population by the larger English culture.

Figure 266. Random-type sampler, dated 1832, stitched by Esther Miller (1818-1904) living in Manor Township, Lancaster County. Samplers such as this were not intended for display but rather fulfilled the traditional role of the Pennsylvania German sampler, as a means of recording needlework motifs for eventual use on other decorated textiles. For this reason little thought was given to the placement of the motifs for her sampler. Esther chose traditional Pennsylvania German motifs for her sampler. The angel with wreath motif is unusual, but such designs have been recorded on a few other Mennonite textiles from the Manor Township region. Esther and her four sisters never married. They were the daughters of John Miller (1784-1868) and his wife Nancy Kauffman (1781-1863); see figure 185. *Homespun linen, cotton threads, 17.5" x 17.5". Collection of Eugene and Vera Charles.*

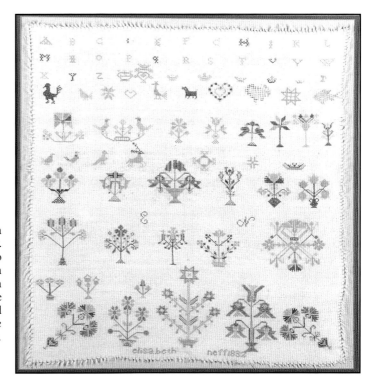

Figure 267. Rowed sampler, dated 1832, stitched by Elisabeth Neff (1818-65), living in Manor Township, Lancaster County. The needleworker selected fifty-two different motifs to decorate her sampler, including a fish, which has been recorded on a few other Manor Township textiles. Elisabeth Neff, who never married, is buried at Masonville Mennonite Cemetery. She was the daughter of Henry Neff (1787-1854) and Susan (Neff) Neff (1786-1870). *Homespun linen, cotton and silk threads, 17" x 17". Collection of Esther Glick.*

151

A few years later, in 1838, Catherine Binkley (1826-82) stitched her sampler (fig. 268). As with the preceding two samplers (figs. 266 and 267), Catherine decorated her textile with a wide assortment of traditional cross-stitched motifs. She seems to have had a penchant for birds, as she included nine of them. While she worked primarily in cross-stitch, Catherine stitched a few floral motifs in the upper corner, using chain-stitch. Her use of highly unusual motifs, such as a beetle and a stick figure perched above a tulip tree, are reminders of the individualistic self-expression that these traditional samplers encouraged. The end result was a textile that was often filled with whimsy and charm, and was in fact a personal expression of not only the needleworkers' art, but of her soul as well.

When needleworker Anna Burkholder stitched her sampler she included a German text, which translates, "The cloth is the field on which I can work, the needle is my plow by which I work beautifully and cleverly. The thread is the line on which I sow finely. This cloth belongs to me Anna Burkholder, made in the year of our Lord 1837." Anna's sentiment underscores the role that decorative needlework played within the Pennsylvania German culture, as a means of affirming the skills and the imagination of adolescent needleworkers.

The sampler seen in figure 269 was stitched by eighteen-year-old Catharine Reist (1828-1902) as she prepared for her 1847 marriage to Henry L. Landis (fig. 270). Catharine stitched her sampler in the latest style, employing brightly colored wool embroidery flosses for her cross-stitch work. The designs that she chose to stitch on her sampler were the naturalistic floral motifs and borders that were rapidly replacing the centuries-old, stylized cross-stitch motifs. Upon completion, Catharine's needlework picture was framed in the mahogany veneer frame that it still retains. Catharine's sampler represents a late phase in Mennonite needle arts, when the then-current needlework fashions had finally all but overwhelmed the Germanic needlework traditions. She was also of the last generation to learn the traditional cross-stitch skills by her mother's side. She would then spend most of her life immersed in the newly adopted quilting tradition (fig. 292).

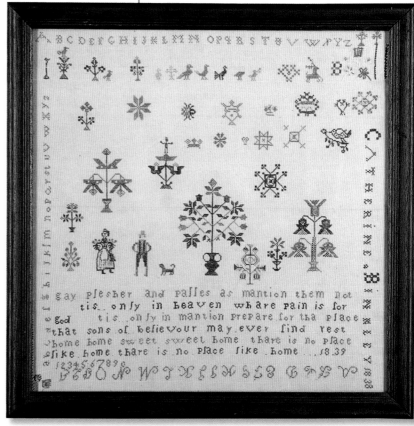

Figure 268. Random-type sampler, dated 1838 and 1839, stitched by Catherine Binkley (1826-82), living in Manor Township, Lancaster County. Twelve-year-old Catherine chose a curious assortment of birds, tulip trees, and people to adorn her sampler. The female figure is exceptional, in her striped petticoat, carrying a handbag, with her arms loaded with flowers. Her English verse is spelled phonetically and was intended to read as follows: "Gay pleasure and palaces mention them not / tis only the heaven where pain is forgot / tis only in mansions prepared for the place / that sons of believers may ever find rest / home home sweet sweet home, there is no place / like home, there is no place like home 1839." Catherine was the daughter of Christian Binkley (1794-1872), a miller and a farmer in Manor and West Hempfield Townships, Lancaster County. In 1845 Catherine married Henry F. Herr (1822-95). They resided near Columbia, Lancaster County. *Homespun linen, cotton and silk threads, 18" x 18". Private collection.*

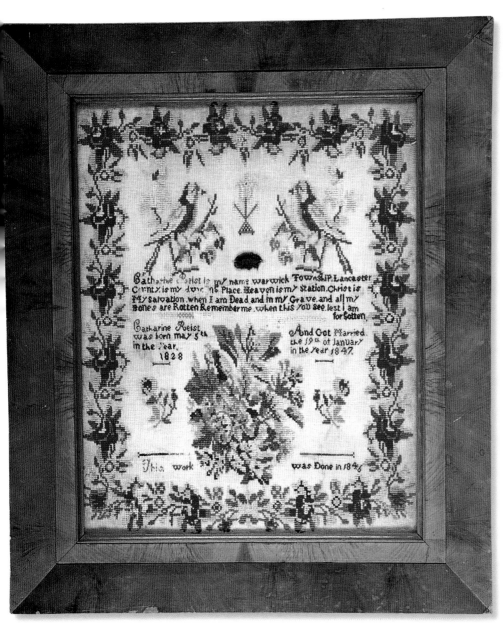

Figure 269. Sampler, dated 1846, stitched by Catharine Reist (1828-1902), living in Warwick Township, Lancaster County. This sampler differs greatly from the traditional Pennsylvania German form. The cotton and silk embroidery flosses have been replaced by brilliantly colored wool threads. Also excluded are most of the centuries-old traditional motifs, replaced here by naturalistic floral designs. This sampler was intended for display, and it still retains the original mahogany veneer frame. The inscription reads: "Catharine Reist is my name Warwick Township Lancaster / County is my dwelling Place. Heaven is my station. Christ is / My Salvation. When I am Dead and in my Grave and all my / Bones are Rotten Remember me. When this you see. lest I am / forgotten. Catharine Reist was born May 5th in the year 1828 / And Got Married the 19th of January in the year of 1847/ This work is Done in 1846." The maker, Catharine Reist (fig. 270), was a skilled needleworker whose sampler quilt is seen in figure 292. After completing her sampler, Catharine added a record of her marriage. She probably intended to add the initials of her children at a later date as she placed her needle with additional black floss in the upper center region of her sampler. Catharine likely never found the time to complete her intentions, as she and her husband, Henry L. Landis (1829-96), raised a family of fourteen children. *Mahogany veneers over pine, linen, wool flosses, 20" x 16". Private collection.*

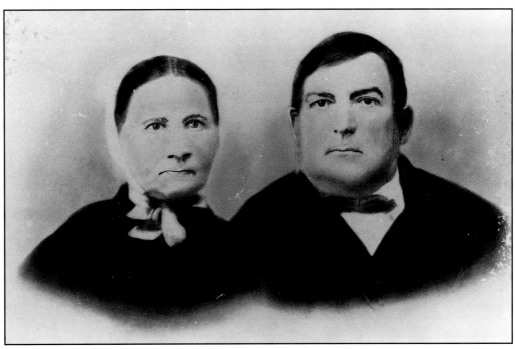

Figure 270. Photograph of Henry L and Catharine (Reist) Landis, c. 1885, by an unknown photographer. Henry L. Landis (1829-96) and his wife Catharine (Reist) Landis (1828-1902) were prosperous farmers in Manheim Township, Lancaster County. They were Mennonites who attended the Landis Valley Meeting-house. Catharine was a skilled needleworker who stitched the sampler seen in figure 269. *Image courtesy of the Lancaster Mennonite Historical Society, Joanne Hess Siegrist Collection.*

The Pennsylvania German decorated towel was by far the most common form of decorated needlework, with more than 2, 000 surviving examples known. Early examples stitched prior to 1800 are typically sparsely decorated, but they often boast elaborate integral drawnwork panels (fig. 271). The popularity of drawnwork continued into the nineteenth century (fig. 260), but cross-stitch decoration soon surpassed drawnwork in popularity. Both techniques required precision needleworking skills to successfully produce a decorated towel that displayed exacting symmetry and tight stitching. The quality of the completed towel obviously varied according to the skills of the needleworker. Typically a Pennsylvania German girl first stitched her sampler, and then within a few years would complete a decorated towel. In most instances the decorated towel represented the finest efforts of her needleworking skills.

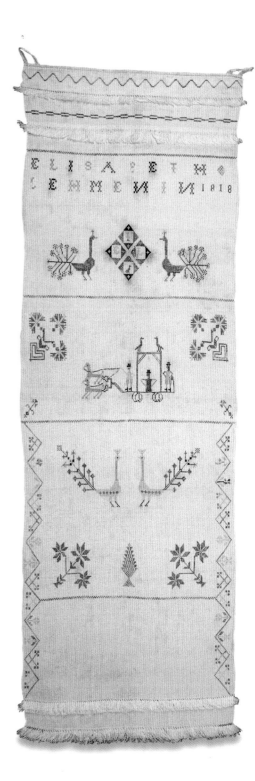

Figure 271. Decorated towel, dated 1799, stitched by "AH," Anna Hershey (1779-1864) probably living in Hempfield Township, Lancaster County. "AH" was the aunt of Anna H. Hershey (1810-55), who married Jacob Martin (1808-70) of Manor Township, and in whose family this towel descended. Eighteenth century Mennonite needleworkers frequently decorated their towels with wide bands of drawnwork, a decorative technique that was far more labor-intensive then was the counted cross-stitch form of decoration. Anna Hershey (1779-1864) was the daughter of Mennonite Bishop Jacob Hershey (1747-1819) and his wife Elizabeth (Eby) Hershey. *Homespun linen, silk and cotton threads, 60" x 17". Private collection.*

Figure 272. Decorated towel, dated 1818, stitched by Elisabeth Lehmen (1798-1890), living in Greene Township, Frankin County, Pennsylvania. Elisabeth chose to decorate her towel with motifs that were popular in the Warwick Township area of northern Lancaster County. The horse and carriage motif is an intriguing design that appears on only a few Pennsylvania German towels and samplers. *Homespun linen, silk and cotton threads, 51" x 17". Collection of the Heritage Center Museum.*

Decorated towels enjoyed tremendous popularity in Pennsylvania, especially in the areas east of the Susquehanna River. Far fewer examples were stitched in the Mennonite settlements in central and western Pennsylvania. The example seen in figure 272 was stitched in 1818 in Greene Township, Franklin County, Pennsylvania, by Elisabeth Lehmen (1798-1890). Her parents had relocated from Rapho Township, Lancaster County, in 1796, settling on a farm in Greene Township. The towel that Elisabeth stitched includes two peacock motifs and an unusual horse and carriage design that appear on earlier textiles stitched in the Warwick-Rapho Townships region of northern Lancaster County. The large scale that she chose to stitch her motifs created a towel with unusually bold graphics. Elisabeth had stitched a towel that closely mirrored her family's Lancaster County origins, but it was a form that would never flourish in the large Mennonite community of Franklin County, Pennsylvania, and the adjoining Washington County, Maryland.

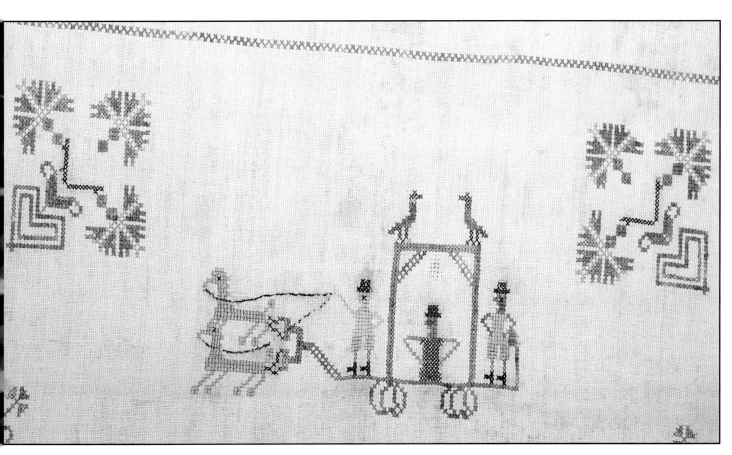

Figure 273. Detail of horse and carriage motif, from the towel stitched in 1818 by Elisabeth Lehmen (1798-1890). This motif appears on towels stitched by both Elisabeth and her sister Anna Lehman (1791-1859). The sisters were daughters of John and Maria Lehman, who left Lancaster County in 1796, joining numerous other Mennonites who had relocated to Franklin County, Pennsylvania. The maiden sisters could only have been inspired by an older relative's towel or sampler that was carried from Lancaster to Franklin County.

The origins and development of textile traditions within the Mennonite communities are fascinating subjects for study. The primary mode of transmission is from mother to daughter, and surviving groups of multi-generation textiles can often document this. Similarly, textiles stitched by siblings have been studied, with the expected results: a close relationship sharing quality, style, and common motifs. Occasionally, seemingly unrelated textiles are discovered that share so many similarities that we are intrigued by their obvious yet unexplained relationship. The two towels appearing in figures 274 and 275 are classic examples. The earlier example was stitched in 1838 by Fanny Stehman (1825-1864), the thirteen-year-old daughter of John and Anna (Reist) Stehman of Manheim Township, Lancaster County. Six years later the piece shown in 1846, figure 275, was stitched by Mary (Stoner) Sheirk, who was about thirty-eight years of age and was a married farm wife living a few miles to the north of the Stehman home, in Penn Township. The similarities between the two textiles are striking. Mary Sheirk copied every motif and the entire text appearing on Fanny's towel onto the textile that she stitched for her ten-year-old son, Samuel Sheirk. The two women were unrelated. How then did this transfer of design occur?

Fanny Stehman was only four years old when her father John Stehman died, leaving a widow and three children. It is likely that when Fanny reached her teen years she was "hired out" as was the custom. She probably went to live with her youngest aunt, Magdalena (Stehman) Summey (1807-1876), and her husband John N. Summey, who owned a large farm in Penn Township. Their farm was conveniently located next to the farm of Daniel and Mary (Stoner) Sheirk, and in fact their two farmhouses were only a short distance apart. Fanny Stehman was twenty-one when Mary Sheirk copied her towel. Her likely presence in her aunt Magdalena's home provided Mary Sheirk with ample opportunity to copy her decorated towel in detail.

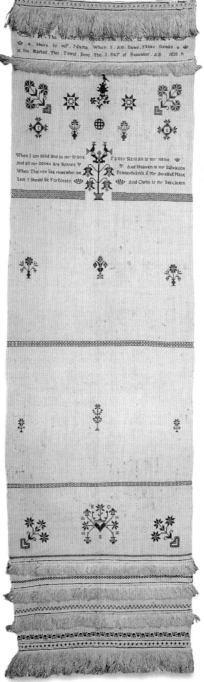

Figure 275. Decorated towel, dated 1846, stitched by Mary (Steiner) Sheirk (born c. 1808), living in Penn Township, Lancaster County. The towel was made for her ten-year-old son, Samuel Sheirk (1836-96). Mary Sheirk appears to have had access to the towel stitched by Fanny Stehman eight years earlier (fig. 274). She copied every motif appearing on Fanny's towel as well as the entire text, including her idiosyncratic capitalization. Mary stitched her motifs on a wider piece of linen, adding several motifs, including the large bird tree that had appeared on a towel she created in 1833. Mary was a daughter of David Steiner (1777-1856) and Barbara (Mayer) Steiner of Manheim Township, Lancaster County; about 1834 she married Daniel Sheirk (born c. 1805). *Homespun linen, cotton thread, 62" x 19". Private collection.*

Figure 274. Decorated towel, dated 1838, stitched by Fanny Stehman (1825-64), living in Manheim Township, Lancaster County. Fanny utilized traditional cross-stitch motifs as well as popular English rhymes to decorate her towel. The sphere and her band motifs were directly copied from the page "For Marking On Linen" that was included in the 1831 edition of Carl F. Eglemann's copybook. Fanny was the daughter of John Stehman (1793-1829) and Anna (Reist) Stehman. In 1851 she married John S. Huber (1820-1911). *Homespun linen, cotton thread, 60" x 16.5". Private collection.*

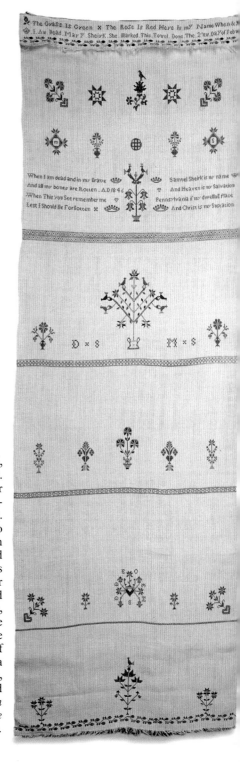

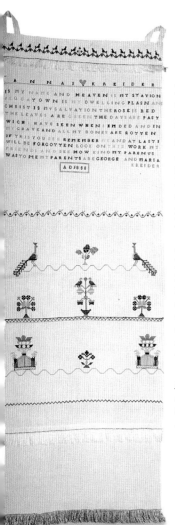

Figure 276. Decorated towel, dated 1858, stitched by Anna S. Kreider (1838-1927), living in Pequea Township, Lancaster County. Anna Kreider was the daughter of George Kreider (1796-1870) and Mary (Swarr) Kreider (1804-69). As the ninth of ten children, Anna was influenced by her elder sisters. In 1844 her eldest sibling, Mary Kreider (1822-98), stitched a decorated towel. Fourteen years later Anna borrowed several motifs and much of the text from Mary's work and used it on her own towel. Unlike her sister, who stitched her motifs entirely in cotton thread, Mary employed the more colorful wool flosses to enliven her textile. *Homespun linen, wool flosses, 52" x 17". Collection of the Heritage Center Museum through the generosity of Hampton C. Randolph, Sr.*

Figure 277. Decorated towel, dated 1849, stitched by Elisabeth Martin, living in Waterloo County, Ontario. This exceptional example of the needleworker's art is the most elaborate towel known to have been produced in Ontario. Many of the twenty-seven motifs that she chose to embroider on her towel reflect the Lancaster County origins of her Martin family. However, the Adam and Eve motif appearing on the top panel is all but unknown on Lancaster County examples. It more frequently appears on the decorated towels of the Franconia region. These motif selections reflect the blending of traditions that occurred in the Waterloo County region. *Homespun linen, silk and cotton threads, 47" x 19". Collection of the Joseph Schneider Haus, Kitchener, Ontario.*

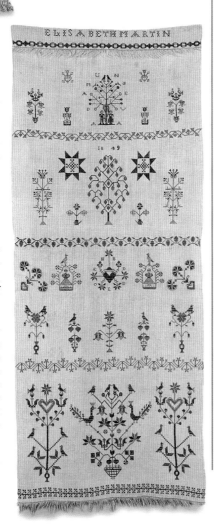

The production of decorated towels peaked during the 1830s, as the towel tradition continued to evolve. By 1835 there was a revival of interest in stitching free-form decorated towels among the young Mennonite women who lived in northern Lancaster County.[15] These towels were generally stitched in chain-stitch, using brilliantly-colored wool flosses (fig. 76). This was quite a departure from the traditional counted cross-stitch technique, as motifs first needed to be drawn on paper, then transferred to the towel with the use of paper patterns. The resulting textile is far bolder in appearance than are the more typical cross-stitched examples. Wool threads were also used on towels that were stitched in cross-stitch (fig. 276). This towel was stitched in 1858, at a time when young Mennonite needleworkers were rapidly losing interest in the form. The maker of this towel, Anna S. Kreider (1838-1927), probably stitched it more out of duty than desire. She likely felt the obligation to complete the task that her elder siblings had already dutifully fulfilled.

The decorated towel tradition never survived the transplant into the Mennonite settlements in the Shenandoah Valley of Virginia, or into Ohio, where numerous Lancaster County Mennonites settled in the 1820s and 1830s, during the peak years of popularity of the textile form. Surprisingly, though it was in the fertile fields of Waterloo County, Ontario, where the textile tradition rooted and flourished for decades. A superb example of a decorated towel was stitched by Elisabeth Martin in 1849 (figure 277). Elisabeth was a descendant of the Martin families that left Earl Township, Lancaster County, about 1820 and settled in the Mennonite community in Waterloo County. Her towel is a virtual catalog of cross-stitch motifs, with many originating in her family's Lancaster county homeland. Decorated towels enjoyed their greatest period of popularity among the Mennonites of Waterloo County from c. 1840 to 1872, ultimately being replaced by other needlework forms.

The production of decorated towels by the Lancaster County Mennonites had largely ended by 1860. A few surviving examples have been recorded as late as 1890. Among the Franconia Mennonites the decorated towel tradition carried on somewhat longer. However, it was the Old Order Amish of Lancaster County who carried tradition well into the twentieth century, often employing Victorian-style turkey-red embroidery to decorate their towels.

As the nineteenth century passed its midpoint, the production of most traditional Pennsylvania German decorated textile forms faltered, and soon they existed only in the memories of the older needleworkers. The decline of those traditional forms coincided with the end of homespinning and the handloomed textile tradition. This change was not caused by a sudden loss of interest in needle arts but rather by acculturation, mechanization, and a shift in the tastes of the Mennonite needleworkers, who now pursued the piecing and stitching of quilts. This new and functional textile art provided a much needed outlet for the skill and creativity of a younger generation of needleworkers.

Chapter Twelve
Pieced Textiles: Quilts, Rugs, and Animals

No domestic art is more closely associated with the Mennonite community than the art of quiltmaking. Every year hundreds of Mennonite quilts are sold at the relief auctions held in the United States and Canada, for the benefit of worldwide relief efforts. These colorful textiles are crafted in an endless array of patterns, both old and new, by church sewing circles and individual quilters. The creation of pieced bed coverings is a tradition within the Mennonite community that is now nearly 200 years old. It is nonetheless a borrowed tradition, for the earliest quilts in Pennsylvania were produced not by Pennsylvania Germans but by their English neighbors.[1] The process of sewing small pieces of textiles together to create a pieced quilt top, adding a layer of batting and a whole-cloth backing, and finally joining the three layers using decorative stitching, creates the textile that is commonly known as a quilt.

The traditional bedcovering in the Germanic regions of Europe is the feather tick. The tick case (fig. 226) was usually made from hand-loomed linen fabric woven in either a check or plaid pattern. By the late eighteenth century many Pennsylvania Mennonite households had added the colorful woven coverlet (figs. 231, 234, 235) as the topmost covering on their featherbeds. The coverlet remained a popular bedding form until the mid-nineteenth century, when it was surpassed in popularity by the pieced quilt.

Although locally woven textiles filled most of the fabric needs of the Pennsylvania German housewife, mill-made cotton prints were desirable for certain clothing items (figs. 278 and 279). A variety of imported mill-made textiles were available in rural Pennsylvania by the late eighteenth century.[2] But they were costly, so were used sparingly. The industrial revolution of the early nineteenth century enabled the production of relatively inexpensive cotton prints in a variety of patterns and colors. The Mennonite housewives used these patterned cotton prints in making dresses for themselves and for their children. With the fabric scraps they created pieced quilts, pillowcases, privy bags, pincushions, and fabric toys.

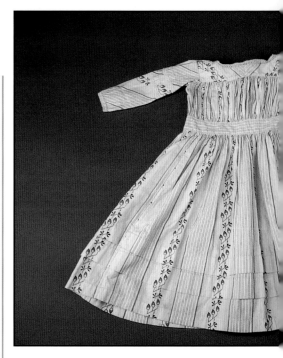

Figure 278. Child's dress, c. 1850, by an unknown seamstress, descended in the family of John M. Shenk (1818-91), Providence Township, Lancaster County. This dress was meticulously handsewn with numerous pleats to allow for vertical expansion. *Cotton print yardage, applied lace edging, 23" x 23". Private collection.*

Figure 279. Drawstring bag, c. 1850, by an unknown seamstress, descended in a Mennonite family in Earl Township, Lancaster County. Drawstring handbags were popular nineteenth century women's accessories. *Cotton print, mill-made tape, 8" x 7.25". Collection of Nan and Jim Tshudy.*

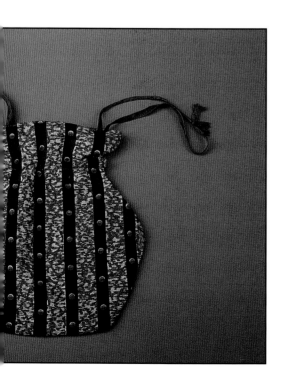

Household inventories of Mennonites living in southeastern Pennsylvania taken during the first decades of the 1800s often include quilts among the list of textiles that were in the possession of the deceased. Few Mennonite quilts, however, survive from this era. The earliest dated Mennonite example known to the author is a full-size quilt in the Irish Chain pattern, marked by Barbara Shenk in 1814.[3] Some quilters also created pillowslips (figs. 281-289), and occasionally a bolster slip, to match their quilts. Pieced pillowslips were seldom quilted; they appear to have been most popular among needleworkers in the Lancaster Mennonite community. Pillowslips rarely survive with their companion quilts. Most likely the quilts were simply worn out, as their popularity continued long after pieced pillowslips faded from common use. The pillowcases were preserved in the blanket chest, and some of them are among the earliest surviving examples of the Mennonite quiltmaking tradition.

Although quiltmaking is often thought of as a salvage art, employing primarily scraps of fabric in the process, in fact the borders and backing cloth were usually cut from yardage that was purchased solely for the production of the quilt. The crib quilt seen in figure 280 is an early example, sewn c. 1840. Rather than piecing the top, the quilter cut two sizes of heart-shaped fabric pieces and appliqued them to a whole cloth background. All of the fabrics used in the creation of this quilt appear to have been specially purchased yardage.

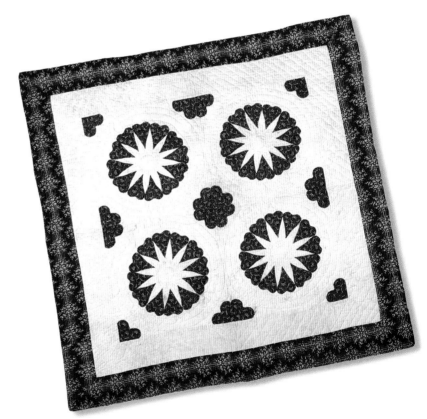

Figure 280. Crib quilt, attributed to Barbara (Charles) Seitz (1808-48), working in Manor Township, Lancaster County, c. 1840. The quiltmaker created a distinctive pattern by appliqueing heart cutouts to create several geometric forms. *Cotton top, cotton batting, cotton backing, 37" x 39". Collection of Dr. and Mrs. Donald M. Herr.*

The Pennsylvania Germans traditionally marked their homespun linens with counted cross-stitch initials, a date, or occasionally a full name. Therefore, it is not surprising that this practice was also employed on some of their earlier pieced textiles. The pair of pillowslips (fig. 281) are marked in cross-stitch "BSH 1826." The maker, Barbara Hostetter (1811-1912), was the daughter of Bishop Jacob Hostetter (1775-1865) of Penn Township, Lancaster County. The pillowslip in figure 282 was stitched in Providence Township, Lancaster County, c. 1840. The needleworker Esther Shenk (b. 1817) signed her name in ink, rather than in stitching. Her Providence Township home was near the southern edge of the Lancaster Mennonite community. Her family also sewed the child's dress seen in figure 278. The pillowcases seen in figure 284 have the initials "CM" and the date 1838 stitched in red cotton floss. This seamstress, working in the Strasburg area, also added tying tape, like that traditionally found on homespun linen pillowslips. The needleworker who created the appliqued pillowslip seen in figure 285 was Fanny Frey (b. 1823), a nineteen-year-old resident of western Lancaster County. She included her name and the date 1842 in cross-stitched initials on the pillowslip that she completed prior to her marriage to Christian Bassler (1815-52).

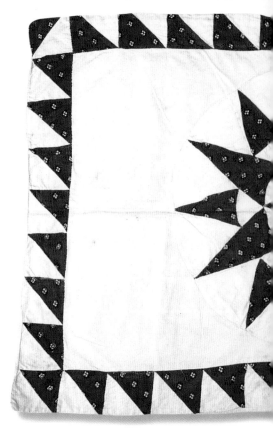

Figure 282. Pillowslip, made by Esther Shenk (b. 1817), working in Providence Township, Lancaster County, c. 1840. Esther was the daughter of John Shenk (1786-1825) and Catherine (Gochenaur) Shenk, prosperous farmers in Providence Township. She signed her pillowslip in ink. *Cotton fabrics, 16" x 24". Private collection.*

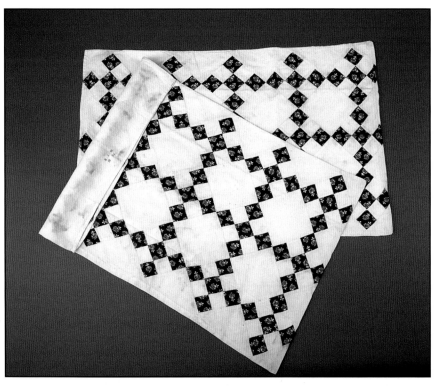

Figure 281. Pair of pieced pillow slips, made by Barbara S. Hostetter (1811-1912), working in Penn Township, Lancaster County, dated 1826. These slips are unusually early examples of pieced work among Mennonite needleworkers. Pieced in the Irish Chain pattern. The maker stitched the date and her initials in counted cross-stitch. *Cotton fabrics, cotton thread, 15.5" x 24.5". Collection of Dr. and Mrs. Donald M. Herr.*

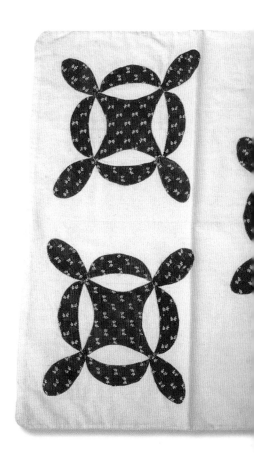

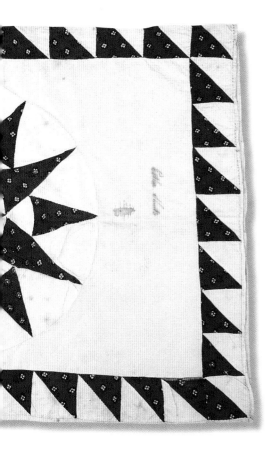

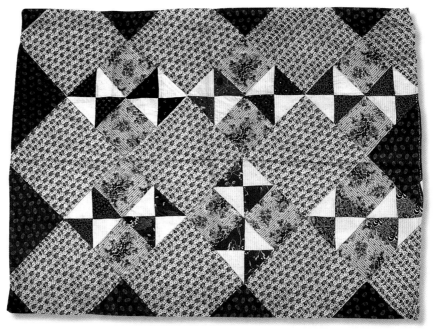

Figure 283. Pillowslip, one of a pair of pieced slips attributed to Elizabeth Houser, probably working in Lampeter, Lancaster County, c. 1820-35. The needleworker stitched her initials, "EH," in counted cross-stitch on the reverse of her Nine-Patch pattern pillowslip. *Cotton fabrics, 17.5" x 25". Collection of Dr. and Mrs. Donald M. Herr.*

Figure 284. Pillowslip, possibly made by Catherine Mylin of Strasburg, Lancaster County, dated 1838. The needleworker stitched her initials, "CM," and the date on the rear of the slip. On the open end she attached two mill-made tapes. Cotton fabrics, tape, 16.5" x 22.5". *Collection of Dr. and Mrs. Donald M. Herr.*

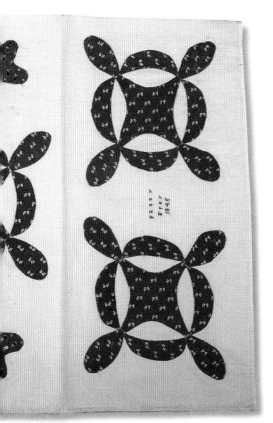

Figure 285. Pillowslip, appliqued by Fanny Frey (b. 1823), working in western Lancaster County, dated 1842. Fanny Frey stitched her full name and date on the front of her pillowslip. A skilled needleworker, she also stitched an elaborately decorated towel. Fanny was the daughter of Johannes Frey (1796-1872). *Cotton fabrics, 16" x 23". Collection of Nan and Jim Tshudy.*

Although calicos were the most popular fabrics used in nineteenth century Mennonite quilts, some quilters employed chintz, creating contrast through the use of both plain and polished cottons (fig. 286). The pillowslip pieced in a Feathered Star pattern (fig. 287) was likely sewn by Magdalena Schaeffer (1819-1902) or one of her four maiden sisters, all of whom lived together in West Earl Township, Lancaster County. The Schaeffer sisters also stitched the pieced privy bag seen in figure 304.[4] Their father, Isaac Schaeffer (1789-1842), was a contributor to the fund for the erection of the 1823 meetinghouse at Groffdale.

Figure 286. Pillowslip, possibly the work of Barbara Hess (1829-1901) of Warwick Township, Lancaster County, c. 1848. The maker employed both cotton prints and glazed cotton prints in her Eight-Point Star pattern pillowslip. Barbara likely made this textile about the time of her marriage to Jacob Bomberger (1824-85). *Cotton prints, chintz, 16.5" x 28". Collection of Sam and Kathy McClearen.*

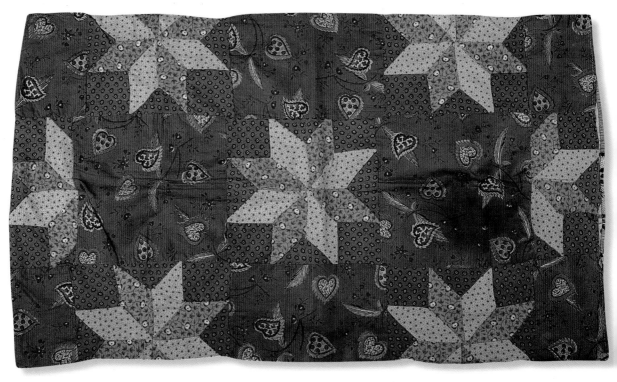

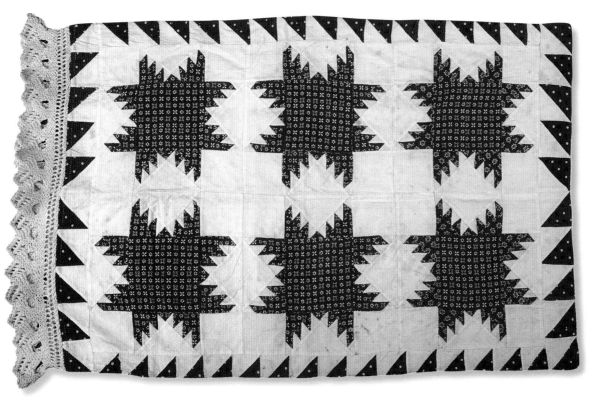

Figure 287. Pillowslip, one of a pair attributed to Magdalena Schaeffer (1819-1902) of West Earl Township, Lancaster County, c. 1850. Magdalena added a knit fringe to her Feathered Star pillowslips. Her use of a red print on a white background was a popular choice among mid-1800s quiltmakers. Mattie was the wife of Daniel Buch (1823-55). *Cotton fabrics, cotton fringe 15.5" x 26". Collection of Mr. and Mrs. Wendell R. Shiffer.*

162

The Log Cabin design was a popular quilt pattern among the Mennonites and others in the last quarter of the nineteenth century. The pillowslip seen in figure 288 was pieced in a Log Cabin pattern, c. 1880-1900, by Mary Ann (Stauffer) Hess (1857-1931) of Mount Joy Township, Lancaster County. The brilliantly colored pillowslip in the Irish Chain pattern (fig. 289) was made c. 1900 by maiden sisters Ann and Rachel Shenk of West Donegal Township, Lancaster County. The ruffle surrounding the open end is an interesting variation found on pillowslips. It seems that the pieced or appliqued pillowslip is a nineteenth century form, as there appear to be few examples dating after 1900. The quilt, however, remains a popular bedcovering even today, a century after pieced pillowslips feel into disuse.

Figure 288. Log Cabin pillowslip, one of a pair attributed to MaryAnn (Stauffer) Hess (1857-1931) of Mount Joy Township, Lancaster County, c. 1880-1900. Although the Log Cabin was a popular quilt, it is difficult to interpret on the small scale of a pillowslip, hence it was rarely attempted. Mary Ann sewed this slip after her marriage to Ezra H. Hess (1852-1930), for their son Elam S. Hess. *Cotton prints, 16.5" x 28". Private collection.*

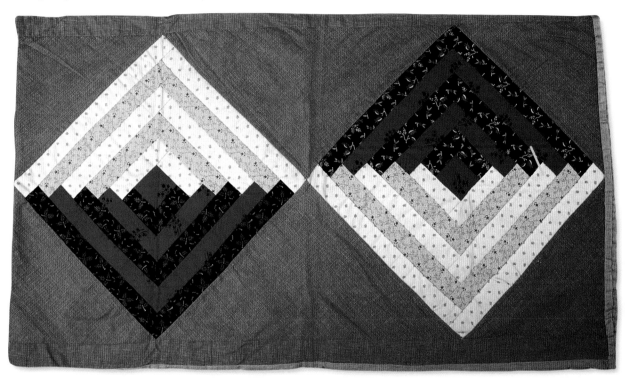

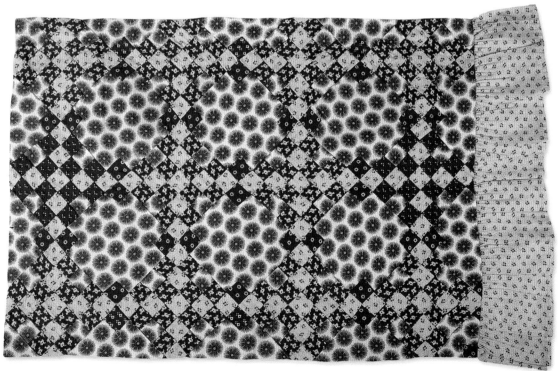

Figure 289. Pillowslip, one of a pair of Irish Chain slips that are attributed to Ann and Rachel Shenk, working c. 1900 in West Donegal Township, Lancaster County. Quiltmakers frequently utilized scraps of similar fabrics in their pieced tops. The Shenk sisters employed three different red prints in their pillowslips, meticulously placing the odd pieces so that the tops are exactly symmetrical. The sisters were obviously skilled and fastidious needleworkers. *Cotton prints, 16.5" x 27". Collection of Dr. and Mrs. Donald M. Herr.*

A few quilts survive with their matching pillowslips (figs. 290 and 291). The Sawtooth Diamond quilt was among the most popular designs used by the Mennonites of Lancaster County during the last decades of the 1800s. On this example, the quilt and companion pillowslips were both embroidered with the recipient's initials and the date, "MBB" 1889, in elaborate Victorian letters. This type of bold ownership embroidery appears only on a small group of related quilts that were made in northern Lancaster County.[5] The probable maker of this quilt, Fannie (Brubaker) Bollinger (1843-1935) of Ephrata Township, presented this colorful bedcovering to her daughter, Mary B. Bollinger (b. 1876). Mary's older brother, Andrew, received a similar quilt at age sixteen. Sawtooth Diamond quilts pieced with patternless fabric provided the perfect textile to showcase the quilting skills of the needleworker. On these quilts, the elaborate patterns and tiny stitches are far more visible than on quilts that were assembled from busy cotton prints.

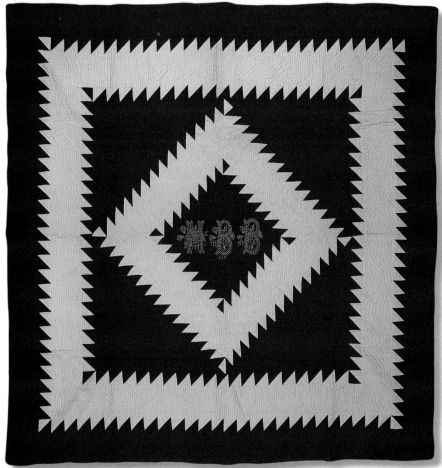

Figure 290. Sawtooth Diamond quilt, attributed to Fannie (Brubaker) Bollinger (1843-1935) of Ephrata Township, Lancaster County, dated 1889. In northern Lancaster County a group of Mennonites and Church of the Brethren women chose to add the date and the initials of the recipient of their quilts in elaborate golden embroidery. Fannie (Brubaker) Bollinger was the wife of Benjamin Bollinger (1839-1906). Their daughter Mary B. Bollinger (b. 1876) was the apparent recipient of this quilt. *Cotton fabric, cotton batting, 80.5" x 78". Private collection.*

Figure 291. Pair of pillowslips, attributed to Fannie (Brubaker) Bollinger (1843-1935) of Ephrata Township, Lancaster County, dated 1889. These pillowslips are companions to the Sawtooth Diamond quilt (fig. 290). The needleworker borrowed the sawtooth borders of her quilt to design a pillowslip pattern that would complement her full-size quilt. *Cotton fabric, 19.25" x 29.25". Private collection.*

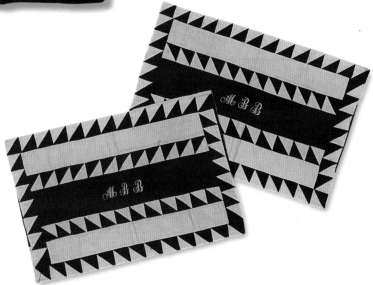

Figure 292. Sampler Friendship quilt, attributed to Catharine (Reist) Landis (1828-1902) of Manheim Township, Lancaster County, dates 1858-60. An exceptional example of a Friendship quilt. Thirty-six sampler patches are signed by friends and relatives of Catharine Landis. Her husband, (fig. 270) Henry L. Landis (1829-96) was a prosperous farmer in Manheim Township. *Cotton fabrics, cotton batting, 86" x 86". Collection of Kathryn M. Shertzer.*

A far different type of quilt is seen in figure 292. This Sampler Friendship quilt was stitched by Catharine (Reist) Landis (1828-1902). Catharine S. (Reist) Landis, a young farmwife from Manheim Township, Lancaster County (fig. 270), seems to have been an enthusiastic needleworker. Her 1846 sampler appears in figure 269. Every patch on Catharine's quilt is of a different pattern, and each is marked with the name of a friend or relative.[6] Although Friendship quilts were quite popular among young Mennonite woman in the mid-1800s, Catharine Landis' textile is exceptional in every respect. Many of the quilt patches are highly imaginative, and the overall composition of the piece is extraordinary. Of course she did have some able assistants; two patches were contributed by her sisters-in-law, Maria (Landis) Getz and Fianna (Landis) Garber. Both were highly skilled needleworkers. They produced the textiles appearing in figures 75 and 76.

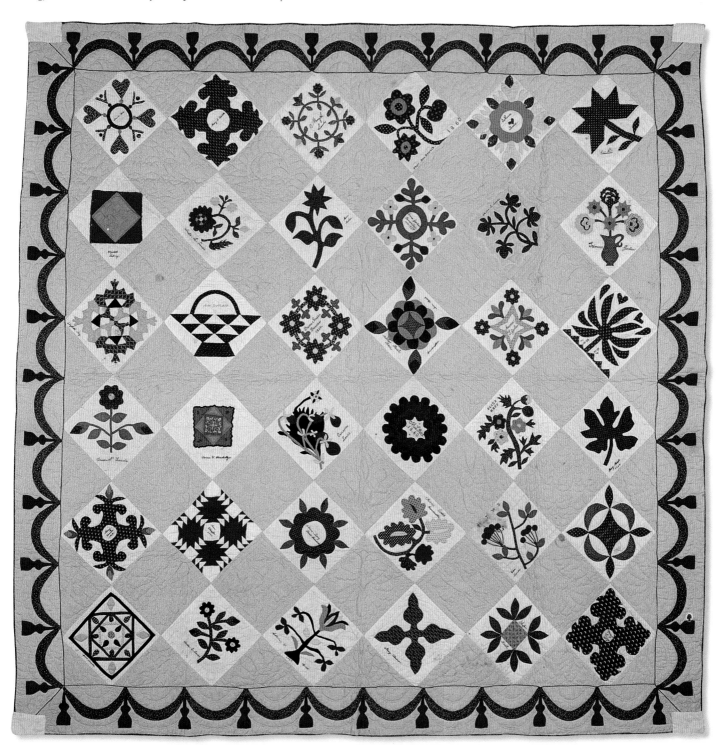

Catharine Landis apparently completed her quilt in 1860, the latest date that appears on any of its patches. At exactly the same time, another young Mennonite woman living a few miles to the northwest in Warwick Township was creating her masterpiece Sampler quilt (fig. 77). By stitching their Sampler quilts, both quilters achieved their goal of having no two patches alike, but with wildly differing results. While Catharine Landis relied heavily on applique work to create naturalistic floral vignettes, Fanny S. Bucher (1841-1910) stitched together tiny fabric scraps to create a tapestry of eccentric geometric patterns. Both quilts are powerful statements about the skill and imagination of their makers. These impressive textiles are reminders that for many Mennonite women quiltmaking provided the rare opportunity for personal artistic expression.

The Sampler quilt seen in figure 294 was sewn a generation later by Barbara B. Snyder (1862-1922), the eldest daughter of Fanny S. (Bucher) Snyder (1841-1910) and her husband Simon B. Snyder (1836-1907), who had moved to their Clay Township farm (fig. 293) following their 1861 marriage.[7] Barbara's quilt, although certainly inspired by her mother's work, differs in several respects. Instead of using the quirky diamond format employed by her mother, she opted for the far more traditional square patch. By adding the wide sawtooth border in combination with the wider square patches, she needed fewer than half the number of sampler patches than her mother's quilt had required. For several years, Barbara spent her spare hours stitching her quilt. The final result was a stunning example of the quilter's art, alive with color and motion. She continued to make quilts after her 1884 marriage to John M. Stoner (1862-1946). The newlyweds moved to the West Earl Township farm (fig. 297) where she pieced and quilted the Puzzle quilt (fig. 298) about 1895 for her daughter, Ida S. Stoner (1891-1978). This quilt is pieced from solid-color fabrics. To achieve the exact color shades she desired, Barbara dyed some of the fabrics herself.[8] This quilt, like her Sampler quilt (fig. 294), displays Barbara's fine sense of color and design.

Figure 293. Barn-raising meal in 1911, taken at the home of Christian B. Snyder in Clay Township, Lancaster County. This photograph is of the second seating. The men were served first. The photo shows the women who provided the meal during construction of the new barn at Willow Spring Farm. The woman holding the plate of food on the left is Barbara B. (Snyder) Stoner (1862-1922), the maker of the quilts shown in figures 294 and 298. Barbara was born in the house in the background. *Private collection.*

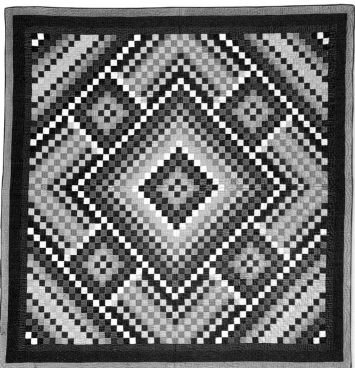

Opposite page, top right: Figure 294. Sampler quilt, attributed to Barbara B. Snyder (1862-1922), made in Clay Township, Lancaster County, c. 1878-82. This elaborate example of a pieced Sampler quilt has patches made with as many as 144 pieces of fabric. Required to work for her parents until 8 p.m., Barbara spent her late evenings, for several years, creating her masterpiece. *Cotton fabrics, cotton batting, 90" x 82.5". Private collection. Photograph by Charles Studio of Photography.*

Center right: Figure 295. Papercut quilt, attributed to Fanny S. (Bucher) Snyder (1841-1910) and daughter Amanda B. Snyder (1872-1956), of Clay Township, Lancaster County, c. 1890. Papercut quilts, like this example, required copious amounts of applique work and were attempted only by the most skilled quiltmakers. The recipient of this quilt, Amanda B. Snyder, likely regarded this as her best quilt, hence it was never used. *Cotton fabric, cotton batting, 89.5" x 89". Private collection.*

Bottom right: Figure 296. Joseph's Coat quilt, attributed to Fanny S. (Bucher) Snyder (1841-1910) of Clay Township, Lancaster County, c. 1880. Joseph's Coat quilts, or Rainbow quilts as they are often called, are among the most exuberant quilts to be found among the Lancaster County Mennonites. This quilter employed a different quilt pattern for each of the seven rainbow stripes. *Cotton fabric, cotton batting, 85" x 85". Private collection.*

Above: Figure 297. The home and family of Barbara B. (Snyder) Stoner, West Earl Township, Lancaster County, taken c. 1902. This house was built in 1854 by Henry H. and Mary (Musselman) Stoner, when their youngest son John M. Stoner (1862-1946) married Barbara B. Snyder. They moved to the home farm. Barbara, posing here with her husband and four children, stitched the quilt in figure 298 for her daughter Ida S. Stoner (1891-1978), second from right. *Private collection.*

Left: Figure 298. Puzzle quilt, made by Barbara B. (Snyder) Stoner (1862-1922) of West Earl Township, Lancaster County, c. 1895. An accomplished quiltmaker, Barbara stitched this quilt for her young daughter, Ida S. Stoner (1891-1978), while living in the house seen in figure 297. A graphic quilt, with the triple border repeating its rainbow theme. Ida received this and several other quilts prior to her marriage to Reuben S. Horst (1891-1987). *Cotton fabric, cotton batting, 84" x 82". Private collection.*

The quilt seen in figure 295 is also a Snyder family quilt, an elaborately appliqued Papercut quilt. It was made c. 1890 by Fanny S. (Bucher) Snyder (1841-1910) of Clay Township, Lancaster County. Fanny was likely assisted by her daughter, Amanda B. Snyder (1872-1956), as Amanda received it as one of her quilts "from home." It was not unusual for the recipients to help sew the quilts that they would be taking to their marriage.

The boldly striped quilt in figure 296 is known as Joseph's Coat, an unusual pattern. It seems to have been made only in northern Lancaster County. This example repeats the seven colors of the rainbow in the central field and in the diagonal border. Each color is quilted in a different pattern. The resulting bedcovering is both bold and graphic and is among the most distinctive quilt patterns used by the Mennonites. This quilt is also likely from the household of Simon B. Snyder and Fanny S. (Bucher) Snyder of Clay Township, as it descended with a Papercut quilt, an identical mate to the example seen in figure 295.

The colorful Triple-lily applique quilt seen in figure 299 is from the Mennonite community in Bucks County, Pennsylvania. The quilter is believed to be Maria (Gehman) Ruth (1835-78), the wife of Noah P. Ruth of Line Lexington. She stitched her quilt about 1875, probably for her daughter, Anna Mary Ruth (1862-1933), using both piecing and applique techniques. She oriented her quilt blocks inward and upward, which gives the quilt a sense of motion. The Fan quilt (fig. 300) is composed of wool patches and closely relates to the Crazy Quilt fad that appeared in the Victorian era. The colorful, fancy stitching and embroidered floral designs are a far cry from the subtlety of the quilting found on more traditional bedcoverings. This quilt is attributed to Elizabeth (Good) Horning (1852-1931), the wife of Joseph G. Horning (1855-1931), a Mennonite deacon in the Bowmansville, Lancaster County, region. She is believed to have made it about 1900 for her daughter, Annie G. Horning (b. 1894).

Figure 300. Fan quilt, attributed to Elizabeth (Good) Horning (1852-1937) of Brecknock Township, Lancaster County, c. 1900. The dark fabrics, colorful embroidery, and erratic design of this quilt were a direct outgrowth of the tradition of the Crazy Patch quilts that were hugely popular in the last decades of the 1800s. *Mixed fabrics, predominantly wool, cotton batting, 77.5" x 76.5". Collection of Nan and Jim Tshudy.*

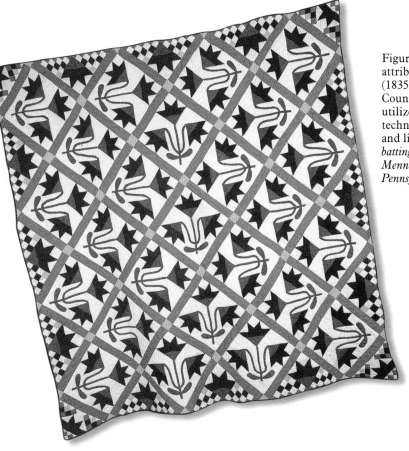

Figure 299. Triple-Lily applique quilt, attributed to Maria (Gehman) Ruth (1835-78) of Line Lexington, Bucks County, c. 1875. The needleworker utilized piecing and appliqueing techniques to assemble this colorful and lively quilt. *Cotton fabric, cotton batting, 85" x 85". Collection of the Mennonite Heritage Center, Harleysville, Pennsylvania. Nathan Cox Photography.*

One of the most original Mennonite quiltmakers is a farmwife from northeastern Lancaster County, Susanna (Sensenig) Gehman (1834-1915). In her retirement years, Susanna appliquéd a group of incredibly innovative textiles as gifts for her grandchildren. Both of her granddaughters received a crib quilt and a full-size quilt (fig. 301). Her dozen grandsons each received small fabric pictures depicting scenes of daily farm life.[9] Susanna's textiles graphically illustrate the orderliness of rural Mennonite life: a four-square garden beside a tidy red farmhouse, children carrying water from the well, and girls picking fruit, feeding the chickens, leading a cow and horses, and hauling a load of hay in from the fields. As a quiltmaker she is in a class by herself, a true folk artist who lovingly recorded her world, using only a needle, thread, and a boundless imagination.

Although quilts were by far the most popular form of textile art among the twentieth century Mennonite needleworkers, a few quilters employed their skills to create other imaginative textile forms including pieced bags, pincushions, and pieced balls. Certainly the most unusual textile form to emerge in the Mennonite community is the privy bag (figs. 302-307). The small pieced or appliquéd privy bags, as the name implies, were used to collect paper scraps that would eventually be recycled in the privy. Surviving examples date from the 1820s to the 1920s, with nearly all of them originating in Lancaster County. The vast majority have provenance to Mennonite families. Their bags were rarely quilted, and most appear to have never been used. In all likelihood they often functioned as a quilt-making exercise for young needleworkers, who pieced and appliquéd these bags in order to hone their skills, prior to undertaking the challenge of making full-size quilts. It is also likely that the finer examples of this form were never intended for use in the outhouse, but rather remained in the house as a decorative receptacle for the accumulation of paper. More crudely made bags, either pieced or made of whole cloth, were commonly used in the privies of rural Lancaster County.[10]

Figure 301. Farm Scene quilt, made by Susanna (Sensenig) Gehman (1834-1915) of East Earl Township, Lancaster County, c. 1905-15. Susanna appliquéd and pieced this quilt top for her eldest granddaughter, Susie H. Gehman (1905-2000). Susanna's fabric landscapes stand alone among the Mennonite quilts of southeastern Pennsylvania. She was a brilliant innovator. *Cotton fabric, 77" x 77". Collection of the Lancaster Mennonite Historical Society.*

Figure 302. Privy bag, made by Fanny Weaver of Lancaster County, dated 1842. A pieced and appliquéd bag with an unusual dentil-blocked border. Its maker, Fanny Weaver, proudly embroidered her name in counted cross-stitch along the top edge. *Cotton fabrics, 20" x 20". Collection of Nan and Jim Tshudy.*

The pieced and appliqued bag seen in figure 302 is an early example. The maker, Fanny Weaver, carefully embroidered her name and the date, 1842, across the top of the bag. Another early bag can be seen in figure 303. The needleworker, Elizabeth Reist (1822-1911), of Warwick Township, Lancaster County, was an older sister of Catharine (Reist) Landis (figs. 269, 270, and 292). Elizabeth stitched her bag in 1843 at age nineteen, prior to her marriage to Samuel Y. Royer (1819-1905). She chose a complex Broken Star design for her textile and also finely quilted the front of the bag.

Figure 303. Star privy bag, made by Elizabeth Reist (1822-1911) of Warwick Township, Lancaster County, signed and dated in pencil 1843. This finely pieced and appliqued bag was stitched by Elizabeth Reist prior to her marriage to Samuel Y. Royer (1819-1905). She also quilted her bag, a detail rarely found on privy bags. Elizabeth was the daughter of Jacob Reist (1790-1872) and Anna (Shafer) Reist (1793-1860), who were farmers in Warwick Township. Her sister, Catharine S. Reist, stitched the quilt seen in figure 292. *Cotton fabrics. 21.5" x 21.75". Collection of Mr. and Mrs. Wendell R. Shiffer.*

The bag pieced in the Lone Star pattern (fig. 304) is a more simply executed example. It is attributed to Magdalena Schaeffer (1819-1902) or one of her several maiden sisters. The Schaeffer sisters of West Earl Township, Lancaster County, used the same red cotton print to piece both the star on their privy bag and the sawtooth border of their pillowslips (fig. 287), both dating c. 1850. The boldly colored bag seen in figure 305 was appliqued in an Oak Leaf pattern by Elizabeth E. Witmer (1842-1924) of East Donegal Township, Lancaster County. Elizabeth, the niece of coverlet weaver Jacob F. Witmer (fig. 241), stitched this bag c. 1860 and embroidered her initials in the center using chain stitch.

Figure 304. Star privy bag, probably made by Magdalena Schaeffer (1819-1902) or one of her unmarried sisters in West Earl Township, Lancaster County, c. 1850. This bag has a 6.5-inch opening on the upper left side. The maker used linen tape for the hanging tabs and incorporated the same red cotton print as seen on her pillowcase (fig. 287). *Cotton fabric, linen tape, 21" x 20.25". Collection of Mr. and Mrs. Wendell R. Shiffer.*

Figure 305. Oak Leaf privy bag, made by Elizabeth E. Witmer (1842-1924) of East Donegal Township, Lancaster County, c. 1860. On her colorful example of applique work, Elizabeth Witmer stitched her initials in the center, using wool flosses. The daughter of Peter F. Witmer (1809-96) and Elizabeth (Eshelman) Witmer (1812-1904), she completed her bag prior to her 1871 marriage to Joseph Nissley (1821-97). *Cotton fabric, wool flosses, 18" x 19". Collection of Dr. and Mrs. Donald M. Herr.*

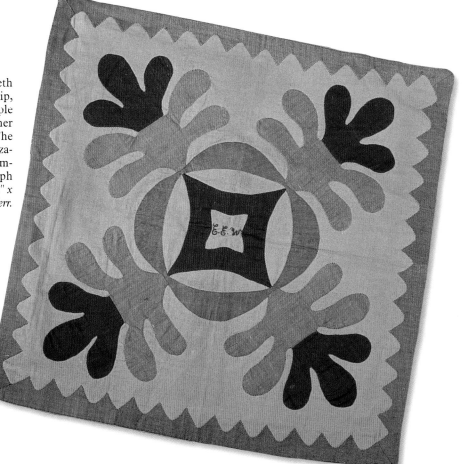

The privy bags seen in figures 306 and 307 were made by two generations of needleworkers in the same family. The bag pieced in the Diamond in Square pattern (fig. 306) was made c. 1860 by Catherine (Miller) Hostetter (1804-85), the wife of David Hostetter (1808-72) of Paradise Township, Lancaster County. The bag shows no evidence of ever having hanging tabs, and it was certainly never used. This textile descended to a great-granddaughter, Alice H. Harnish (1884-1910) of Strasburg, Lancaster County, who sewed the bag seen in figure 307, about 1900. Alice appliqued her bag, adding her initials in chain stitch, prior to her 1906 marriage to Elam M. Wenger (1882-1956). Both bags descended to Alice's daughters and stepdaughters, who were aware of their function and used the term privy bag when describing them.[11]

Figure 306. Diamond in Square privy bag, made by Catherine (Miller) Hostetter (1804-85) of Paradise Township, Lancaster County, c. 1860. Catherine Hostetter was a middle-aged farmwife when she stitched this bag. She never fitted it with hanging loops, and it appears that it was never used. A bag stitched by her great-granddaughter, Alice Harnish, is seen in figure 307. Catherine Miller was the daughter of Jacob Miller and Esther (Groff) Miller. She was the wife of David Hostetter (1808-72). *Cotton fabric, 21" x 21". Private collection.*

Figure 307. Privy bag, made by Alice Harnish (1884-1910) of Strasburg, Lancaster County, c. 1900. Alice appliqued her bag in a simple stylized floral design, fitting it with hanging tabs made from folded cotton fabric. The opening into the bag spans the full width of the top edge of her privy bag. A pieced bag made by Alice's great-grandmother can be seen in figure 306. The daughter of Andrew Harnish and Letitia (Hostetter) Harnish, Alice married Elam M. Wenger (1882-1956) of West Earl Township. *Cotton fabric, 21" x 22". Private collection.*

Innovative Mennonite needleworkers found other challenges for their sewing skills in the pieced pincushions, hot pads, and fabric toys that they created. Among the most challenging of small fabric objects sewed by these women are the pieced balls (fig. 308). A number of these have been found in northwestern Lancaster County dating c. 1830-1900. This ball is attributed to Anna H. Bamberger (1843-1901) of Warwick Township, Lancaster County. Anna made this object c. 1860 and used eighty-six pieces of fabric in its construction, most measuring one-half inch square. Although the hanging loop suggests that it functioned as a decoration, some similar examples have interior rattles and were likely intended as toys. Perhaps Anna was inspired by her next-door-neighbor and future sister-in-law, Fanny S. Bucher (1841-1910), whose Sampler quilt (fig. 77) exhibits the same needlework discipline of piecing miniature patches. In 1865 Anna H. Bomberger married Christian R. Bucher (1844-1920). They farmed in Penn Township, Lancaster County.

Other popular pincushion forms include pieced stars (fig. 308), puzzle balls (fig. 309), and spool birds (fig. 310). The eight-pointed star dates c. 1860. It descended in the Ebersole and Ober families of West Donegal Township, Lancaster County. A thread serves as the hanging loop. Puzzle balls were enormously popular in southeastern Pennsylvania in the last quarter of the 1800s and the first quarter of the 1900s. This example was pieced by Fianna E. (Nissley) Reist (1861-1947) of Mount Joy, Lancaster County, about 1900. Fianna also pieced the Crazy Patch pin cushion in figure 309 and the black fabric spool chicken seen in figure 310. Fianna was the wife of Eli G. Reist (1855-1932), a prominent farmer and churchman, who served as a treasurer for the Eastern Mennonite Board of Missions and Charities.

Figure 308. Pieced ball with hanging loop, attributed to Anna H. Bomberger (1843-1901) of Warwick Township, Lancaster County, c. 1860. Precision needlework was required to piece this tiny ball. Eighty-six patches form this sphere which was likely intended as a decoration. Anna was the daughter of Mennonite Bishop Christian Bomberger (1818-98), and Catharine (Hess) Bomberger (1819-75), who farmed in Warwick Township. *Cotton fabric, unidentified stuffing. 2.5" x 2.5". Private collection.* Eight-Point Star pincushion, descended in the Ebersole and Ober families of West Donegal Township, Lancaster County, c. 1860. The needleworker who stitched this star used a different combination of fabrics on each side of the star. The tassels are formed with wool yarn. *Cotton fabric, unidentified stuffing, wool yarn. 5" x 1.25" x 5". Private collection.*

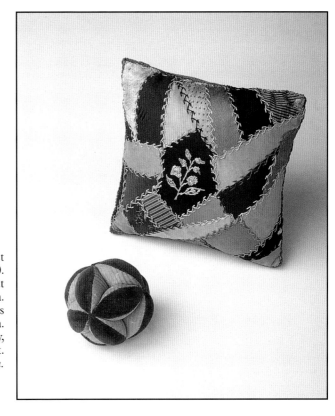

Figure 309. Pair of pincushions made by Fianna E. (Nissley) Reist (1861-1947), living near Mount Joy, Lancaster County, c. 1900. Puzzle balls and Crazy Patch pin cushions were novelty forms that were popular among the Mennonites of southeastern Pennsylvania. The feather-stitching and embroidered flower design are details that are commonly seen on crazy quilts of the late Victorian era. The daughter of Christian S. Nissley and Mary N. (Eby) Nissley, Fianna lived at Walnut Grove Farm with her husband, Eli G. Reist. *Mixed fabrics. 6.5" x 2" x 6.5", and 2.75" diameter. Private collection.*

One of the more unusual folk textile forms to have been crafted by Mennonite needleworkers is the spool chicken. These clever fabric sculptures were simply constructed, using an empty wooden thread spool as a base. The bird, usually stuffed with cotton, is tied to the base with thread or a narrow ribbon. These birds were a popular needlework fad in Lancaster County from about 1880 to 1920, with some Old Order Mennonites continuing to craft them into the 1970s. Some examples clearly functioned as pin cushions; others were intended as toys for young children, with some having interior rattles. A gingham-clad bird (fig. 310) was made in 1911 for Anna R. Gochnauer (b. 1911) and has an inscription on the base that reads "Anna Gochnauer from the baby nurse Mother Landis."

The strawberry make-dos seen in figure 311 represent an even more eccentric pincushion form. Mennonite farmwives, known for their frugality, were adept at creating clever fabric sculpture on top of the bases of their broken glassware. Rather than discarding the broken kerosene lamp, some imaginative needleworker conceived the strawberry make-do form. The glass base supports the main berry, while a cluster of smaller berries is either sewn to the large berry or suspended on hanging threads. The result is a functional pin cushion that is also a zany folk sculpture. The example (fig. 311) with the blue glass base was made by Fannie W. (Burkholder) Martin (1865-1951) of Hinkletown, Lancaster County. Fannie was a talented seamstress who also made the objects seen in figure 315. She reportedly made a strawberry make-do for each of her granddaughters.

Figure 310. Flock of spool chickens, made by six different needleworkers in the Lancaster Mennonite community, dating 1900-60. The ubiquitous spool chicken served as either a pincushion or a child's toy. Clockwise, starting in foreground: gingham chicken, made in 1912 as a gift for infant Anna R. Gochnauer (b. 1911) by Mrs. Lizzie Landis, East Hempfield Township. Cotton print bird with yellow ribbon, c. 1900, unknown maker. Black chicken with red crest, c. 1920, by Fianna E. (Nissley) Reist (1861-1947), Rapho Township. Brown fabric rooster, c. 1960, by Mrs. Martin, of near Ephrata. She also made the checked example in the center. Both birds have interior rattles. The pair of birds covered in upholstery fabrics and having large feather tails, date c. 1910, by an unknown needleworker. The small brown bird in the foreground was made c. 1920 by Martha Oberholtzer (b. 1908), the daughter of Nathan R. Oberholtzer, and Martha B. (Bucher) Oberholtzer of Penn Township. *Wooden spools, assorted fabrics, feathers, embroidery flosses, 4"–5" x 2.5"-4.5". Private collections and collection of Dr. and Mrs. Donald M. Herr.*

Figure 311. Strawberry make-dos. The example on the left was made by Fannie W. (Burkholder) Martin (1865-1951) from near Hinkletown, Lancaster County, for a granddaughter, c. 1930s. The example on the right comes from a Mennonite family in northeastern Lancaster County and dates c. 1900-20. The strawberry made-do, a clever form of fabric sculpture, was constructed around the base of a broken piece of glassware. It was a popular form among the Lancaster County Mennonites and Amish. *Glass, fabric, unidentified stuffing. 8"-9" x 4"-4.5". Left: collection of Sam and Kathy McClearen; right: collection of Nan and Jim Tshudy.*

Hand-stitched fabric birds (fig. 312) are also found in some Mennonite homes. Most date from the early to mid-1900s, although a few are from the nineteenth century. Some birds exhibit considerable wear and were likely used as children's toys. Others were given as keepsakes to young relatives and friends. Each example has a charm all its own and is a tribute to the needleworker's whimsy. Both examples seen in figure 312 are from northeastern Lancaster County. The towering roosters (fig. 313) are exceptionally imaginative examples of fabric folk sculpture. They are likely the work of one needleworker who lived in East Lampeter or Manheim Township, Lancaster County. Three of the five recorded examples, dating c. 1865-85, were owned by families having ties to the Landis family of Mellingers Mennonite Meetinghouse in East Lampeter Township. The most likely creator of those lovable creatures is Sarah Landis (1845-1924), the daughter of Emanuel Landis (1812-74) and Martha (Kurtz) Landis (1815-1879), farmers in East Lampeter Township. Sarah didn't marry until age thirty, and she may well have supported herself by doing needlework, possibly including these fantastic fowls. In 1876 she married Benjamin H. Huber (1846-1925). The couple farmed at Roseville, Manheim Township, where they raised a family of four children, at least two of whom owned fabric roosters.[12]

Figure 312. Fabric birds. The example on the left from the family of David and Lizzie Martin of Narvon, Lancaster County, c. 1920s. The bird on the right is from the Eli Martin family of Stevens, Lancaster County, c. 1940s. Fabric birds were used as children's toys, pincushions, or decorations. Assorted fabrics, wool embroidery flosses. *Left: 2.75" x 1.5" x 4.5"; right: 5.5" x 1.75" x 6". Collection of Sam and Kathy McClearen.*

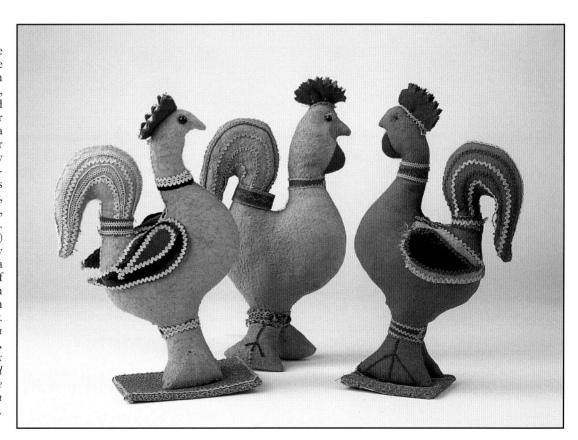

Figure 313. Fabric roosters were likely made by the same needleworker, possibly Sarah (Landis) Huber (1845-1924), working in East Lampeter and Manheim Townships, Lancaster County, c. 1865-85. Left: From a Mennonite family in Lancaster County. Center: Owned by Mary B. Siegrist (b. 1911), Bird-in-Hand, Lancaster County; it was likely made for her mother, Susanna Burkhart (1877-1944), the daughter of Samuel H. Burkhart and Mary G. (Landis) Burkhart. Right: Owned by Landis L. Huber (1877-1924), a Mennonite deacon, the son of Benjamin H. Huber and Sarah (Landis) Huber of Manheim Township, Lancaster County. *Twill-weave flannel, wool, cotton [c]ut, rickrack, woven tapes, buttons, [u]nidentified stuffing, 12.5"-13.5" x [?]" x 7"-7.5". Collection of Dr. and Mrs. Donald M. Herr; private [coll]ection; collection of Nan and Jim Tshudy.*

Many young mothers utilized their needleworking skills to create fabric toys for the amusement of their young children. Rag dolls and stuffed animals were among the most popular forms of juvenile playthings. The tiny rag doll in figure 314 is a representation of the earliest type of fabric toy. Once commonplace, they are so simply constructed that few were saved. Constructed from homespun fabrics, the doll has no body, only a petticoat lashed to the excess fabric at the base of the doll's head. Linen strips, folded and sewn, create the tiny arms of this primitive yet endearing toy. This doll was found beneath the attic floor of a c. 1785 log farmhouse near Akron, Lancaster County, that was built by the family of "Ephrata" John Landes (1696-1756), a prominent member of the Dunkard Church.

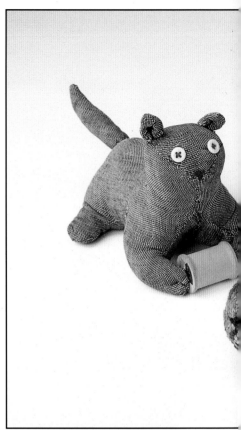

Figure 314. Large rag doll, by an unknown needleworker, probably working in Earl Township, Lancaster County, for a child of the Stauffer Mennonites, c. 1890. *Cotton and wool. 13.5" x 3" x 8.25". Collection of Lars Cain.*
Small rag doll, stitched by an unknown needleworker in the Landes family of Ephrata Township, Lancaster County, c. 1785-1825. *Homespun linen fabric, cotton lace, homespun linen thread. 4.25" x .75" x 3". Private collection.*
Letter "A" doll quilt, stitched by Anna Miller of Brownstown, West Earl Township, Lancaster County, c. 1935, made for her daughter Anna. *Cotton prints. 14.5" x 14.5". Collection of Lars Cain.*

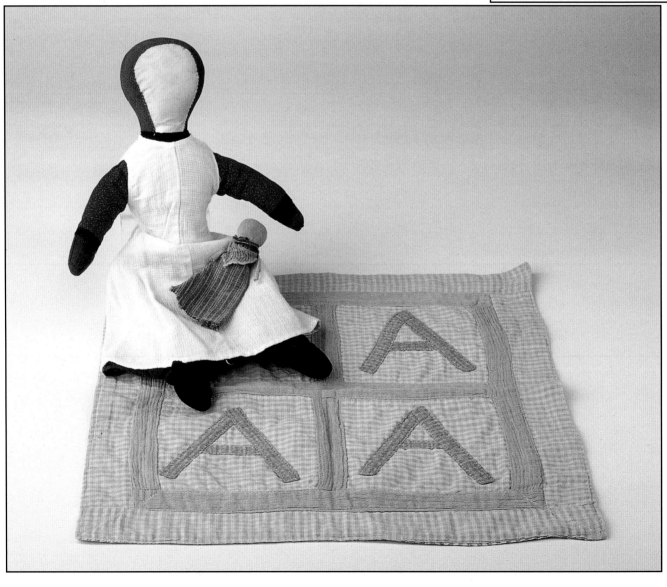

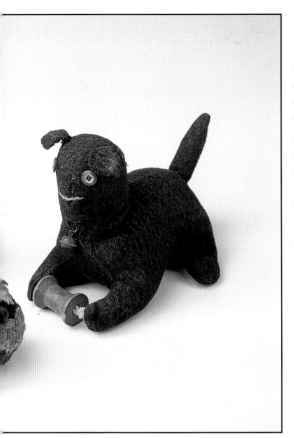

The larger rag doll (fig. 314) is without facial features. It is a doll form that is usually associated with the Amish. This finely crafted example was made c. 1890, probably for a member of the Stauffer Mennonites, an ultra-conservative Mennonite group that originated in Earl Township, Lancaster County. By the late 1800s many Mennonite children in southeastern Pennsylvania received store-bought dolls with china heads. The rag doll tradition, however, continued unabated among the Old Order branches of the Mennonite Church. Doll quilts, on the other hand, were often made by pre-teen needleworkers and vary greatly in quality. The fine example seen in figure 314 was made by Anna Miller c. 1935, working in Brownstown, Lancaster County, for her young daughter Anna. The four square design, emblazoned with Anna's initial, is an unusual format that was surely treasured by its young recipient.

A few needleworkers who were creative and highly skilled in the art of making fabric sculpture found a ready demand for their toys among their extended family and friends. One such toy maker was Fannie W. (Burkholder) Martin (1865-1951), the wife of Henry W. Martin, a farmer who lived near Hinkletown, Lancaster County. Fannie was the daughter of Daniel S. Burkholder (1833-1915), a deacon in the Mennonite Church who sided with the conservatives during the division of 1893, which shook the Lancaster Conference Mennonites. A prolific needleworker, Fannie crafted toys for her ten children and fifty-eight grandchildren (figs. 311 and 315), as well as some for sale to friends. Fannie reportedly made no fabric toys for some years prior to her death.[13] The pair of cats (fig. 315) were both stitched by Fanny for the enjoyment of grandchildren. The black cat was made c. 1915, while the brown cat was crafted c. 1940. In the interim, she improved her pattern to give the cat's head a more angular form. Undoubtedly, both equally delighted their young recipients. The sheared yarn ball (fig. 315) and the strawberry make-do (fig. 311) are both examples of the whimsy and talent of Fannie W. Martin.

A second fabric toy maker, an Old Order Mennonite woman, Mrs. Martin of Ephrata, Lancaster County, created the imaginative group of toys seen in figure 316. Her unusual choice of animals, domestic chickens (fig. 310), and squirrels as well as exotic creatures, the elephant and giraffe, reflect her broad imagination and skills. Displaying a keen sense of detail, she chose coarse upholstery fabrics for the elephant and squirrel and a polka-doted cotton print for the giraffe. She fitted her giraffe with clothespin antlers, button eyes, and a braided tail. All three animals were made c. 1950-1970 and demonstrate the continuity of the folk toy making tradition among the Mennonites.

Figure 315. Cats with spools and yarn ball, all three by Fannie W. (Burkholder) Martin (1865-1951), working near Hinkletown, Lancaster County, c. 1915-40. Fannie, a member of the Old Order Mennonites, was a prolific toymaker. She also made strawberry make-dos (fig. 311). Her sheared yarn ball contains a rattle. *Cats: fabric, wooden spool, button eyes, 5"-5.5" x 8.5"-9". Left and center: collection of Sam and Kathy McClearen. Right: private collection.*

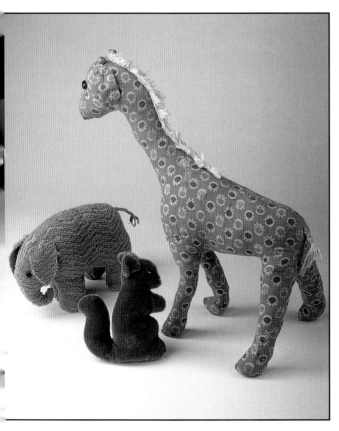

Figure 316. Stuffed animals, made by Mrs. Martin, working near Ephrata, Lancaster County, c. 1950. An imaginative group of fabric toy sculptures, made by an Old Order Mennonite needleworker. *Upholstery fabrics, cotton print, wooden clothespins, buttons, unidentified stuffing, 7" x 4" x 10", 6" x 2" x 7", 19" x 5" x 17". Private collection.*

The Old Order Mennonites, like the Amish, have retained the practice of crafting handmade toys for their families. It's a tradition that both cultivates skills and teaches frugality. This craft is still alive and well among the Old Order Communities in Pennsylvania, Ohio, Ontario, and beyond.

Perhaps the latest significant form of textile art to be embraced by Mennonite women was the practice of rug making. Prior to the second quarter of the nineteenth century, Mennonites, like the broader Pennsylvania German community, typically had no floor coverings over the wooden floors of their farmhouses. The introduction of rag carpet changed all that. These long strips of professionally woven carpet, usually a little over three feet in width, could be stitched together to create a room-size rug. This carpet was enormously popular from the mid-1800s to the early 1900s, and it continues to be made and used by Old Order Mennonites. Other rug making traditions also entered the vocabulary of Mennonite needleworkers. The penny rug (fig. 317), a part of the Anglo rug-making tradition, appeared among the Mennonites in the last quarter of the 1800s. This miniature example, with its charmingly naive cat, was likely made c. 1890 as a gift for a special child. The maker, Frances (Buch) Royer (1846-1925), was the daughter of Daniel Buch and Mattie Schaeffer (figs. 287 and 304). Frances and her husband Isaac R. Royer lived near Groffdale in West Earl Township. She stitched her round cutouts onto the homespun blue plaid backing. She fashioned the cat by stitching snibbles, small bits of fabric, onto the backing. A sawtooth border completes the composition.

Mennonites have traditionally been slow to embrace new trends, so it should be no surprise that the art of making hooked rugs, long a tradition in New England, emerged as a rug form among the Mennonites only about 1900. Rug hooking was soon a popular pastime among women, children, and even some elderly Mennonite men. Worn-out scraps of clothing were cut into strips and soon were transformed into colorful throw rugs, the best of which were reserved for the parlor. Although floral pattern rugs predominated, some of the most appealing rugs featured the pet dog (fig. 318) or a favorite horse (fig. 319). On this example, the dogs are visually contained by the use of the strong double border. Their stance is playful, imbuing a simple rug with great charm. This rug was found in a Mennonite household near Blue Ball, Lancaster County.

Figure 318. Dog hooked rug, made by an unknown rugmaker, probably working in Earl or East Earl Township, Lancaster County, c. 1910-20. This hooked rug was found in a Mennonite home near Blue Ball, Lancaster County. *Wool, cotton, burlap backing, 21" x 39". Collection of Nan and Jim Tshudy.*

Figure 317. Miniature Penny rug, made by Frances (Buch) Royer (1846-1925) of West Earl Township, Lancaster County, c. 1890. Frances stitched wool pennies and bits of fabric onto a homespun canvas to create this playful rug. *Homespun linen, wool, button eyes, 10.5" x 10.5". Collection of Mr. and Mrs. Wendell R. Shiffer.*

The horse rug in fig. 319 is an unusual composition. The star and arrow motifs may relate to the horses' names. The red tulip border is a bold addition. This rug was likely made c. 1910-20 as a remembrance of the family horse. It was owned by the same Mennonite family as the dog rug (fig. 318).

Some rug makers exhibit a great deal of originality in the designs of their rug patterns. Paper patterns often were exchanged among families and friends, who would then alter the pattern to personalize their rugs. The Dancing Rabbits rug (fig. 320) is an engaging design. The subject matter is so whimsical that I suspect it may have been inspired by an illustration in a children's book. The rabbits, all in a different pose, and the striated background greatly enhance the motion of their dance. Obviously the creation of a clever rug maker, this rug was owned by the Huber family of Manheim, Lancaster County.

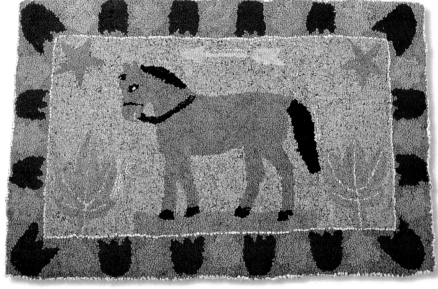

Figure 319. Horse hooked rug, made by an unknown rugmaker, probably working in Earl or East Earl Township, Lancaster County, c. 1910-20. Obviously made from an original pattern, this rug was found in a Mennonite household near Blue Ball, Lancaster County. *Wool, cotton, burlap backing, 26.5" x 41.5". Collection of Nan and Jim Tshudy.*

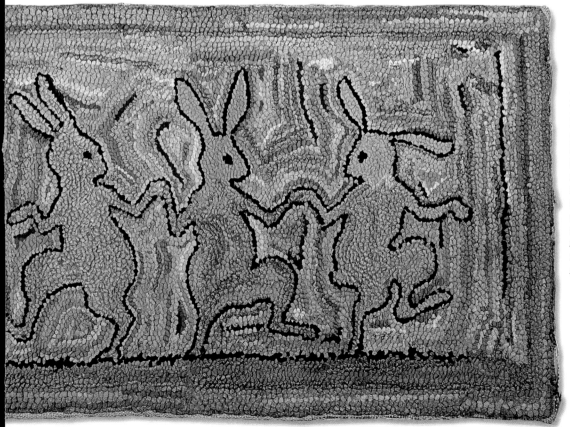

Figure 320. Dancing Rabbits hooked rug, made by an unknown rugmaker, probably working in the Manheim area, Lancaster County, c. 1930-50. By making a lively rendition of an unusual subject, dancing rabbits, this rug maker displayed her skill and her sense of whimsy. *Fabric strips, 18.75" x 30.5". Collection of Sam and Kathy McClearen.*

Perhaps the most popular hooked-rug pattern among early twentieth century Mennonite rug hookers was the hearth scene. A colonial revival phenomenon, the hearth scene embodied the nostalgic longings of early twentieth century Americans who were still rooted in the past century. Wildly popular among Mennonites and non-Mennonites alike, this pattern was executed with endless variations, most of which were far more simple than the example seen in figure 321. This rug was made in 1930 by Minnie (Nissley) Stehman (1883-1951), after she and her husband John N. Stehman retired from their East Hempfield Township farm. Minnie was a prolific and creative rug maker who used no patterns. Instead she designed her rugs as she worked on them.[14] On this rug, she took the popular hearth design but greatly expanded it, adding numerous original details. A vision of coziness, the cats are being warmed by the fire as the moon rises above a snow-covered tree. All are part of the peaceful vision of Minnie Stehman, a talented Mennonite rug maker.

Figure 321. Hearth scene rug, made by Minnie (Nissley) Stehman, working in Penn Township, Lancaster County, dated 1930. A prolific rug maker, Minnie hooked rugs for sale and for her own use. This rug has a tag sewn to the backing that reads, "fire-place sell $8." The rug never sold during the lean years of the Great Depression, but instead descended to her daughter, Anna Mae. Minnie was the daughter of Reuben Stehman and Anna (Wolgemuth) Stehman of Mount Joy Township, Lancaster County. *Wool strips, burlap backing, 39" x 68". Private collection.*

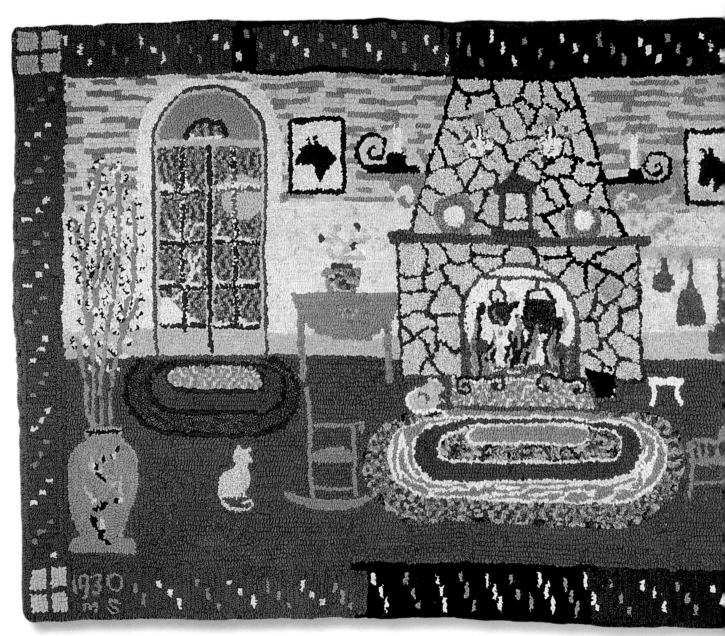

Chapter One

1. For more information concerning Ibersheim see "Mennonites at Ibersheim, Germany." *Mennonite Family History.* Volume 9, Number 3, 1990.
2. Gratz, Delbert L. *Bernese Anabaptists and Their American Descendants*, pp. 34 to 38.
3. Ruth, John L. *Maintaining the Right Fellowship*, pp. 67 and 68.
4. Peter and Elizabeth (Hershey) Risser together with Elizabeth's parents, Christian Hershey (1690-1745) and Esther (Egli) Hershey (d. 1792), arrived in Philadelphia aboard the *Robert and Alice* on September 3, 1739. Christian's parents, Christian Hershey (d. 1720) and Oade Hershey, had left Friedelsheim c. 1717, traveling to Pennsylvania with three of their children: Benjamin (1696-1789), Andrew (1702-1792), and Ann Hershey. Peter Risser and all three Hershey brothers were ordained as preachers among the Lancaster County Mennonites.
5. Correll, Ernst H. "The Mennonite Agricultural Model in the German Palatinate." *Pennsylvania Mennonite Heritage.* Volume 14, Number 4, pp. 8 to 10.

Chapter Two

1. Krefeld is located in the lower Rhine region, northeast of Düsseldorf, Germany. It became a center of tolerance, giving shelter to displaced Mennonites and others.
2. A small stone building nearby is believed to have been constructed c. 1690 by William Rittenhouse (1644-1708). The three structures compromise Historic Rittenhouse Town, a National Historic Landmark site that is operated as a public museum.
3. This clock is mentioned in the *History of the Mennonites* by Daniel K. Cassel, p.421. Philadelphia: Daniel K. Cassel, 1888.
4. For extensive information concerning seventeenth and eighteenth century Mennonite immigration see: John L. Ruth, *Maintaining the Right Fellowship.* Scottdale, Pennsylvania: Herald Press, 1984.
5. Friesen, Steve. *A Modest Mennonite Home*, p. 33.
6. Shumway, George, et. al. *Conestoga Wagon, 1750-1850.* York, Pennsylvania, 1964.
7. Receipt in 1828 German *Bible* printed by Kimber and Scharpless, Philadelphia. Purchased November 14, 1828 by John Rupp (1790-1852). "Recd. Nove 14th 1828 of John Rupp Ten Dollars in full for a Famely [sic] Bible, David Coggins agent."
8. When Anna Bare (d. 1758) the widow of 1727 immigrant Samuel Bare (d. 1743) wrote her will, she requested that her large Bible be given to Michael Shenk (d. 1785). The Bible, a 1571 Froschauer imprint remained in the possession of the Shenk family of New Providence Township, Lancaster County, for more than 230 years.

Chapter Three

1. Of this group of clothespresses, there are three additional examples which are housed in museum collections. An example inscribed "IH KAUFFMANN AN KAUFFMANNIN 1766" is housed at the William Penn Memorial Museum, Harrisburg, Pennsylvania. A second example is inscribed "EMANUEL HERR MA HER FEB D 17 1768" is in the collection of the Winterthur Museum. The third clothespress in inscribed "GEORG HUBER ANNO 1779" and is in the collection of the Philadelphia Museum of Art.

2. The will of John Bamberger was written in October 1816, and probated in 1818. Lancaster Court House will Y-2-127.

3. For additional information on Mennonite arts in Ontario see Michael S. Bird, *Ontario Fraktur: A Pennsylvania Folk Tradition in Early Canada,* also Michael S. Bird, *A Splendid Harvest: Germanic Folk and Decorative Arts in Canada.* See also Susan Burke, *From Pennsylvania to Waterloo: Pennsylvania-German Folk Culture in Transition.*

Chapter Four

1. Bomberger, Lloyd H. *Bomberger: Lancaster County Roots 1722-1986.* Lancaster, Pennsylvania, 1986.

2. The inventory of the possessions of Christian Bamberger is on file at the Lancaster County Historical Society. Although the widow had already removed her one-third share of the household goods, the remaining two-thirds appearing in the inventory suggest that their household was sparsely furnished.

3. I am indebted to R. Martin Keen, who produced a plot plan showing the Kauffman tract, and the adjoining Hiestand and Long tracts, which surround the Landisville Mennonite Meetinghouse.

4. John Mumma later re-sold the lands and moved to York County, Pennsylvania.

5. George Danner, proprietor of the Danner Museum in Manheim, Lancaster County, purchased this high chest from Franklin M. Heistand, (b. 1855) a farmer in Rapho Township, Lancaster County. Franklin's father, Christian J. Heistand (1821-1896), was a miller and farmer in

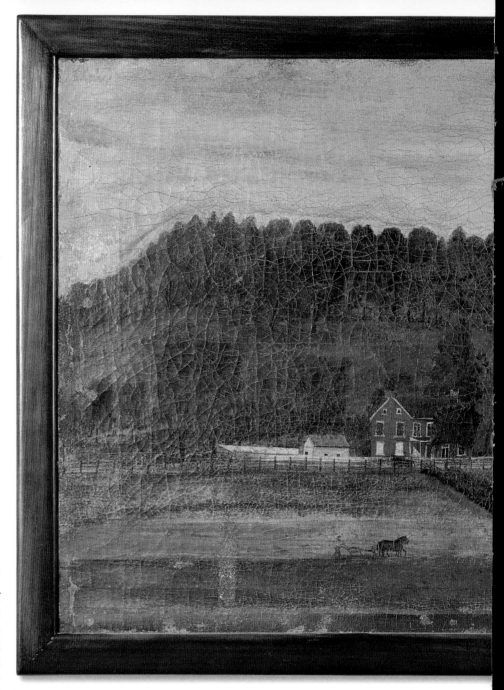

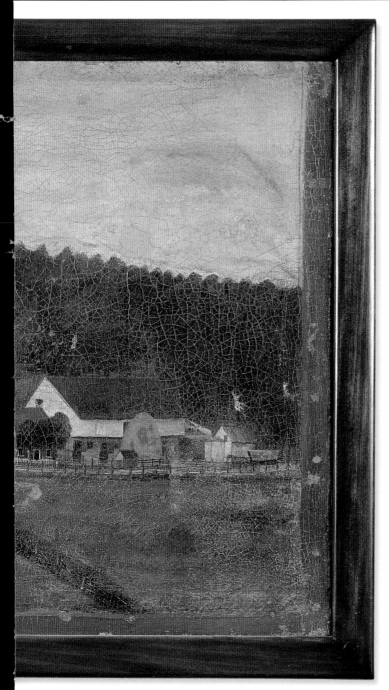

Mount Joy Township, Lancaster County. The name Christian Hiestand is written on the interior of the piece, and apparently refers to grandfather Christian Hiestand (1792-1877), the original owner.

6. The 1860 Manufacturers Census for East Hempfield Township records that the shop of "Henry Hoffman Saddler and Harness Maker" produced $2,500 in harnesses, $1,470 worth of saddles, and $5,833 worth of other mixed articles in the previous year.

7. Bamberger drawings for Catherine Westenberger (1820-1848) and her sister Elizabeth, both dated 1832, were included in the Sotheby's Auction of the Collection of Dr. and Mrs. Henry P. Deyerle, lot number 723, May 27, 1995.

8. *The Lititz Record*, a newspaper printed in Lititz, Lancaster County, reported on November 25, 1910 that Peter Burkholder of Lititz owned an Easter egg dated 1774 and initialed "MB." The Burkholders were Mennonites who had located in Warwick Township, Lancaster County, in the 1730s.

Chapter Five

1. Alderfer, Joel D. "Pennsylvania German Furniture Makers of Bucks and Montgomery Counties," p. 6.

2. Ibid.

3. For additional information see Alan G. Keyser, Editor, *The Accounts of Two Pennsylvania German Furniture Makers-Abraham Overholt, Bucks County, (1790-1833), and Peter Rank, Lebanon County, (1794-1817).*

4. For additional information see the *Daybook 1769-1828*, of Johannes Bachman.

5. Snyder, John J., Jr. *Chippendale Furniture in Lancaster County, Pennsylvania, 1760-1810.*

6. Bachman's ledger records the production of twenty clothespresses between 1771 and 1810 for sixteen different clients. All but one of the purchasers appear to have been Mennonite, most of whom were living in the present-day townships of East Lampeter, West Lampeter, Pequea, Martic, and Manor.

7. The *Daybook 1822-1861*, of Jacob Bachman is in the collection of Winterthur Museum.

8. The birth records of John Bamberger and his siblings were recorded on a piece of paper that was inserted into the *John Bamberger Copybook* c. 1795-1802.

9. See the 1815 Direct Tax of Lancaster County, Pennsylvania. The joiners shop is not listed in the 1798 Direct Tax. Both lists are housed at the Lancaster County Historical Society.

10. Six of the seven chests that are listed in Bamberger's ledger sold for $3.50 each. The last recorded chest sold for $3.00. It appears that all of the chests that were manufactured between 1831 and 1847 were of softwood construction.

11. For an example of a chest by this decorator see Monroe H. Fabian. *The Pennsylvania-German Decorated Chest*, p. 151.

12. See *Bomberger: Lancaster County Roots*, p. 82.

13. See "Taking It and Leaving It: Fraktur in Waterloo County," pp. 54 to 65. *From Pennsylvania to Waterloo: Pennsylvania-German Folk Culture in Transition.*

14. Eby, Ezra E. *A Biographical History of Early Settlers and Their Descendants in Waterloo Township*. Kitchener, Ontario. Eldon D. Weber, 1971, p. 216.

15. See Charles R. Muller. "The Furniture of Soap Hollow." pp.

2 to 7.

16. See *Manufactured By Hand: The Soap Hollow School*, pp. 19, 47.

Chapter Six

1. Garvan, Beatrice B. *The Pennsylvania German Collection*, p. 356.
2. Ibid., p. 371. Additionally, other sources have identified him as John Weber and Christian Weber.
3. I am indebted to Alan G. Keyser for locating and translating the reference.
4. The majority of the Weber woodenwares that appear in the Abraham Weber ledger were sold a few months prior to and just after the death of Anna (Horst) Weber (1808-50) the wife of Jonas Weber. It seems probable that the Abraham Webers were traveling to and from their son's Leacock Township home, in order to assist Jonas during the last illness of his wife, and immediately following her death.
5. The auction of the household of Willis W. Futer, a great-grandson of Isaac Weaver (1812-1905), was held at Horst Auction Center, Ephrata, Pennsylvania, on January 10, 1998.
6. As related to Alan G. Keyser by Orpha M. Hoover (b. 1903). Hoover was the granddaughter of Maria (Weaver) Martin (1838-1922), who was the daughter of Jonas Weber. Miss Hoover did not know her great-grandfather's name, but only that he had made her small woodenwares about 1850.
7. The only recorded slide-lid document box by Weber is inscribed "Joseph Oberholtzer 1851." This is currently the latest recorded object with a painted date. Several small objects that are attributed to Weber bear pencil inscriptions dating 1852 to 1857. They suggest that Weber likely continued to produce a few objects for several years after the death of his wife.
8. See *The New Holland Clarion*, Saturday, November 25, 1876.
9. Bell, Gary P. *Joseph Lehn-Woodturner*, p. 29.
10. Ibid., p. 32.
11. Spohn, Clarence Edwin, Ed. *Joseph Long Lehn's Day Book (1856-1876) and His Painted Woodenware*, p. IV.
12. Ibid., pp. 1 to 45.
13. Letter by Jacob N. Brubacher. *The Herald of Truth*. Elkhart, Indiana, February 1, 1888.
14. William C. Heilig had been a prolific chairmaker. The 1860 Manufacturers Census lists Heilig in Earl Township where he had produced 25 settees and 975 windsor chairs during the previous year.
15. Interview with Walter L. Bomberger, January 1999. Mr. Bomberger recalled hearing his grandfather Sem S. Brubaker's account of a visit to Joseph Lehn while accompanying his father, Jacob N. Brubacher.
16. Machmer, Richard S. and Rosemarie B. Machmer. *Just for Nice: Carving and Whittling Magic of Southeastern Pennsylvania*, p. 68.
17. Koybayashi, Teruko. "David B. Horst: St. Jacob's Woodcarver."

Chapter Seven

1. Interveiw with John J. Snyder, Jr., 1998.
2. Bruen, Frank. *Christian Forrer: The Clockmaker and His Descendants*. Rutland, Vermont: The Tuttle Publishing Company, Inc, 1939. p. 1.
3. Wood, Stacy B.C. *Clockmakers and Watchmakers of Lancaster County, Pennsylvania*, p. 37.
4. Christiana Forrer was married on October 17, 1758, to Frantz Muller (d. 1760). She married a second time to Jacob Witmer of Lampeter Township, Lancaster County.
5. From 1792 to 1794 Bretz paid the taxes on Stauffer's Manheim real estate. In 1795 Bretz was paid for building a *Klabord* fence, and repairing the bake oven at Stauffer's house. It appears that Bretz may have been occupying the property.

6. See John and William Bausman. *Quit Rent Books for Manheim Borough 1796-1812 and 1812-29.*

7. See Mathias Long. *Blacksmithing Ledger 1790-98.*

8. The records of Zion Lutheran Church, Manheim, Pennsylvania, record the birth of Christian and Maria's only child Johannes Eby on July 30, 1803. The minister noted that the father was "Christian Eby who is not yet baptized."

Chapter Eight

1. Inventory of John Landis (1748-1823) in the collection of the Lancaster County Historical Society.

2. Bausman, John and William Bausman. *Quit Rent Books for Manheim Borough 1796-1812 and 1812-29.*

3. In the 1860 Manufacturers Census Hersh is listed in Manheim Township, Lancaster County, where he reported building one broad wheeled wagon for $55, five carriages for a total of $160, and producing custom smithwork totaling $600 during the previous year.

4. A set of tool box hardware signed "HS HERSH" is in the collection of the Landis Valley Museum, Lancaster, Pennsylvania.

5. See "Sexton, 91, Advises 'work hard': Ex-Smithy Recalls His Strasburg Shop As Village News Center." Headline from an unidentified Lancaster newspaper, March 10, 1946.

Chapter Nine

1. Garvan, Beatrice B. *The Pennsylvania German Collection*, pp. 170, 357.

2. Jacob Bock (1798-1867) is the earliest documented Waterloo County potter. A surviving molded redware jar is dated 1822. See Susan M. Burke, *From Pennsylvania to Waterloo*, p. 121.

3. George Eby was the son of George Eby (1748-1800) and Barbara (Sensenig) Eby (1750-87) and the grandson of Christian Eby (1698-1756) who settled in Warwick Township, Lancaster County, along the Hammer Creek. See Ezra E. Eby, the *History of the Eby Family*. Berlin, Ontario: Hett and Eby Printers, 1889.

4. Bird, Michael S. *A Splendid Harvest: Germanic Folk and Decorative Arts in Canada*, pp. 76 to 78.

Chapter Ten

1. Recorded bookplates include: Benjamin Bauman 1751, Samuel Herr 1751, Michael Mayer Jr. 1752, Benedict Mellinger 1756, Christian Hirschy 1757, Elisabeth Meylin 1757, (2) Joh. Jacob Bayer, Carl Christophel, Jacob Graff, Benedict Hirschy, Jacob Hirschy, Hans Jacob Huber, Isaac Kauffman, David Langenecker, Daniel Langenecker, Jacob Mayer, Martin Meylin, Ludwig Stein, Peter Zimmerman.

2. See Mary Jane Lederach Hershey. *Andreas Kolb, (1749-1811)*, pp. 122-124.

3. For additional information see David R. Johnson, "Hans Jacob Brubacher Fraktur Artist," pp. 11-17.

4. For a second example of his work see Frederick S. Weiser, *The Pennsylvania German Fraktur Collection of the Free Library of Philadelphia*, volume 1, figure 131.

5. For additional information on Eyer see Frederick S. Weiser, "IAE SD The Story of Johann Adam Eyer (1755-1837) Schoolmaster and Fraktur Artist with a translation of His Roster Book 1779-1787."

6. This bookplate was penned for Magdalena Martin and is dated November 2, 1791.

7. There are three nearly identical bookplates penned by Strenge: one for Daniel Maurer dated January 1797, one for Elisabeth Lichty dated March 17, 1797, and the last one for Maria Schwahr dated March 27, 1797.

8. MacMaster, Richard K. *Conscience in Crisis: Mennonites and Other Peace Churches in America 1739-1789*, pp. 516-518.

9. For additional information see Mary Jane Lederach Hershey, *Andreas Kolb, (1749-1811)*.

10. See Frederick S. Weiser, "IAE SD The Story of Johann Adam Eyer (1755-1837) Schoolmaster and Fraktur Artist with a Translation of His Roster Book," pp. 482, 494.

11. See Michael S. Bird, *Ontario Fraktur: A Pennsylvania-German Folk Tradition in Early Canada*, p. 45, figure 20.

12. Ibid., p. 50, figure 29.

13. Johnson, David R., *Christian Strenge's Fraktur*.

14. Walters, Donald R. "Jacob Strickler, Shenandoah County, Virginia, fraktur artist." *The Magazine Antiques*, pp. 536-543.

15. The family record translates as follows: Abraham Miller born Manor Township November 2, 1756, son of Abraham Miller and Anna Hochstatter/married June 6, 1778 in Manor Twp./Barabara Havecter who was born January 1, 1758, the daughter of Joseph Havecter (Habecker) and Barbara Ehrisman/son Joseph Miller born in Manor Twp. on September 27, 1779/son Henrich Miller born in Manor Twp., on December 6, 1782/son of Johannes Miller born in Manor Twp., December 26, 1784/daughter Anna Miller born in Manor Twp., on December 28, 1778/daughter Barbara Miller born in Manor Twp., on December 24, 1790/daughter Elisabeth Miller born in Manor Twp., on March 29, 1793/son Christian Miller born in Manor Twp., on April 27, 1799.

16. "The Earl Township Artist" was identified by David R. Johnson in "The Work of Christian Alsdorff the Earl Township Artist," pp. 45-59.

17. Alsdorff penned a bookplate dated January 10, 1790, for David Horst (1769-1845), about the time of Horst's marriage to Anna Weber (1766-1823). The drawing created for neighbor, Anna Groff (b. c. 1780), is dated March 16, 1791.

18. For an example of this anonymous artist's work see Frederick S. Weiser, *The Gift is Small, the Love is Great*, p. 65, figure 56.

19. Example of Meyer's work appear in Beatrice B. Garvan, *The Pennsylvania German Collection*, p. 316, figure 2. See also Frederick S. Weiser, *The Pennsylvania Fraktur Collection of the Free Library of Philadelphia*, Volume 2, figure 865.

20. See Joel D. Alderfer. "David Kulp, His Hand and Pen Beet [sic] it if You Can: Schoolmaster David Kulp of Deep Run, the Brown Leaf Artist Identified," pp. 3-6.

21. See Karl R. Arndt, "Teach, Preach, or Weave Stockings?" *Pennsylvania Folk Life*. Volume 27, number 1, 1977.

22. Information from Joel D. Alderfer, who reported seeing a number of Hunsicker bookplates in the Montgomery County community, that are dated decades later than Hunsicker's relocation to Ontario.

23. See Martin G. Weaver, *Mennonites of Lancaster Conference*.

24. See Russel D. and Corinne P. Earnest, *Papers For Birth Dayes*. Volume 1, pp. 325-327.

25. See Frederick S. Weiser, *The Pennsylvania German Fraktur Collection of the Free Library of Philadelphia*. Volume 1, figures 187-189.

26. For a second example by Weaver see Frederick S. Weiser *The Pennsylvania German Fraktur Collection of the Free Library of Philadelphia* – Volume 2, figure 960.

27. For additional information concerning Anna Weber see E. Reginald Good. *Anna's Art: The Fraktur Art of Anna Weber a Waterloo County Mennonite Artist*.

Chapter Eleven

1. For an excellent description of the processes involved in textile production see Ellen J. Gehret, *The Homespun Textile Tradition of the Pennsylvania Germans*.

2. See John W. Heisey. *A Checklist of American Coverlet Weavers*, p. 40.

3. See Martin G. Weaver. *Mennonites of Lancaster Conference*, p. 60.

4. See Ron Walter. "Samuel B. Musselman: Coverlet Weaver in Milford and Hilltown Townships, Bucks County, Pennsylvania," pp. 8-11.

5. See Ron Walter. "Coverlet Weavers of Bucks County."

6. Burke, Susan M. *From Pennsylvania to Waterloo: Pennsylvania German Folk Culture in Transition*, p. 91.

7. See Tandy Hersh and Charles Hersh. *Samplers of the Pennsylvania Germans*, pp. 21-31.

8. Ibid., this sampler is illustrated on page 50.

9. This sampler remained in the possession of a lineal descendant of Elizabeth Bear until 1998.

10. See Tandy Hersh and Charles Hersh. *Samplers of the Pennsylvania Germans*, p. 211. Also see Ellen J. Gehret. *This is the Way I Pass My Time*, pp. 270-285.

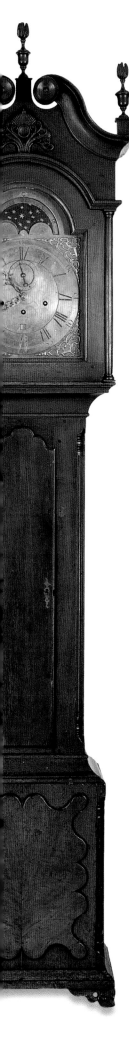

11. Tandy Hersh, "Decorated Aprons." *Der Reggeboge* Journal of the Pennsylvania German Society, Volume 22, Number 1, 1988.

12. Tandy Hersh, "Pennsylvania German Decorated Handkercheifs," *Der Reggeboge*, pp. 1-15.

13. According to a family tradition, the house was expanded to accommodate worship services by its owner, John Hess (1768-1830), a Mennonite preacher. During renovations in 1986, the foundations of a log wing were uncovered. The wing measured approximately 16' x 19', and it appears that it was removed shortly after the construction of the Hess Mennonite Meetinghouse nearby, in 1856.

14. Anna Groff's sampler is dated 1796, and an undated decorated towel also survives. The towel descended through the family of Anna's sister, Feronica (Groff) Huber (1787-1845). The threadcase, sampler, and frakturs, descended through the family of sister Mary (Groff) Stauffer (b. 1793).

15. Although free-form decorated towels were stitched at least as early as 1801, most of the documented examples were created between 1835 and 1850 by members of the Landis, Hess, Huber, and Reist families of Warwick and Manheim Townships—Lancaster County. The epi-center of their popularity appears to have been the Landis Valley and Hess Mennonite congregations who were still meeting in homes and schoolhouses prior to the erections of their meetinghouses, Landis Valley in 1847 and Hess Mennonite in 1856. The popularity of the form spread, and one example was stitched in 1852 by Mary Snyder (1832-1916) living in Waterloo County, Ontario.

Chapter Twelve

1. See Patricia T. Herr, *Quilting Traditions: Pieces From the Past*, pp. 9 and 10.

2. For a study of eighteenth century fabrics which were available in rural Pennsylvania see, Tandy and Charles Hersh, *Cloth and Costume, 1750 to 1800, Cumberland County, Pennsylvania.*

3. See Patricia T. Herr, *Quilting Traditions: Pieces From the Past*, figures 32 and 49.

4. The Schaeffer sisters were prolific needleworkers. For examples of their cross-stitch decorated textiles see Ellen J. Gehret. *This Is the Way I Pass My Time*, pp. 220-221.

5. See Patricia T. Herr, *Quilting Traditions: Pieces From the Past*, p. 145.

6. The names appearing on the quilt include a few patches which memorialize decreased relatives. The names are as follows: [I have added the bracketed information]; Anna Bear, [sister, (1826-1905)]; Catherine Landis, [quilt owner, (1828-1902)]; Mary Ann Rexroth, 1860; Mary S. Landis; Mary A. Schlott; Fannie Hess, [sister-in-law, (1833-98)]; Elizabeth Lehmy; Amelia L. Landis, [sister-in-law, 1842-97)]; Ann Rooher; Anna Garber, Remember Me, 1859, [niece]; Anna L. Landis, [sister-in-law, (1838-1905)]; Fianna Gerber; [sister-in-law, (1818-93)]; E.R. 1859; Anna L. Gerber; Mother Ann Reist-Grandmother-Anna Reist, [Ann (Shaffer) Reist, (1793-1860) and Anna (Stauffer) Reist, (1769-1842)]; Fianna S. Grabill, 1858; Barbara Grabill 1857, [sister, (b. 1829)]; Elizabeth Fry; Susan N. Landis, [sister-in-law, (1833-1900)]; Levina L. Overholtzer, [sister, (1834-1904)]; Catherine Landis [owner, (1828-1902)]; M L Getz, 1860, [sister-in-law, (1828-89)]; Eliza Hess, [sister-in-law, (1820-1908)]; Mary Reist, 1860, [sister-in-law, b.1828)]; Catharine Rupp, Aprile 1859; AEL Evan Landis; Anna Landis, Grandmother, [grandmother-in-law (1766-1845)]; Anna Long, Great-grandmother, [great-grandmother-in-law]; Anna Schaeffer, 1860; Mary Landis, 1860; Ann Landis, [mother-in-law, (1800-85); Amelia L. Landis [sister-in-law, (1842-97)]; Catherine Raeist (?), 1860; Mary Schreiner; Susan Reist; Polly Landis.

7. Simon and Fanny (Bucher) Snyder were reared on nearly adjoining farms in Warwick Township. Simon's parents, Christian Snyder (1809-68) and Barbara (Brubacher) Snyder (1813-93) purchased the Clay Township farm for their son. It is still owned by descendants.

8. Interview with Ida (Stoner) Horst (1891-1978), in May 1975. She also recalled that her mother was always dissatisfied with one patch of her sampler quilt. She had always intended to replace the patch near the quilt's center, the one that was pieced with a solid orange colored fabric, but she never got around to doing it. She died of pneumonia on her sixtieth birthday, at her home in Murrel, Lancaster County.

9. For additional examples of her work see Patricia T. Herr, *Quilting Traditions: Pieces From the Past*, pp. 65-70.

10. Interview with Anna Mae (Charles) Fretz in Vineland, Ontario, March 1999.

11. Interview with A. Grace Wenger, Edna Wenger, and Esther H. Wenger, Leola, Pennsylvania, March 7, 1987.

12. I am indebted to Nan Tshudy for providing information on the ownership of the roosters.

13. Interview with a daughter of Frances M. (Hoover) Sensenig on September 28, 1991.

14. Interview with grandson, Dr. J. Harold Housman, July 1991.

Bibliography

Abraham, Ethel Ewert. *Frakturmalen und Schönschreiben*. North Newton, Kansas: Mennonite Press, Inc., 1980.

Alderfer, Joel D. "David Kulp. His Hand and Pen, Beet [sic] it if You Can: Schoolmaster David Kulp of Deep Run, the 'Brown Leaf Artist' Identified." *Mennonite Historians of Eastern Pennsylvania Newsletter*. Volume 22, Number 1, 1996.

Alderfer, Joel D. "Pennsylvania German Furniture Makers of Bucks and Montgomery Counties." *Mennonite Historians of Eastern Pennsylvania Newsletter*. Volume 23, Number 4, 1997.

Bachman, Johannes. *Daybook 1769-1828*, microfilm at Joseph Downs Library, Winterthur Museum, Wilmington, Delaware.

Bachman, Jacob. *Daybook 1822-1861*. Collection of Joseph Downs Library, Winterthur Museum, Wilmington, Delaware.

Bamberger, John. *Copy Book c. 1795-1802*. Copywork, receipts, and drawings. Warwick Township, Lancaster County, Pennsylvania. Collection of the Author.

Bamberger, John. *Farming and Cabinetmaking Accounts 1831-1848*. Warwick Township, Lancaster County, Pennsylvania. Collection of the Author.

Barber, Edwin A. *Tulipware of the Pennsylvania-German Potters: An Historical Sketch of the Art of Slip Decoration in the United States*. Philadelphia: Pennsylvania Museum of Art, 1926.

Bausman, John and William Bausman. *Quit Rent Book for Manheim Borough, Lancaster County, Pennsylvania, 1796-1812*. Collection of the Author.

Bausman, John and William Bausman. *Quit Rent Book for Manheim Borough, Lancaster County, Pennsylvania, 1812-1829*. Collection of the Author.

Bell, Gary P. "Joseph Lehn-Woodturner." *Community Historians* Vol. 6, No. 6. Lancaster, Pennsylvania: Lancaster Theological Seminary, 1967.

Bender, Harold S., Dr., editor. *The Mennonite Encyclopedia. Vol.1-4*. Scottdale, Pennsylvania: Mennonite Publishing House, 1955.

Benson, Cynda L. *Early American Illuminated Manuscripts From the Ephrata Cloister*. Chicopee, Massachusetts: AM Lithography Corporation, (1995).

Bird, Michael S. *Ontario Fraktur: A Pennsylvania Folk Tradition in Early Canada*. Toronto: Feheley Publishing, 1977.

Bird, Michael S. and Terry Kobayashi. *A Splendid Harvest: Germanic Folk and Decorative Arts in Canada*. Toronto, Canada: Van Nostrand Reinhold Ltd., 1981.

Borneman, Henry S. *Pennsylvania German Bookplates: A Study*. Philadelphia, Pennsylvania: Pennsylvania German Society, 1953.

Borneman, Henry S. *Pennsylvania German Illuminated Manuscripts*. New York, Dover Publications Inc., 1973.

Burke, Susan, and Matthew Hill. *From Pennsylvania to Waterloo: Pennsylvania-German Folk Culture in Transition*. Kitchener, Ontario: Joseph Schneider Haus, 1991.

Drepperd, Carl W. "Joseph Lehn, The Wood Turner." *Papers Read Before the Lancaster County Historical Society*, Volume 58, Number 7, 1954.

Duck, Dorothy Hampton. "The Arts and Artists of the Ephrata Cloister." *Journal of the Lancaster County Historical Society*, Volume 97, Number 4, 1995.

Dyck, Cornelius J., Editor. *An Introduction to Mennonite History*. Scottdale, Pennsylvania: Herald Press, 1967.

Earnest, Corrine and Russell D. Earnest. *Fraktur: Folk Art and Family*. Atglen, Pennsylvania: Schiffer Publishing Ltd. 1999.

Earnest, Corinne and Russell D. Earnest. *Papers for Birth Dayes*. York, Pennsylvania: Shuman-Heritage Printing Company. 1997.

Fabian, Monroe H. *The Pennsylvania-German Decorated Chest*. New York: Main Street Press, 1978.

Faill, Carol E. *Fraktur: A Selective Guide to the Franklin and Marshall Fraktur Collection*. Lancaster, Pennsylvania: Franklin and Marshall College, 1987.

Friesen, Steve. *A Modest Mennonite Home*. Intercourse, Pennsylvania: Good Books, 1990.

Garvin, Beatrice B. *The Pennsylvania German Collection*. Philadelphia: Philadelphia Mu-

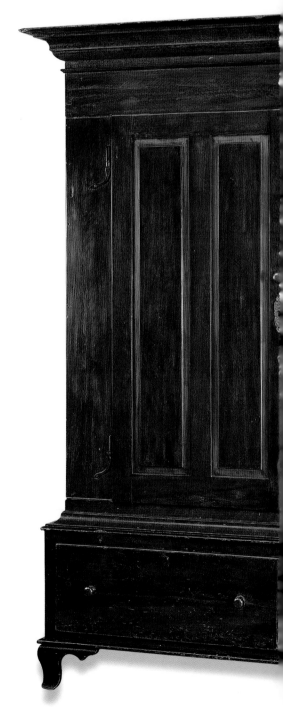

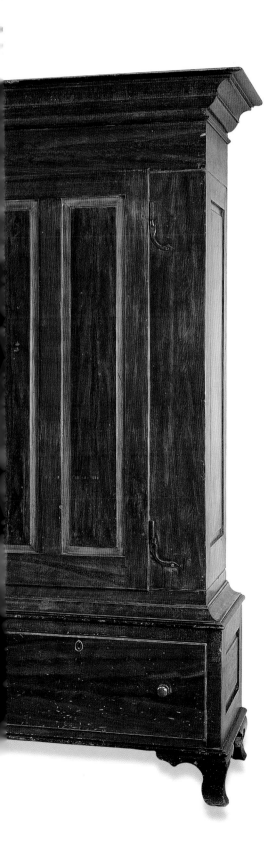

seum of Art, 1982.

Garvin, Beatrice B. and Charles F. Hummel. *The Pennsylvania Germans A Celebration of their Arts, 1683-1850.* Philadelphia: Philadephia Museum of Art, 1982.

Gehret, Ellen J. and Alan G. Keyser. *The Homespun Textile Tradition of the Pennsylvania Germans.* Lancaster, Pennsylvania: Pennsylvania Farm Museum of Landis Valley, 1976.

Gehret, Ellen J. *Rural Pennsylvania Clothing.* York, Pennsylvania: Liberty Cap Books, 1976.

Gehret, Ellen J. *This is the Way I Pass My Time.* Birdsboro, Pennsylvania: The Pennsylvania German Society, 1985.

Gibbs, James W. *Pennsylvania Clocks and Watches: Antique Timepieces and Their Makers.* University Park, Pennsylvania: The Pennsylvania State University Press, 1984.

Good, E. Reginald. *Anna's Art: The Fraktur Art of Anna Weber, a Waterloo County Mennonite Artist 1814-1888.* Kitchener, Ontario: Pochauna Publications, 1976.

Gratz, Delbert L. *Bernese Anabaptists: and Their American Descendants.* Goshen, Indiana: The Mennonite Historical Society, 1953.

Gross, Suzanne. "The Notenbüchlein (Manuscript Songbooks) Tradition in Early Franconia Conference Mennonite Communities." *Mennonite Historians of Eastern Pennsylvania Newsletter.* Volume 21, Number 6, 1989.

Heisey, John W. *A Checklist of American Coverlet Weavers.* Williamsburg, Virginia: The Colonial Williamsburg Foundation, 1978.

Herr, Donald M. *Pewter in Pennsylvania German Churches.* Birdsboro, Pennsylvania: The Pennsylvania German Society, 1991.

Herr, John. *Blacksmithing and Farming Accounts 1796-1803.* Eden Township, Lancaster County, Pennsylvania. Collection of John Tannehill.

Herr, Patricia T. *Quilting Traditions: Pieces From The Past.* Atglen, Pennsylvania: Schiffer Publishing Ltd., 2000.

Hersh, Tandy and Charles Hersh. *Cloth and Costume, 1750 to 1800, Cumberland County, Pennsylvania.* Carlisle, Pennsylvania: Cumberland County Historical Society, 1995.

Hersh, Tandy and Charles Hersh. *Samplers of the Pennsylvania Germans.* Birdsboro, Pennsylvania: The Pennsylvania German Society, 1991.

Hersh, Tandy. "Pennsylvania German Decorated Handkerchiefs." *Der Reggeboge.* Journal of the Pennsylvania German Society, Volume 20, Number 1, 1986.

Hershey, Mary Jane Lederach. *Andreas Kolb, 1749-1811.* Reprinted from the Mennonite Quarterly Review, April 1987.

Janzen, Reinhild K. and John M. Janzen. *Mennonite Furniture: A Migrant Tradition (1766-1910).* Intercourse, Pennsylvania: Good Books, 1991.

Johnson, David R. "Christian Alsdorff, the 'Earl Township Artist'." *Der Reggeboge.* Journal of the Pennsylvania: German Society, Volume 20, Number 2, 1986.

Johnson, David R. "Christian Strenge, Fraktur *Artist.*" *Der Reggeboge*, Journal of the Pennsylvania German Society, Volume 13, Number 3, 1979.

Johnson, David R. *Christian Strenge's Fraktur.* East Petersburg, Pennsylvania: East Petersburg Historical Society, 1995.

Johnson, David R. "Hans Jacob Brubacher, Fraktur Artist." *Pennsylvania Mennonite Heritage*, Volume 9, Number 1. Lancaster, Pennsylvania: Lancaster Mennonite Historical Society, 1986.

Kauffman, Henry J. *Architecture of the Pennsylvania Dutch Country.* Elverson, Pennsylvania: Olde Springfield Shoppe, 1992.

Kaufman, Stanley A. and Ricky Clark. *Germanic Folk Culture in Eastern Ohio.* Walnut Creek, Ohio: German Culture Museum, 1986.

Lasansky, Jeannette. *Bits and Pieces: Textile Traditions.* Lewisburg, Pennsylvania: Union County Historical Society, 1991.

Lasansky, Jeannette. *A Good Start: The Aussteier or Dowry.* Lewisburg, Pennsylvania: Union County Historical Society, 1991.

Lasansky, Jeannette. *Pieced by Mother: Over 100 Years of Quiltmaking Traditions.* Lewisburg, Pennsylvania: Union County Historical Society, 1988.

Lasansky, Jeannette. *To Draw, Upset, and Weld: The Work of the Pennsylvania Rural Blacksmithing.* State College, Pennsylvania: Pennsylvania State University, 1980.

Locher, Paul G. et al. *Decorative Arts of Ohio's Sonnenberg Mennonites.* Kidron Ohio: Kidron Community Historical Society, 1994.

Long, Matthias, *Blacksmithing Ledger 1790-1798 Manheim Borough, Lancaster County, Pennsylvania.* Collection of the Historical Society of the Cocalico Valley, Ephrata, Pennsylvania.

Machmer, Richard S. and Rosemarie B. Machmer. *Just for Nice: Carving and Whittling Magic of Southeastern Pennsylvania.* Reading, Pennsylvania: Historical Society of Berks County, 1991.

MacMaster, Richard K. et al. *Conscience in Crisis: Mennonites and other Peace Churches in America 1739-1789.* Scottdale, Pennsylvania: Herald Press, 1979.

Magee, D.F., Esq. "Grandfathers' Clock: Their Making and Their Makers in Lancaster County." *Papers read before the Lancaster County Historical Society*, Volume 43, Number 5, 1939.

Moyer, Dennis K. *Fraktur Writings and Folk Art Drawings of the Schwenkfelder Library*

Collection. Kutztown, Pennsylvania: The Pennsylvania German Society, 1997.

Muller, Charles R. "The Furniture of Soap Hollow." *Pennsylvania Mennonite Heritage,* Volume 23, Number 3. Lancaster, Pennsylvania: Lancaster Mennonite Historical Society, 2000.

Nykor, Lynda Musson and Patricia D. Musson. *Mennonite Furniture: the Ontario Tradition in York County.* Toronto, Canada: James Lorimer and Company, 1977.

Overholt, Abraham. *The Accounts of Two Pennsylvania German Furniture Makers-Abraham Overholt, Bucks County, (1790-1833), and Peter Rank, Lebanon County, (1794-1817).* Ed. and trans., Alan G. Keyser, et. al. Breinigsville, Pennsylvania: The Pennsylvania German Society, 1978.

Pellman, Rachel and Kenneth Pellman. *A Treasury of Mennonite Quilts.* Intercourse, Pennsylvania: Good Books, 1992.

Reist, Arthur L. *Conestoga Wagon-Masterpiece of the Blacksmith.* Lancaster, Pennsylvania: Forry and Hacker, 1975.

Ruth, John L. *Maintaining the Right Fellowship.* Scottdale, Pennsylvania: Herald Press, 1984.

Shelley, Donald A. *The Fraktur-Writings or Illuminated Manuscripts of the Pennsylvania Germans.* Allentown, Pennsylvania: Pennsylvania German Folklore Society, 1961.

Snyder, John J., Jr. *Chippendale Furniture in Lancaster County, Pennsylvania, 1760-1810.* MA Thesis. University of Delaware, 1976.

Siegrist, Joanne Hess. *Mennonite Woman of Lancaster County: A Story in Photographs from 1855-1935.* Intercourse, Pennsylvania: Good Books, 1996.

Southern Alleghenies Museum of Art. *Manufactured by Hand: The Soap Hollow School.* Loretto, Pennsylvania: The Southern Alleghenies Museum of Art, 1993.

Spohn, Clarence Edwin. *Joseph Long Lehn's Day Book (1856-1876) and His Painted Woodenware.* Lititz, Pennsylvania: The Historical Society of the Cocalico Valley, 1999.

Stopp, Klaus. *The Printed Birth and Baptismal Certificates of the German Americans.* Vols. I-V. Mainz, Germany: the Author, 1997-99.

Stoudt, John Joseph. *Early Pennsylvania Arts and Crafts.* New York: Bonanza Books, 1964.

Swank, Scott T., et al. *Arts of the Pennsylvania Germans.* New York: W.W. Norton, 1983.

Tomlonson, Judy Schroeder. *Mennonite Quilts and Pieces.* Intercourse, Pennsylvania: Good Books, 1985.

Walter, Ron. "Coverlet Weavers of Bucks County." *Mennonite Historians of Eastern Pennsylvania Newsletter.* Volume 15, Number 5, 1988.

Walter, Ron. "Samuel B. Musselman: Coverlet Weaver in Milford and Hilltown Townships, Bucks County, Pennsylvania." *Mennonite Historians of Eastern Pennsylvania Newsletter,* Volume 15, Number 1, 1988.

Weaver, Martin G. *Mennonites of Lancaster Conference.* Scottdale, Pennsylvania: The Mennonite Publishing House, 1931.

Weber, Abraham. *Ledger 1842-52. Brecknock Township. Lancaster County, Pennsylvania.* Collection of the Author.

Weber, Anna. *Seamstress' Ledger 1843-51. West Earl Township, Lancaster County, Pennsylvania.* Collection of the Lancaster Mennonite Mennonite Historical Society.

Weiser, Frederick S. *The Gift is Small, the Love is Great. Pennsylvania German Small Presentation Pieces.* York, Pennsylvania: York Graphic Services, 1994.

Weiser, Frederick S. *Fraktur: Pennsylvania German Folk Art.* Ephrata, Pennsylvania: Science Press, 1973.

Weiser, Frederick S. "IAE SD The Story of Johann Adam Eyer (1755-1837) Schoolmaster and Fraktur Artist with a Translation of His Roster Book 1779-1787." *Publications of the Pennsylvania German Society* Volume 14. Breinigsville, Pennsylvania: The Pennsylvania German Society, 1980.

Weiser, Frederick S. and Howell J. Heaney, comps. *The Pennsylvania German Fraktur Collection of the Free Library of Philadelphia, 2 vols.* Breinigsville, Pennsylvania: The Pennsylvania German Society, 1976.

Weiser, Frederick S. "The Place of Fraktur Among the Mennonites: An Introduction to the Fraktur Collection of the Lancaster Mennonite Historical Society." *Pennsylvania Mennonite Heritage,* Volume 4, Number 1. Lancaster, Pennsylvania: Lancaster Mennonite Historical Society, 1981.

Wismer, Abraham, Jr. *Weaver's Accounts 1813-1828. Bedminster Township, Bucks County, Pennsylvania.* Collection of the Mennonite Heritage Center, Harleysville, Pennsylvania.

Wismer, Henry. *Weaving, Farming, and Distilling Ledger 1768-1800. Bedminster, Bucks County, Pennsylvania.* Collection of the Mennonite Heritage Center, Harleysville, Pennsylvania.

Wood, Stacy B.C., Jr. *Clockmakers of Lancaster County and Their Clocks 1750-1850.* New York: Van Nostrand Reinhold Company, 1977.

Wood, Stacy B.C., Jr. *Clockmakers and Watchmakers of Lancaster County, Pennsylvania.* Morgantown, Pennsylvania: Masthof Press, 1995.

Wust, Klaus. *Virginia Fraktur: Penmanship as Folk Art.* Edinburg, Virginia: Shenandoah History, 1972.

Index